BLACK PERFORMANCE AND CULTURAL CRITICISM
Valerie Lee and E. Patrick Johnson, Series Editors

MAMA'S GUN

BLACK MATERNAL FIGURES AND THE POLITICS OF TRANSGRESSION

MARLO D. DAVID

THE OHIO STATE UNIVERSITY PRESS
COLUMBUS

Library of Congress Cataloging-in-Publication Data

Names: David, Marlo D., 1974– author.

Title: Mama's gun : black maternal figures and the politics of transgression / Marlo D. David.

Other titles: Black performance and cultural criticism.

Description: Columbus : The Ohio State University Press, [2016] | Series: Black performance and cultural criticism | Includes bibliographical references and index.

Identifiers: LCCN 2016021234 | ISBN 9780814213131 (cloth ; alk. paper) | ISBN 0814213138 (cloth ; alk. paper)

Subjects: LCSH: African American mothers in literature. | African American women in motion pictures. | Motherhood—Political aspects. | Motherhood—Social aspects.

Classification: LCC PS153.N5 D316 2016 | DDC 810.9/3525208996073—dc23

LC record available at https://lccn.loc.gov/2016021234

Cover design by Thao Thai
Text design by Juliet Williams
Type set in Adobe Minion Pro

Cover image: "Jade." Mixed Media, 2006. By Aja Roache.

∞ The paper used in this publication meets the minimum requirements of the American National Standard for Information Sciences—Permanence of Paper for Printed Library Materials. ANSI Z39.48–1992.

9 8 7 6 5 4 3 2 1

For all the mothers who raised me, especially Gwen Ford Roache, and for the young men who call me Mom: Tunde and Ade

CONTENTS

PREFACE

MOTHERING WHILE BLACK

> There is also undeniably a personal genesis for Black feminism, that is, the political realization that comes from the seemingly personal experiences of individual Black women's lives.
>
> —*Combahee River Collective Statement*

GROWING UP in Reagan's eighties, I could not help but be influenced by the specter of the "welfare queen" or the "teen mom" perpetuated throughout our culture. These women were the televised terrors who were most often represented in the media as black, and if I believed these characterizations, they were women who threatened the morals of the civilized and had the ability to bankrupt the nation through their wombs. No matter how much my family assured me that these were phantoms conjured up by white supremacist ideologies, I couldn't reconcile that with the imagery and rhetoric that made these women seem all too real and overwhelmingly present. These were stereotypes that I never wanted to be mistaken for because they seemed to substantiate ideas that black girls and women were thoughtless, careless breeders and unfit mothers. Though I was raised by strong, intelligent, and resourceful black women who defied those stereotypes every day, I was still aware that I might be seen in the same way that politicians and the media portrayed me and other black teenage girls to be—promiscuous and reckless. When girls I grew up with started having babies in high school, I didn't understand how they could betray the values I thought we all shared and feed into these myths. Instead, I wanted to prove society wrong and be seen as a respectable young woman, "a credit to my race," which reflected the uplift values of my middle-class nuclear family.

Raised in a politically and socially conscious household, I understood that being a "good girl" had consequences beyond my developing womanhood,

effects that related to our entire community. There is no doubt that the neo-liberal value of "personal responsibility" circulating in my post–Civil Rights childhood contributed to the formation of such ideas, not to mention values passed on by my family. Cathy Cohen reminds us that in daily black experience, the stark divide between "respectable" and "deviant" behavior determines "one's access to needed resources. If we take, for example, the idea of the family, specifically the ideal of the nuclear family, we find its continued prominence or at least one's conformity to it, as a standard in determining the distribution of political, economic, and social resources."[1] Cohen notes that the refutation of black deviance, particularly in family formations that reflect the nuclear ideal, has long stood as a major pillar in black politics in America, affecting our political, economic, and social survival. My parents, extended relatives, and family friends had tacit and explicit understanding of these facts and shaped my world accordingly.

By the time I became a mother in the late 1990s, many of these ideas still held weight for me. Unmarried at the time of my first pregnancy, my fiancé and I rushed to the courthouse to "make things right" before my due date. I wasn't prepared to tell certain family members about my pregnancy until I could announce that I was married too. Although I refused to let stereotypes define me in so many aspects of my life, certain attitudes and expectations impacted decisions I made and helped construct my personal identity as a mother. I wanted to be a "good mother," and the personal genesis for this book emerges from reflection on the experiences I have faced trying to fit that ideal, to make myself feel legitimate, respectable, normal, and responsible as a black woman and mother within the various social spheres to which I belong.

I began thinking about these ideas in earnest when I began graduate school in 2004. At the time, I was a married mother of two sons and I had just left a career as a newspaper reporter and editor to pursue a doctorate. The summer before I entered my graduate program, I attended an orientation program meant to help nonwhite students acclimate to entrance into predominantly white graduate programs. In the course of a particular workshop on work-life balance—attended almost exclusively by women because we all *know* that men don't have to balance their work and lives—I was advised by a recently minted PhD, a black woman, that I should not mention that I am a mother to my professors. The speaker, a single mother, felt that she had been beset by unspoken judgments about her quality as a researcher and her seriousness as an academic in part because she is black, single, and a mother. To claim these identities in the ivory halls of academia was anathema, and she felt she had paid an emotional price and had been marginalized for mothering while black. She offered her advice to me like a coded quilt hung on a

fence on the Underground Railroad. The message read: Don't bring unnecessary attention to your mothering self, unless you want a kind of scrutiny in excess of what was to be expected generally as a black woman in the upper echelons of higher education. This advice overwhelmed me because it asked me to deny or hide one of the most critical aspects of myself—my life as a mother—one of the very reasons that I chose to pursue a PhD in the first place.

So what did I do? I immediately "outed" myself. The first short paper I wrote for a graduate seminar discussed this woman's advice and how it spoke to aspects of difference that intersect with race or gender or class. I argued that "difference" in environments that proscribed normativity can operate on levels beyond simply embodied visual markers, such as race and gender. I argued that there are differences that can sometimes be perceived only by the individual, and that as teachers we cannot presume we know the diversity of our classrooms simply by looking at who fills the seats. Not only that, I argued that at any given moment these visual markers of difference and unseen identities are working in tandem to create a holistic experience. I used myself as an example. Motherhood for me was another minoritized status in academia, even if half of my professors were women and a couple of them were black. I still felt outside of this community, even if I could somehow hide my motherhood so that no one would know. The socially normative "intellectual" is rarely embodied by a black woman, and hardly ever thought of with a child in her arms, despite efforts to reclaim the single-mother figure as a "domestic intellectual."[2] My motherhood seemed to contradict my identity as scholar, a fact that seemed magnified after I divorced during graduate school and became a single mother.

I also come to the topic of this book as a woman who has spent the last eighteen years mothering while black. I use the phrase "mothering while black" to suggest all of the same connotations that the phrase "driving while black" brings forth. "Driving while black" has become a popular shorthand to describe the effects of racial profiling on black drivers who are stopped by law enforcement officers who assume on the basis of race that the black occupants of the car have broken the law. Therefore, to do anything "while black" presumes criminality and guilt without evidence. So when I say "mothering while black," I am drawing on situations where I have experienced questioning or judgment of my mothering that I attribute to notions of "good" and "bad" mothering that are raced, classed, and gendered. More insidious than the outright insults I have endured (like the time a white man asked my playful sons if they had been "raised in a barn") is the undeniable sense of surveillance that I feel in public. All mothers face, in some way, sexist social expectations about

the quality of their care, whether the care conforms properly to normative notions of feminine parenting, and whether their child behaves in idealized ways and is on his or her way to becoming a good citizen. Yet, the particular ways that these expectations are shaped by racial biases in this country contribute to a special scrutiny of black mothers.[3]

The political and social effects of this scrutiny are undeniable. Observing the last three presidential election cycles—2008, 2012, and 2016—as well as the general news and popular culture of the last several years has reminded me how fraught black motherhood is in America and how easily it can be mobilized through language and image toward the prevailing neoliberal agenda of our times. Remember these moments? The hostile language and imagery circulated about First Lady Michelle Obama's work as "Mom in Chief." The Republicans' return to welfare scapegoating as campaign tactic.[4] The claim by Bill Bennett, after Hurricane Katrina devastated New Orleans in 2005, that crime rates would go down if more black women had abortions. The arrests of Kelley Williams-Bolar and Tonya Chase, two black mothers accused of "stealing" a public education for their children.[5] The Internet shaming of a black mother after her daughter was sexually victimized, as Jimi Izrael did in his essay "I am Amber Cole's Father."[6] Or, the sad, inevitable position of women like Sybrina Fulton, mother of Trayvon Martin, and Lesley McSpadden, mother of Michael Brown, whose public grief and outrage over the murder of their teenage sons reminded so many of us of the particular risks of raising black children. Black mothers are routinely pointed to as the source of criminality in our youth as well as part of the reason for the nation's economic decline. Each of the examples I've cited and the others I explore in this book are part of our recent past, and they each shape how we imagine who belongs to our nation and who does not. They determine who deserves our sentiment or our judgment. Whose children are deemed valuable or expendable. Which women are protected and empowered and which ones are available for abuse or scorn. This book traces the contemporary symbolic life of the black mother as cultural symbol, literary figure, political icon, and subject-citizen not only to describe the pressing political and social realities of this this figure today but also to offer examples of literary and cultural moments that resist prevailing narratives. How do black mothers "talk back" to power? They use "mama's gun."

ACKNOWLEDGMENTS

I COULD NOT have completed this book without the advice, support, and assistance of countless teachers, mentors, colleagues, friends, and family members. I am eternally thankful for the guidance of my mentors at the University of Florida, who first helped me shape this project: Stephanie Y. Evans, Tace Hedrick, and L. H. Stallings. I give many thanks to Kevin E. Quashie at Smith College for his brilliant suggestions in the early stages of this book. I especially appreciate the fierce direction of Debra Walker King, my primary advisor, a brilliant scholar and taskmaster with prose, who always supported my eclectic ideas and vision for this book. The strong support of each of you has helped shape this book and launch my career.

I must also acknowledge the Florida Education Foundation and its McKnight Doctoral Fellowship, which allowed me to leave a ten-year career in newspapers to pursue the life of a scholar and researcher.

To the reviewers who sent excellent suggestions and agonizing feedback, I thank you for your time and interest in my work. Your ideas have made this book so much stronger. Special thanks to the editors of the Black Performance and Cultural Criticism series, Valerie Lee and E. Patrick Johnson, who endorsed this book for publication. Your belief in my project means the world to me. My appreciation extends also to Lindsay Martin, acquisitions editor for The Ohio State University Press, for your capable handling of my manuscript.

I have been fortunate to meet wonderful friends and supportive colleagues while working and teaching at Purdue University. Thank you: Langs-

ton Bates, Elena Benedicto, Evie Blackwood, TJ Boisseau, Marianne Boruch, Nadia Brown, Cornelius Bynum, Susan Curtis, Dorothy Deering, Wendy Flory, Laurie Graham, Leonard Harris, Chrystal Johnson, Mike Johnston, Su'ad Khabeer, Julie Knoeller, Maren Linnett, Al Lopez, Robyn Malo, Valentine Moghadam, Bill Mullen, Venetria Patton, Nancy Peterson, Mike Ryan, Aparajita Sagar, Patsy Schweickart, Matilda Stokes, Sandra Sydnor, Renee Thomas, Natasha Watkins, and Irwin "Bud" Weiser. Each of you in your own way offered me the friendly encouragement and professional support that I needed to get this book off of my desk and into the world. A special shout-out goes to my Purdue "NPG" crew: Jennifer Freeman Marshall, Cheryl Cooky, and Alicia Decker. You are three amazing feminist scholars who helped me stay sane and keep laughing during my years on the tenure track. I will cherish our bond forever. While at Purdue, I also have been fortunate enough to work with passionate graduate students who have kept me thinking and growing as a scholar. Many thanks to Bianca Batti, Juanita Crider, Chelsea Frazier, Casarae Gibson, Aria Halliday, Ivan Jackson, Daniela Jimenez, Christopher Munt, Deena Varner, and Lisa Young.

I appreciate the advice and energy of my colleagues and friends outside of my Purdue community: Zakiya Adair, Adam J. Banks, Marlon M. Bailey, Kevin Brown, Giles Harrison-Conwill, William Conwill, Tanisha C. Ford, DoVeanna Fulton, Kai M. Green, Faye Harrison, Kermit Harrison, Chioke Ianson, Patricia Williams Lessane, Mel Michelle Lewis, Cassandra Lord, Uri McMillan, Mirielle Miller-Young, Amy Ongiri, Greg Tate, Greg Thomas, Aishah Shahidah Simmons, Stephanie Troutman, and Erica Williams. I absolutely could not have finished writing this book without the loving insights from the members of the S.P.A.C.E. intellectual collective: Treva B. Lindsey, L. H. Stallings, Angelique V. Nixon, Darius Bost, Marlon R. Moore, Rachel Robinson, and C. Riley Snorton.

To the incomparable Antonio Tillis: thank you for helping me get on my feet in Lafayette and becoming a great friend in the process.

One love to my forever FAMUily: Paloma McGregor, Rashida Clendening, Lawrence Patrick, Tacuma Roeback, and Elton Bradman. The third floor of Tucker Hall cannot be stopped. I am so proud to see where our passions have taken us over these years.

To all my hustling mamas who are holding it DOWN: I see you. Your efforts to maintain strong families and healthy children are not invisible, at least not to me. Big thanks to my personal mama circle: Abigail Apolinaris, Ebony Barrett-Kennedy, Nicole Banton, Atheka Graham, Tanita Harris-Ligons, Shellie Minnis, Sophia Buggs, Leslie Waldon, and Tenisha Waddell. Each of you is a part of this book.

I come from an amazing, artistic, political, outspoken family that supported me emotionally and financially through the process of writing this book. First, I have to say thank you to my ancestors, my grandparents and great-grandparents, who, through their examples and hard work, instilled a love of learning in me. To my lovely sister, Aja Roache: thank you a million times for being my #1 Ace. I have too many aunts, uncles, cousins, play-family, and extended kin to name here, but to all of the people who raised me and were raised with me: I love you and cherish you. Above all, I give my deepest gratitude to my parents, Joseph C. Roache Jr. and Gwen Ford Roache. I write this book to honor you for the opportunities you've provided. Thank you for raising me to be the "free spirit" I have become.

I don't know if my sons, Tunde and Ade Azikwe, will ever understand how essential they were to the creation of this book. When I started thinking of this project, they had just started elementary school. Now they are nearly high school graduates. My experiences as their mother inspired my ideas, and the need to work and support them kept me grinding even when my tank was empty. I hope you two are proud of what I have accomplished.

Finally, to my best friend and husband DuShaun Goings: I did not believe I could love someone as deeply as I love you. And then you walked through that door. It was serendipity (kind of). Thank you for joining me on this journey. Freedom is ours.

I **ALSO** gratefully acknowledge permission to reproduce the following material:

Chapter 1: *"I Got Self, Pencil and Notebook": Literacy and Maternal Desire in Sapphire's* PUSH is reprinted with permission from *Tulsa Studies of Women's Literature,* published by the University of Tulsa.

Lyrics for "And On (. . . & On)": Words and Music by Erica Wright, Jahmal D. Cantero, Harold Lashaun Martin, and James Poyser Copyright © 2000 by Universal Music—MGB Songs, Divine Pimp Publishing, Universal Music Corp.

McNooter Publishing, Jajapo Music Inc. and Shunwun All Rights for Divine Pimp Publishing Controlled and Administered by Universal Music—MGB Songs All Rights for McNooter Publishing Controlled and Administered by Universal Music Corp. All Rights for Jajapo Music Inc. Administered by Songs Of Peer, Ltd. International Copyright Secured All Rights Reserved *Reprinted by Permission of Hal Leonard Corporation.*

Lyrics for "Evalina Coffey (The Legend Of)": Words and Music by Abbey Lincoln Copyright © 1992 Moseka Music All Rights Administered by BMG Rights Management (US) LLC All Rights Reserved Used by Permission *Reprinted by Permission of Hal Leonard Corporation.*

Lyrics for "Me": Words and Music by Erica Wright, Taz Arnold, Shafiq A. Husayn, and Ommas Keith-Graham Copyright © 2000, 2008 by Universal Music—MGB Songs, Divine Pimp Publishing, Universal Music Corp., Ommas Keith Music LLC, Jajapo Music Inc., Ruff Edge Music, and Big Yacht Music All Rights for Divine Pimp Publishing Controlled and Administered by Universal Music—MGB Songs All Rights for Ommas Keith Music LLC Controlled and Administered by Universal Music Corp. All Rights for Jajapo Music Inc. Administered by Songs Of Peer, Ltd. International Copyright Secured All Rights Reserved *Reprinted by Permission of Hal Leonard Corporation.*

INTRODUCTION

BAD MOTHERS AND BAAAAD MUTHAS

BLACK MATERNAL FIGURES IN POST-CIVIL RIGHTS AMERICA

Poor single black women with children . . . are reminded daily of their distance from the promise of full citizenship.

—Cathy J. Cohen, "Deviance as Resistance"[1]

Throughout the [2008] campaign [Michelle Obama] was caricatured as a Sapphire-like loud-mouth matriarch.

—Farah Jasmine Griffin, "At Last . . . ?: Michelle Obama, Beyoncé, Race and History"[2]

Although historical myths are seldom imported wholesale into the contemporary era, they are meaningfully connected to 21st-century portrayals of black women in public discourse.

—Melissa Harris-Perry, *Sister Citizen*[3]

IT HAS BEEN FASCINATING yet also frustrating to watch the nation engage with First Lady Michelle Obama throughout the historic two-term presidency of Barack Obama. Among the numerous representations of the First Lady, the April 2013 issue of *Vogue* magazine, which I keep on my coffee table at home, stands out. The cover image depicts her smiling, with the headline "Michelle Obama: How the First Lady and the President Are Inspiring America."[4] She strikes a friendly and confident pose, adorned in a jewel-toned sleeveless dress, baring her arms in a way that no other First Lady before her has. Inside, the magazine displays a photograph of the First Lady with her arms draped around the Leader of the Free World, and the

headline labels them an "American Family." Deeper inside the feature, the words "American Ideal" appear opposite an image of Michelle Obama standing in an august room of the White House in a grand black ball gown. The article focuses on how the Obamas managed family life at the start of their second term, particularly portraying Michelle Obama as the quintessential modern American mother: accomplished and outspoken, yet primarily concerned with supporting her man and raising her children. After all, "first and foremost, Michelle thinks about the girls."[5] The combination of image and text reminds readers that there is much to admire about the First Lady as a wife and mother, and because of these qualities, there is cause to celebrate too. To see a black woman from a working-class community in a primarily black section of Chicago embody such a visible position of power and privilege exemplifies national progress. *She is living the American Dream. The nation is moving beyond race.* Yet, the reality is it has been a tough climb for Michelle Obama to go from the "Sapphire-like loud-mouth matriarch" depicted during her husband's first campaign to the "inspiring" and "ideal" *American* wife and mother during her years in Washington. Indeed, the image of progress conveyed in the *Vogue* article belies the disparagement Michelle Obama continues to receive, which she openly addressed in a commencement speech to Tuskegee University graduates in 2015. Describing her coverage in the media, she identified "conversations sometimes rooted in the fears and misperceptions of others. Was I too loud, or too angry, or too emasculating? Or was I too soft, too much of a mom, not enough of a career woman?"[6]

The variety of insults and slights directed toward Michelle Obama reflect a set of recurring representations of black womanhood, and specifically draw on lingering racialized maternal imagery and narratives that show we have not come as far along as we would like to think. She's been depicted as a radical, fist-bumping militant, a failed feminist savior, a baby mama, an eye-rolling shrew, and a cool mom who can teach everyone to dance, among other things.[7] As America's self-proclaimed Mom-in-Chief, what can Michelle Obama tell us about the shifting and strategic invocation of tropes of black motherhood in an allegedly post-racial America? How are the historical myths that Melissa Harris-Perry describes in her book *Sister Citizen* connected to contemporary portrayals of black maternal figures in literature and popular culture? If Michelle Obama stands as one of the closest possibilities for black women's symbolic inclusion into the "American Ideal" of motherhood, yet is subjected to race, class, gender, and sexual fictions similar to those experienced by other black mothers in everyday America, what does that say about the continuing political and cultural significance of those dominant maternal

representations? Why do certain negative perceptions about black mothers continue to circulate despite our nation's alleged racial progress?

This book explores these overlapping questions through an analysis of undesirable stereotypes about black mothers appearing in African American cultural production in the post–Civil Rights era. Since the 1990s, important scholarly work has been done to identify controlling images of black motherhood and elucidate their functions. However, for this project, I shift my "angle of seeing" toward an examination of the ways that black writers and performers use those very images of unmotherly mothers in their imaginative works.[8] From this vantage point, I locate transgressive black maternal figures that transform dominant images and narratives of black motherhood that appear in contemporary media and political discourse into alternative cultural symbols that work to revise and resist hegemonic power.[9] The appearance of these altered maternal figures in novels, film, and popular culture also powerfully refuses a racial progress narrative that supports the dangerous and false belief that we are living in a post-racial America. By continuing to bring these stereotypical narratives and images to our consciousness, the works included in this study force readers to confront their continued salience and address their implications. Throughout this book, I suggest new ways of interpreting these socially marginalized and wild women characters, not simply as confirmations of negative stereotypes, but rather as representations of blackness that centralize the subjectivities and citizenship of black women against a tide of marginalizing social and political realities. By examining the texts compiled here, I also hope to challenge prevailing notions that posit "positive representation" and respectability as the only viable cultural strategies against the misrepresentation of black womanhood.

So, what is mama's gun? Like other tropes within black cultural studies, such as Henry Louis Gates's signifying monkey, Houston Baker's blues ideology, or bell hooks's notion of "talking back," mama's gun is a vernacular-derived metaphor naming a set of distinctive thematic or aesthetic patterns appearing in black culture that can be grouped based on unifying elements.[10] Some readers may be immediately familiar with the phrase "mama's gun," which is the title of an album by experimental soul singer and performance artist Erykah Badu. Considered a neo-soul classic, Badu's *Mama's Gun* (2000) serves as a significant inspiration for the development of this trope, in part because Badu's phrase juxtaposes the contradictions of nurturing and violence, protection and threat, or care and disregard, and this project is concerned with theorizing paradox, incongruity, and disruption in contemporary black cultural production. Badu's phrase, along with other vernacu-

lar citations discussed later in this chapter, help develop the trope's general meaning, one that refers to the precariousness of black motherhood as a status of both reverence and disregard. However, for the purpose of this book, mama's gun specifically signals the appearance of controlling images of black motherhood that operate recursively as alternative cultural symbols with the ability to resist the marginalizing function of the stereotypes that they perform. The trope identifies both a kind of character and a way of reading. In the first sense, I identify mama's gun figures throughout the book with the following rubric: (1) the maternal figure draws on one or more controlling images or significant stereotypes of U.S. black motherhood, (2) the controlling image or stereotype is signified upon in the text or performance in some way, and (3) the act of signifying has the ability to, but does not always, alter the denigrating and marginalizing function of the stereotype in ways that centralize subjectivities of black mothers. Using this rubric throughout the book, I identify specific characters as mama's gun figures, including Erykah Badu herself, whom I discuss in chapter 3. In the second sense, *mama's gun* describes an analytical perspective toward reading black cultural texts. It is a way of reading that privileges the non-normative, the off-kilter, the abrasive, the discomforting, or the "ratchet" in black cultural production. A mama's gun analysis seeks to reveal the subversive *potential* in the contradictions and messiness found in a variety of texts as a means of destabilizing ideologies of moral and aesthetic perfection that are used to judge black art and discriminate against black people in everyday life.

Mama, Mami, Mummy, Ma, Nana, Mother, Big Mama, M'Dear, Sweet Mama, Baby Mama, Hootchie Mama, Lil Mama, and even *Mom-in-Chief.* Sometimes terms of endearment and sometimes terms of derision, these names exemplify the multiplicities of black motherhood expressed in contemporary American life. Whether she is a working-poor single mother or the First Lady of the United States, the black maternal figure bears powerful representational weight among members of dominant and marginalized groups. Through the circulation of images and narratives, black maternal figures are marked as villain or victim within hegemonic discourses of the family and nation in ways that are distinct from other racial maternal figures.[11] Intraracially, black mothers often signify origins, tradition, family cohesion, strength, and survival among their racial familiars. Black mothers are considered the initial and instrumental conduits to blackness itself; being born to a black mother is, in part, what makes one black in America. Although affirming in many ways, this intraracial high esteem can be precarious and stifling because prescriptions of respectability and expectations of racial conformity often place black mothers under undue scrutiny by members of their

own family and community. On the other hand, black mothers also function as fungible signs of excess, violence, trauma, pathology, laziness, or victimization to a variety of privileged groups in America, including white men and women as well as groups of men and women of all racial and ethnic backgrounds. Whether these identifications produce scorn or pity, they draw on deeply embedded ideologies about black womanhood—what Patricia Hill Collins calls "controlling images"—that fail to recognize the subjectivities of black women and seek to exclude them from locations of power and privilege.[12] Imagining black women as Mammys, Matriarchs, Jezebels, and Sapphires makes it easier to scapegoat black women for a number of social ills. An emphasis on respectability, marriage, domesticity, self-reliance, normative gender roles, and heterosexuality permeates these controlling images both inter- and intraracially, coding all black mothers as "bad mothers" who are unfit child-bearers for the idealized white, heteropatriarchal nation.

Images and narratives that distinguish "good" and "bad" mothers produce, regulate, and discipline ideologies of national belonging. Ideologies of national belonging identify which groups of citizens are worthy of protection and inclusion in the "imagined community" of the nation and which groups have access to the American Dream.[13] The oppositional designations of "good" and "bad" mothers help mark the boundaries between what Inderpal Grewal identifies as subject-citizen and Other.[14] The "good mother" is the maternal subject-citizen *par excellence,* the idealized child-bearer of the nation. Whiteness, traditional femininity, affluence, legal citizenship, heterosexuality, fertility, monogamy, and marriage work intersectionally to improve one's access to the designation "good mother." In other words, being deemed a "good mother" has less to do with quality of care, love, or nurturing of children than it does with social location. The "good mother" reproduces ideal citizens by conforming to the gender, sexual, class, and racial expectations of the American nuclear family.[15]

On the other hand, "bad mothers" are nonsubjects and Other because they represent the failure of certain women to live up to the expectations and prescriptions of feminine parenting. "Bad mothers" may also fail to conform to class-based, racial, and sexual norms in the national imagination. A "bad mother" cannot reproduce the ideal national subject-citizen, who is any individual of any background that most closely identifies with the power and privileges of affluent, straight white men. Unable to reproduce ideal citizens, "bad mothers" threaten the American project. The specter of the "bad mother" often drives legislative, judicial, law enforcement, and economic actions set out to restrict the rights of all women.[16] By scapegoating mothers who do not fit a normative ideal, dominant groups of men and women have

been able to justify eugenic "family planning" programs, state-enforced sterilization, welfare discrimination and cutbacks, immigration abuses, attacks on reproductive freedom, and other regressive political schemes. While some white women, especially poor and working-class white women, have faced significant marginalization as "bad mothers" and have been designated as "unfit" by social service, law enforcement, and religious institutions, the scale, scope, and contours of their marginalization are different from those experienced by black mothers and other women of color.

The interaction between controlling images of black womanhood and the construction of "bad mothers" bears a significant role in understanding how black maternal figures function in contemporary U.S. culture as distinct from other groups of women. In fact, in many cases various kinds of mothers are compared to each other in order to mark the opposition between "good" and "bad." Keeping these intersectional concerns in mind, I focus on a variety of black maternal figures with a keen sense of how all racialized motherhoods work together to produce and maintain certain hierarchical arrangements of power.[17] Throughout this book, I move between the polarities of inter- and intraracial perspectives about black mothers in order to consider the complex and contradictory functions of black maternal figures in recent African American literature and performance.[18] I am concerned with the following critical questions: How have black writers and performers responded to black maternal controlling images? What happens when a black text employs a controlling image of black motherhood? Do these texts simply reinscribe controlling images, or can they provide a break in the signifying chain of historical myths? If a text breaks a signifying chain, then how is that accomplished, and what are its effects?

One way to break a signifying chain is through vernacular revision and repetition with a difference. For example, the black vernacular phrase "baaaad mutha" disrupts the standardized meaning of "bad mother" to connote a variety of behaviors, relationships, identities, genders, and value that are divergent from the dominant rule of language. The phrase "baaaad mutha," with its alternative intonation and meaning, demonstrates the dynamic flexibility of black vernacular to take the words, signs, and symbols of the dominant culture and repurpose them.

Zora Neale Hurston describes this kind of cultural transformation in her classic text "Characteristics of Negro Expression" when she explains that "the Negro, even with detached words in his vocabulary—not evolved in him but transplanted on his tongue by contact—must add action to it to make it do."[19] The need to "make it do" refers to the ways in which black culture produces alternatives to the symbolic order of domination and exclusion. Reworking

standard English phrases and ideas is a creative way to get by with the means available. The "bad mother" is a corrupt or unfit figure that exists in a rigid binary relationship to its idealized opposite, the "good mother." However, a "baaaad mutha" could be a strong, outspoken grandma, a sexually bold and attractive woman with no children, or even the fictional black private detective Shaft.[20] L. H. Stallings explains that the term *mutha* works to "blur the line that separates the sacred and the profane, and its usage in African America does the same with the binary of good and bad since its meaning can have either positive or negative connotations."[21] Therefore, it does not matter if the "baaaad mutha" is actually good or bad in a traditional sense, because the binary of good and bad itself is undermined in this act of vernacular revision or signifyin(g).[22] I am concerned in this book with those texts that signify on "bad mothers" through an attention to "baaaad muthas," those black maternal figures that transgress or subvert the powerful influence of controlling images of black motherhood.

I categorize the figures studied through the mama's gun trope. Mama's gun draws upon a black vernacular expression to illustrate culturally specific ways of knowing. The juxtaposition of *mama*, which connotes nurturing and femininity, and *gun*, which signifies destruction and masculinity, enacts the duality of these qualities in the figures that I study here. Much like the expression "baaaad mutha," mama's gun resists binaries and exemplifies the flexibility of black cultural expression to reimagine dominant representations in order to connote variations in behaviors, relationships, identities, genders, and value. Mama's gun offers an approach to reading contemporary texts that privileges non-normative and gender-fluid depictions of black maternal figures as transgressive and subversive manipulations of dominant images and narratives of black motherhood that appear inside and outside of black cultural spaces. Keeping in mind that not all black vernacular revisions result in transformative cultural practices, this text also addresses the conceptual limitations of this kind of resistance. A mama's gun analysis seeks the subversive and transgressive possibilities found in the appearance of black maternal figures in contemporary culture. Specifically, I explore both literary and performance texts of the post–Civil Rights period: *The Color Purple* by Alice Walker (1982), *Dawn* by Octavia Butler (1987), *PUSH* by Sapphire (1996), *Getting Mother's Body* (2004) by Suzan-Lori Parks, and the recent performances and writings of actors Tyler Perry and RuPaul, as well as the work of singer and performance artist Erykah Badu. In the texts used in this project, black maternal figures speak, sing, write, and generally "come to voice" and "talk back" through experiences that are connected to nontraditional, non-normative versions of motherhood. These characters are "baaaad muthas."

Mama's gun figures—the names I have given to identify the transgressive black maternal figures in this study—recur and revise well-known controlling images through creative self-fashioning, self-definition, and reclaimed subjectivity. However, what these mama's gun figures say, sing, write, or do may not generally be understood as expressions of maternal subjectivity or any engagement with motherhood at all. In fact, in some cases, the figures in this book may reject motherhood altogether. Still, whether motherhood is rejected or accepted, voluntary or forced, "good" or "bad," these mama's gun figures appearing in literature and performance interact with the social and cultural anxieties of their time and provide insights into their meanings.

Contemporary representations of black mothers are profoundly and uniquely affected by a set of intertwined sociocultural anxieties emerging in the post–Civil Rights era. As U.S. society has made limited progress toward the inclusion of marginalized groups into once impenetrable bastions of white privilege, fears arise that the "traditions" of the nation have been abandoned or are under attack. Politicians, corporate media personalities, and religious leaders often stoke these fears through coded language meant to heighten the political backlash toward any sort of progressive movement. Rhetorical appeals to the "founding fathers" or the language of "taking our country back" and "Make America Great Again" are just a few examples of the coded language that express this longing for a "tradition" that relied on physical and epistemic violence, genocide, disenfranchisement, dehumanization, and other technologies of exclusion. Each black maternal figure examined in this book emerges from a historically embedded signifying chain (controlling image) that has responded to new forms of racialization surfacing through these sociocultural anxieties, which will be described in more detail later in this chapter. What is important to remember, however, is that these political shifts are about the maintenance, promotion, and regulation of white, heterosexual, middle- and upper-middle-class norms as well as the consolidation of wealth among a very small percentage of people. Therefore, this project uses interdisciplinary black feminist and cultural studies methods and methodologies to examine the relationships among society, culture, and politics as a means of undermining those exclusionary and violent aims.

In some ways, I am walking over a well-laid path with this study; throughout the book, I engage with some of the most influential concepts within studies of black motherhood. Ideas like "controlling images" and figures such as the Mammy and the Matriarch or the enslaved black mother and the welfare queen have become common lexicon in the fields of African American studies, American studies, and women's, gender, and sexuality studies. The significant contributions of black feminist scholars have helped identify and

interrogate these signs throughout society, particularly providing detailed explanations of how these representations sustain hegemonic notions of race, gender, family, home, and nation. Building from the critical work by such scholars as Joanne Braxton, Barbara Christian, Patricia Hill Collins, Angela Davis, Trudier Harris, Evelyn Higginbotham, bell hooks, Wahneema Lubiano, Hortense Spillers, Claudia Tate, and E. Frances White, I detail the performativity of these well-rehearsed figures to show how contemporary black maternal figures function as assemblages of these distinct yet related expressions of power. Likewise, the work of black queer studies scholars such as Marlon Bailey, Cathy J. Cohen, Sharon Holland, E. Patrick Johnson, Aliyah Abdur Rahman, and L. H. Stallings inform my considerations of processes of normalization, the imbrication of sexuality in racial formations, and the malleability of gender and sexuality within black cultural and political contexts. Drawing from their insights, I describe new figurations and explore what they might say about sociocultural anxieties of belonging in post–Civil Rights America. My textual analysis in this book sets out to defamiliarize the familiar, and I draw on alternative cultural histories of maternal figuration to challenge our common knowledge about black motherhood within these particular scholarly fields. My readings here are not meant to be necessarily comprehensive, but rather I have selected flashpoints in our cultural landscape that exemplify encounters with transgressive figures.

In this book, I identify five variations of well-known black maternal controlling images, and I describe how each new figuration engages with neoliberal sociocultural anxieties circulating during the post–Civil Rights period. The mama's gun figures I name and examine are the Young Mother, the Surrogate, the Blues Mama, the Big Mama, and the Mothership. Each figurative variation operates as a site through which readers can examine multiple contemporary sociocultural concerns and historic controlling images about black motherhood that have reassembled themselves during the post–Civil Rights era. Contemporary anxieties about dependency, domesticity, marriage, and sexual modesty as well as new formations of racial identification and racial authenticity all underlie these new figurations. During this recent period, black writers and performers depict mama's gun figures that challenge dominant assumptions about black motherhood, often adapting the very controlling images that are part of efforts to exclude black women from roles as subject-citizens in the American project. The transgressive narratives that they tell about black mothers illuminate multiple distributions of power along the lines of race, gender, class, sexuality, and nation, and they reveal the interdependency between systems of domination in our recent past and our contemporary moment.

RACIAL NEOLIBERALISM AND THE PRODUCTION OF BLACK MATERNAL FIGURES

The rise of racial neoliberalism—the coterminous development of free-market-driven economic expansions and the new "color-blind" structures of racism emerging in the latter twentieth century—produces the new sociocultural anxieties of the post–Civil Rights period. Although the transformative legislative and judicial gains of the Civil Rights era (the *Brown v. Board of Education* decisions of 1954 and 1955, the Voting Rights Act of 1965, the Civil Rights Acts of 1964 and 1968) marked the *de jure* end of America's brutal Jim Crow past, the equality that those advancements promised were not fully realized. In fact, the post–Civil Rights period spawned new anxieties and new technologies of racial exclusion and violence, which have flourished under the imperatives of racial neoliberalism. As an ideology, racial neoliberalism dictates that the state should be removed from any substantial corporate oversight or market regulation and that the government has no place in enforcing equal protection under the law, legislating fairness and equality of opportunity, or eliminating poverty as targeted forms of racial redress. Instead these social goals should be left up to "the market," and Susan Searls Giroux aptly describes racial neoliberalism as "deregulated markets and deregulated racisms."[23] The mutually constitutive nature of these relations of power—economic expansion of the wealthy and racist retrenchments in policy—creates a feedback loop of ideological constructions and coded language that amplifies its effects.[24] The circulation of coded terms such as "personal responsibility," "color-blindness," and "family values" has been essential in building public skepticism about the role of government in American life, as well as maintaining boundaries of race, class, gender, and sexual belonging. Specifically, these three terms operate as key technologies of racial exclusion and violence that have been critical in the production of black maternal controlling images, such as the welfare queen, throughout the post–Civil Rights era.

However, before discussing the function of coded language in the construction of the black maternal figures identified in this book, it is important to sketch some of the political and economic developments that undergird the rise of this neoliberal racial regime. During the past forty years, trends in elections, labor, housing, policing, and incarceration illustrate the changing face of American racism from one in which racial categories were explicitly used as forces of life-or-death inclusion or exclusion to a situation in which race is supposedly ignored and America's racial history forgotten.

Critical race scholar David Theo Goldberg effectively traces these shifts in his book *The Threat of Race: Reflections on Racial Neoliberalism* (2009). Gold-

berg describes the intensification of privatization and individualism as key tenets of American neoliberalism, which means that social inequalities, when rarely acknowledged, are understood as "individual preferences" or anomalies of "intolerance" rather than as resulting from systemic and structural forces. This "just so happened" form of racism marks racial injustice as a fluke and allows individuals to refuse to interpret unjust social scenarios as racially overdetermined. Rather, the individual casualties in a scene of injustice are coincidentally positioned as happening to someone who "just so happened" to be black, Latino, Muslim, and so on, and problems from workplace and housing discrimination to hate crimes are easily explained away. However, Goldberg explains, this logic operates only in order to justify white innocence; the corollary is rarely upheld, which can be tested by examining the practice of racial profiling, in which state-enforced racial categories are considered a *necessary* function of protecting (white) safety and security. In other words, black suspects are never coincidentally black in their encounters with police. Their blackness—coded with terms like "thug" or "gangbanger"—is considered endemic and essential to their perceived criminality; blackness is positioned as a "threat" to civil society, law and order, and democracy. Thus, the concept of "threat" reveals itself as a central legitimizing technique in the neoliberal order because it can "fuel fears of loss—of power, of resources, of competitiveness, of life itself."[25]

Goldberg further details how a host of neoliberal maneuvers, often presented in public discourse as methods to limit state control, are actually extensions of antiblack racism. Essentially, he explains, the transformations of the Civil Rights movement helped solidify the notion in the dominant white imagination that the state itself had become a "black institution," because it had become for blacks "the largest post-segregation employer, the instrument of affirmative action, the educator of choice, if not necessity, the guarantor of welfare rights when all else failed . . . the underwriter of housing for those who might otherwise have none."[26] Therefore, the "state," acting as synonym for "blackness," had to be opposed, dismantled, and undermined at every turn, with the exception of a ramping up of policing and security enforcement, functions that largely discriminate against black and brown people. In this paradoxical world of supposed race neutrality, state interventions into the lives of racial minorities deemed "threatening" to the national project were considered the only remaining appropriate use of government budgets. So, in the last several decades, the nation has seen not so much an end to social spending by the state as a privatization of that spending, which, Goldberg notes, allows the economically enfranchised to drive the decision making about what gets funded and how policy is administered.

Take housing policies, for example. In the early twentieth century, hous-
ing segregation was maintained and enforced, in part, through the outright
refusal of FHA mortgages to racial and ethnic minorities and through the
federal practice of redlining, which marked areas for home buyers, banks, and
other lenders as spaces undesirable for development based on the racial and
ethnic makeup of the residents. In addition, the use of restrictive covenants,
which prevented homeowners from renting or selling their houses to racial
and ethnic minorities, was deemed discriminatory in 1948, but it was still
legal to write a restrictive covenant, and many homeowners' associations con-
tinued to use them for another twenty years after they were legally challenged.
As these deleterious practices became outlawed due to the Fair Housing Act
of 1968 and the Community Reinvestment Act of 1977, Goldberg explains,
housing segregation and urban blight become enforced through "privatized
preference schemes rather than explicitly institutionalized legalities."[27] Sub-
urbanization, the proliferation of gated communities, and predatory lending
practices helped continue the geographic isolation of blacks, so much so that
by the 1990s there were fourteen major cities with majority black popula-
tions. There were none just forty years before. These cities, such as Baltimore,
Detroit, and New Orleans, then become further isolated and impoverished
by the educational apartheid, deficits in health care access, and food deserts
that come along with housing segregation. The experiences of black residents
of New Orleans during Hurricane Katrina in 2005 became a starkly visible
reminder of the unjust effects of these new practices of housing segregation
in the post–Civil Rights period.

The cumulative effects of these political and economic shifts are also
clearly demonstrated in the exponential rise of industrialized punishment
in the United States since the 1980s. Also known as the prison industrial
complex, this convergence of carceral privatization in collusion with state-
sanctioned racism has contributed to the devastating fact that in 2014, there
were nearly 2.4 million Americans incarcerated. The rapid rise in mass incar-
ceration disproportionately affects people of color with such force that "many
black, Latino, and Native American communities now have a far greater
chance of going to prison than of getting a decent education."[28] Geographer
Ruthie Wilson Gilmore's book *Golden Gulag: Prisons, Surplus, and Oppo-
sition in Globalizing California* (2007) traces these trends in the California
Department of Corrections, one of the nation's largest and fastest-growing
prison systems. She describes how the criminal justice system unfairly treats
people of color, such that "white defendants would be far more likely to have
charges reduced from felonies to misdemeanors or dropped completely, while
people of color are more likely to have the harshest possible charge leveled

against them. Both federal and California laws allow radically different treatment of people who have done essentially the same thing."[29] These situations of "wobble," in which individual judges and prosecutors can choose to categorize certain crimes as felonies or misdemeanors is one of the tactics that Gilmore identifies as contributing to the prison industrial complex, in which black people are five times more likely to be locked up than whites. In her study of mass incarceration, *The New Jim Crow: Mass Incarceration in the Age of Colorblindness,* Michelle Alexander puts it plainly: "Mass incarceration—not attacks on affirmative action or lax civil rights enforcement—is the most damaging manifestation of the backlash against the Civil Rights movement."[30]

Sadly, the new racial technologies and their interlocking effects are too numerous to account for fully here, but these examples are meant to elicit an understanding of the ways racial neoliberalism has required symbols of black inferiority, which help fuel processes such as private prison construction and the defunding of public education in order to support privately run charter schools, for example. Against this backdrop, it is important to see black maternity as one of the required symbols of black inferiority through which state-interventionist policies and private enterprise help prop up neoliberal outcomes for the rich and powerful. Whether it's discourses about criminality, poor test scores, or welfare dependency—you name it, images of bad black mothers become necessary scaffolding used to support the processes of neoliberal wealth accumulation. Therefore, as a black feminist scholar interested in resisting the dominance of these ways of thinking, I focus on black motherhood as an analytic in this text because it emerges as a critical, but not solitary, site in which the moves of racial neoliberalism can be observed. By tracing the symbolic effects of contemporary representations of black mothers, I intend to contribute to a growing body of work that seeks to name and describe the effects of racial neoliberalism in American social and political life as a means of dismantling its effects. One of the primary ways racial neoliberalism functions is through the masking or naturalizing of its operations through the use of coded language meant to intensify "us against them" fears and anxieties within public discourse.

Coded language allows those in power to maintain boundaries of belonging by constructing certain people as undeserving, lacking, or un-American without using explicitly racist, sexist, homophobic, or classist language. Republican campaign strategist Lee Atwater, who was known for perfecting the political strategy of coded language, explained the phenomenon in a 1981 interview: "You start out in 1954 by saying, 'Nigger, nigger, nigger.' By 1968 you can't say 'nigger'—that hurts you, backfires. So you say stuff like, uh, forced busing, states' rights, and all that stuff."[31] The alternative phrases trigger

racist responses in the court of public opinion while maintaining the appearance of impartiality.

Coded language persists in the contemporary American political landscape. For example, the use of the phrase "47 percent" by 2012 presidential candidate Mitt Romney to identify people who he believed would vote for President Obama exemplifies the consistent, evolving salience of coded language. At a fundraiser for well-heeled donors, Romney explained that

> there are 47 percent who . . . are dependent upon government, who believe
> that they are victims, who believe the government has a responsibility to
> care for them, who believe that they are entitled to health care, to food, to
> housing, to you-name-it. . . . My job is not to worry about those people. I'll
> never convince them they should take personal responsibility and care for
> their lives.[32]

Terms such as "dependent," "victims," and "entitled" do not specifically identify groups with explicit race, class, and gender words. Romney does not have to say "blacks," "Latinos," "women," "working class," "elderly," or "poor" to describe the Americans he believes will not vote for him. Yet, the supposedly benign language meaningfully conjures images and narratives about those specific demographic groups through an intricate chain of symbolic associations cultivated over generations. In addition, those three words act in juxtaposition to the phrase "personal responsibility," which is the valorized quality of the idealized American subject-citizen. During the rise of racial neoliberalism, old words take on new meanings. "Entitlement," "underclass," or "47 percent" work to signify implicitly which groups deserve access to prosperity and the American Dream, who has the right to civic participation and political visibility, and even who has the right to life itself. The hegemonic force of these race, class, gender, and sexual signs is used to maintain boundaries of belonging.

Neoliberal boundaries of belonging are policed by cultural standards and representation, monitored though law enforcement and schools, and sanctioned and militarized by the state through what Henry A. Giroux identifies as a new American cultural and political norm based in "fear, surveillance, and control."[33] Under this new norm, anxieties about the Other—the undeserving, immoral, entitled, or lazy—compel individuals and groups to be vigilant against those who fail to conform to the principles of personal responsibility, color-blindness, and family values. The contradictions and cognitive dissonance that racial neoliberalism creates produces these anxieties, yet it is the very sense of unease and insecurity that helps maintain its arrangements of

power. Individuals and groups are encouraged to watch out for and punish those who do not adequately fulfill the normative functions of the neoliberal project because, we are told, the safety and security of the nation is constantly threatened by the failures of the Other. Coded language embedded within a variety of images and narratives helps us identify which people to blame for economic crises and social unraveling. Public discourses about jobs, crime, welfare, health care, and education are primary sites in which these normalizing and moralizing battles are fought, and poor, black mothers are frequent targets.

The lingering image of the welfare queen, for example, relies on the interlocking fictions that poor women on welfare callously use public assistance to live the high life, that the majority of women on welfare are black, and that black women are hyperfertile breeders who carelessly have children to avoid work. President Ronald Reagan tapped into the intersection of these beliefs when he popularized the term "welfare queen" as a means to shore up votes during his 1976 presidential campaign. Running on a platform of government reform and cuts to public assistance spending, Reagan did not identify his phantom welfare queen by race in his stump speech, because the image of excess and dependency that he described—"she used 80 names, 30 addresses, 15 telephone numbers to collect food stamps"—fit within a signifying chain of historical myths about black mothers, including the image of the emasculating and pathological matriarch described in the 1965 Moynihan Report.[34] Daniel Patrick Moynihan's project built off of the work of black sociologist E. Franklin Frazier, whose *The Negro Family* study also foregrounded the cultural "pathology" represented by single black mothers. Political opposition to social welfare programs that offer assistance to millions of women and children relied upon the layered construction of black families as culturally outside the norms of middle-class white standards and undeserving due to the presence of a dependent black mother. As journalist Josh Levin notes, "the 'welfare queen' became a convenient villain, *a woman everyone could hate.* She was a lazy black con artist, unashamed of cadging the money that honest folks worked so hard to earn."[35] Being the "woman everyone could hate" juxtaposed with "honest folks," the figure of the welfare queen has remained a menace in American political life ever since the 1970s.

The controlling image of the "welfare queen" incites and is incited by a sociocultural anxiety about dependency, which is a fear that lazy welfare recipients will bankrupt America. This fear manifests most often in representations of poor black mothers, but it can also include associations with black women generally, regardless of class background or maternal status, and with blackness itself. In *The Politics of Disgust: The Public Identity*

of the Welfare Queen (2006), political scientist Ange-Marie Hancock uses an empirical study of news media data during the 1995–1996 debates over welfare reform to demonstrate the "coherent construction" of the "welfare queen" as an amalgamation of two preexisting stereotypes and moral judgments about black women—that they are hyperfertile and that they are lazy. Hancock concludes, "The public identity that is cued in welfare discourse is not merely one of blacks . . . but that it is one of black *women* especially devalued as *mothers*."[36] Not only that, Hancock's study showed the "absolute absences" of voices of black mothers as decision makers or political agents within the congressional debates that shaped this historic legislation.[37] Therefore, coded language not only targets black mothers for public scorn, but it also effectively eliminates their voices from the democratic process. The effects of coded language undermine the functioning of democracy. Racial neoliberalism regularly uses the coded language of personal responsibility, family values, and color-blindness to tap into other sociocultural anxieties that maintain their powerful hold on American politics. Although other concepts are vital to the neoliberal project, I will concentrate on these three terms because they have been essential in the production of the five black maternal figures examined in this book.

The rhetoric of personal responsibility is really more than simply calling for accountability in one's daily actions. It's an ideological diversion from a critique of structural forces and our shared influence in a myriad of social problems. Legal scholar Kent Greenfield points out in *The Myth of Choice: Personal Responsibility in a World of Limits* that "too often, the rhetoric of personal responsibility is a way for those who ought to admit shared responsibility to point the finger at someone else."[38] Personal responsibility forecloses complexity; failure to succeed is simply due to one's own shortcomings rather than interlocking, unequal structural forces. Personal responsibility also undermines ideas of community and the public good, and as activist-scholar Angela Davis writes, this disconnect results in "pressuring the poorest people in a society to find solutions to their lack of healthcare, education, and social security all by themselves—then blaming them if they fail, as 'lazy.'"[39] The historic 1996 welfare reform bill signed by President Bill Clinton is titled the Personal Responsibility and Work Opportunity Act, a name that reinforces a perceived opposition between welfare and personal responsibility.[40] The assumption that people who use welfare do not work or do not work hard enough is common and pervasive. For black mothers, like me, who have turned to government and nongovernment assistance to help raise their children, these negative associations become attached to racialized stereotypes of motherhood.

As a sex and gender ideology, personal responsibility has also been essential in the public regulation of women's sexual choices. Recent debates over the birth control provision in the Affordable Healthcare Act (ACA)—or "Obamacare"—illustrate the ways in which women's access to birth control pills has been misconstrued as dependency brought on by sexual immorality. In 2012, radio host Rush Limbaugh called Sandra Fluke, a thirty-year-old white Georgetown law student, a "slut" for testifying before a congressional panel in support of a birth control provision in the law that would improve health care access for women. In 2014, former Arkansas governor and Republican presidential candidate Mike Huckabee attacked Democrats who backed the ACA by claiming that their support made women "believe that they are helpless without Uncle Sugar coming in and providing for them a prescription each month . . . because they cannot control their libido or their reproductive system without the help of the government." Using the laughable pejorative "Uncle Sugar" to indicate the government, Huckabee's comment, as well as Limbaugh's outburst, perpetuates an idea that women lack sexual personal responsibility, and as a group they are particularly susceptible to reliance on the government—an idea that emerges from an anxiety about dependency.

The popularity of recent reality television shows such as *Teen Mom* and *16 and Pregnant* also operate in service to the anxiety of dependency.[41] The teen mothers on the shows represent dangerous female sexuality and irresponsibility. They are not ideal liberal citizens because unlike true "individuals," teen mothers must rely on a number of social structures to help them raise their children, and their hypervisibility in contemporary popular culture helps confirm public opinions that teen motherhood is a gendered failure of belonging.[42] Black mothers of all ages and class backgrounds face additional scrutiny, slut shaming, and disrespect about sexual personal responsibility because of historical myths of their hypersexuality. Beliefs that black women are sexually deviant and promiscuous are woven into the fabric of the nation's symbolic economy and circulate both inside and outside of black cultural spaces. Therefore, personal responsibility acts as a powerful sex and gender ideology that renders black women as sexually irresponsible women who expect others to care for their children.

Another powerful concept that has been vital to the project of racial neoliberalism is family values, a set of expectations that calls for patriarchal gender roles in nuclear family formations, with an emphasis on marriage, domesticity, and "good" motherhood. As the number of female-headed families increased in the latter half of the century, nostalgia for so-called traditional families took root in public discourse. Single mothers, mothers who

work outside of the home, and same-sex parents stand in stark contrast to the expectations of the family values rhetoric, and the judgment against these kinds of families are moral in nature. Families that do not fit the normative ideal are said to produce children who contribute to the worst of America's ills, such as crime, poverty, and gun violence. Family values ideology illustrates the neoliberal shift from the public to the private domain in that it seeks solutions to social problems in the realm of the family rather than in the government. The phrase sparked intense media coverage in 1992 when Vice President Dan Quayle mentioned "family values" in a speech in which he criticized the television character Murphy Brown, an affluent white woman TV journalist, for promoting single motherhood as a potentially positive choice. Yet, the media practically ignored Quayle's sustained racialized use of family values in the speech, in which he also invoked images of single mothers on welfare, gangs, the ghetto, and inner-city turmoil.[43] Legal scholar Twila L. Perry describes the coded language of family values as marked by a "lurking racial subtext," explaining that black mothers are constructed in the national imagination as a negation of family values due to intersecting factors of race and gender and controlling images of black motherhood.[44]

Family values ideology produces sociocultural anxieties about marriage, domesticity, and respectability. Mothers who do not marry and same-sex marriages contribute to fears that there is a "marriage crisis." Mothers who reject gender and sexual norms of proper care of the home, feminine propriety, and sexual modesty are blamed for the "fall" of the American family. The effects of these anxieties on the production of black maternal figures are exemplified by remarks made about First Lady Michelle Obama during the historic 2008 presidential campaign. In 2008, news producers for Fox News network repeatedly used a stigmatizing caption with the phrase "Obama's Baby Mama" to refer to Michelle Obama. The term "baby mama" comes from the hip-hop generation of African American culture to define an unmarried woman who has "had a child by a man but is no longer his partner" and who has "sex to maintain a financial or emotional connection with the man through the child."[45] While the vernacular phrase has a variety of values within black cultural spaces, reflecting the general acceptance of single motherhood within black communities, it has slipped uncritically into mainstream American popular culture as a sign of irresponsible and unrespectable black womanhood. The caption used to call Michelle Obama a "baby mama" was just one of numerous incidences that summer in which the conservative network sought to undermine the Obamas' public image through tacit and explicit language inciting fears of race, gender, class, and sexual difference.[46] Using the racially inflected terminology helped cast the Obamas

as interlopers in the Great American Presidential Journey, as not-quite-credible national symbols. Their opponents used coded language that invoked a signifying chain of deviant blackness that would resonate most with fearful audiences. Therefore, the term "baby mama" operated as a politically expedient technique to undercut Michelle Obama's worthiness to represent the nation as the preeminent example of respectable motherhood. Using coded language that questioned her family values in ways that traded on her blackness, the simple phrase operated as a way to detract from her qualifications as a potential American national mother.

Yet, just a few weeks later, the nation was informed that the unmarried teenage daughter of Republican vice-presidential candidate Sarah Palin was six months pregnant. Though Bristol Palin had unprotected sex and conceived a child out of wedlock with her teenage boyfriend, she was never called a "baby mama" on Fox News because of her privileged intersection of race, class, and gender identities. In fact, the network went so far as to suggest that the young Palin might consider a presidential bid. Bristol Palin's legitimacy as a young woman poised to represent one of the nation's most esteemed families was sheltered from attack because she is a young, economically privileged white woman. Negative publicity about her pregnancy was further forestalled by the announcement that she planned to marry her boyfriend Levi, demonstrating her family values by pursuing marriage, having the child, and not considering an abortion. In this situation, Palin's family values are connected to her whiteness. The boundary between inclusion in and exclusion from the highest echelons of power in the United States is marked by incongruous racialized maternal imagery. The proximity of these two moments, which occurred within three months of each other, highlights the intense contrast in portrayals of black motherhood and white motherhood in the post–Civil Rights era.[47] Despite Michelle Obama's "respectability"—demonstrated through her professional accomplishments, her long and loving marriage, and her well-mannered children—her status as a black woman and a black mother left her vulnerable to misnaming and misrecognition.

Finally, color-blindness is a neoliberal ethic that insists that racism is no longer a factor in American social life because whites "do not see" skin color (race), and therefore existing economic and social inequalities cannot be explained by racism. Color-blindness and the fantasy of a postracial America are vital concepts in what Goldberg calls "born-again racism," a newer hierarchical formation that relies upon indirect forms of exclusion that do not reference race or color explicitly. Instead, as Eduardo Bonilla-Silva describes, "colorblind racism serves today as ideological armor for a covert and insti-

tutionalized system. . . . And the beauty of this new ideology is that it aids in the maintenance of white privilege without fanfare, without naming those it subjects and those it rewards."[48] Liberties afforded to the wealthy and racially privileged are mystified by claims that racism no longer exists. Furthermore, to "call out" or critique racial inequality is seen as "making excuses" and "dwelling too much on the past." In some cases, racial critiques are said to harm white people, and to call out racism is considered itself racist. In order to disavow one's own white racial privilege or avoid being called a racist, all one has to do is simply publically claim not to "see" color. The emphasis on not "seeing color" diverts attention away from the myriad ways that racial hierarchies are maintained outside of visible markers of difference, such as through cultural or even genetic claims. Now that "color" is no longer a legitimate way to maintain hierarchical relationships in postracial America, individuals and groups are much more insecure about boundaries of racial identification and racial authenticity. Therefore, the rhetoric of color-blindness actually enacts the sociocultural anxieties of racial identification in the post–Civil Rights era.

In the era of color-blindness, many black Americans have found it socially and politically necessary to promote racial authenticity as a kind of cultural common sense that maintains group identity and cohesion. Since skin color is supposedly no longer the way to organize racial sentiment and the dominant culture has turned to genetic or cultural markers of difference to stabilize racial hierarchies, African Americans have frequently reclaimed and revalued aspects of black culture as a means of reinforcing group solidarity and political efficacy.[49] Blackness itself becomes intraracial cultural capital, as it did in public discourse about Barack Obama during his first presidential campaign. While some of his detractors used images and narratives to portray Obama as "too black," some African American voters asked if he was "black enough" because he is biracial and was not raised in primarily black communities. Although he met the American genetic standard of black identity and identifies as a black man, his cultural blackness was questioned, in part, because he was not raised by a black mother or within predominately black communities. Black mothers are perceived to perform a primary function in the maintenance of black racial realness by passing on the instrumental knowledge of being black. Without the signifier of having a black mother, Obama's racial credibility was validated through his marriage to Michelle Obama. What Farah Jasmine Griffin calls "Mrs. Obama's unmistakable blackness" was one of the qualities that helped consolidate support for the president among black voters by legitimizing his racial authenticity and alternately "for some whites . . . became the lightning rod, the persis-

tent reminder of his race," exemplified by the "baby mama" comment and others.[50]

As the dominant culture continues to present black motherhood as deviant, neglectful, and unsuccessful, black culture resuscitates images of "real" black motherhood in the figure of the Big Mama, whose mothering is strong and good. The nostalgia associated with Big Mama in the post–Civil Rights era shores up a sense of racial difference that critically rejects color-blind ideology. Color-blindness is refuted through an emphasis on cultural and racial particularity that is revalued within African American cultural spaces for the purposes of group identity and cohesion.

Powerful cultural anxieties of racial neoliberalism organize everyday life and politics to produce a variety of black maternal figures within and outside of African American culture. As a complex system, racial neoliberalism relies upon notions of personal responsibility, family values, and color-blindness to construct black mothers as culturally outside the norms of middle-class white standards and as illegitimate citizens. As the Obama-Palin example illustrates, the specter of the single black mother bears considerable figurative weight as a signifier of the undeserving and un-American. From an intersectional standpoint, one might say that all notions of motherhood bear figurative weight on the boundaries of national belonging. However, it is important to understand how that weight is distributed differently at each location of identity, particularly understanding how class and race shape these situations and how multiple histories inform these differences. Even within the category "black women," there are differences in how class and sexuality, for example, mark black maternal figures, and there are differences in how the figures function interracially and intraracially. Hortense Spillers captures the significance of the production of black maternal figures when she writes that as a black woman, "my country needs me, and if I were not here, I would have to be invented."[51] Studying the invention of and reproduction of black maternal signifiers during the rise of U.S. racial neoliberalism provides a way of interrogating how these figures continue to function socially and politically and how African American culture has responded in the post–Civil Rights era.

READING BLACK MATERNAL FIGURES IN THE POST-CIVIL RIGHTS ERA

Black culture has been and continues to be a vital location of resistance to hegemonic assumptions about deviant black motherhood and the negation of black citizenship and humanity through the use of coded language. While

the media, academics, and politicians continue to circulate controlling images of black mothers, black writers, artists, and performers signify on dominant representations in ways that challenge their ideological power and occasionally provide pleasurable escape from their control. Far from being superfluous to politics and "reality," the realm of imagination and creativity found in black cultural production offers robust sites for social critique and activism. My goal in this book is to provide novel ways of reading transgressive maternal figures in post–Civil Rights literature and performance in order to reimagine the devalued and marginalized Other as a maternal subject-citizen.

Political theorist Cathy J. Cohen calls for the reorientation of African American studies that is "centered around the experiences of those who stand on the outside of state sanctioned, normalized White, middle- and upper-class, male heterosexuality."[52] By exploring this "politics of deviance," Cohen suggests that scholars turn their attention toward the most marginalized members of the black community, especially those who are considered to be "morally wanting by both the dominant society and other indigenous group members."[53] I take up Cohen's call for a reworking of queer theory and black feminist analysis toward a politics of deviance in *Mama's Gun*. What the imaginative texts explored in this book share is their concern with the subjectivities of black maternal figures that in some way transgress or subvert the cultural anxieties of racial neoliberalism outlined above. Using black feminist and queer theoretical lenses, I explore the ways that these narratives revise and resist black maternal controlling images, remaking them into alternative black maternal figures—the Young Mother, the Surrogate, the Blues Mama, the Big Mama, and the Mothership.

Chapter 1 explores the sociocultural anxiety about dependency in Sapphire's 1996 novel *PUSH* as an extension of a tradition in black women's literature that challenges respectable motherhood as a method of social and political resistance. *PUSH* aesthetically and ideologically transgresses earlier modes of expression by featuring a Young Mother who functions both as caricature and character, stereotype and subject. When Sapphire imagines Precious, the overweight, poor, HIV-positive, black teen mother protagonist of *PUSH*, writing "I got self, pencil, and notebook," she allows Precious to transgress the boundaries that would keep a mother like her on the margins of her community and outside of the boundaries of national belonging. In chapter 2, I examine Suzan-Lori Parks's 2004 novel *Getting Mother's Body*, which tells the story of pregnant sixteen-year-old Billy Beede, who goes on an interstate trip to dig up her mother's grave in order to take possession of a treasure that is supposedly buried with her mother's body. Parks's multivoiced text takes place during the Civil Rights era through the primary voice of Billy Beede and

her dead mother, a blues singer named Willa Mae. While Billy exemplifies the Young Mother figure, I concentrate most on Parks's use of the Blues Mama to explore sociocultural anxieties about domesticity and respectability. Blues themes and aesthetics consistently contest the narratives of the Civil Rights moment in ways that privilege the experiences of black women as central to the freedom struggles of that era and that resonate in recent history. Chapter 3 explores the work of neo-soul singer Erykah Badu. As an experimental black artist, Badu frequently uses her aural creations as well as her other expressive modes to share with audiences aspects of her personal life, including her choice to have three children, as an unmarried woman, with three different men. By close-reading Badu's songs, lyrics, interviews, and visual productions, such as concert posters and music videos, I identify her as the Mothership, a transgressive maternal figure that challenges the sociocultural anxieties about marriage through Afrofuturist aesthetics.

In chapter 4, I extend my use of Afrofuturism to consider Octavia Butler's science-fiction novel *Dawn* (1987) as an exploration of the anxiety of racial identification. The novel's heroine, Lilith, is a black woman who survives a cataclysmic war on Earth and must repopulate the planet with the assistance of a three-gendered alien species called the Oankali. The humanlike Oankali reproduce by fusing genetically with other species, and Lilith will be the first human to give birth to this new hybrid being. Lilith's maternal options are controlled, manipulated, and exploited by the Oankali, which Lilith associates with histories of reproductive experimentation and surrogacy. As an example of the Surrogate maternal figure, Lilith transgresses all bounds of identity to engage in a complicated revision of black motherhood that includes hybridity and queer sensuality.

The final chapter considers the work of Tyler Perry, who performs in popular movies in drag as the maternal figure known as Madea. This chapter concentrates on Perry's performances as well as interviews with the actor and other written accounts of the development of his character, particularly Perry's humorous self-help book, *Don't Make a Black Woman Take Off Her Earrings* (2006). From these texts, I consider the cultural anxiety of racial authenticity through the Big Mama maternal figure that Perry performs. Through a critique of Perry's Madea, I illuminate an alternative Big Mama in the drag performances of RuPaul Charles.

In this work, I combine analyses of traditional literature, black popular culture, and performance. The importance of visual media and popular culture to the racial politics of our times should not be underestimated. Sights and sounds of blackness circulate throughout the post–Civil Rights era through various types of media—film, television, live and recorded perfor-

mance, and the Internet—and these sites of interaction between audiences and performers are profoundly influential in shaping the meaning of blackness among various American publics. Visual media and popular culture provide audiences/consumers instruction in how to perceive racialized people, creating and disseminating controlling images that define and reproduce ideas about who can and should belong to the American enterprise. These textual forms are also responsible for the propagation of sociocultural anxieties expressed through coded language that undergird the problematic representations of black mothers at issue in this book. Historically, these images have been created by and disseminated by majority-white artistic and media institutions, but that fact began to change during the last two decades of the twentieth century. As Nicole R. Fleetwood notes in her book *Troubling Vision: Performance, Visuality and Blackness,*

> advances in black mass media and cultural production occurred during the height of the Reagan era and the presidency of George H. W. Bush . . . [and] this era saw the consolidation and rise of a black culture industry that would continue to grow and become incorporated into dominant visual media and popular culture throughout the 1990s.[54]

The rise of a "black culture industry" in the late twentieth century provides an ideal site of exploration into black maternal figures because it has developed during a political moment shaped by the right-wing's vilification of black mothers and by the centrality and ubiquity of visual media in the socialization of Americans' notions of national belonging.

MAMA'S GUN: A LOADED TERM

The idea for mama's gun began with my interest in singer and performance artist Erykah Badu. In 2000, Badu released her third CD, entitled *Mama's Gun.* The meaning of the title baffled many listeners, until Badu revealed in an interview her own concept of mama's gun. She explained to an interviewer, "Most of the time, you don't know your mama has a gun. When she pulls it out, it's got to be something serious."[55] Perhaps referring to an instance when she discovered her own mother's firearm, Badu draws on the element of surprise that one might have to discover that your mother or another close maternal figure is packing heat. I can relate.

My maternal great-grandmother, Louria "Yoya" Elbert (1900–1990), was a woman known to regularly have a pistol and a rifle in her home in the back-

woods of north Florida in an all-black settlement called Buckhorn, which I have never found on a map. All my life until I was sixteen years old, we visited Yoya on Sundays, and I had no idea about this aspect of my great-grandmother's life. She was simply a quaint old woman who lived "down home," made breakfast for us, and told us stories while we swept her dirt yard. My favorite stories were about my grandmother and my mother when they were children. I always wanted to know what they were like when they were kids like I was then, and Yoya was one of the only people who knew them all as children. In all of my memories, she was a very "motherly" woman to me. It wasn't until after her death that I learned from other family members of her exploits as a young mama—her divorce, her cursing, her fighting, her life as a single mother cleaning white people's houses, her blackberry wine "side" business, and her guns. I found out that she armed herself for a number of reasons. First, she kept guns as a defense against the Klan, which regularly marched through Buckhorn to intimidate, harass, and murder. This practice, I discovered, was not uncommon; Civil Rights activist Fannie Lou Hamer recalls in her biography how her mother carried a 9mm Luger in her covered lunch bucket as she worked in the fields "in case a white man decided to attack her or her children."[56] I have had numerous conversations with black friends from the Deep South who also had maternal relatives who carried guns and were not afraid to use them. My Yoya also kept guns to defend her body and property from insincere and irresponsible lovers. My grandmother, her daughter Annie Louise, told me that Yoya once shot at a beau after she discovered he had been stealing the blackberry wine she made for her own profits in order to raise money to give to his *other* sweetheart. I guess he learned his lesson! Upon hearing stories like this, I became fascinated with this "other side" of my sweet, dear old great-grandmother. These observations are not meant to condone gun violence, although it seems reasonable for my great-grandmother to have armed herself under the circumstances that she lived.

Badu extends her observation of the "serious" surprise of finding mama's literal gun into metaphor. She explains that mama's gun does not have to refer to an actual firearm, although in some cases it does, but that it also refers to the explosive power available to black women when their creativity is unfettered. So when Badu tells the interviewer that "they [audiences] can put my album in they holster," she proposes a way of imagining her music, her singing, and her performance style as a kind of creative weapon.[57] For Badu, mama's gun refers to her lyrical prowess and dexterity, skills that she calls upon throughout her music to eliminate "demons," which can be thought of as any of the numerous social, political, ideological, and material assaults that

black women face in their everyday lives. When Badu sings about "demons," I think of the sociocultural anxieties that produce coded language as new technologies of racism. The attacks experienced by black mothers—through social welfare policies, reproductive control, diminished health care and education systems—could all be envisioned as "demons." Therefore, mama's gun can be thought of as a tongue, the organ most associated with speech. Mama's gun can serve both militant and violent purposes, but it also can be thought of as persuasive, supporting, or even comforting. Badu uses her performances to tell her life story, appeal to lovers, express vulnerability, assert strength, bond with other women, and navigate the world. Mama's gun can be fired with destructive intent, brandished with threatening intensity, revealed menacingly, or simply concealed, but it is there to provide protection when necessary. For all of these reasons, mama's gun serves as a useful trope in that it captures the polyvalent nature of black women's expressive speech generally, as well as describes the simultaneous creative and destructive potential of the specific experiences of black mothering women.

Interested in using this metaphor to describe and categorize the texts in this study, I began to search for other instances of mama's gun appearing in black vernacular and literary spaces. My next encounter came when reading Paule Marshall's brilliant coming-of-age story *Brown Girl, Brownstones* (1959).[58] In the novel, a group of women from Barbados who have immigrated to Brooklyn, New York, spend time together talking about their lives while they cook and care for their children. Florrie, along with Iris and other Bajan immigrant women, come and talk with their neighbor, Silla, while she cooks. Silla, the prototypical strong black mother, is frustrated by a comment Iris makes that praises their colonial oppressors in England. Silla snaps back, asking, "What John Bull ever do for you that you'se so grateful?"[59] From there the sharp-tongued and politically astute Silla deconstructs how colonial powers have relegated black women to lives of poverty and subservience. She goes on to define how many of the Bajan immigrant women have changed their situations by moving away and working toward homeownership, in direct opposition to racist ideologies espoused by the British and sexist notions held by their husbands. Florrie and Iris sit in the kitchen and listen to Silla "rapt," "respectful," and "solemnly."[60] Florrie encourages Silla to "talk yuh talk. Bejees. In this white-man world you got to take yuh mouth and make a gun."[61] While I am familiar with the U.S. black vernacular phrase of "talk that talk" as a way for a listener to affirm the words of a speaker, I was struck by Florrie's expression of "you got to take yuh mouth and make a gun." Silla's daughters sit in the kitchen while she "talks that talk," leaving the novel's protagonist, Selina, entranced by her mother's "*power* with words."[62]

Another sense of mama's gun can be observed in public discourses about Michelle Obama, particularly descriptions of her body and personal style. Harris-Perry and sociologists Carmen Lugo-Lugo and Mary Bloodsworth-Lugo, among others, have addressed the impact of Obama's "sculpted biceps" in photographs and argued convincingly about how transgressive her personal style has been to public concepts of black womanhood. In their study, Lugo-Lugo and Bloodsworth-Lugo specifically identify transformations in controlling images of black womanhood in the post-9/11 era and demonstrate how descriptions of Obama's arms rely on post-9/11 updates to longstanding historical myths about black women. On one hand, her bare arms are considered symbolic confirmation of her "militancy" and her refusal to be a Mammy. However, as Lugo-Lugo and Bloodsworth-Lugo note, she has also been described as "hot" because of those arms: "To be so designated [hot] is precisely to keep with the Jezebel stereotype—it garners fascination at the same time as it poses threat."[63] While it may be impossible to explain why Obama has consistently made such style decisions, the representational effects of those choices are important to consider. So, in another sense, mama's gun is demonstrated in Michelle Obama's choice to display her toned, sleeveless arms—her "guns"—on the cover of *Vogue* magazine, in her official White House portrait, and elsewhere.[64] It's those same arms that are seen draped lovingly around the shoulders of her husband, her daughters, her mother, and countless numbers of everyday people she meets through her career as First Lady. Showing off her "guns," which are considered both alluring and threatening, Obama seems to signify on all of the stereotypes and controlling images of black motherhood in order to make a claim to personal style as kind of expressive creative freedom.

Yoya's daughter, my grandmother Annie Louise Ford, kept her mother's rifle, which I asked to see once as an adult. Grandma led me to a closet in the back of her house where she kept the rifle, tucked away and wrapped up inside one of Yoya's quilts. Besides being an expert bootlegger and a "baaaad mutha," Yoya, and all of her sisters, sewed the most beautiful quilts from scraps from their dresses, their husbands' and brothers' military uniforms and work shirts, and the muslin sacks that carried flour and rice into their homes. The quilt has long served as a revered symbol of black women's creative agency. It is a symbol saturated with meaning attached to femininity, motherhood, and community, most popularly invoked in Alice Walker's short story "Everyday Use." So to see this brutal weapon and a box of shells wrapped inside of these quilts made me think about the relationship between the two, and how both have been essential parts of black women's lived experiences in ways that cannot be separated. The image of shotgun and the quilts together inform my

development of mama's gun.[65] These metaphors of contrast, contradiction, but also cohesion—of making the soft flesh of the mouth into a pistol or of a rifle wrapped in soft quilts—act as entry points for imagining the trope of mama's gun. Other scenes of survival, memory, and history come together in the texts and performances addressed in this book in order to show how transgressive black motherhood is creatively conceived within contemporary African American culture.

1

"I GOT SELF, PENCIL AND NOTEBOOK"

LITERACY AS MATERNAL DESIRE IN SAPPHIRE'S *PUSH*

> The most recognizable and enduring symbols of social and sexual degeneracy and historical black victimization are the single black mother and the little black girl.
>
> —Aliyyah Abdur-Rahman, *Against the Closet: Black Political Longing and the Erotics of Race*[1]

THE UNNERVING STORY of sexual abuse of a poor, illiterate black teenage mother named Precious Johnson in Sapphire's controversial 1996 novel *PUSH* converges at the intersection of race, class, gender, sexuality, and age suggested in the epigraph, and this juncture offers a particularly instructive initial vantage point to explore mama's gun figurations.[2] Coming of age in the 1990s, Precious exists in *PUSH* as both a single black mother and a little black girl, thereby marking her compounded abjection, multiple marginalization, and illegibility as a subject-citizen, and yet the novel manages to recuperate Precious from this mire in multiple ways. As other scholars have importantly noted, Precious reimagines and reconstructs family through her friendships with Miz Blue Rain, her literacy teacher, and the other young black and brown women she meets in an alternative school. By the end of the novel, she jettisons the violence of her biological parents and the sexualized domesticity of her cramped apartment in favor of a freeing sense of self-discovery in a lesbian and women-centered community.

While this sense of overcoming ameliorates some of the representational problems of the novel, most notably the blatant invocation of stereotypes of unwed teen mothers and black welfare dependency, *PUSH* remains one of

the most emotionally harrowing texts to read in recent memory. Sapphire places the reader within the confines of urban blight and familial dysfunction that incite the worst symbolic associations of black motherhood—hypersexuality, sexual deviance, ignorance, victimization, ugliness, and economic dependency. That the novel appeared the same year that President Bill Clinton signed his "welfare reform" bill, legislated by placing black mothers in the cross hairs of neoliberal political discourses of "personal responsibility," makes these narrative associations all the more problematic. As a reading practice, mama's gun allows us to confront the use of multiple controlling images in this text not simply as a reification of stereotypes and fodder for political scapegoating, but as narrative sites in which Sapphire's use of signifyin(g), black vernacular, and intertextuality transforms caricature into character. In this chapter, I describe how Precious shifts from the controlling images of the unwed teenage mother and welfare queen into an alternative mama's gun figure called the Young Mother, which signifies on contemporary anxieties about the economic dependency and sexual deviance of black "underclass" women.

Key to this transformation is the intertextual relationship between Precious and the familiar literary figure of the enslaved mother, which provides the deep structure for the Young Mother that Sapphire constructs through Precious. Aliyyah Abdur-Rahman emphasizes that the enslaved mother figure reminds us of "the legacy in which black motherhood and girlhood appear to be one and the same . . . [; they] exist along the same continuum of black female representation."[3] The exploitation of black women's reproductive capabilities during centuries of racial slavery through rape and coerced sex as well as the denial of their maternal rights imprint contemporary black motherhood with vestiges of loss, regulation, and dependency. As a result, black women writers have often reimagined the enslaved mother—sexually vulnerable, dispossessed of her ability to mother freely, and silenced by illiteracy—in ways that empower these figures through related tropes of orality, such as speaking and singing.[4] In these texts, the enslaved mother responds to and resists her marginalization by (re)producing both language and life. In a similar vein, Sapphire links reading, writing, and motherhood in *PUSH* by tying the emerging literacy of Precious to her desire to mother. The maternal embodiment of pregnancy, childbirth, and nursing as well as the maternal experiences of naming and teaching a child appear in this novel as episodes that parallel Precious's desire to learn to read and write.

The corresponding motifs of motherhood and literacy are linked through their mutual ability to constitute the viability and visibility of black mothers as subject-citizens in the national imagination. This chapter establishes

the maternal-literacy narrative of Precious through an examination of the political, social, and cultural milieu in which the contested novel appeared, the legacy of the historical moment, and it considers the novel's intertextual relationships with prominent, familiar literary antecedents within U.S. black women's written traditions. In particular, Alice Walker's 1982 novel *The Color Purple* sets a precedent for the maternal experiences depicted in *PUSH,* and typifies another appearance of the Young Mother in late twentieth-century fiction. Using black feminist literary critic Claudia Tate's concept of "heroic maternal self-transformation," which she applied to nineteenth-century black women's writing, I suggest that Precious becomes a subject-citizen through an actualization of her maternal desire vis-à-vis her acts of childbirth and childrearing. This chapter centralizes both the biological and nonbiological aspects of mothering in order to address how *PUSH* reconstructs Precious in light of her status as the prototype of the abject and hyper-reproductive welfare queen and the dependent unwed teen mother. While nonbiological maternal acts are significant aspects of black women's history and fiction, it is important to centralize both the biological and conceptual aspects of motherhood here in order to demonstrate how Precious negotiates her claims to maternal status. Depictions of biological motherhood, such as pregnancy, childbirth, and breastfeeding, appear in the novel along with other maternal experiences, such as naming, teaching, and nurturing, and both sets of experiences stage the relational aspects of motherhood that are important to the various subversions occurring in this text. The relationship between embodied reproductive aspects and cultural conceptual aspects of mothering undergirds the application of heroic maternal self-transformation in the case of Precious.

Cited for depictions that are "pathological" and "quasi pornography," *PUSH* creates certain challenges for readers who are appalled at the graphic portrayals of emotional torture and sexual abuse in this poor, black, mother-headed household.[5] Since Precious "embodies the very prototype of the black urban 'underclass,'" the novel risks reinscribing the stereotypes that I suggest that it subverts.[6] These issues become more sensitive for black readers, according to Janice Lee Liddell, because of their worry that *PUSH* only verifies ideas about dysfunctional black families and feeds the "perennial curiosity about the sexuality of Africana peoples."[7] Fortunately, despite these reservations, critical attention to this novel has grown in recent years, and there have been a number of essays that engage with *PUSH* and the 2009 film adaptation of the novel, *Precious.*[8] The release of the novel's sequel, *The Kid* (2012), will undoubtedly continue to inspire new critical perspectives on this story and the enduring effects of poverty in African American life. However,

this chapter will concentrate solely on the literary contribution of the original novel.

Liddell's essay "Agents of Pain and Redemption in Sapphire's *PUSH*" is among the earliest critical treatments of the novel, and it contends with some of its most disturbing material: the mother-daughter relationship between Mary Johnson and Precious. Liddell argues that Mary's character violates the "fundamental themes of motherhood" typically found in black women's literature and "becomes a virtually inconceivable image of black motherhood."[9] The fundamental themes Liddell identifies are the possession of women-centered networks of mothering, the desire to socialize the child toward survival, and the practice of motherhood as a source of transformative power. Mary Johnson possesses none of these qualities. She lives in isolation from any women-centered networks of mothers who could help her take care of Precious, with the exception of her own mother, Toosie, a minor character who helps Mary scam the welfare office. Mary fails to socialize Precious for survival, and instead she uses her power over her daughter to thwart her efforts at development and to destroy her spirit to live. However, by concentrating on Mary's failures in these areas, Liddell's essay does not consider Precious as a maternal figure. Instead, Liddell suggests that readers grapple with their issues with Mary's character by inviting them to "an interrogation of the mother's own victimization."[10] While it is important to frame Mary Johnson as victim of psychological and physical abuse in order to understand the devastating effects of multiple marginalization on her black motherhood, a mama's gun reading of this text also calls us to center on Precious's maternal narrative too, particularly her use of motherhood as a source of transformative power allowing her to learn to read and learn to mother. Therefore, I wish to extend the growing conversation on *PUSH* by examining how Precious's maternal experiences revise the pervasive and damaging contemporary controlling images of the welfare queen and the unwed teen mother. Sapphire's work uses mama's gun, so to speak, in order to stage a Young Mother figure through Precious, whose textual presence pushes back against the hegemonic constraints of other figurations of black motherhood.

In describing Precious as a Young Mother, I also wish to place her within a much broader discourse about teen motherhood emerging in contemporary U.S. culture. In the previous chapter, I described the new normalizing references to young women who become mothers. Reality television shows like *Teen Mom* and *16 and Pregnant* airing on MTV have become ubiquitous if not progressive portrayals of unwed teenage motherhood that place the once hidden shame of out-of-wedlock pregnancy into public discourse. In addition, recent feminist scholarship has been essential in developing new

perspectives on teenage mothers, particularly from those involved in feminist girlhood studies. However, there has been a recorded lack of attention to black girls in girlhood studies scholarship. Black girls' experiences are not fully integrated within these hopeful spaces of teen maternity. Instead, working-class or poor (ratchet) black girlhood remains tethered to popularized names, such as hood rats, hoochies, baby mamas, and THOTs (thirsty hoes over there).[11] The terms in this constellation are all variations on the welfare queen figure, and they situate young black girls, especially those identified as "ratchet," as sexually and economically dependent, as well as disposable and interchangeable. Therefore, the precariousness of the Young Mother figure as a recuperative project cannot be overstated. In *PUSH*, Precious is not completely rescued through the Young Mother figuration; she remains an incest survivor and a poor, HIV-positive young black woman. Her station in life does not fundamentally change, and she still faces misrecognition and stereotyping from the social service workers managing her case. However, imagining Precious as a Young Mother and not a welfare queen allows readers to *see* her in agential ways that are not possible within a hegemonic framework. It is my hope that this mama's gun angle of seeing can extend beyond the literary into ways that we think about real black girls and women. Mama's gun centralizes the maternal subjectivities of those social outcasts who have been reduced to contemporary national caricatures—the hood rats, hoochie mamas, baby mamas, and welfare queens. Living at the edge of innocence and transgression, knowledge and ignorance, voice and silence, the Young Mother figure has the potential to destabilize the rhetorical effects of controlling images that render black girls who mother ineffable.

Importantly, Precious comes of age in 1980s Harlem, a period and location highly symbolic of the real and imagined "inner city," which has become emblematic of black cultural difference in the post–Civil Rights Era *sine qua non*. The representation of dysfunctional "urban" blackness reached a zenith in the 1980s as the figure of the welfare queen rose in the national imagination, instigated by that fiction of President Reagan and fed ever after by politicians, academics, and members of the media who drew on racist cultural theories and neoliberal political ideologies to explain black women's failure to belong. The idea of the welfare queen also kept alive fears about the black matriarch, a mid-century figuration perpetuated in social science research, and turned her into the embodiment of the fallen promise of an American racial utopia in the post–Civil Rights era. Even for black researchers and writers, the "inner city" was pressed into multiple symbolic functions. The "inner city" helped bolster black social and political perspectives that centralized the need for middle- and upper-class blacks to "give back" to the economi-

cally devastated, majority-black urban areas, or at the very least to distinguish their upward mobility from the situations of those who live in the ghetto. These settings also served as sources of nostalgia and sites through which concepts of black authenticity were measured, as if "real" blackness could be experienced only on "the streets." The cumulative effects of these myriad meanings are more than can be addressed here. However, the real effects of deindustrialization, intensive policing, white and black flight, and educational apartheid notwithstanding, it is important to understand how the imagined ghetto serves as a setting for black writers to engage with these multilayered issues.

Therefore, *PUSH* situates Harlem as a critical site for the post–Civil Rights failure that the figure of the welfare queen enacts. However, as I describe in subsequent sections, the novel intervenes in the rationales of racial neoliberalism, and instead implicates institutional or systemic functions—such as increasing concentrations of state power and media inundation—as the causes of familial discord and estrangement from community. Primarily through the narration of Precious, *PUSH* indicts structural causes for the intensification of fear and violence in the inner city rather than simply pointing to a failure of personal responsibility. Precious endures a girlhood beset by neglect, emotional and sexual abuse, and incestuous rape from her parents within her home. However, throughout the novel, her character acknowledges how the poverty, racism, sexism, and homophobia of the outside world structure her dismal family life. Madhu Dubey writes that Precious's illiteracy "reinforces her sense of enclosure within the narrow and segregated space of Harlem. As she acquires literacy, Precious begins to understand her own restricted place within the wider urban system."[12] Literacy pushes Precious's consciousness outward into the public sphere, presenting her less as a specter or a ghost, and more as a subject-citizen who can address others in her social worlds through reading and writing. Precious consciously seeks alternatives to her abjection, and throughout the novel she progressively insists upon her own social viability and visibility through her simultaneous quest for literacy and motherhood.

HEROIC MATERNAL SELF-TRANSFORMATION AND HISTORICAL MYTHS

Claudia Tate's conception of "heroic maternal self-transformation" becomes useful in reading *PUSH* because Tate provides a way of reading episodes of "domestic defilement" as controversial yet progressive moments in black

women's literature.[13] In her analysis of Harriet Jacobs's *Incidents in the Life of a Slave Girl* (1861), Tate notes the ways that the text "mourn[s] the persistent violation of black womanhood, maternity, family, and home."[14] In *Incidents*, Jacobs reveals her own experiences of violation as a slave girl, shining a light on the systematic sexual abuse of young female slaves and forcing her primarily white abolitionist readers to confront sexual tyranny in this brutal system. In order to do so, Jacobs had to usurp the formal conventions of the slave narrative and women's sentimental literature to expose details that were considered salacious and inappropriate for public discussion in the nineteenth century. Tate explains, "By portraying her experience of sexual molestation, Jacobs dared to breech social and literary convention as well as make the sexual oppression of an *adolescent* black female a symmetrical paradigm to that of the brutally whipped bondsman."[15] The previously silent figuration of the enslaved mother speaks through Jacobs, who writes her self and her experience into the public sphere in the authoritative role of "mother," enacting what Tate describes as "heroic maternal self-transformation." In other words, Jacobs enters the social and political discourses of abolition and liberation by participating in the nineteenth-century cult of true womanhood, which included a maternal ideology that emphasizes women's "natural" roles as child-bearers and nurturers. The expression of maternal feelings of protection, nurturance, and love for children allows Jacobs a kind of "fictive participation in these institutions (womanhood, motherhood, and family) [that] constitutes a political discourse of desire."[16] The powerlessness and invisibility of the enslaved mother gets reconfigured in *Incidents* via the black heroine's successful fulfillment of motherhood *and* her accomplishment as a writer, despite the (relatively) sensational and disturbing subject matter. Tate's concept helps reveal the mama's gun reading available in *PUSH* by illustrating how the presentation of "disturbing" material in service of making political claims for equality has always been a central strategy in black women's literary traditions. *Incidents* also works intertextually with *PUSH* in its centralization of a Young Mother figure as worthy of voice.

While Jacobs wrote her life story in an effort to win support for abolition, the 1990s presented starkly different social, economic, and political challenges to black citizens. The post–Civil Rights era and the entrenchment of racial neoliberalism meant that overt racism had been replaced with coded language that would compel dominant citizens to blame black people, along with other racial and ethnic minorities, LGBT individuals, Muslims, and immigrants, for a host of problems. Black mothers were especially implicated as abusers of state resources because of beliefs that black women are wanton and careless breeders, an idea that emerged several centuries before.

In her essay "Surrogates and Outcast Mothers," Angela Davis connects black women's reproductive experiences in the 1990s to U.S. racism and the legacies of slavery. She shows how the histories of breeding, wet nursing, forced sterilization, state surveillance, child abduction, and maternal vilification reveal a collective history of black women whose reproductive choices have been disregarded and devalued, and asserts that any reading of contemporary black motherhood requires an understanding of how history has affected current social relations and cultural production, an idea addressed also in the work of Hazel Carby, Patricia Hill Collins, Barbara Omolade, Dorothy Roberts, and Laura Doyle.[17] Davis concludes that women's reproductive politics in the 1990s, which included emerging concerns with new reproductive technologies, must grapple with the exigencies of black women's reproductive histories, or what she calls their "alienated and fragmented maternities."[18]

The black single mother, unwed black teen mother, and black welfare mother emerge as ubiquitous variations on a single type founded in the institution of plantation slavery: the hyper-reproductive black woman, who was positioned in the eighties and nineties as a threat to the nation because she gave birth to a permanent underclass. Barbara Omolade's study *Rising Song of African American Women* shows how "Black single mothers, especially poor teenagers, had become the symbol of all that was wrong with Black people and women and their movements."[19] Politicians exploited these maternal figures in public discourse in order to scale back social welfare programs, such as Aid to Families of Dependent Children (AFDC), while sustaining social control programs, such as coerced sterilization and birth control. This intertwined yet contradictory neoliberal logic prevailed during the post–Civil Rights era.[20] Therefore, the symbolic refuge of motherhood and maternalism, which situates childbearing white women as noble and nurturing, did not apply to black mothers in welfare discourse because black mothers have little access to a history of positive maternal signifiers. Being labeled as "dependent" on welfare in the neoliberal logic of the post–Civil Rights era was, in effect, a way of stripping black women of their viability as legitimate or worthy citizens because, as Ruth Sidel describes, dependence is "an absolute negative, a polar opposite from that valued American characteristic, 'independence.'"[21] Ideological support for President Clinton's welfare reform tacitly relied on these associations in public conversation. However, this same regressive social policy that sought to strip subsistence benefits from the most vulnerable Americans on the backs of black mothers also was understood publically as part of a movement toward "small government." Ironically, the rhetoric of government reduction did not extend to black women's reproduc-

tive choices; their maternity remained under state surveillance and control. In fact, government programs proliferated in the latter twentieth century that sought to curb or eliminate black pregnancy, especially among the women who qualified for welfare benefits. In the name of so-called small government, states repeatedly intruded into the private lives of black girls and women in order to monitor and control their fertility throughout the 1990s through the imposition of pharmaceutical birth control. Long-term contraceptive drugs such as Norplant, Depo-Provera, or the "contraceptive vaccine" all appeared in the nineties and were used as tools by legislators and law enforcement to curb black women's fertility. Bills appeared across the country that pressured or required women on welfare to use Norplant, an injectable, long-lasting contraceptive, in order to continue receiving benefits. So, even while welfare budgets were being slashed, many legislators fought hard to fund Norplant. Some states even considered making the drug mandatory and aggressively distributed the drug to black teenage girls.[22] Legal scholar and reproductive rights expert Dorothy Roberts notes, "In the new era of welfare [reform], government assistance has become a tool of social control" that requires conformity among mothers.[23]

The narratives and images of hyper-reproductive black mothers helped maintain the racialized social order in the 1990s, but in this time their progeny, deemed "illegitimate" and "underclass," became almost as useful as political scapegoats as they were as exploitable laborers. The persistence of this "American grammar" of black women's procreation continues to present itself in the new millennium in the suggestion made by former U.S. education secretary Bill Bennett in 2005: "You could abort every black baby in this country, and your crime rate would go down."[24] Bennett was riding the wave of ethos created by the images and narratives surrounding the Hurricane Katrina disaster that year in suggesting the abortion of black babies as a solution to the problems of crime. Bennett, who is a staunch antiabortion/pro-life politician and former member of the Reagan administration, imagines abortion as a "solution" to the social problem of "criminality," which, as Michelle Alexander points out in *The New Jim Crow*, is coded language for people of color.[25] His eugenic comment renders actual black women invisible; he never names or blames black mothers directly. Yet, of course, black mothers remain overwhelmingly present and visible in his comment. Embedded within the crevices of his statement, black women are substituted as *bodies* available for compulsory abortions or *bodies* responsible for giving birth to and raising "criminal" children. Black entertainer Bill Cosby perpetuated a similar logic in 2004 in his now infamous "Pound Cake" speech when he publicly targeted black women as responsible for the lack of economic and political gains in

urban black communities since the Civil Rights era. In the name of black uplift ideology and respectability, Cosby described images of young black women as hypersexual and hyper-reproductive:

> Five or six different children, same woman, eight, ten different husbands or whatever . . . I'm telling you, they're young enough. Hey, you have a baby when you're twelve. Your baby turns thirteen and has a baby, how old are you? Huh? Grandmother. By the time you're twelve, you could have sex with your grandmother, you keep those numbers coming. I'm just predicting.[26]

In other words, Cosby invokes the stereotypes of unwed black teenage mothers and their "deviance," which would produce a grandmother at age twenty-five. Cosby's "prediction" operates in ways that are barely distinguishable from Bennett's assertion. Both powerful men—one in government and another in entertainment, one white and the other black—collude in perpetuating a litany of references to the hyper-reproductive black mother in the post–Civil Rights Era. The characteristics assigned to those mothers—promiscuity, immorality, criminality, lack of marriageability, ignorance, and youth—work to displace structural inequality as the source of social problems and instead focus public opinion on issues of "personal responsibility" and "family values," which are clear examples of the new racism undergirded by the language of neoliberalism.[27]

With these examples in mind, I return to one of my central questions outlined in the introduction. How can black fiction break the signifying chain of historical myths of black womanhood? What can black fiction do to counter the overpowering and inundating effects of this sensationally racist and sexist imagery? Returning to Tate's idea of heroic maternal self-transformation and mama's gun, I suggest that some black writers pull black mothers out of the shadows of the national imagination and give voice to these ignored and maligned maternal figures through art. Sapphire's text uses forms of signifyin(g), intertexuality, and vernacular revision to develop Precious from a stereotypical unwed teenage mother and welfare queen into a Young Mother, a heroic black girl who learns to read, write, and mother. The course of Precious's heroic maternal self-transformation and its link to literacy is the topic of the following sections. Importantly, I compare Precious's development to that of Celie in Alice Walker's novel *The Color Purple* (1982).[28] Sapphire explicitly references Walker's Pulitzer Prize–winning novel in *PUSH* when Precious reads the novel in school and connects her experiences to Celie's. Both girls are incest survivors, give birth as teens, live in poverty, have

their children taken from them, learn to read and write through the course of the novel, and find love and acceptance through a connection with a lesbian black woman. These significant links make the two novels important to be considered together even though their settings are distinct (*The Color Purple* takes place in 1920s rural Georgia). However, I hope to draw readers' attention to ways that Sapphire references and extends the depiction of the Young Mother in Walker's acclaimed novel.

"PUSH, PRESHECITA. PUSH": BECOMING THE YOUNG MOTHER

Though the structures of her world render her young, black girlhood invisible to all except the police and social welfare agencies, Precious enters *PUSH* with a strong voice. This is one of the first departures Sapphire makes from the literacy narrative of Celie in *The Color Purple*. Unlike Celie, Precious is not silent, and she begins her story orally, trying to explain "why I'm talkin'" (3). She regularly talks back to teachers, classmates, and others that she encounters. As the first-person narrator of the story, Precious also presents her lively inner monologue that suggests her worldliness and critical self-fashioning. Sapphire captures the cadences and rhythms of Precious's speech on each page. The sense of Precious's functioning voice is also exemplified through her quick wit and penchant for sexually explicit similes—"she look at me like I say I wanna suck a dog's dick or some shit" (7). Coming to voice and coming to self through literacy is no small feat in the confines of Precious's world. Although she is old enough to be in the eleventh grade, she has been held back and languishes in the "ninfe" grade.[29] She is functionally illiterate, and she finds herself inundated regularly with the tyranny of print: school files, social service files, tests, and schoolbooks. Each site of writing stands as a marker of her inadequacy and failure to "learn, catch up, be normal" (5). Precious describes her suspicion of tests: "There has always been something wrong wif the tesses. The tesses paint a picture of me wif no brain. The tesses paint a picture of me an' my muver—my whole family, we more than dumb, we invisible" (30). The tests possess the institutional power to invalidate not only her existence but also the presence of everyone in her social world. In passages like these, Sapphire's experimental form forces readers to push through the fragmented linguistic representation of Precious's African American vernacular English (AAVE) and her New York dialect. This use of morphological distortions calls attention to the difference between Precious's speech and standard spoken English. In doing so, Sapphire requires that

readers take time to understand what Precious says. In fact, the beginning of the story has a speakerly feel in the sense that readers often have to say the words out loud to understand their meaning. Depending on the linguistic communities to which one belongs, this act can be fairly easy or extremely difficult. Either way, the act of "hearing" Precious in this text mirrors a larger act of learning to understand the subjectivity of a marginalized black girl. It's a process that draws us nearer to Precious, much in the way you might lean in if you could not hear another person in a conversation.

As a whole, *PUSH* describes the harrowing coming-of-age that Precious endures: rape by her father, molestation by her mother, and neglect and abuse by both. Outside of the confines of her apartment, Precious encounters hostile education and social welfare systems that figure her as another statistic of the rising black underclass. Junkies, pimps, and prostitutes scatter the streets of her Harlem world like detritus; they are discarded, wasted lives that prefigure the only future Precious can imagine—that is, until she becomes pregnant for the second time by her father and enters an adult literacy program. In the program, Precious not only learns the rudiments of literacy but she also becomes a poet and enters a loving community of other women who become a surrogate family to her. The emerging literacy that Sapphire traces in this novel is motivated by Precious's maternal desire; her commitment to writing tightly parallels her commitment to caring for her children. The act of childbirth—the push necessary to deliver her babies—becomes the novel's central metaphor for agency.

Sapphire crafts this maternal metaphor of agency against the grimmest of circumstances, and it is in this way that textures of Walker's novel can be seen showing through in Sapphire's narrative. In the same way that a teenaged Celie must deal with the confusion at the circumstances of her pregnancy, so too does Precious. Importantly, however, Precious's motherhood and reproduction remain negatively marked in the novel (and in the wider arena of critical reception and reader response). Precious has no redemptive moment where she realizes that the father who raped her is not biologically her father, as Celie does, which goes far to help the latter legitimize her experiences of maternity. Precious, who reads *The Color Purple* in her literacy class, references the importance of Celie's revelation and later asks her mother if Carl Jones really is her father. She finds out he is her biological father, thereby abandoning her motherhood in the realm of incest. Precious's motherhood remains marginalized and stigmatized because it exists in contradistinction to the bourgeois family unit, and it makes her struggle to access the symbolic privileges of good motherhood more difficult. Unlike Celie, who gets to claim triumphantly at the end of her story a reunited and healed family unit

redeemed, Precious ends her story with further estrangement from her family and a diagnosis of HIV.

Nevertheless, in the episode in the novel that depicts Precious's first day of school, details emerge that expand the parallels between Precious's determination to be a mother and her desire for literacy and, by extension, social visibility. Early in the novel, Precious anxiously prepares to attend her first day in the new literacy program, and on her way out of the door, she says, "I double back to my room. On top my dresser is notebook. I got self, pencil and notebook. Can I get a witness! I'm outta here!" (36). In this instant, Precious confidently invokes her personhood in relationship to the instruments of literacy—the pencil and the notebook. Her words not only foreshadow the importance of literacy to her emotional and educational development in the novel but also signal a critical connection between this novel and other works by black women that correlate literacy with social recognition, which I address in the final section of this chapter. For Precious, learning to read and write holds out the promise of a self-determined visibility in the wide-open world, a visibility that would counteract the stain of abjection, absence, and dependency that her poor, black girlhood signifies. Through this phrase, "I got self, pencil and notebook," Precious merges the ideas of selfhood and text, and she imagines writing her "self" into figurative existence.

Furthermore, her exclamation of "Can I get a witness!" acts as a vernacular call to the reader to bear witness to the transformation that she anticipates on her journey into the world of reading and writing, and perhaps her eventual escape—"I'm outta here." The call—"Can I get a witness?"—alludes to an African American church tradition of a minister calling upon members of a congregation to verify or affirm the will or observation of the speaker. Precious, acting as authorized speaker, punctuates the phrase "self, pencil and notebook" by staking her claim to the legitimacy of her own voice and the power behind her act of attending school. The liberatory insistence of the black voice—its oral manifestations—predominate many readings within black literary studies, yet one cannot escape Henry Louis Gates's observation that historically for black writers, "text created author" and not the other way around. In other words, being and becoming for black people involved reading and writing in order to disprove white supremacist claims of black inferiority and cultural absence. Therefore, the phrase "self, pencil and notebook" becomes emblematic in my reading of this novel, because it reiterates the lasting power of text to create the black subject, and in this case a visible Young Mother, in the American imagination.

Yet, just as soon as Precious leaves the claustrophobic setting of her apartment that day, she must encounter the harsh realities of her life outside her

abusive home, a set of realities dictated by her race, gender, and class. On her way to school, she is gripped by hunger. The welfare support that is supposed to provide humane living to those in need barely provides Precious and her mother enough to eat other than an abundance of poor-quality, unhealthy foods. Overwhelmed by her hunger, Precious enters a chicken joint with the intention of stealing something to eat. She draws upon her street knowledge, or a set of vernacular skills, to distract the cashier by requesting food from the back of the store. While the cashier is in the back, Precious grabs the meal on the counter and runs. Though she succeeds in stealing some fried chicken and a roll from the restaurant, she leaves her pencil and notebook behind.

This episode stages a critical conflict that lies at the heart of this narrative—the difficulty for a black girl to realize the promise and hope of the American Dream when she is beset by institutionalized inequality, such as poverty, racism and sexism, and intense violence at the hands of her parents. It is a conflict articulated by education scholar Sharon Darling, who writes, "The myth is 'through literacy, all can be overcome.' The truth is that the Black woman has much more to endure in our society . . . The history and structure of society created a situation whereby the Black woman has been in an unrelenting uphill battle to be a recognized member of society."[30] The hunger that Precious experiences on the way to school exemplifies the "unrelenting uphill battle" that Darling describes, and it is enough to cause Precious to leave her pencil and notebook, which she metaphorically recovers by the end of the novel. I am interested in what caused her to pick up the pencil and notebook in the first place. Sapphire connects Precious's reading and writing to her commitment toward becoming a mother—a good mother—and caring for her children. In fact, the act of childbirth—the push necessary to deliver her babies—recurs throughout the novel as a symbol of Precious's perseverance, reminding her that she must push past the obstacles in her life in order to learn to read and write, skills that mark her as human, as citizen, as subject, and eventually, as poet.

Precious expresses a desire to advance academically and, specifically, to learn to read and write, which emerges in the narrative coextensive to her pregnancy. Impregnated for the second time by her father, Precious faces expulsion from her public high school until a school administrator suggests that she enroll in an alternative school. Precious is not sure what an "alternative school" is or how it can help her, but she has a feeling that it will be an opportunity for her finally to get the education that she has missed. The night before she visits the alternative school she has a dream: "I dream I'm in an elevator that's going up up up so far I think I'm dying. The elevator

open and it's the coffee-cream-colored man from Spanish talk land. I recognize him from when I was having my baby bleeding on the kitchen floor. He put his hand on my forehead again and whisper, "Push, Precious, you gonna hafta *push*" (16). Within Precious's dream, she equates learning and literacy with ascendancy and upward, progressive movement. Moving forward also means coming close to dying. To attend the alternative school will allow her the opportunity to ride that elevator "up up up" toward education, but she is fearful of coming close to death, perhaps a figurative death of the only social world that she has known. What stands out in this passage, too, is how closely Precious aligns her progressive struggle toward education with her experience of childbirth. The Puerto Rican paramedic who helped deliver her first baby on her kitchen floor reappears in this dream. In their real encounter, he gently touches Precious on the head and belly and tells her as she has contractions: "I want you to push, you hear me mami, when that shit hit you again, go with it and push, Preshecita. Push" (10). He returns in the dream repeating these words. His return in the dream draws a parallel between the intense transformation Precious fears as she embarks on her literacy quest and the transformation she has endured during pregnancy and childbirth. Her sense of progress entails both literacy and childbirth. Bridged by the notion of moving forward and pushing hard, literacy and childbirth are linked narratively by way of parallelism.

Sapphire makes an important link between print literacy and maternal embodiment and experience consistently throughout the novel: to push past the private shame of illiteracy into the public strength of literacy, even poetry, is a metamorphosis akin to the shift from the alienating experience of rape and forced pregnancy into the empowered status of motherhood. Giving birth to her first child—who is born with Down syndrome and is eventually placed in an institution—provides Precious a catalyst for describing how she became invisible to the world. In the hospital, just after giving birth, a swirl of memories rush her mind as she cries for her "ugly baby" and then cries for her *self.* She mourns for her girlhood that has been devastated by the molestation and abuse she suffers in her home. She realizes how that abuse cut her off from her education, rendering her illiterate. Remembering the filthy touch of her father, Carl, when she was in elementary school, she says:

Carl is the night and I disappear in it. And the daytime don't make no sense . . . What difference it make whether gingerbread house on top or bottom of the page . . . I disappears from the day, I just put it all down—book, doll, jump rope, my head, myself. I don't think I look up again till EMS find me on floor. (18)

The elements of her child identity and her education must be abandoned in order to cope with the trauma of her experience, and in the process she also abandons her head and herself. Significantly, however, the catalyst for her emergence from this nightmare world into the realm of literacy and visibility as a member of the social order and as a subject-citizen corresponds to her maternal desire, which pushes her to attain the status of mother through both maternal experience and maternal embodiment.

In her literacy class, Precious begins to make further connections between her life as a mother and her subjectivity. Clearly, she has much to learn in class in order to read, but her ability to imagine herself as a mother to her new baby coincides with her burgeoning ability to write about life. Precious begins this journey from private to public, to transgressive maternal identity, by revealing her second pregnancy. Precious is an overweight girl, so she has been able to hide the pregnancy thus far in the story. The administrators at her public school suspect that she is pregnant, but Precious denies it. She is ashamed. She also has not told her mother. She is afraid of being beaten. However, after attending literacy class for a month, where she "sits in the circle" with other girls in similar circumstances, she "don't pretend I'm not pregnant no more. I let it above my neck, in my head. Not that I didn't know it before but now it's like part of me; more than something stuck in me, growing in me, making me bigger" (62). Here she is able to claim the child as part of her new, more hopeful self-concept. It is interesting how her sentence makes a double gesture toward the literal and the figurative. The child that she now accepts is "growing in me" and "making me bigger," which makes literal reference to the biology of pregnancy. However, the language here also suggests figurative forms of personal transformation, such as intellectual and social growth or a bigger sense of her self and her world.

She makes this clear again via her connection with her baby, when she proudly proclaims "I bet chu one thing, I bet chu my baby can read. Bet a mutherfucker that! Betcha he ain' gonna have no dumb muver" (63). Precious holds fast to the ideal of mother and child together, growing together, getting bigger together. She ties her literacy to the baby and vice versa. She says that "soon as he git born I'ma start doing the ABCs. *This my baby.* My muver took Little Mongo but she ain't taking this one" (64; emphasis added). Precious's confidence is shown with the claim that "this my baby." She becomes more resolved to protect her baby and raise him on her own. More than that, she expresses the maternal desire to have control over what and how her baby will learn. This education, however, will be specific to the subject space she occupies as a young black woman growing up in urban America. She describes how she wants to put pictures on the wall of her baby's room, and how she

plans to read to her son each night. She even begins to teach the unborn baby the alphabet by reading aloud, hoping he can hear her in the womb. Rather than simply recite the ABCs, however, Precious writes in her barely literate script her own version of a grade-school primer: "A is fr Afrc (A for Africa) / B is for u bae (you baby) / C is cl w bk (colored we black)" (65–66). She does the entire alphabet, including "F is Fuck," "I I somb (somebody)," and "N nf kkk (North America = KKK)." Miz Rain provides the parenthetical notes in order to encourage her students to write even though they have not mastered reading and spelling skills yet.

Miz Rain has authorized her students to unlearn the rules of school, and by transgressing the bounds of what constitutes good written English, she allows Precious to write about her world with whatever basic skills she has at that time. Precious begins to feel comfortable in this liberatory space and from this location of power. It is here that she defines herself as subject. The dialectic between mothering as metaphor and experience resounds strongly in the passages above. Precious's difficult labor acts as a metaphor for her emerging literacy; the way she pushes against intersecting oppressions to claim her right to write acts as a reflection of the process of giving birth. On the level of experience, Precious struggles to learn to read and write in order to provide education for her son. Each and every day she picks up a pen to write, in part because she does not want to be a "dumb muver" and in part because she realizes that she, too, has something important to say. Precious's voice joins those of other black mothers in a literary tradition that has sought to revise and reimagine the silenced, enslaved black mother in a variety of fictive ways. *PUSH* accomplishes these associations through an intertextual dialogue with prominent antecedents in black women's literary tradition using the metaphor of mother's milk to illustrate the textuality of maternal experience. However, Sapphire's use of this imagery most significantly parallels Walker's uses in *The Color Purple,* and both texts are distinguished in their focus on the protagonists' literal acts of writing.

WHITE INK, BLACK INK: TEXTUALIZING EXPERIENCE OF THE YOUNG MOTHER

Rich with nutrition and meaning, mother's milk supplies a plenitude of symbolic wealth to many of the maternal figures imagined by contemporary black women writers. In a number of texts, including Alice Walker's *The Color Purple* (1981), Sherley Anne Williams's *Dessa Rose* (1986), Toni Morrison's *Beloved* (1987), Sapphire's *PUSH,* and Olympia Vernon's *Eden* (2002), the recurring

imagery of breastfeeding links milk, mothering, and writing to autonomous black female subjectivity. The idea that mother's milk symbolically corresponds to feminine self-expression, specifically writing, is not new, but I am interested: if mother's milk is the metaphorical "white ink" through which women "come to language and launch their force," as French feminist Hélène Cixous writes, then what happens when the production of milk is blocked or thwarted or the milk is wasted or stolen?[31] Keeping in mind the histories of "alienated and fragmented maternities" described by Davis, the figure of the enslaved black mother, and the history of wet-nursing, it becomes clear why depictions of breastfeeding often demonstrate a supreme act of personal autonomy for fictional black maternal figures. Anne Goldman explains in her study of *Beloved* and *Dessa Rose* that when nursing appears in black women's texts, mother's milk operates as "a sign of herself as author of her child's development, the ink evidence of the authority of her word."[32] The milky white ink has the potential to act as black ink, reinscribing the subjective voice of the suppressed, silenced, or appropriated black mother. Breastfeeding episodes in *PUSH* build on this literary foundation, although it diverges in significant ways from earlier works, such as *Beloved* and *The Color Purple*.[33]

Goldman's analysis of the image of milk and breastfeeding in *Beloved* helps to further contextualize the act of re-memory as a rewriting of the figure of the enslaved black mother. Goldman reads Sethe's nursing as a countertext to the "official" story that typically erases the presence of the enslaved black mother. She concludes that since black women's bodies and words have both been "commodified; texts upon which the white man makes his mark," milk emerges in these two texts as the only aspect of a slave woman's experience that is not "other-directed." Since it is a representation of an "intersubjective bond between mother and child [breastfeeding] is unmediated by the slaveholder," and therefore "it is a signifier of an identity—a subjectivity."[34] Thus, the reproduction of children is linked to the reproduction of words, or rather a metaphorical textuality of black women's experience. The nursing black mother writes her *self* into being through her claims to motherhood. While this trope is related to my reading of *PUSH,* there is an important distinction between textualizing subjectivity, as seen in Sethe's situation, and the effect of actual literacy—the practice of reading and writing text—in terms of the formation of the black mother as subject-citizen. Sethe's milky "writing" occurs solely at the conceptual level; she never literally writes anything in the novel. In fact, her relationship to actual print remains fraught, as demonstrated in the episode in which Paul D discovers a newspaper article describing Sethe's infanticide. In this case, the actual text of the dominant white world negatively intervenes in her self-making via the white ink of mother-

hood.³⁵ My interests lie in texts that depict black maternal figures that literally read and write, and how that acquisition and use of literacy coincides with or parallels their claims to motherhood, creating opportunities for heroic maternal self-transformation.

The Color Purple privileges literacy in ways that are similar to Sapphire's work, especially in the ways that the novels parallel breastfeeding, literacy, and naming. For example, in *The Color Purple,* the image of Celie's "breasts full of milk running down" places mother's milk at the center of her physical trauma, exemplifying her loss of control over her own body.³⁶ Celie writes to God about her engorged breasts that involuntarily overflow with the milk that would have fed her newly born son. Pa, the man whom she believes to be her father and who has impregnated her twice, has taken Celie's son and daughter away at birth. The biological imperative for Celie's body to produce milk following childbirth continues even when her baby is no longer present, and this descriptive moment represents the futility of fertility that black women have faced when their babies have been taken from them. Importantly, Celie seeks to verbalize the pain of her maternal estrangement through the process of writing.

In *PUSH,* Precious evokes the image of breastfeeding as well, but as a way to celebrate her determination to keep and raise her second child, Abdul, who "gets to suckes from my bress" (68). With her first child already taken from her and institutionalized, Precious resolves to raise Abdul, who, like Celie's children, is fathered by a dominant paternal figure. Despite the incestuous sexual violence both characters endure, both Precious and Celie express love and a desire to care for their babies, as if their love for their children allowed them to love themselves. Precious connects her autonomous claim as a mother to Abdul's nursing. She reflects on how good her son is and how special he is because he "gets to" nourish himself from her breasts, unlike her first child. In this passage, her breast milk becomes a privileged site of real and symbolic nurturance, and it is from that point of view that she defines her sense of agency as a mother who has control over her body and her child's body simultaneously. Her presentation of this act of maternal agency is incited by her quest for literacy in an inner-city alternative school.

The episode in *The Color Purple* when Celie sees her daughter in a store exemplifies this access to social recognition through maternal experience as expressed through a kind of literacy—an inscription. On a chance visit to the general store, Celie sees a young girl whom she believes to be her daughter, who had been taken from her by Pa right after birth. The girl is with another adult black woman, her adoptive mother, who is described as "a lady." Celie sees the pair in the store and describes a maternal desire and longing that

reaches back to her memories of her daughter as an infant. Celie says she saw her "baby girl" and invokes a naturalized recognition of her: "I think she mine. My heart say she mine" (14). Celie expresses a maternal sweetness and concern for the girl because she senses that she is her own biological child. She recalls how she embroidered the child's name on her "daidies," her diapers, which is another kind of writing or inscription that creates a sense of self for Celie.

Interestingly, as Celie continues to describe watching her daughter and the lady in the store, she also describes the lady's exchange with the white shop clerk. The store clerk, who has been watching Celie and the lady speak to one another, rudely interrupts them and rushes the lady's purchase. Celie continues to write: "He snatch the cloth and thump down the bolt. He don't measure. When he think he got five yard he tare it off" (15). Celie is careful to detail in her letter the blatant disregard she observes in the clerk's treatment of the lady, who has done nothing but "speak pleasant." The clerk's racist treatment of the black lady in the store leaves Celie diminished. She writes that after she walks out of the store, "I don't have nothing to offer and I feels poor." The other woman leaves the store upset as well; when she realizes that her husband, the reverend, is not already there to pick her up, she appears as if "she gon cry" (15). In this exchange, both black women of differing class status have had the warmth of their meeting and conversation ruined by their encounters with racism and sexism in the store.

Still, even at this low point, Celie's letter shifts the narrative to recover their dignity. Outside of the store, they each wait for their husbands, and Celie asks the name of the little girl. "She say, oh we calls her Pauline. My heart knock. Then she frown. But *I* calls her Olivia" (16). The typographical emphasis on the "I" comes from Celie, indicated in her written words. By distinguishing that personal pronoun, Celie calls attention to the sense of self that the black lady, the adoptive mother, possesses by having the power to call her daughter what she wants. For Celie this revelation is a joy because Olivia is the name that Celie gave the child before Pa took her away. Though the adoptive mother has another explanation of the source of the name—"Don't she look like an Olivia to you?"—Celie still experiences maternal validation in this exchange through her power to name her daughter.[37] Both women seem to erase, or at least ameliorate, their sense of dismissal at the clerk's counter through their mutual power to name the child. In Celie's letter, the name conversation has the effect of recovery and healing for the women. This healing is demonstrated by the ease and freedom with which Celie and the lady laugh at a joke just moments after they discuss the name. *The Color Purple* presents Celie as a woman who transforms herself from the darkness, silence,

and ignorance of her victimization and pregnancy into the status of mother-hood, a status validated in part through sentimental tropes of love, care, and nurturing of babies and children, as well as the power to name and inscribe names. Celie's experience belongs to Tate's category of heroic maternal self-transformation, because the text shows the protagonist's ability to "replace the social alienation inherent to racial oppression with symbolic mother love."[38]

PUSH echoes *The Color Purple* in this regard, and the maternal act of naming becomes another important site of Precious's development and self-actualization as a Young Mother. For Precious, however, there is a definitive shift in the authority of naming that she claims between the births of her two children, her daughter, Little Mongo, and her second child, her son, Abdul. She gives birth to her daughter when she is only twelve years old, and she is told in the hospital that the daughter has Down syndrome, a genetic condi-tion that was once known by the offensive term "mongolism." Reflecting Pre-cious's lack of knowledge and insight about her daughter's condition and the unpleasant connotation of the word "mongoloid," she names her daughter Little Mongo. She explains her rationale: "Mongo sound Spanish don't it? Yeah, thas why I chose it, but wat it is is short for Mongoloid Down Sinder, which is what she is; sometimes what I feel I is. I feel so stupid sometimes. So ugly, worth nuffin'" (34). On one level, Precious chooses the name because it sounds striking or perhaps glamorous in her twelve-year-old mind. On another level, it is purely descriptive. She names Little Mongo in such a way because she also understands the irony of her own name—Precious—given to her by a mother who treats her as anything but prized or valued. Rather than replicate the confusion that her own name conjures for her throughout the novel, she opts for a fully descriptive name by calling Little Mongo "what she is," which she understands as ignorant, ugly, and worthless. Even so, the first thing that Precious inscribes in her writing journal in her literacy class are the letters "li Mg o mi m," which she explains to Miz Rain means "Little Mongo is on my mind" (61). When Miz Rain asks Precious who Little Mongo is, Precious writes the reply, "Little Mongo is my child." In this episode, Pre-cious instantly feels understood and recognized, and she explains, "Miz Rain know Little Mongo is my child 'cause I wrote it in my journal. I am happy to be writing. I am happy to be in school" (62). Her recognition as a mother becomes inextricably linked to her ability to write and be seen as a Young Mother while in school. Even though her daughter's name is a variation on a pejorative term for her disability, Precious claims a small sense of respon-sibility and control in this naming act, which develops in the birth of her second child.

By the time Precious gives birth to Abdul, she is fully ensconced in the alternative school and Miz Rain's learning community. As a result, she names her son Abdul Jamal Louis Jones, and says, "That's my baby's name. Abdul mean servant of god; Jamal, I forgot; Louis for Farrakhan, of course" (67). The symbolic differences in the meaning of Abdul's name and Little Mongo's names are apparent, and yet the *process* that Precious uses to name her son reflects a major leap in terms of her claims of heroic maternal self-transformation. Abdul is born on January 15, 1988, which would have been the date of the first observance of the Martin Luther King federal holiday. The narrative makes no mention of the King holiday explicitly, but the embedded reference provides deeper meaning to the way that Abdul's character functions in the novel. Precious associates Abdul with black freedom leaders, including Dr. King and Minister Louis Farrakhan, which allows her to envision her son through the legacies of these two men. Throughout the novel, Precious describes her admiration for Honorable Minister Louis Farrakhan, the controversial leader of the Nation of Islam since the late 1970s. Precious is not an official member of the religious organization, but she respects Farrakhan's message of self-determination for black people spread throughout cities like New York, Chicago, Los Angeles, and Detroit in the pages of his publication, *The Final Call,* and through recordings of his speeches. By the late 1980s, when the novel is set, the Nation of Islam had begun a powerful resurgence in black communities, seeking to find solutions to issues such as drug addition, joblessness, and violence. Precious is influenced by the authoritative voice of Farrakhan, who identifies white supremacy as the source of black misery. She keeps a picture of him on her wall because "he is against crack addicts and crackers. Crackers is the cause of everything bad. It why my father ack like he do. He has forgot he is the Original Man!" (34). Therefore, Precious sees Farrakhan as a righteous leader who helps her understand the influence of "crackers" (white supremacy) on the cycles of violence and spiritual poverty that motivate the depravity and abuse in her home. In reverence for Farrakhan, she selects the Arabic name Abdul even though "I didn't know what it mean" when she selected it.[39] After Abdul is born, she looks his name up in a book and discovers that it means "servant of god."

Precious revises her naming process through Abdul. She selects a name not simply as a description, but rather as a concept, which she correlates with black freedom and self-sufficiency. Even though she does not fully understand the meaning of the names she selected for Abdul, they represent her claim to a kind of "good" motherhood that would be unrecognizable to the social service workers, doctors, and other officials who read her file and determine her fate. This sense of maternal self-recognition through naming provides Pre-

cious the strength to resist the social service agency's suggestion that she give up on her dreams of getting a GED and going to college in order to become a low-wage home assistant.

The novel ends before we can find out whether Precious can fulfill her dreams to live independently with Abdul. Toward the end of the novel, she is diagnosed with HIV and begins the slow process of sexual abuse therapy. Even with these grim details, the novel ends with not so much as hope for a "happy ending," but with a satisfaction that such an abused and neglected black girl can eventually see herself as part of a community and worthy of love.

PUSH rewrites and revises the story of Celie through Precious within the urban decay of 1980s America. Unwed, functionally illiterate, and victims of incest and rape, Celie and Precious narratively embody the worst ideological stereotypes about black mothers. They are unwed at the time of their pregnancies; they are adolescents and impregnated by men who are either biologically or socially considered their fathers. Yet, these two women pursue literacy in resistance to the ideologies that have sought to define them. When Precious, the overweight, pregnant, poor, HIV-positive, black teen mother protagonist of *PUSH* says, "I got self, pencil and notebook" (36), she crosses those figurative boundaries that keep welfare queens and unwed teenage mothers like her outside of the norms of social acceptance and national belonging. The trinity of "self, pencil and notebook" allows her to leave the boundaries of her small apartment and literally cross the boundary of her doorstep and enter public space. But, at the point in the novel when she invokes this trinity, she also crosses a figurative border into the world of recognition. Once in that public space, Precious has the opportunity to reimagine herself as a Young Mother, a more visible and viable subject-citizen, albeit a woman still intensely constrained through the biopolitics of her everyday life.

It's not as if the figure of the Young Mother can undo centuries of symbolic work and material deprivation that established the enslaved mother in the first place. It's not as if recognition as a Young Mother places a character fully within the sanctuary of hegemonic "good" motherhood. If anything, the Young Mother can only gesture toward possibilities in reimagining black maternal subjects in terms not wholly dictated by dominant norms. Precious demonstrates the permeability of social boundaries between transgressive and normalizing that are often experienced as rigid, and she suggests that one must learn how to shift back and forth across that imagined line.

In fact, Sapphire's work suggests that black women and other marginalized women frequently create and share knowledge on how to move back and forth across that imagined line. In her quest for literacy and mother-

hood, Precious forms relationships with her teacher and classmates, creating an alternative family that consists primarily of black women, Latinas, and lesbians.[40] In this community, Precious joins other women in the desire to claim self through the practice of reading and writing. She distinguishes herself in this community of women in the way that her pursuit of literacy is related to her pursuit of motherhood. Black women have frequently approached issues of motherhood from a reproductive justice perspective that acknowledges empowerment as not only freedom from compulsory childbearing but also as the choice to birth and raise one's biological children, and Precious exemplifies this motivation. Therefore, the experiences of birthing, nursing, naming, raising, feeding, clothing, teaching, and nurturing children become privileged in fictional narratives, because black women historically have identified these activities as sites of social recognition as subjects, citizens, and mothers.

From Harriet Jacobs's *Incidents in the Life of a Slave Girl* to *The Color Purple* and *PUSH,* black women writers, working in a number of genres—particularly slave narrative and autobiography, but also novels and poetry—have connected motherhood and writing. However, unlike other studies that have focused on the textuality or voice of the mother, this chapter explicitly links literacy—the process of reading and writing or learning to read and write—to motherhood. I privilege the meaningful connections between the literacy process and the maternal process on both biological and nonbiological levels. Literacy and motherhood operate as technologies of citizenship, and *PUSH* extends a tradition in black women's fiction that centralizes the maternal figure's quest to share her story through writing in order to refute the racial progress narratives of the post–Civil Rights moment.

PUSH tests the boundaries of tradition by appalling readers with its grim images, and herein lies the difficulty of reading maternal heroism or empowerment within this text. I ultimately agree with bell hooks, who calls for new critical lenses for black cultural production that defy the politics of positive representation. She writes that "even on cultural ground, discussions of black subjectivity are often limited to the topic of representation, good and bad images, or contained by projects concerned with reclaiming and/or inventing traditions . . . Interestingly, both these endeavors are not in any essential way oppositional."[41]

Here, hooks explains that arguments about "good" and "bad" representations of blackness reinforce the binary thinking inherent in the philosophies that have propagated racism and sexism in the first place. She argues that the process of tradition formation and canon formation within black arts and letters often legitimizes a hegemonic high/low dichotomy, and oppositional thinking comes from artists "poised on the margins." For Sapphire to craft a

novel in the mid-1990s about a fat, loud, ignorant black teen on welfare that invokes claims to "good" motherhood exemplifies what hooks calls "counter-hegemonic cultural practice." Precious Jones becomes a mama's gun figure because her narrative presence largely disavows the dominant white gaze while privileging self-recognition and self-expression of the black maternal subject.

The Color Purple and *PUSH* emerge at different points in the post–social movement era, and even though some racial ideologies changed during the years from 1982 to 1996, ideas about hyper-reproductive, irresponsible black mothers did not change much. During this time, black writers, especially black women writers, told stories that placed transgressive black maternal subjects front and center, including neo-slave narratives that centralize the figure of the enslaved black mother. These two novels stand out for the way that they propose print literacy as a viable method of challenge and critique of hegemonic ideas about black motherhood, specifically the marginalized black teen mother. *PUSH* and *The Color Purple* suggest in different registers that the desire for motherhood—particularly among those most economically deprived, abused, and stigmatized—can be a privileged site of opposition and resistance, even for black girls.

2

THE BLUES MAMA IN SUZAN-LORI PARKS'S NEO-SEGREGATION NOVEL *GETTING MOTHER'S BODY*

> Shining a spotlight on a pregnant black teenager would only fuel white stereotypes of black women's uninhibited sexuality. [Claudette] Colvin's swollen stomach could have become a stark reminder that desegregation would lead to sexual debauchery.
>
> —Danielle L. McGuire, *At the Dark End of the Street*[1]

THE YOUNG MOTHER figure reappears in Suzan-Lori Parks's novel *Getting Mother's Body* (2004), which tells the story of a poor, pregnant, and unwed sixteen-year-old black girl named Billy Beede living in the Jim Crow–era American Southwest. Parks details Billy's experience through the multiple perspectives of her working-poor black family and other members of her small-town community, and like Precious in *PUSH,* the sharp-tongued Billy transforms her abject status as an unwed teen mother into a subjectivity of self-recognition, emotional trust, and social visibility. In other words, she becomes the mama's gun figure of the Young Mother in the course of the novel. While *PUSH* addresses the controlling images about unwed teen mothers and welfare queens in the stark shadow of the Reagan-Bush-Clinton years in which the novel was set and published, Parks's novel addresses these maternal stereotypes through a dialogic mediation between the past and present. The social and cultural anxieties about the moral implications and economic impact of black teen pregnancy were not isolated to the eighties and nineties, nor were they confined to the imagery of the urban North. Out-of-wedlock births among teens were also stigmatized during the Civil Rights era, and historian Danielle L. McGuire's account of Claudette Colvin's experience as

a young activist in Montgomery, Alabama, has become exemplary of these perceptions.

In March of 1955, Colvin, then a straight-A tenth-grade student, was arrested and dragged off a segregated bus for not giving up her seat to a white passenger. She fought her arrest in court and pleaded not guilty to charges of violating segregation laws and resisting arrest. In the months between her arrest and her trial, she got pregnant. So, when members of Montgomery's elite class of civil rights champions considered using Colvin's situation as a test case for a legal challenge to segregation laws, her pregnancy—as well as her lower-working-class status and dark skin—made her a liability to the success of the movement.[2] Later that year, Rosa Parks—already a civil rights and anti-rape activist in the community—was also arrested for not surrendering her seat, and she became the ideal symbol to launch the groundbreaking Montgomery bus boycott. Conventional wisdom about representations of blackness prevented movement leaders from taking a chance with Colvin, and as a result, her story was silenced and largely forgotten in the popular discourse of the movement. Fortunately, her experience has been recovered in recent historical accounts of the period, but her unsuitability, her illegibility as a representative for the cause of black equality, remains collapsed under the weight of discourses of black women's hypersexuality both then and now. Writing at the start of the new millennium about the Civil Rights era, Suzan-Lori Parks draws linkages between ideologies of black motherhood and sexuality during the desegregation era and its aftermath in *Getting Mother's Body*. In doing so, she calls on contemporary readers to interrogate master narratives of the Civil Rights era in order to disrupt post–Civil Rights nostalgia for the imagined authentic "family values" of that earlier time.

Set in 1963 Texas, *Getting Mother's Body* centers on the lives of Billy Beede and her mother, Willa Mae, an itinerant blues singer and grifter. Willa Mae dies from a botched abortion when Billy is ten years old, and Willa Mae's transgender lover, Dill Smiles, moves the orphaned Billy from Arizona to live with her aunt and uncle, June and Teddy, in Lincoln, Texas. Pregnant at sixteen by a philandering coffin salesman, Billy sets out on a quest to recover a treasure that is supposedly buried with her mother in Arizona. Billy hopes she can dig up and sell her mother's pearls and diamond ring in order to pay a doctor for an illegal abortion, and hopefully avoid the same grim fate as her mother. The plot unfolds through chapters narrated by each of the novel's major and minor characters, a technique that signifies on William Faulkner's tale of the poor, white Bundren family in *As I Lay Dying* (1930). Laura Wright, in her study of Parks's intertextual use of Faulkner's novel, explains that the story of the struggling Beede family "extends Faulkner's work beyond the

realm of white, heterosexual identification."[3] I would add that the multivocal formal structures of Parks's novel also write against the predominance of black heteropatriarchy in narratives of the Civil Rights era.

Although there have been numerous efforts in recent years to centralize the lives and contributions of women in black freedom struggles, a pervasive image of elite male leadership remains a legacy of the movement in the contemporary moment. Erica R. Edwards traces the figural processes of the charismatic black (male) leader as icon throughout the twentieth-century in her work *Charisma and the Fictions of Black Leadership,* and in doing so, points to black cultural productions that undermine the "official" history of the movement. Edwards describes the charismatic leader who "is always already dead and gone and always already just about to appear" as a "specter" who "haunts" contemporary black public culture. This haunting is complicit in the erasure of women's resistance from the national narrative or, when women are present in the master narrative, they are associated with domesticated activism and devalued "women's work" in freedom struggles.[4] Shifting that gaze, Edwards's work indexes "the moments and place at which black popular culture registers the blindness and silences of formal black politics" and instead identifies black fiction and film of the 1990s and early 2000s that act as "an archive of the curious, a body of texts guided by an aesthetic logic that activates gaps, silences, and interrogations to register the exclusions of official history and canonical knowledge formations."[5] Therefore Edwards's "archive of the curious" seems at least partially inclusive of Parks's postmodern novel because it is a literary representation the Civil Rights era that explores the "gaps and silences" left in the official record through an attention to the imagined voices of marginalized black women and non-elite black men. While Edwards's formulation focuses on narratives specifically referencing black leadership, I am interested instead in the analytic of black motherhood as a means of exploring the ways that the quotidian experiences of black people during the Civil Rights years might be depicted in recent literary memory. Specifically, reading *Getting Mother's Body* through a mama's gun analytical frame allows for an exploration of the ways in which transgressive black maternal figures imagined both then and now form a dialogic response to the rhetoric of racial neoliberalism.

Against the backdrop of the 1963 March on Washington for Jobs and Freedom, Parks's story highlights not one but several transgressive maternal perspectives in the characters of Billy and Willa Mae, as well as June and Dill, who are each centralized despite their status as social outcasts. Billy is a wild young woman who is ostracized because of her illegitimacy, which makes her the target of scorn and pity from the more respectable members of her small-

town community. However, her outcast status and her independence ulti-
mately free her from concern about their restrictive thinking, allowing her
to prioritize her sense of self and survival as a Young Mother. Billy's mother,
Willa Mae, taught her daughter psychologically astute yet morally ambigu-
ous ways of making it in a world in which her black woman-ness would have
marked her primarily as "mule."[6] Importantly, Willa Mae's modes of living
and radical worldview are revealed throughout the novel in the lyrics of her
blues songs, which appear intermittently placed among the other chapters.
Willa Mae is already dead during the primary action of the narrative, so her
blues songs allow her voice to be heard as both an ancestral presence and at
a remove in the form of memory, transcending the boundaries between life
and death.[7] While Willa Mae was alive, her career as a blues singer, her sex-
ual promiscuity, her relationship with Dill, and her ability to pass for white
marked her as a racial and sexual anomaly among the black townspeople. Yet
these qualities also allowed her opportunities to rebel against the denigration
of segregation and heteropatriarchy in order to live independently. She trans-
fers this knowledge to Billy through the lyrics of her songs.

In this chapter, I wish to illuminate Parks's use of blues themes, styles,
and aesthetics as critical to the development of another mama's gun figure,
the Blues Mama. Blues has been a vital sign of transformative voice for black
women, especially when depicted through the real or fictionalized lives of
the classic blueswomen of the 1920s, such as the "queens" "Ma" Rainey and
Bessie Smith. However, there are few studies that draw direct links between
the representations of blueswomen and maternal signifiers, unless to point
to the fact that the freedom and independence of blueswomen correlate with
their refusal of domestic and maternal roles. Instead, I argue here that as an
alternative figure, the Blues Mama draws on both the transgressive tropes of
blueswomen's sexual and economic freedom as well as vernacular maternal
signifiers that, when read together, make the Blues Mama a mama's gun fig-
ure, an unmotherly mother who accesses social recognition through a rejec-
tion of hegemonic maternal ideals. In *Getting Mother's Body*, Willa Mae and
Billy signify on familiar blueswomen tropes seen throughout twentieth-cen-
tury black literature: in novels like Walker's *The Color Purple* and Gayl Jones's
Corregidora; in short stories by Richard Wright and Zora Neale Hurston; in
popular film, such as Diana Ross's portrayal of Billie Holiday in *Lady Sings
the Blues*; on stage in August Wilson's "Ma Rainey's Black Bottom"; and in
poetry by Langston Hughes, Sterling Brown, Sonia Sanchez, Nikki Giovanni,
Sherley Anne Williams, to name just a few. As Blues Mamas, Willa Mae and
Billy signify on the popular symbolic functions of the blueswomen in black
literature and serve as sites of revision in the national memories of the Civil

Rights era. By centralizing these Blues Mamas, Parks's novel asks contemporary readers to reconsider the master narratives of the mid-century freedom struggle in order to subvert their assumptions about the race, class, gender, and sexual dynamics of the present.

While Billy and Willa Mae draw the primary critical attention in this chapter, it is important to acknowledge both Billy's Aunt June and Dill's characters as part of the transgressive maternal matrix of this novel. June is biologically childless and an amputee; she lost a portion of her leg in an accident when she was sixteen. While her disability is perceived as a site of loss and impairment to her husband and others, June's absent leg has been figuratively replaced through a sensitivity to and insight about her social world. Although submissive in many ways, especially in comparison to her foil Willa Mae, June possesses exceptional observational skills that allow her to act as an "othermother" to her niece, Billy, in ways that do not force Billy to submit to male dominance or compromise her willful vision. Finally, there is Dill, who passes as a man throughout the story and can never fully escape the judgment of the people of Lincoln. However, Dill's pride and financial success as a pig farmer refute the gossip of the townspeople, and she nevertheless asserts her place within the community as a man.[8] Dill assumes a parental role toward Billy and takes pride in being recognized as her father. The ability for Dill to act as a maternal figure through a performance of masculinity suggests ways of destabilizing the gender normativity embedded within the idea of motherhood as solely a function of femininity. I take up the possibilities of drag performance as another means to destabilize gender expectations of maternal signifiers in chapter 5.

Altogether, the queer, disabled, and poor black women and men of *Getting Mother's Body* ask contemporary readers to reimagine the Civil Rights era as a location of intraracial diversity and a site of constant contestation of hegemonic "family values" ideology. Although the specific coded language of "family values" was not dominant during the Civil Rights era, anxieties about black people's attainment of the American nuclear family ideal exerted tremendous influence on interracial and intraracial politics. Furthermore, the need to play up a "good old days" narrative of postwar blackness accentuates perceptions of black "underclass" immorality for today's black political public. Today's ratchet black girls and women are imagined as having nothing to offer socially, culturally, or politically in the shadow of the inviolate images of Rosa Parks or Coretta Scott King. Therefore, Parks's novel acts as an important counter-narrative to the dominant description of the Civil Rights era. As a method, Parks draws on classic blues motifs and aesthetics to challenge the

invisibility of these black maternal figures in the literary historiography of the period.

JANE CROW AND THE NEO-SEGREGATION NOVEL

The stories we tell each other about the Civil Rights period have as much to say about the "back then" as the "right now." Before exploring the role of blues figuration in the novel, it is important to apprehend how Parks's novel formally exists in dialogic conversation with past and present, and how her work helps to reveal the often-muted narratives of Jane Crow subjugation. Civil Rights–era black feminist legal scholar Pauli Murray established the phrase "Jane Crow" in 1947 as a way to describe the intersecting structural forces of sexism and racism that black women experienced. In doing so, Murray provided a lens through which to interpret the important role that sex discrimination—in employment as well as reproductive and domestic life—had in the expanding struggles for racial equality.

Brian Norman describes Parks's novel as a "neo-segregation narrative," a term he uses to catalog contemporary fictional accounts of the Jim Crow past that are often historiographical in nature. In his book *Neo-Segregation Narratives: Jim Crow in Post-Civil Rights American Literature,* Norman compares the functions of neo-segregation narratives with those of neo-slave narratives also appearing in late twentieth-century African American literature, finding similarities in the ways that writers of both genres engage with explorations of history as much as they engage with the present.[9] Examples of neo-segregation novels include well-studied texts such as *The Color Purple,* Toni Morrison's *The Bluest Eye,* and Ernest Gaines's *A Lesson Before Dying* and lesser-known works such as Wesley Brown's *Darktown Strutters.* By exploring novels that appear in the decades after the de jure end of Jim Crow, Norman asks, "What lingering concerns and anxieties can stories of Jim Crow address?"[10] He concludes that in some ways, the post–Civil Rights national imagination needs "segregation signs"—imagery of segregation and its companion social problems such as Sundown Town signs, lynching postcards, blackface performance, "Whites Only" signs, and the like—to help mark progress in the here and now.

Specifically, in his discussion of *Getting Mother's Body,* Norman identifies scenes in the novel in which the physical signage of the Jim Crow era operates as a graphic reminder of the bad old days, and he argues that "when we encounter a segregation sign in historiographical fiction, its very legibility

threatens our intellectual certainties that these signs are artifacts, dead or wooden objects from an era that is past but has not passed."[11] The legibility of these signs provides an uncanny sensation for readers of neo-segregation novels in the contemporary, supposedly color-blind, moment. Therefore, he explains that seeing a drawing of a sign that reads "We don't serve NO niggers"[12] in *Getting Mother's Body* serves as the kind of graphic reminder that not only provides details for the setting of the novel's action but also bears the weight of recognition for a contemporary reader who may never have seen a sign like this in real life. Remembrances of the Jim Crow era become particularly salient in light of the rhetoric of postracial color-blindness because as "neo-segregation narratives seek to expose systems of exclusion and disenfranchisement today, they upset dominant national narratives of achieved equality and Jim Crow's passing."[13] *Getting Mother's Body* works as a neo-segregation narrative because it uses "segregation signs" to stimulate the uncanny sensation that the systems of exclusion that existed in the Jim Crow past have not fully disappeared.

In addition to invoking the "segregation signs" described by Norman that yoke racial past to racial present, Parks's novel maps the gender and sexual signs of discrimination known as Jane Crow. Parks's novel also makes Jane Crow signs visible and legible, which acts as an important counter-narrative to the dominant description of the Civil Rights era as a political project primarily led and defined by black men and their interests. The signs of gender and sexual discrimination appearing in this novel serve as reminders of present struggles to maintain the social progress achieved through the women's movement in that same historical period. For example, the unplanned and unwanted pregnancy that Billy experiences in the novel highlights the relative nonexistence of effective contraception for girls and women. While the Pill was approved for use as a contraceptive in 1960, it still took several years for it to become widely available to girls and women. By encountering Billy's story in the novel, readers are reminded of the historic lack of both contraceptive access and adequate sexual education, especially for poor, rural black women like Billy. In that process of reflection, readers can also consider a variety of recent threats upon contraceptive access and sex education that have been part of a political retrenchment around women's reproductive health concerns. The retreat from contraceptive access and comprehensive sexual education has been fueled by increased government funding for abstinence-only-until-marriage programs. According to the Sexuality Information and Education Council of the United States, abstinence-only education has been subsidized by the federal government since 1981, and reached a peak between 1996, the year of Clinton's welfare reform, and 2006.[14] Despite

research pointing to the inefficacy of abstinence-only strategies, programs have proliferated in the last thirty-five years that encourage young people to wait until marriage to have sex rather than providing information on health, contraception, sexually transmitted infections, and emotional wellness.

The novel also depicts the nation's ugly history of illegal abortion, and it depicts the great risk many women took to terminate pregnancies. Much of the novel's plot centers on Billy's quest to raise the money for a back-alley abortion, which she learns about from a white woman named Myrna while riding a bus across Texas.[15] The conversation between a white, married mother of two and a black, unmarried teen highlights a site of common struggle regarding access to abortion services as a primary women's issue of that time. Billy's clandestine encounter with Myrna, who gives her the name of a doctor who helps girls who are "in trouble," recalls the stark realities of abortion access in the 1960s. Parks illustrates Billy's difficulty in seeking an abortion in a number of ways, including through a depiction of Billy's accounting of the money she will need to see a man named Dr. Parker. After selling some of her belongings and giving her mother's pearl earring to Dr. Parker as a down payment, Billy calculates that she still needs $78 to have the procedure done.[16] By graphically depicting Billy's calculations in the novel, Parks draws attention to the minute details that might have existed for a poor girl seeking an abortion in 1963 in rural Texas. In the decades before the 1973 *Roe v. Wade* decision, abortion services were illegal, expensive, secretive, and dangerous. In fact, Billy's mother, Willa Mae, died after trying to induce her own abortion, which also affects Billy's determination to have an abortion done by a doctor. By depicting these situations, Parks's novel calls readers to confront the issues of gender and sexual discrimination of the past as well as the contemporary political attacks on abortion access today.[17]

Finally, Parks creates scenes of patriarchal dominance within families to illustrate how women were expected to submit to their husbands' decisions and whims. For example, June was given by her father to marry Teddy on the side of road without her knowledge or permission. This portion of the narrative illustrates the outlandish level of powerlessness some women had in families during this time. The fact that June could be literally handed over—her father carried her in his arms to give to Teddy—in marriage calls forth the problem of patriarchy that existed during the Jim Crow era. Parks presents a number of women who feel controlled by their husbands and fathers. Taken together, these signs of patriarchy and sexism act in ways that are similar to the "segregation signs" that Norman describes as signifiers of a racial past that act as uncanny signposts in a supposedly postracial and postfeminist present. Instead of physical signage that marked the boundaries of racial segregation,

what I am calling "Jane Crow signs" exist throughout the novel in situations and episodes experienced by women characters whose access to freedom and equality are severely circumscribed by race and gender.

The post-Civil Rights era remembrance of gender and sexual discrimination of the past helps illuminate the contemporary moment, especially calling attention to the ways these sites of women's oppression are consistently indexed under the frame of "family values" in recent history. Attacks on access to legal abortion, reductions in sexual education and contraceptive access for women, and the privileging of old-school, man-of-the-house marriage arrangements are the contemporary gender and sexual politics that Parks's work talks back to in the early twenty-first century. The novel's gender and sexual signs act as reminders of the powerful structural forces of racism and sexism continuing to operate in the post–Civil Rights era. Therefore, as a work of neo-segregation literature, *Getting Mother's Body* not only focuses on and complicates the narrative of Civil Rights–era elite masculine leadership, but it also privileges the important histories of everyday gender and sexual injustice experienced by black women.[18]

Parks's novel memorializes an alternative history of the Civil Rights era that centralizes intersecting race, class, gender, and sexual politics of that time that have been erased, forgotten, or misrepresented. Her narrative revises the dominant assumptions about the everyday concerns of the people of that time, specifically centralizing the interests of black women and black queer subjects. At this point, I will develop the figure of the Blues Mama to identify these radical figures appearing throughout Parks's work. As I suggested earlier, the appearance of the Blues Mama figure in *Getting Mother's Body* extends a tradition in black women's fiction that engages with blueswomen as symbols of black women's sexual freedom, autonomy, and creative power. However, the iconic blueswomen, such as Bessie Smith and Ma Rainey, are rarely imagined with maternal characteristics or as maternal figures. The Blues Mama is structured through a maternal framework that is rarely perceived because blueswomen typically exist outside the norms of traditional or normative motherhood. Yet, if our gaze turns *away from* the common comparison of blueswomen and normative mothers toward a mama's gun focus on transgressive mothers, then the bluesy connections become more apparent. Exploring the roots of the literary blueswoman figure as well as the black vernacular meanings of the term "mama" illuminates my transformation of this signifier. The radical Blues Mama appears in *Getting Mother's Body* through the characters of Willa Mae and Billy. After tracing my development of the Blues Mama figure in the following section, I provide close readings of these characters though the Blues Mama framework, which centralizes both

the figure as well as other blues motifs and aesthetics that the novel uses to indicate an alternative history of the Civil Rights period.

FROM BLUESWOMAN TO BLUES MAMA: TRANSGRESSIVE MOTHERHOOD IN BLACK WOMEN'S FICTION

Throughout the twentieth century, black women writers turned to the image of the "classic blues woman" as a figure of female resistance and empowerment.[19] Exemplified by the lives of real women like Gertrude "Ma" Rainey, Bessie Smith, Gladys Bentley, Alberta Hunter, Ethel Waters, Ida Cox, and Billie Holiday, the figure of the "blueswoman" still permeates late-twentieth-century and twenty-first-century black women's writing.[20] Blueswomen's claims to female autonomy as well as sexual and financial independence make them idealized "icons" of black women's resistance to racial discrimination, male domination, and economic exploitation. Yet, as Emily Lordi cautions in her study *Black Resonance: Iconic Women Singers and African American Literature,* there are limitations to using these figures as icons without considering them fully as complicated artists who negotiated multiple sites of power through their work. Instead, Lordi suggests an approach that looks at black women vocalists, including blueswomen, as "artists-at-work . . . and that [approach] would take their intellectual labor seriously enough to analyze their formalistic and performative choices."[21] Lordi's perspective helps nuance the absolute nature of freedom that has been ascribed to representations of blueswomen in ways that are productive for the interpretative evolution of this figure. In fact, it is those iconic, naturalized qualities of blueswomen that have made it difficult to imagine these solitary and independent figures as maternal.

Black feminist and womanist scholars have been essential to the identification of blueswomen as feminist icons. The work of Angela Y. Davis, Hazel Carby, and Daphne Duval Harrison, for example, situates blueswomen within a framework of prototypical black feminist thought in the early twentieth century. In her influential study *Blues Legacies and Black Feminism,* Davis writes that the recorded performances of blueswomen "divulge unacknowledged traditions of feminist consciousness in working-class black communities."[22] Significantly, Davis demonstrates how the blues emerged as a popular music form that voiced the social and sexual realities of newly emancipated black people. Still faced with many of the same social, legal, and economic reali-

ties of enslavement, newly emancipated black folks expressed their sense of freedom in the realms of personal relationships and sexuality. In opposition to the spirituals, which promised a heavenly reward for a life of piety, sacrifice, and struggle, the blues grappled with the here and now and expressed a search for relief from racism and economic exploitation through sex and love. The raunchy performances of the blues acted in contrast to the performances of the spirituals, which were often used as cultural signs of black dignity and respectability, and whose lyrics and performance styles eventually became symbolic of the Civil Rights era. Blues, therefore, was the secular art form that dominated post-slavery life as an articulation of working-class desire meant primarily for the enjoyment of working-class black audiences.

Women were central to the rise of the blues as an American popular music form, and their songs focused even more than men's folk and blues songs on concerns of love and sexuality.[23] What is remarkable about the songs and the blueswomen who sang them are the ways that both critique popular, sentimental notions of love, marriage, and domesticity that circulated among middle-class whites as well as among middle-class blacks. Their songs often mocked traditional ideas about marriage and highlighted the subjugation that women experienced in relationships with men. Blueswomen's performances were also highly sexualized, filled with carnal innuendo and performed with wanton sensuality. Taken together, the songs and performances troubled the stark boundaries of masculinity and femininity espoused in the dominant culture. Blueswomen pursued sex, repudiated monogamy, and mocked domesticity in ways that have been traditionally associated with masculinity. Gertrude "Ma" Rainey and Bessie Smith both sang about the "Jail House Blues," in which the singer mourns her incarceration for a violent act against a former lover. Smith sings about her hard-drinking ways in the song "Me and My Gin," in which she intones: "Stay 'way from me 'cause I'm in my sin / Stay 'way from me 'cause I'm in my sin / If this place gets raided, it's me and my gin."[24] Blueswomen like Rainey and Smith were considered tough, no-nonsense women. Though they sang often of depression over lost loves, many of their songs articulated a desire for independence, a propensity for violence, and a habit of hard drinking. Davis identifies these themes as the "beginnings of an oppositional attitude toward patriarchal ideology."[25]

Blueswomen's oppositional and critical standpoint also critiqued heteronormativity. Some of the best-known classic blues singers, including Smith, Rainey, Hunter, and Bentley, had lesbian relationships, sang about relationships with women, or dressed as men during their performances. Ma Rainey's song "Prove It On Me Blues" has become a signature song of the period that declares the blueswoman's enjoyment of sex with women. Hazel Carby

explains that the "liminal" figure of the blueswoman is "used to meditate upon conventional and unconventional sexuality."[26] In particular, Rainey's revolutionary song "vacillates between the subversive hidden activity of women loving women with a public declaration of lesbianism. The words express a contempt for a society that rejected lesbians," and that vacillation between opposing forces is a signature aspect of what Carby identifies as blueswomen's "liminal" status.[27]

Davis points out that in the heyday of classic or vaudeville blues performance, "most black heterosexual couples—married or not—had children," but "blues women rarely sang about mothers, fathers, and children."[28] She continues,

> The *absence* of the mother figure in the blues does not imply a rejection of motherhood as such, but rather suggests that blueswomen found the mainstream *cult of motherhood* irrelevant to the realities of their lives. The female figures evoked in women's blues are independent women free of the domestic orthodoxy of the prevailing representations of womanhood through which female subjects of the era were constructed.[29]

While mothers may have been largely absent from the songs of the classic blues and many of the most popular blues-recording artists did not have children, it seems safe to imagine that many of the everyday blueswomen had maternal responsibilities of some sort. They were "independent women, free of domestic orthodoxy" and in many cases they rejected, or were at least ambivalent about, the conscription of traditional femininity and the "cult of motherhood." Yet, their critiques of respectability and heteropatriarchy do not preclude experiences as mothers, and, returning to Lordi's point, we should refrain from interpreting their song lyrics and their biographies solely as mimetic representation or accounts of their "natural" expressivity. Rather, it is important to engage with blueswomen and other black women performers with an eye toward their artistic consciousness and their narrative skills. Their songs and stage personas cannot always be taken as literal demonstrations of their autonomy, but rather as dramatic renderings of black women's consciousness and resistance to power through creativity and performance.

Literary critic Ann DuCille raises the specific problem of maternal representation and blueswomen in *The Coupling Convention: Sex, Text, and Tradition in Black Women's Fiction*. She writes that blueswomen's "omission of this 'typical female' subject matter"—that is, motherhood, reproduction, and children—is often set in stark opposition to the "middle-class" black women character narratives produced by Harlem Renaissance writers such as Nella

Larsen and Jessie Fauset.[30] DuCille explains that black feminist critics who
contrast the freedom of the blueswomen with the restraint of middle-class
black women maintain a false binary that undermines a multilayered under-
standing of black women's lives as depicted in fiction. In other words, the
valorization of blueswomen as the primary literary figure of black women's
sexual agency and as the antithesis of the conventional wife and mother fig-
ure overlooks "the actual human conditions of the masses of black women of
their era."[31] For example, it seems apparent that actual everyday blueswomen
who worked in the juke joints and honky-tonks of the Jim Crow South would
have gotten pregnant and had children or grappled with responsibilities of
caring for relatives in their extended families just as most teenage and adult
women would have experienced in that time. One might also imagine that the
performance of black middle-class femininity was not always as "respectable"
as we categorize it, and it certainly included wives who left their husbands,
engaged in extramarital affairs, took women as lovers, refused domesticity for
careers, and the like. The messiness of life would have necessarily made the
binary between blueswoman and wife difficult to maintain in the everyday,
and DuCille's observation serves as a reminder of this fact. Therefore, the
Blues Mama figure attempts to reconcile the perceived binary between the
raunchy and the respectable in order to imagine transgressive black mother-
hood as a vital site of cultural resistance in black fiction. A closer reflection on
blueswomen and their stature within black communities, especially their use
of maternal nomenclature such as "Ma" and "Mama," points to an alternative
way of imagining these women and interpreting their appearance in fictional
texts not solely as foils to the married black lady, but as figures in dramatic
conversation with themes of marriage and motherhood.

Blueswomen possessed and flaunted maternal names that I contend act as
distinctly maternal signifiers. As "Mothers," "Mamas," and "Mas," the blues-
women used maternal language and situated their music and performance
styles, their audiences, and their collaborators as their "children." The words
Mother, Mama, and *Ma* act as terms of reverence for the kind of independent
black women embodied by the blueswomen, even though they were unlikely
to enact the traditional domestic characteristics of a mother.[32] By looking at
the blueswomen from this vantage point, it is possible to add complexity to
renderings of both blueswomen and black mothers. The terms *Mama* and
Ma, which began as black slang, became popular in the mainstream Ameri-
can lexicon through the popularity of jazz and blues recordings in the early
twentieth century, and they implied visions of working-class blackness. The
"blackness" of terms like *Mama* (or *Daddy*) eventually "tainted" the songs
of white Tin Pan Alley composers, which were seen as evidence of moral

decline.[33] Although linguists and other social observers of the 1920s were loath to make direct racial associations to the growing racialized and sexualized meaning of the terms, it is clear that *Mama* was seen as "a new connotation for the once highly respectable nomenclature of the family."[34] James Hart cites the 1917 recording of the song "I'm a Real Kind Mamma, Lookin' for a Lovin' Man" as the advent of the "new connotation" of *Mama* in white popular culture, but he is quick to comfort his readers with a reminder that "a 'mama' or 'mammy' need not be 'cullud' ['colored']."[35] His effort to efface the particularly African American meaning of the term and its association with the sexuality of black performers of classic blues and jazz music may have been a way to affirm the consumption of "race records" by white audiences, who needed to retain, on some level, a sense of their own respectable superiority in relation to blacks.

Even so, within black communities, concerns around respectability have historically taken on different meanings, particularly when intraracial class politics are added to the analysis. So while the slang terms *Ma* and *Mama* are certainly not typically considered "respectable" ways of addressing a black woman in middle- and upper-class black society, they do act as terms of respect and endearment within poor and working-class black communities. Ma Rainey's life exemplifies this sense of reverence.[36] Jazz musician Danny Barker describes what Rainey's status as "Ma" meant to the musicians and audiences who enjoyed her music in the documentary *Wild Women Don't Have the Blues*:

> Ma Rainey was Ma Rainey. When you said Ma that means mother. Ma, that means the tops. That's the boss, the shag bully of the house. Ma Rainey. She take charge. Ma. Ma Rainey coming to town. The boss blues singer, and you respect Ma. Grandma, May-Maw, Maw-Maw. That's a mother. Someone you respect. That's mother. Not Papa. Mama.[37]

Barker's reflection reinforces how the term *Ma* is used to identify black women worthy of high esteem. "Ma" was a woman in control, a boss. Blueswomen derived their esteem from their vocal stylings—not just their big, resonant voices, but also their way with words in comedy skits, their wicked double entendres, and their perceptive monologues onstage. Daphne Duval Harrison, who writes about Rainey and other blueswomen in her study *Black Pearls: Blues Queens of the 1920s,* confirms that "fluency in language is considered a powerful tool for establishing and maintaining status in the black community. Thus a man or woman who has mastered the art of signifying, rapping, or orating can subdue any challenger without striking a blow."[38]

Therefore, the Blues Mama could also be thought of as a woman who has a way with words.

Blueswomen are iconic within African American literature and popular culture as quintessential signs of women's autonomy and sexual freedom. Yet they are rarely thought of as mothers in the most traditional senses. Using a mama's gun analytical perspective transforms the blueswoman into a Blues Mama and allows for new ways of thinking about black motherhood that highlight the bossy, autonomous, linguistically gifted, and sexually bold aspects of the blueswomen as affirmative qualities that can talk back to contemporary controlling images of black motherhood that enforce "family values" rhetoric as a singular moral standard both in the past and in the present. The Blues Mama signifies on the prescriptions of docile femininity and submissiveness that are supposedly the standard for "good" motherhood to which black mothers are constantly compared. The Blues Mama figure appears in *Getting Mother's Body* in the characters of both Willa Mae and Billy Beede, and Parks heightens their bluesy effects through formal techniques reminiscent of blues music. Structures of call and response, repetition, rhythm, and silence are all blues-inflected literary modes that are found throughout Parks's work. Parks, who is also a blues guitarist and singer, has described the influence of blues music on her literary career.[39]

MOTHERING FROM THE GRAVE: WILLA MAE'S BLUES SONGS AS MATERNAL GUIDANCE

In *The Grasp that Reaches Beyond the Grave: The Ancestral Call in Black Women's Texts,* Venetria K. Patton traces the special significance of ancestral presences in contemporary black women's fiction. In particular, she highlights the cultural significance of maternal ancestors who communicate with various related and unrelated "daughters" in order to pass on "ancient wisdom, which forms the backbone of the community."[40] Patton explains that this wisdom often appears in ways that capture the unique race, class, gender, and sexual subjugation that black women have experienced, especially during slavery, in order to help living black women—their "daughters"—survive and thrive. The kind of messages that maternal ancestral figures provide allows them to "express the inexpressible."[41] In many ways, Willa Mae acts as an ancestral figure in *Getting Mother's Body* by expressing the inexpressible through the ten blues songs that appear throughout the novel. Since the primary action of the novel takes place after Willa Mae's death, she appears as a character only through memories provided by each of the other characters and in the chap-

ters dedicated to her songs. As a result, these songs and the brief prose narrations that occasionally accompany them allow Willa Mae to speak from the grave, transgressing the very boundaries distinguishing life from death. Billy explains that "even though she's passed, I feel like she *still* wants to be a singer" (183). Each of the songs offers glimpses into and metaphors for Willa Mae's life experiences, which are often paired with key scenes of Billy's advancement through the text. Therefore, the songs act as instructional interjections into Billy's narrative or as ways of illustrating how Willa Mae impacted the lives of the other characters.

Billy is presumed to be "motherless" throughout the novel and pitied by members of her community in Lincoln, Texas. Billy's uncle Teddy, who runs a filling station on the outskirts of town, asks:

> I've always wondered what happens when you don't got a mother. Without a mother you don't get born. But after birth, what then? . . . A mother helps a child learn the basics. Billy don't know the basics. Basic: *don't go opening yr legs for a man who ain't yr husband lest you wanna be called hot trash.* (51)

Teddy believes that because Billy's mother was not "motherly" and died while she is still young that Billy lacks the essential maternal training that would help her show the sexual modesty that is expected of her. He identifies Billy's pregnancy as the result of her lack of mothering, when in fact it has more to do with the predatory advances of a much older man named Snipes who romances her. Even so, Billy also facetiously invokes motherlessness as a way of resisting the assumption that she lacks maternal supervision or that her mother was "unmotherly." In a memory of her early childhood, Billy recalls a time when she and Willa Mae were thrown in jail for stealing, and a woman clerk at the desk asked if Willa Mae was her "real" mother, and Billy pretended that she did not know what a mother is: "'I ain't come out of nobody,' I told her and that made her shut up" (175). Billy sarcastically invokes motherlessness to resist the condescension and judgment that is forced upon her by the white woman clerk who cannot fathom a "real mother" like Willa Mae.

Billy's mark of motherlessness inscribes the limits of the social imagination to conceive of the wild and audacious Willa Mae as a maternal caregiver. However, the blues songs left by Willa Mae act as key sites of mothering that Billy reflects on her journeys in the novel. Billy draws on Willa Mae's knowledge and guidance during her trip from Lincoln to Texhoma to marry the no-good Snipes. After she arrives in Texhoma and meets Snipes's pregnant wife and other children, Billy seeks an abortion and needs the money pay for it. She embarks on a second journey with Uncle Teddy, Aunt June, and her

cousin Homer to LaJunta, Arizona, to dig up Willa Mae's body because she was supposedly buried with a pearl necklace and diamond ring. On these journeys, readers realize that Billy is not "motherless" as Teddy, the jail clerk, and others believe. Willa Mae mothers Billy in death throughout the narrative through the lyrics of her blues songs and through Billy's memories of her mother's transgressive life.

In some cases, the blues songs included in the narrative have titles, such as the "Big Hole Blues," which provide direct descriptions of the "lesson" that Willa Mae gives to her daughter. Six of the songs are untitled, leaving their lessons more ambiguous.[42] Some of the song lyrics are accompanied by brief sections of prose, which capture Willa Mae's thoughts about the song or a reflection on the circumstances that led her to compose the song. The prose sections create the sensation that one is watching a live jazz or blues performance; Willa Mae introduces the song by preparing the audience for what she's about to sing, she sings, and then she banters with the audience afterward. As an ancestral presence, Willa Mae offers instruction, guidance, support, and nurturing to her daughter as she tries to live her life without the moralizing judgment of others. However, Willa Mae's wisdom derives less from ancient beliefs or the trauma of enslavement that animates the characters taken up in Patton's study. As a Blues Mama, Willa Mae's songs help guide Billy toward survival through subversive lessons in manipulation, crime, revenge, sexual and romantic love, heartbreak, and loss.

The first of Willa Mae's songs is "Big Hole Blues," in which she describes multiple meanings of the word *hole* in each of the three verses, which serve as lessons in the dangers of transgressive female sexuality. The song's "big hole" is meant as both a euphemism for a vagina and a grave, thereby conflating sex with death. In the first verse, Willa Mae sings the repeated lines "My man is digging in my dirt / Digging a big hole just for me." The phrase "digging in my dirt" describes sexual intercourse and the pleasure Willa Mae experiences with "my man," who could have been any of her numerous lovers, including Dill. The sex between the two lovers is described as "deep as the deep blue sea," which suggests the boundlessness of that sexual pleasure. However, by the second verse, Willa Mae revises that idea and describes the limits of physical joy with her man after he discovers that she has a boyfriend on the side: "He says the hole he's digging is hole enough for two." The "hole enough for two" describes a grave, and she sings that "he'll put me down there in it / and put my boyfriend in it too." Willa Mae's "Big Hole Blues" draws on the familiar blues themes of sexuality, love, infidelity, and jealousy by describing a polyamorous woman who experiences sexual satisfaction with her man and keeps a "boyfriend" on the side. Keeping a boyfriend violates the expected

standards of traditional femininity, which is structured as monogamous and faithful, and Willa Mae's expression of sexual enjoyment with two different men leads one of her lovers to threaten her and the boyfriend with murder. Yet in the final verse, Willa Mae provides the "lesson" for her audience, including her daughter Billy, who is named after Billie Holiday. First she sings that "my man says he's just pulling my leg," which means he was just joking about threatening to kill her and her boyfriend and put them in a "hole enough for two." However, Willa Mae plans to "play it safe" and "leave this big old holey place." Even though her man says he is not actually going to kill her and her boyfriend, the threat is real enough to lead Willa Mae out of this "holey" place. The play on the word *holey,* which is a homophone for *holy,* seems to be key. Willa Mae's refusal to live by the "holy" standards of monogamy for women is dangerous and could get her killed. In order to avoid this threat, she must move on and leave that dangerous situation rather than change her sexual behavior and become monogamous. This perspective explains Willa Mae's itinerant lifestyle that Billy experienced while her mother was still living. Moving from town to town and lover to lover, Willa Mae avoided trouble and the holes of life. The song also foreshadows the revelation of Willa Mae's infidelities to Dill, first when she becomes pregnant with Billy and a second time when she is expecting again and attempts to terminate her pregnancy.

Willa Mae creates another sense for the word *hole* in the prose section that accompanies this song. She explains that after she sings that the "Hole," now capitalized, signifies a "soft spot, sweet spot, opening, blind spot, Itch, Gap, call it what you want but I call it a Hole" (31). This Hole describes various locations of emotional weakness and the places of longing and desire that animate many social interactions. She explains that "a man could have a Hole just about anywhere: in the head, in the wallet (which means he burns his money), in the pocket (which means he don't got no money to burn but would like some), in the pants, in the guts, in the stomach, in the heart" (31). As a keen observer of human nature, Willa Mae develops this Hole philosophy in order to exploit different situations in her favor for money, lodging, work, and even love. As an independent black woman with a young child in the 1950s and '60s rural Southwest, Willa Mae has to develop strategies that will help her survive within the structures of race, gender, class, and sexual discrimination and violence that she faces daily. Identifying a person's Hole allows her to fill it to her advantage, and she shares that philosophy with her young daughter.

Billy first uses the Hole philosophy when she goes to Mrs. Jackson's shop to buy a wedding dress. Billy is already "five months gone," and she naively

believes Snipes's promises that he will marry her. As she prepares for their wedding, which is to be held several hundred miles away in the town of Texhoma, she goes to the local formal wear store to buy a dress with the $63 that Snipes has given her. Mrs. Jackson's store represents the seat of respectability in the town; Mr. and Mrs. Jackson are both successful black business owners who are considered to be pillars of the community. Rather than fear the judgment of Mrs. Jackson, Billy uses the skills that she learned from her mother to help her buy the dress. At the store, Mrs. Jackson stares at Billy's "babybelly" while Billy works to convince her to sell her a $130 wedding dress for only $63 (27). Billy remembers Willa Mae's lessons about the Hole, and Billy explains that "words shape theirselves in my mouth and I start talking without thinking of what I need to say. It's like The Hole shapes the words for me and I don't got to think or nothing" (27). Therefore, the Hole represents a site of inexplicable creativity and a way with words that are characteristic of the Blues Mama. The Hole, which might typically be thought of as an absence, is actually a presence and a location for generative language to emerge. Billy sees Mrs. Jackson's Hole and begins to ask her about her marriage. Although she is a respectable business owner who might typically shun Billy because of her pregnancy, Mrs. Jackson secretly identifies with Billy's youth and excitement. As a result, Mrs. Jackson softens as she tells Billy that the dress she wants to buy is a replica of her own wedding dress. Mrs. Jackson explains that she was married at fifteen, "one year younger than you are now."

Throughout their exchange of words, Billy and Mrs. Jackson also connect through empty spaces and silences in their conversation. Parks's narrative suggests that these pauses occurring between dialogue and thought can be productive locations of connection for the women. These rests can also be thought of as rhythmical musical breaks, akin to those found in blues music when singers and musicians halt the music for effect. The first moment occurs when Mrs. Jackson explains that her mother made her wedding dress. Suddenly, she "goes quiet," and the narrative implies that she pauses because she remembers that Billy's birth mother is dead. The pity that Mrs. Jackson feels for Billy's motherlessness leaves her speechless. Yet, Mrs. Jackson is the first person in Lincoln to acknowledge Billy's pregnancy, and Billy assumes it is because "I'm gonna have a husband to go with it" (28). In a subsequent chapter, Mrs. Jackson explains that she too "was in the family way" when she got married, which further establishes her connection to the young girl, and returning to DuCille's point, it narratively destabilizes the neat binary between raunchy and respectable. However, Mrs. Jackson distinguishes her situation from Billy's through an appeal to marriage, stating that she had been "*spoken* for" and that both her parents were living when she got married (32).

Mrs. Jackson explains that she could "walk around this town with my head up," which she contrasts with the case for Billy, who hangs her head "like a buzzard" out of shame.

Despite these observations, the connection Billy and Mrs. Jackson share in the gaps of their conversation lead to ways of reading a sense of commonality that is built between the women, which is a technique Billy learns from Willa Mae's Hole philosophy. Ultimately, Mrs. Jackson sells Billy the wedding dress at a discount. She swears Billy to secrecy and enforces her silence about the price of the dress, telling Billy, "And when I say don't tell no body I mean don't tell no body, you hear?" (29). Billy uses Mrs. Jackson's Hole—her memories of her own marriage as a teenage mother as well as her longing to care for the "motherless" Billy—to her gain. Billy is therefore able not only to purchase a dress but also to establish an emotional connection to one of the most respectable women in the town and avoid her potentially harsh "family values" judgment. Willa Mae's Hole philosophy helps guide Billy in ways that help her creatively capitalize on her observations of emotional need, which ultimately provides Billy opportunities that she would not have had otherwise.

Memories of Willa Mae and the lyrics of her songs continue to influence Billy as she embarks on her journey to dig up her mother's grave. The third untitled song, which I am calling the "Gone to Jail Blues," describes the numerous jails that Willa Mae found herself in during her travels, and it is this song that Billy reflects on when she and June are faced with spending the night in a Tryler, Texas, jail. Willa Mae's song provides a critical perspective on the use of jail to lock up the innocent or to be used by the powerful to subjugate those who have less power in society. Willa Mae's song recalls jails from "Abilene way down to Galveston" and near the "Gulf of Mexico" (176). After describing the locations that she's been in jail, Willa Mae sings, "I wore my chain gang stripes digging ditches by the road / But I swear to you I never did much wrong." By proclaiming her innocence, her song tells the stories of numerous innocent black people jailed all over the South for crimes that they did not commit or for minor infractions. Willa Mae's song recalls this history of racist chain gangs and indicates that black women during the Jim Crow era also faced unfair incarceration, including being placed on chain gangs.

Women were also especially vulnerable to the threat of sexual violence and exploitation at the hands of white law enforcement in this time. Returning briefly to the story of Claudette Colvin's arrest in Montgomery, Alabama, for a moment, she recalls being called a "black whore" in the patrol car and thinking, "I was afraid they might rape me" because of the well-known stories of sexual violence other black women reported after being arrested.[43] There-

fore, Willa Mae's song testifies to the kind of fear and helplessness that accompanied being a black woman in the segregated South. In the second verse of the song, Willa Mae repeats the line about wearing stripes and digging ditches but ends with the line: "The bad they do's worse than the bad I done" (176). Here she uses her voice to critique the relative nature of crime, indicating that the supposed innocence of white law enforcement officers is a lie. The racial injustices perpetrated by white police officers, including the beatings and rape of black women, are worse than the crimes supposedly committed by blacks. As a Blues Mama, Willa Mae uses her song as a warning to Billy about the injustices that are perpetrated by police. Rather than admonishing her child about immoral behavior or teaching her to be a "good girl" to avoid being incarcerated, Willa Mae instead equips her daughter with an insightful perspective on the nature of race and the justice system, teaching her to be wary of police.

Billy and June are faced with spending a night in jail on their trek to LaJunta. While Homer and Uncle Teddy are driving Homer's "late-model red Mercury convertible," they are pulled over for speeding by a deputy sheriff. Rather than giving Homer and Teddy a speeding ticket, the officer takes both men to jail and keeps them overnight for "questioning" because he cannot understand how the black men have such a nice car. The officer explains in his narrative chapter, "I could let them go. Give them a ticket for going too fast and let them go . . . But the Sheriff wouldn't never let me hear the end of it" (163). Racism prevents the white deputy from treating the men fairly and letting them go without harassment. The expectations of the racist sheriff structure the deputy's decision to hold the men without any due process or legal standing, a practice that was common during the Jim Crow period and still is today.

While Homer and Teddy spend a night in jail, Billy and June, who were driving in a truck behind the men, have to wait for them to be released the next morning. Officer Masterson, the deputy who arrested the men, offers to let the women stay inside the jail overnight rather than in their truck. However, Billy refuses the racist officer's gesture of "kindness," explaining that "Willa Mae got me locked up more than once, that's how come I ain't too partial to them, you know" (173). The pronoun "them" remains ambiguous in this sentence, possibly referring to police, white men, jails, or all three at the same time. In any case, it is clear that Billy learned from her mother to be extremely cautious around police, who will use their authority and power against innocent black women.

Billy deepens her explanation in her next chapter, in which she recalls the sexual exploitation that she witnessed as a result of being jailed with

her mother while she was young. Billy says she remembers jails in Abilene, Frenchburg, Sweetwater, Wildarado, Galveston, Brownsville, Santa Anna, and Greenville and the beds that "smelt like bad luck and piss and sweat" (175). By reviewing this litany of jail cells, readers understand how familiar Billy is with the inside of jails. Billy then remembers an instance when she was locked up with Willa Mae that "Mother did something with a man and he turned the key" (175). The implication in this memory is that Willa Mae slept with her jailer, which helped secure their release. Throughout this memory, the words of Willa Mae's "Gone to Jail Blues" resonate through Billy's mind, reminding her of the legal and sexual danger posed inside of jails. Not only could black women face the same kind of racial profiling and illegal incarceration that men faced—as exemplified by the jailing of Homer and Teddy—but they also faced additional sexual threats in their encounters with law enforcement. While it is not clear whether Willa Mae willingly chose to sleep with the officer or whether she was coerced or raped when she got the man to "turn the key" and release her from jail, the encounter demonstrates the unique gender and sexual dynamics experienced by black women during the heights of the Jim Crow/Jane Crow era. Here Willa Mae's blues lyrics emerge in the narrative as a site of instruction and memory that assists Billy in protecting herself under circumstances that were not in her favor. Billy chooses to avoid the risk of sexual exploitation with the deputy by sleeping in the truck with June overnight.

Willa Mae's songs also provide Billy with instruction on romantic relationships with men. In particular, two songs emphasize the lack of stability of men's fidelity. In "Willa Mae's Blues" and in an untitled song I am calling "Lucky Day," Willa Mae provides the emotional backdrop for Billy to understand that men are untrustworthy when it comes to love. While this lesson may seem harsh for a young girl to learn, it is in keeping with the characterization of Willa Mae as a "hard" blueswoman. In "Willa Mae's Blues" and "Lucky Day Blues," Willa Mae describes the instability of love and the fleeting nature of men's affection, particularly sexual attention. Both songs appear at critical moments in the narrative when Billy experiences the hopefulness of romantic and sexual love with men only to find out that some men are unfaithful liars, that they use their patriarchal power to use women, and that they have insatiable sexual appetites.

The first instance occurs when Billy arrives in Texhoma and discovers that Snipes has a wife and six children and another one on the way. Billy had ridden the bus from Lincoln all day with the wedding dress that she purchased from Mrs. Jackson, all on the promise Snipes gave her that they would be married. While on the bus, she has several recollections of her mother's wis-

dom and reflects on the experiences she had riding through the countryside with Willa Mae when she was alive. Just as she gets off the Greyhound bus, a dual symbol of both freedom and danger during the Civil Rights era, Billy recalls that "Mother tolt me once how when a person jumps off a bridge, on their way down, before they hit the dirt or the water or whatever, they got plenty of time to reconsider" (65). This recollection foreshadows the sensation of falling, death, and disappointment that Billy feels when she arrives at Snipes's home and meets his pregnant wife. The lines of "Willa Mae's Blues" resonate with Billy as this episode unfolds, and they act not so much as a warning but as a site of understanding and commiseration from one woman to another.

"Willa Mae's Blues" consists of three verses that describe Willa Mae's love affair with "my man." She proclaims that her man loves her because "he bought me a diamond ring" (66). The diamond ring is a symbol of romantic love, particularly love that will endure through the act of marriage. As a symbol of fidelity and longevity in romantic relationships, the diamond ring that Willa Mae sings about turns out to be an ironic symbol, because the verse ends with the line: "Well, his wife, she found out, she says my pretty ring don't mean a thing" (66). The diamond ring, therefore, does not act as the enduring symbol of romantic love because, as Willa Mae's song points out, a man has the power to offer a ring and already have a wife. The second verse follows the pattern of the first, but replaces the ring with a "Cadillac car." In this case, Willa Mae sings that her man has given her a Cadillac, but when the wife finds out about it, she "says we done gone too far." Ultimately, even though "my man" professes love through the exchange of expensive gifts and symbols of attachment, Willa Mae's song cautions against believing in the endurance of these symbols. Any man could potentially have a wife who can "put her big foot down" and buy "me a ticket on the very next train." The wife of Willa Mae's lover can easily dismiss Willa Mae despite the ring and the Cadillac. This song operates as an important lesson for Billy, and the song appears right after one of Billy's chapters in which she describes riding the bus to Texhoma with her wedding dress in order to marry Snipes. The song also describes Willa Mae's experience with Huston Carmichael III, her white lover who gave her a car and the diamond ring that is buried with her. Huston had promised to marry Willa Mae and move her to Hollywood with him, but he "jilted" her, leaving her only with another pregnancy to contend with (224).

The short song "Lucky Day Blues" appears during the portion of the novel when Billy rides to LaJunta in a car with her second cousin Homer to dig up her mother's body. Homer is a handsome, middle-class college student, who becomes attracted to Billy during their road trip and begins to flirt with her.

At first, Billy is skeptical about his advances, especially because Homer seems most excited that Billy is a "hot and wild mamma" (184). However, he seems to treat her sweetly, promises to help her recover her mother's treasure, and romantically kisses her hand while he's driving. Billy is momentarily seduced by this gesture, saying, "His kiss feels better than Snipes's. Smarter maybe" (184). When Homer reaches in to touch Billy's breast after the kiss, she allows the pleasurable touch for a moment and then pushes his hand away, which angers him. At that point, Homer's affections turn quickly, and Willa Mae's "Lucky Day Blues" narrates the fleeting nature of men's affection exemplified by Homer's reaction. The song begins with hope and joy with lines about the "lucky, lucky day / all day long the day that I met you" (185). The "sunshine and roses / and Valentine-proposes," however, quickly turn sour. The man described in the "Lucky Day Blues" eventually leaves, and the singer must accept that "I guess my lucky day's done passed."

In the next scene, when Homer and Billy stop for gas, Homer goes behind the filling station and initiates a sexual encounter with the white woman clerk named Birdie. Billy wanders around to the back of the station and sees "Homer leaning against the wall and the gal is kneeling in front of him. She got his thing in her mouth." (189). The moment of affection that she felt in the car when Homer kissed her hand is like the "lucky day" of Willa Mae's song. It is filled with dreamlike romantic possibility but is easily undermined by men's unfaithful nature and their equation of sexuality with power. Although he was literally and figuratively in the driver's seat during his encounter with Billy, Homer becomes angry when Billy exercises her right to choose what kind and how much physical contact she wants. He then easily engages in a sexual encounter with Birdie behind the filling station, which Billy sees. Both "Willa Mae's Blues" and "Lucky Day Blues" act as Willa Mae's instructional interjections and moments of emotional connection from the grave. As an ancestral presence, Willa Mae provides her daughter with songs that narrate tough life lessons about heartbreak, disappointment, and patriarchal power through the placement of her songs within Billy's developing narrative on her two journeys in the text. In both cases, Willa Mae's wishful thinking about love and romance are consistently undermined by male infidelity, and they mirror Billy's romantic hopefulness and disappointment.

The gendered double standard of monogamy insists on women's fidelity in relationships, while men are expected to be promiscuous, with few, if any, moral consequences awaiting them. Resistance to this double standard explains why Willa Mae consistently refused to have only one lover at a time. By having a central lover and other boyfriends, Willa Mae acted in masculine ways, yet this always put her at risk of losing her relationships or being abused

and threatened when her romantic entanglements were revealed. The exception for this was in her relationship with Dill, who accepted Willa Mae's other love affairs during their relationship. One of those infidelities produced Billy. Yet, after Billy was born, Willa Mae and Dill raised her together until Willa Mae's infidelity with Huston leads to another pregnancy. It is this pregnancy that eventually leads to Willa Mae's death and sets Billy on her bluesy path. As a transgressive Blues Mama, Willa Mae mothers Billy from the grave through her songs as well as through the memories that Billy reflects on throughout her journeys. The wild and carefree ways in which Willa Mae lived invoke all of the familiar tropes of blueswomen, both real and fictionalized. Yet, Parks's treatment of these blueswoman tropes undergoes an important modification in that those experiences are applied to the mothering of a daughter. However, in keeping with blueswomen's non-normative perspectives on marriage, fidelity, and domesticity, Willa Mae's lessons are not instructions on moral behavior, family values, or the "cult of motherhood." Instead, Willa Mae's ancestral presence repeatedly appears in the text as a maternal voice that provides radical wisdom about sexuality, love, encounters with police, and how to "get over."

RING TRICKS: BILLY'S DEVELOPMENT INTO A BLUES MAMA

Throughout the novel, diamond rings are the symbol of multiple sites of illusion and trickery that become emblematic of Willa Mae's Blues Mama stature and present opportunities for Billy to become transformed into a Blues Mama herself. Huston gives Willa Mae a diamond ring as part of his promise to take her to California. However, he leaves her pregnant without fulfilling his promise. That ring eventually becomes a vital inheritance for Billy, who is able to recover it from her mother's grave. During her life, however, Willa Mae also kept a fake diamond ring that she used for a con that she called the "Ring Trick." For the Ring Trick, Willa Mae poses as a wealthy white woman who has lost her ring in order to swindle greedy filling station clerks into giving her the contents of their cash register. Knowing that greed is a common "hole," Willa Mae promises a big reward to the gas station clerk, gives him a fake phone number, and then drives away. Later in the day, Billy shows up with the fake ring she's "found." The clerk, thinking of the big reward, offers Billy money from the cash register, sometimes $30 or $40, in exchange for the fake ring. The Ring Trick was frequently the key to Willa Mae's and Billy's survival, and Billy uses the con to scrape up enough money to finish her

trip to LaJunta to get the real diamond. However, when Willa Mae's body is unearthed, the real diamond ring is not found on her hand. It is found sewn into the hem of her dress, which was a secret hiding place that Billy remembered from their days on the road together.

In the six years since Willa Mae's death, Dill believes he has had the real diamond ring all along, having pulled the ring and a pearl necklace off of Willa Mae's body before she was buried. However, he has had the fake all along and realizes at the end of the novel that Willa Mae, even in death, tricked him again. Billy gives the real ring to Laz Jackson, the son of Mrs. Jackson, who sold Billy her wedding dress, to sell for her back at home. He returns from the sale with $1,623 and a wedding proposal for Billy. Throughout the novel, Laz has been in love with Billy and has shown that love through an unwavering friendship with her. Laz is considered meek and soft by all of the townspeople, and his masculinity is constantly scrutinized or threatened by other men. On the other hand, Billy just considers him odd and quirky, and by the end of the novel, her attitude toward him shifts, and she agrees to marry him and have the baby. Finally, it is revealed that the money that Laz gave to Billy from selling Willa Mae's real ring was actually money from his own savings; he did not actually sell the ring. After Laz and Billy marry, he gives back her mother's diamond ring as a gift.

In all of these instances, illusion reappears as a theme in which the trickery associated with the diamond ring could also be read along with the narratives of passing and secrecy that are central to the novel. Willa Mae passes as a white woman throughout the novel, and Dill passes as a man. Therefore, the continuous appearance of the diamond ring, both real and fake, throughout the novel disrupts its presence as a primary symbol of love, fidelity, and marriage. Parks threads the image of the diamond ring through the narrative in such a way that it also operates as a recurring signifier of race, gender, class, and sexual illusion and artifice. The emphasis on trickery in the novel and the trickster skills and strategies that Billy develops to determine real from fake allow her to take on the bluesy qualities of worldly knowledge and toughness that ultimately lead to her survival and triumph at the end of the novel. Although she does not become a singer like her mother, Billy emerges at the end of the novel with the kind of blues wisdom that Willa Mae left for her, which makes her into a Blues Mama figure as well as a Young Mother.

Although Billy ends up married at the end of the novel and has her baby, the novel does not capitulate to a "family values" resolution to the plot. Since the Blues Mama is not conceived of as a stark boundary between radical rebellion and total conformity, readers do not have to interpret the culmination of Billy's story as a retreat to normative discourse and a rejection of

symbolic freedom and autonomy for a black maternal figure. Billy remains firmly entrenched in blues ideology throughout the novel, and she remains intimately connected to the emotional devastation of traumatic life experiences that face black girls and women that make up that blues perspective. Growing up, she has been involved in her mother's numerous arrests and ultimately witnesses her mother's gruesome death because of a botched abortion. She also has to transcend fear and revulsion in order to dig up her mother's body as a way of securing the financial means that she needs to have an abortion performed by a doctor rather than taking the chance and risking the same fate as her mother.

Throughout the novel, Billy is intrepid and resourceful, and when she is not, her mother's voice appears in the narrative as a sign of maternal reassurance and transgressive guidance. In a final sense, her mother's body itself is Billy's final blues lesson from Willa Mae. Learning from the blues songs left to her by her mother as well as from her mother's body, Billy chooses to give birth to her baby and pursue a transgressive form of motherhood. She marries Laz Jackson, the gender-ambivalent son of the upstanding Jackson family in Lincoln. In choosing Laz, who spends much of the novel trying to learn how to be a man from Dill, Billy rejects the normative patriarchal family structure that is supposedly the appropriate way to raise a child. Billy's marriage and motherhood is not figured in the novel as redemptive so much as it is simply a "life goes on" conclusion to the story, and a narrative manifestation of Willa Mae's final song, about the Great Wheel that "keep rolling along" (255).

Getting Mother's Body depicts a bluesy alternative to the elite black male-dominated narratives of the Civil Rights era. The historic account of the 1963 March on Washington gets glossed in the novel as a conversation, aptly held inside the men-only space of the black barbershop. Yet, even the inviolate nature of that space of black masculinity is altered through the presence of Dill, a queer black subject who is depicted and affirmed in Parks's narrative. As Norman explains, Parks's novel "turns away from federal politics and toward an integrated literary history to tell the story of a black community living under Jim Crow whose members never make it to the nation's capital or into its history books."[44] Furthermore, her multivocal text enacts new possibilities for imagining the late Jim Crow period and the Civil Rights era as a woman-centered, queer, and transgressive space of negotiation of love and family. By rethinking the master narratives of the Civil Rights period in subsequent generations, readers have an opportunity to consider not only the alternative stories that Parks suggests but also the ways in which a neo-segregation novel can change the racial progress narrative that predominates our contemporary moment. The novel also gives readers the opportunity to reconsider how Jane

Crow necessarily affected the experiences of black women and to continue to think about the enduring signs of gender and sexual discrimination in the lives of contemporary black women, especially black mothers like Billy and Willa Mae. Through the invocation of a Blues Mama figure in Willa Mae and eventually in Billy, who is both Blues Mama and Young Mother, *Getting Mother's Body* helps readers reimagine the iconic blueswoman figure as both a sexually autonomous, independent trickster and as a much-needed fictionalized portrait of a transgressive maternal figure.

3

TOWARD A NEW AMERYKAH

THE MATERNAL "FREAKQUENCIES" OF ERYKAH BADU AS MOTHERSHIP

> To enact excess flesh is to signal historical attempts to regulate black female bodies, to acknowledge black women's resistance of the persistence of visibility, and to challenge debates among black activists and critics about what constitutes positive or productive representation of blackness, by refusing the binary of negative and positive.
>
> —Nicole R. Fleetwood, *Troubling Vision: Performance, Visuality, and Blackness*[1]

IN THE PREVIOUS chapter, I detailed the narrative functions of the Blues Mama figure, which revolve around the application of the iconicity of sexual and economic independence of literary blueswomen to maternal characters in contemporary literature. I want to return to the discussion started there, and draw on Emily Lordi's insights about the artistic consciousness of black women performers in this chapter's examination of singer, songwriter, and performance artist Erykah Badu, who uses her songs and other expressive modes to depict aspects of her maternal and romantic life, including her choice to have three children with three different fathers and to remain unmarried.[2] Lordi's primary intervention in *Black Resonances: Iconic Women Singers and African American Literature* (2013) insists that we think about black women vocalists as *literary artists* rather than just muses for black writers, which seems particularly applicable to an analysis of Badu's multivalent creativity.[3] Therefore, I approach Badu's performances as "intellectual labor," drawing on the "fact that vocalists have specific ideas about what they want to do and make choices that produce meaningful effects."[4] In addition, Nicole R. Fleetwood's notion of "excess flesh," suggested in the epigraph, becomes

useful in interpreting the popular discourses about Badu's "excessive" (single) childbearing. I see Badu's work through a similar lens as Fleetwood's idea of "excess flesh," which describes representation that acts not so much as a corrective of controlling images of black motherhood than as a "refraction" of their effects through visual signification and performance. This chapter identifies Badu as a transgressive black maternal figure and "artist-at-work" who resists the privileging of marriage by seeking alternative family structures that affirmatively centralize black women as mothers and heads of households. Badu uses her music, visual style, and linguistic play to offer an Afrofuturistic vision of family that embraces black women's sexual autonomy and transgressive motherhood as an important part of a black collective identity that resonates in the post–Civil Rights era.

The relationship between marriage and motherhood and their connection to the American Dream have changed remarkably in the past half-century as more women raise children without a spouse. However, perception has not kept up with practice. Even though single mothers raise more children than ever before, considerably normalizing the experience, the nuclear family ideal maintains a strong influence over public opinion and social policy. For decades, studies have verified that black men and women marry less frequently than any other racial group in the United States. Yet concern over a "marriage decline" among blacks reached an alarming peak at the turn of the new millennium. In the past decade, declining marriage rates among black people has been redefined in the public sphere as a marriage "crisis," framed as a failure of black families to achieve the nuclear family ideal. The belief that heterosexual, married, two-parent families are best equipped to raise children and that a host of social ills, from incarceration to poverty, emerge when black unwed mothers raise children fuels this sense of emergency.[5] Additionally, the recurring cultural and social anxieties of "personal responsibility" and "family values" continue to shape intraracial maternal ideologies toward the picture-perfect black family that looks like the Huxtables or the Obamas. These heterosexual, two-parent families are lauded as the most suitable to represent black citizenship in the American racial landscape and are identified as the healthiest family formations for children.

Narratives like these fail to take into account the ways that two-parent families can also be locations of physical, emotional, and economic violence and discount the extended, non-nuclear family networks that have been vital to black survival for generations. In addition, marriage gets cast as the ultimate romantic, happy ending for black women, who are said to suffer emotionally because they lack "marriageability."[6] Therefore, black women, like Badu, who *choose* single motherhood over marriage and whose children have

different fathers fall into categories of social illegibility and disrepute within black social spaces. In fact, Badu has been decried publicly as a "bad mother" because she dares to remain an unmarried single mother and offers no apologies for this choice. Therefore, using a mama's gun analysis, I interpret Badu's vocal and performance art as a bold refutation of the idea that black women must always desire marriage along with their motherhood, and I describe her work as the manifestation of the black cultural trope of the Mothership.

Since the mid-1990s, Erykah Badu has stood at the vanguard of black popular culture, as she has captivated audiences and critics through her distinctive vocal style; her organic fusion of seventies funk, soul, and classic hip-hop; her eclectic fashion; her distinctive use of visual/video culture; and her notoriously cryptic lyrics. In 2000, Badu released her third CD, entitled *Mama's Gun*. The obscure meaning of the title baffled many listeners until Badu revealed what the phrase means in an interview. In that interview, Badu explained that she uses her lyrical "gun" through her songwriting, her singing, and her style, and that she likens the effect of her music to the feeling a person might have if she discovered that her mother carried a gun in her purse. Badu suggests that her music is similarly a powerful surprise. *Mama's Gun*, in addition to inspiring the title of this book, showcases Badu's gift for linguistic play. She frequently modifies words and phrases in ways that suggest a perspective about mothering, womanhood, and relationships that counters social norms. In particular, the terms "freakquency," "queendom," and "wombiverse" have appeared in Badu's songs and in her interviews as critical terms in which she defines these perspectives, suggesting that standard English cannot sufficiently convey her experiences.

As a literary artist, Badu seems to revel in the complexity of her words and acknowledges how her wordplay often baffles her listeners. In the song "& On," she signifies on the enigmatic quality of her writing style with the chorus: "What good do your words do, if they can't understand you? Don't go talking that shit, Badu, Badu." These lines, sung by her back-up vocalists, give voice to the confusion that audiences experience when listening to her music, and the back-up singers facetiously call Badu into question for her writing. Badu acknowledges how her wordplay seems impenetrable and questions whether it is worth using language that listeners might not immediately understand. Yet, the rest of the song answers this rhetorical question by continuing to describe her life through figurative language that must be deciphered by listeners, or it simply leaves them puzzled. In other words, Badu keeps talking "that shit" in defiance of those who wish her to be a one-dimensional or simplistic songwriter.

In this chapter, I interpret two of Badu's maternal neologisms— "queendom" and "wombiverse"—as examples of the possibilities of transgressive black popular culture to be used as a tool to redefine intraracial maternal ideologies, specifically controlling images of single motherhood. Her song lyrics, texts from interviews, and other related performance materials, such as Internet videos and concert posters, provide the background for defining and analyzing these terms.

Badu energizes her performances through the use of multiple personas, changing her image, her costuming, or her moniker during live shows or between various appearances. She uses the stage names Low Down Loretta Brown, Medulla Oblongata, and Sara Bellum, among others, in shows to suggest the multiplicity of her identity. "Erykah Badu" itself is the stage name for Erika Abi Wright, born February 26, 1971, in Dallas, Texas, where she was raised by her single mother, Kolleen Gibson Wright, a singer and actress.[7] After attending a performing arts high school, Erika Wright attended Grambling State University, and later began to pursue a career in music. She renamed herself Erykah Badu, was signed to Universal Records, and released her first album, *Baduizm,* in 1997, for which she won a Grammy in 1998 for Best R&B Album. Her first single from that album, "On & On," which also won a Grammy that same year, arguably remains her most well recognized hit, and it was her signature vocal style, her distinct African-styled head wraps, and her complex lyrics that skyrocketed her to national attention, particularly on black radio stations in the late nineties. Her look and persona reflected an image of black womanhood that attracted the admiration of many young women, including myself. She seems dignified yet funky, wise and witty. Her image is unapologetically black and African-inspired, but also universal, multicultural, and futuristic. Her songs are socially and spiritually conscious, yet also playful, funny, carnal, and filled with ironic and sarcastic wit. She fuses her identity as a "southern girl" who drawls as she sings with the distinctively urban influences of hip-hop.

Throughout her career, Badu has transformed her image in ways that demonstrate her complex subjectivity and creativity as well as her command of dramatic costuming and theatricality. During the release of *Baduizm,* which helped define the emerging neo-soul genre and aesthetic, Badu was mostly seen with her hair wrapped high in a gelee, a West African–inspired head wrap, wearing dresses and large jewelry with Kemetic symbols. In the last several years, Badu's style has become more eclectic, including elements that simultaneously reference futurism, hip-hop, and world cultures. She has shared her vibrant image through social media sites such as Twitter, Facebook, and Vine.

Since her start, Badu's personal and musical styles have evolved dramatically. She has released four studio albums following *Baduizm*: *Mama's Gun* (2000), *Worldwide Underground* (2003), *New Amerykah Part One: Fourth World War* (2008), and *New Amerykah Part Two: Return of the Ankh* (2010), as well as an online mixtape, *But You Caint Use My Phone* (2015), and she has expanded her artistic life to include acting, painting, deejaying, and performance art. Recently, Badu has also trained as a doula, or labor assistant, and has reported on Twitter that she's training to become a midwife.[8]

Her personal life has also kept her in the spotlight, in part because she frequently dates notable black musicians, and has had three children with three of her lovers: a son named Seven with MC/actor Andre 3000 of the hip-hop group OutKast, a daughter named Puma with Dallas rapper The D.O.C., and another daughter, Mars Merkaba, with rapper Jay Electronica. Not surprisingly, her non-nuclear family has drawn public scrutiny among those who see her refusal to marry her children's fathers as not only a detriment to her children but also a bad example for other black women. In her 2008 song "Me," released before the birth of her third child, Badu radically and triumphantly claims her choice to have "two babies [with], different dudes," responding to the public criticisms she has faced for her choice to remain a single mother.[9] The fact that her multiple children have multiple fathers has also placed a large amount of scrutiny on her sexual life, contributing to perceptions that she is promiscuous—a "freak"—and that she has a magical seductive sexual power over men. These perceptions have cast her as temptress or a femme fatale, one who cuckolds powerful male hip-hop performers with the power of her stunning glance.[10] Despite these impressions, Badu's performances reject these disciplining discourses of filial and sexual respectability, and instead she uses her songwriting and performance style to craft her own image as a mother and as an artist.

Badu's work exemplifies a tradition among black women vocalists, who have historically demonstrated significant power to influence their audiences, especially black women spectators who identify with the singer/performer through commonalities of race, class, gender, and sexuality. Like many women before her, Badu becomes the vehicle—a mothership—by which her fans are transported throughout their interconnected lives, making visible and audible the experiences of women who rarely see their realities portrayed in popular culture in ways that capture the breadth and fluidity of black womanhood, particularly black motherhood. R. A. Emerson notes in her study of black women in music videos at the turn of the twenty-first century that "pregnant women and mothers, as well as women older than 30, are not desirable as objects of the music video camera's gaze, reinforcing the sense that

only women who are viewed as sexually available are acceptable in music videos."[11] Emerson cites Badu as one of only two black women vocalists at that time who depict motherhood in a music video for her song "Tyrone" (1997), in which Badu appears performing the song live as she is pregnant with her son. Therefore, Badu has the ability to alter perceptions of motherhood among her listeners and spectators in ways that validate black maternal figures that are nurturing but not self-sacrificing; independent, yet focused on community and collectivity; mothers who are spiritual and sacred, yet sexual, earthly, material, and embodied. Just as the classic blueswomen furnish the symbolic material for the Blues Mamas in Suzan-Lori Parks's *Getting Mother's Body* and the soul divas of the 1970s contribute the signifiers used in the drag and camp performances of Big Mama in the work of Tyler Perry and RuPaul studied in chapter 5, Badu's performances contribute alternative maternal signifiers that allow for different expressive possibilities when thinking about, talking about, and representing black women who mother outside of dominant norms. Furthermore, even as Badu creates these moments of possibility in her work and through her public image, she is reiterating the performative legacies of black women vocalists who came before her. Therefore, the following section considers how Badu taps into the figurative power of black women singers of the past.

Hortense Spillers and L. H. Stallings provide critical perspectives for interpreting the role black women vocalists play in the expression of black women's sexual subjectivities, which includes those singers' perspectives on marriage and motherhood. Spillers and Stallings point to the critical flexibility of black female vocalists, who emphasize self-creation in their performances, as well as the elasticity of black vernacular and oral traditions that those vocalists draw on in their lyrics and theatricality. Spillers describes this creative supply as "vivid thereness," the public speaking and singing presence of black women performers used to undercut the silence and invisibility—or hypervisibilty—imposed on black women more generally within U.S. political and social relations. Badu's "vivid thereness" taps into the symbolic resources within black women's performance traditions, and her work is especially comparable to the performance personas of Chaka Khan and Betty Davis, two women who transformed the soul and funk genres in the 1970s. The edgy, free, sexy, loud, unfettered images of Khan and Davis as well as their innovations in sound and songwriting inform the stylization of Badu, allowing her performances to resonate within black popular culture in similarly transgressive ways. In order to make connections between Badu and earlier black women singers, the first section of this chapter will take up Spillers's concept of "vivid thereness" as a means of interpreting Badu's most recent work on

her two *New Amerykah* albums. These two albums, released within two years of each other, work together to form a panoramic view of Badu's larger artistic project, which synthesizes her interest in social consciousness and personal transformation. Her *New Amerykah* work also signifies on her public persona as a single mother, black woman, and artist.

In many ways, this chapter also takes up where I left off in my 2008 essay "Analog Girl in a Digital World: Afrofuturism and Post-Soul Possibility in Black Popular Music," which argues that Badu's early work (1996–2007) participates in and invigorates black popular music through its Afrofuturistic approaches.[12] As an emerging subdiscipline within black cultural studies, Afrofuturism situates historic and contemporary diasporic black expression within futuristic, technological, and science-fiction narratives. Afrofuturism pursues visionary discourses and futuristic counter-narratives in black cultural production that speak to the intersections of history and progress, tradition and innovation, technology and memory, the authentic and engineered, analog and digital within spaces of African diasporic culture. In that earlier essay, I define Badu's music and persona as sonically and visually Afrofuturist, and I interpret Badu's signature song "On & On" as a call to collective black consciousness, which she effectively makes through futuristic allegory and the language of the Five Percent Nation, a black religious sect connected to the Nation of Islam. Badu's sonic, lyrical, and visual play with Afrofuturist notions, black esoteric traditions, and hip-hop make room for other postmodern black identities to circulate more freely in late-twentieth-century black popular culture via the medium of R&B music. This chapter applies a mama's gun analysis to Badu's Afrofuturist ideas and imagery. Her work and public persona continue to stretch the bounds of black identities through the use of Afrofuturist themes, and these enactments offer progressive representations of black maternal figures.

Badu's "vivid thereness" expresses itself through the Afrofuturist trope of the mothership. Popularized in the jazz of Sun-Ra and the funk compositions of George Clinton, the mothership acts as a symbol of transport and transcendence appearing in the music and iconography of these artists. Throughout the twentieth century, mention of this vehicle appears in black music culture often to symbolize the ways in which black people have transcended their experiences of racism in America, and "mothership connections" emerge from those collective identities created by that experience. Erykah Badu extends these uses of the mothership and mothership connections to develop specifically black woman–centered perspectives on this trope of transport and transcendence. In all, Badu acts as a notable transgressive maternal figure in black popular culture that rejects contemporary politics of respectability and

anxieties about a black "marriage crisis." Instead, she projects a compelling vision of motherhood that embraces divine and sacred aspects of this role and centralizes an alternate politics of black collectivity in ways that do not insist that black women sacrifice their creative autonomy and sexual pleasure on behalf of nationalist ideals, be they participation in a patriarchal white "nation" or access to the American Dream. Badu expresses her perspective through the reclamation of the Afrofuturistic trope of the mothership, as well as through the creation of her own terms: queendom and wombiverse. Her neologisms guide listeners toward a maternally focused alternative black nation, a "new Amerykah."

In this chapter, I will explain how "vivid thereness" provides the critical lens necessary to interpret Badu's performance as part of a legacy of rebellious black women vocalists who confront cultural fears of black women's sexual agency through their performance. Badu's rejection of marriage as well as her sexual agency in selecting her lovers is part of that legacy, and her work talks back to ideologies that blame single mothers for black family failure and the marriage "crisis." After that, this chapter describes the significance of motherships and mothership connections to concepts of black collectivity and black family ideology in the latter twentieth century, and explores how Badu operates as a transgressive maternal figure in black popular culture that has transformed Afrofuturistic themes through her linguistic invention, song lyrics, and performance style into mama's gun.

"VIVID THERENESS": THE TRUTH AND POETRY OF BLACK WOMEN VOCALISTS

In her essay "Interstices: A Small Drama of Words," literary scholar and cultural critic Hortense Spillers identifies the figure of the black woman vocalist as a privileged site of analysis of black women's sexuality because the singer is "in the moment of performance, the primary subject of her own invention."[13] A multitude of sounds and images readily jump to mind when thinking of the moments of self-invention of performers such as Ma Rainey and Bessie Smith, or vocalists such as Nina Simone, Chaka Khan, Eartha Kitt, Etta James, Betty Davis, Abbey Lincoln, Diana Ross, Grace Jones, Betty Wright, Natalie Cole, MeShell Ndegeocello, Whitney Houston, and many more. Each of these iconic women, who perform in a multitude of genres—blues, rock, jazz, funk, and soul—offer examples of their transformations, evolution, and growth through their music. Spillers describes how black women performers revise and subvert dominant ideologies about their sexuality in these instances of

self-making. At the moment of performance, these black women singers com-
bine vocalization, music, writing, dance, gesture, countenance, costuming,
body posture, sweat, and spirit into a subjectivity that is

> likely closer to the poetry of black female sexual experience than we might
> think, not so much, interestingly enough, in the words of her music, but in
> the sense of dramatic confrontation between ego and world that the vocalist
> herself embodies. . . . I do not intend to take the vocalist out of history, but
> to try and see her firmly within it.[14]

Spillers's focus on the intersection of "ego" and "world" recognizes the com-
posite identities of black women performers, taking into account their self-
conscious interactions with the "world"—those dominant images, narratives,
and discourses about black women's sexuality that operate in the binaries of
asexual/hypersexual, Mammy/Jezebel, or invisible/hypervisible. Against that
stark backdrop, those moments of radical self-fashioning must also negotiate
the ideological and material constraints of capitalism, racism, and patriarchy.
But it is that very irony—the black woman's ego confronting a "world" and a
"history" that is decidedly not made in her own image—that marks the audac-
ity of the black woman performer. Even as these performances are mediated,
if not constituted, by the motivations of patriarchy and capital, they still speak
into history's void. In these scenes of self-creation, black women performers
produce counter-narratives to dominant figurations of black womanhood and
sexuality. These moments suggest what Spillers calls a "truth" or "poetry" of
black women's sexuality, which actively reflects the complexities, contradic-
tions, and ironies of that subject position. These moments might also be said
to "refract" in the ways that Fleetwood describes in *Troubling Visions*.

Erykah Badu's controversial video for the song "Window Seat" (2010)
exemplifies this dynamic of reflection and refraction by addressing black
women's sexuality through the depiction of the performer's nude body. Badu's
video was inspired by a 2009 video for the song "Lessons Learned" by a duo,
Matt & Kim, in which the white couple stroll through New York's Times
Square disrobing on a winter day, prompting reactions from onlookers and
eventually the police, who arrest them.[15] Badu interpreted their daring gesture
into her own music video, which features Badu walking through downtown
Dallas undressing as stunned bystanders watch. The camera's eye is focused
on the unembellished Badu—she is dressed in sweats and wears no makeup—
while the reactions of the onlookers are captured surrounding her in a blurry
haze. At the end of the film, after she has removed her clothes, bra, and pant-
ies and is completely nude, a single gunshot is heard. She dramatically falls to

the ground. "Blood" flows from her head the color of blue ink and spells the word *groupthink*. The trope linking black women's blood and ink return in this single image, which Badu explains was meant to "protest groupthink."[16]

In an interview, Badu explained how "groupthink," which is based on the psychological research of Irving Janis, diminishes individuality and creativity, and that those who dare not to conform to social expectations or ideology are often "assassinated verbally, mentally, spiritually or worse." Her use of the word *assassinated* also references the location of her video, Dealey Plaza, which is the site of President John F. Kennedy's murder in 1963. Her video, like many others throughout her career, extends, expands, reflects, mimics, or signifies upon other concepts circulating in various cultural spaces. For example, she revised Stephen Spielberg's *The Color Purple* film in her video for "On & On" (1997), referenced the color-coded characters in her sly take on Ntozake Shange's play "For Colored Girls" in her video for "Bag Lady" (2000), and styled herself to mimic the images on iconic album covers for the video for "Honey" (2008). These intertextual moments of visual sampling allow her to reflect and refract her sensibilities about herself and her art through a visual language that may at once be familiar but also foreign.

Badu explained at length in a 2011 interview what motivated her to disrobe in public in order to make the "Window Seat" video, for which she faced a misdemeanor charge of disorderly conduct for filming. Inspired by performance artists such as Josephine Baker and Yoko Ono, Badu outlined her motivations for taking up such a radical act:

> Symbolically I assassinated myself in the video after I took off all the layers of things that people felt I was supposed to be doing and wearing. And it was, like I said, petrifying. I was horrified to do it, because I don't love my body. I don't love those things. I think we as women have been put in such a position or a predicament to try to fit a criteria that we will never fit into physically, you know. I'm a mother of three. I'm 40 years old. I am also beautiful and also relevant. The nudity I think scares the nation as a whole or people in the world as a whole because we are taught that nudity is a bad thing, but what I really learned was that when it was packaged the way I was with no high-heel shoes, or long hair, or spinning around a pole or popping it, people have a hard time processing it when it's not packaged for the consumption of male entertainment, so they don't know quite what to do with it, because surely a woman couldn't be intelligent enough to make a point.

In this extended quote, it is clear that Badu's "vivid thereness" enacts the confrontation between ego and world described by Spillers. Badu's perfor-

mance embraces the personal risk and fear associated with being physically naked in front of others to encourage onlookers and her audience to interrogate their own relationship to nudity. Badu seems to want viewers to grapple with nudity here, both figuratively and literally. Nudity signifies the unexposed, the hidden, the inner aspect of self, but it is also visceral, embodied, and carnal. Those latter, literal aspects, particularly as they relate to women's bodies, intensify the brazenness of her performance. She dares to present her nude body in terms that are meaningful to her rather than in ways that are co-opted for "male entertainment." She refuses the beauty norms of the mainstream that include high-heeled shoes or long hair by appearing barefoot and with her short hair covered in a small stocking cap. Badu occasionally wears heels or long hair when she performs, so she is not simply condemning those bodily expressions of mainstream hyperfemininity. However, her video asks viewers to explore their reactions when those physical trappings of sexual attractiveness are absent. Moreover, in her interview, she draws attention to the fact that she is a mother of three and a forty-year-old woman. In a culture obsessed with youth and virginity, Badu's exposure of her black maternal body, which is *not* defined as desirable in the mainstream sexual marketplace, as highlighted in Emerson's study, adds another layer of truth and poetry to her defiant act. She confronts her fears and insecurities by acting boldly and against the norm.

Her embodiment of black womanhood in the video is itself a text even as it is further textualized by other symbols drawn on her body, such as two circles on her forearms, a crescent moon on her upper arm, and the word *EVOLVING* written across her back. The writing on her body strikes a curious sense of palimpsest and suggests the possibilities through which her work can revise the textuality of black women's bodies, particularly their histories of public consumption. At the end of the video, audiences see a fully naked black woman's body in the public square—Dealey Plaza. Badu's use of such a historic site not only calls the Kennedy killing to mind but also signifies on the historic practice of parading nude black women on the slave coffle on the way to auction in public squares all over the South.[17] Those who registered shock at Badu's brazen disregard for legal codes and social mores may not have been able to make that connection to history in the instance of their surprise, but the video seems to present that as a possible reading. Badu's agency in her selection of nudity in the public square marks the difference it means to walk freely exposed to the world rather than bound and flaunted as merchandise.[18]

Spillers further suggests that the "*practicing* singer" has more to contribute positively to the progressive development of black women's sexual auton-

omy than the polemicist, even as she warns against the urge to romanticize the singer. Scenes of self-creation, as exemplified in the "Window Seat" film, amplify the cultural presences of black women who have been denied access to the power to name and define themselves for themselves. Furthermore, these moments also serve as conduits for other black women, those who witness the singer in person or through audio and visual recordings, to "articulate both her kinship to other women and the particular nuances of her own experience."[19] Ever since the days of the classic blueswomen of the 1920s, black women singers have served not only as sources of entertainment for a variety of admirers of various backgrounds, but also, and importantly, as symbolic resources for black women and girls and, in some cases, gay black men and black trans women who look to these entertainers as guides to navigating their own gender and sexual identities.[20] Further, black women performers have also had an impact on the literary world, which I discussed in chapter 2. Angela Davis explained that her interest in studying the blueswomen in her groundbreaking book *Blues Women and Black Feminism* was inspired by the emerging voices of black women writers during the 1970s, such as Toni Cade Bambara, Gayl Jones, Sherley Anne Williams, and Alice Walker, who created fictionalized portraits of blueswomen, and Toni Morrison, whose character Sula, she reasons, "might well have been a blueswoman had she only found her voice" (xiv). Badu extends the transgressive reach of other black female vocalists, centralizing her performance of "vivid thereness."

"SWING DOWN, SWEET CHARIOT": MOTHERSHIP CONNECTIONS IN BLACK POPULAR CULTURE

To begin my discussion on the meanings of the mothership and Erykah Badu, I start with Parliament's 1975 album *Mothership Connection,* which is widely considered the first all-funk concept album. It is on this record that George Clinton, front man and bandleader for both Parliament and Funkadelic, expanded on what Amy Nathan Wright calls "his philosophy and system of myth."[21] Funk scholar Rickey Vincent agrees, calling *The Mothership Connection* "the first post-industrial black mythology."[22] Clinton's P-Funk mythology wove together out-there notions of time and space travel and classic American sci-fi pulp fiction with symbolism from ancient African civilizations, such as pyramids, ankhs, and masks. The latter elements particularly appealed to urban black audiences of the era, who found Clinton's hybrid "cosmic slop" to be the pleasurable anecdote to the disappointments of post–Civil Rights social and political conditions.

The LP is packed with classic jams like "P-Funk (Wants to Get Funked Up)," "Give Up the Funk (Tear the Roof off the Sucka)," and the eponymous single "Mothership Connection" (written by George Clinton Jr., William Earl Collins, and Bernard G. Worrell Jr.). On the latter single, Clinton's alter ego, Star Child, opens the song by explaining his mission to return funk music from space and deliver it to "the people from the mothership." It is important to note that one of the sonic signatures of funk music, as pioneered by James Brown, Clinton, and others, is the concept of being "on the one," or structuring musical time in order to emphasize the first beat of each measure. In the performance setting, this sense of auditory oneness permeated boundaries between performers and audience. P-Funk's intricate live shows, eccentric costuming, and deployment of Afrocentric concepts and symbolism offered a compelling alternate version of black oneness or nationhood that certainly rejected the white conservatism of political figures of that time like Barry Goldwater or Richard Nixon, but also looked suspiciously upon the mainstreaming of middle-class black leadership, and instead advocated freedom, funkiness, and freakiness, truly creating "one nation under a groove."

At the beginning of "Mothership Connection," Clinton addresses "citizens of the universe" and tells them: "We have returned to claim the pyramids, partying on the mothership." The call to "return to claim the pyramids" is suggestive of the Afrocentric cultural and political project that sought to identify and celebrate African contributions to world civilizations, ones that had been attributed to European sources throughout Western history. Pyramids particularly have long been acknowledged as marvels of math and engineering, and as signs of the technological advancement of Egyptian society in the ancient world. Therefore, mapping Egyptian civilization within the geographical boundaries of Africa contributed to a larger cultural effort to decolonize Eurocentric histories that claimed contributions of African-descended people as Western inventions, all while suggesting that the "darkness" of Africa produced no significant advances in technology, no written language, and no culture. Clinton's incantation at the beginning of "Mothership Connection" assumes a consciousness of this cultural and political project of reclamation, yet it does not literally invoke Africa or blackness per se. Instead, the P-Funk *sound* works to identify these "citizens of the universe" as primarily black diasporic subjects without reference to the limited modes of identification posited by American racializing discourses. The notion of citizenship itself is dislodged from the legitimizing project of the (U.S.) nation and opened up to include individuals outside the bounds of the modern state or even the planet. Furthermore, this song suggests that this cultural and

political project of reclamation occurs through the act of "partying" on a vehicle called a mothership.

The imagery on the album cover shows how Star Child's sense of abandon and fun are embodied on the mothership. Donning futuristic garb, the Star Child reclines with legs held open in a sexually suggestive posture of either surrender or release, while beckoning viewers with his hands and open mouth. Clinton's call at the beginning of "Mothership Connection," along with the album cover art, propose pleasurable enjoyment of music, dancing, and celebration as culturally and politically significant, and indicate that this otherworldly spacecraft is the appropriate and desired vehicle for this intervention. Although it seems that Clinton's mothership notion might have first started as a joke between him and legendary bassist Bootsy Collins, the idea eventually took on quasi-religious overtones to his audiences, amplifying a concept already circulated by jazz innovator Sun-Ra, who had sought to extend black identity and consciousness into the realms of outer space and himself claimed to be from Saturn.[23]

Vincent links the mothership concept to a variety of black worship traditions. The live shows, music, and concepts "drew listeners into a coded philosophy of black nationhood of freedom of expression and personal salvation through the use of symbols and double meanings that had deep roots in black music and religious traditions."[24] Most significantly, the song "Mothership Connection" features two "sweet chariot" interludes that dramatically shift the feeling of the music and focus on the repetition of the phrase "Swing down, sweet chariot / Let me ride," which is then punctuated by improvisational wails. Signifyin(g) on one of the most memorable of the spirituals, "Swing Low, Sweet Chariot," Clinton repurposes its lyrics from their use in the Civil Rights movement, which was already a refashioning of the song from its use along the Underground Railroad and in black Christian traditions. Drawing on the invocations of freedom inherent in the notion of the "sweet chariot," Clinton intones a newfangled mantra of spiritual deliverance in this song. The mothership, like the spiritual chariots before it, provides another vehicle of escape for black people in search of freedom. Therefore, even as the circumstances of the 1970s suggested that the "world is a ghetto," Clinton's "Mothership Connection" offered a perspective that perhaps "space is the place" for black liberation to occur.[25]

Clinton's mothership is significant to this study of Badu because its appearance in the mid-seventies synthesized a number of prominent, prevalent tropes of flight and freedom circulating in black cultural production, which Badu draws on in her work and her maternal figuration as the Mothership. In addition to the Christian interpretative possibilities of the mothership

as a chariot, Clinton's mothership also resonates with the folkloric "Flying Africans," a myth taken up in Toni Morrison's 1978 novel *Song of Solomon* and in children's stories such as Virginia Hamilton's *The People Who Could Fly* or Faith Ringgold's *Tar Beach*.[26] The mothership could also be interpreted through its relationship to the mystical "Mother Plane," a vehicle for spiritual and bodily liberation espoused by members of the Nation of Islam and its offshoot, the Five Percent Nation.[27] While no direct link appears between George Clinton and either of these religious groups—the Nation of Islam or the Five Percent Nation—it is not unlikely that Clinton might have been exposed to their teachings, which gained wide circulation in black urban centers throughout the twentieth century and are still widespread today. Black musician, cultural critic, and former *Village Voice* writer Greg Tate suggests a cultural synthesis as the origin of Clinton's mothership trope:

> I think George may have taken the mothership term from one of the Von Daniken books, like *Chariots of the Gods* or some other UFO tome, that were so popular back then. The Biblical story of Ezekiel and the Flying Wheel is definitely a precedent and there's a great song by the Golden Gate Quartet about that.[28]

The NOI Mother Plane and the Von Daniken books do share a basis in the Biblical story of Ezekiel's "flying wheel," and Clinton's mothership does integrate these possibilities. These multiple and intersecting sites in which the "mothership" or some related version of it appear in black vernacular culture all acknowledge the spiritually transcendent as well as the quasi-nationalist foundations of this cultural iconography, such as references to "citizens of the universe." Clinton's mythical mothership proposes funk music and funky experience as the source or origin of personal and collective transformation.

In his essay "Extensions on a Black Musical Tropology: From Trains to the Mothership (and Beyond)," Horace J. Maxile Jr. calls the mothership an "extension of tropes of transit" that repeatedly appear as symbols of black freedom and liberation throughout black popular music. Like images of trains, chariots, planes, and cars appearing in blues, spirituals, and R&B music, the mothership appears in the late twentieth century as a vehicle that "signifies freedom and liberation."[29] In the case of Clinton's formulation, Maxile confirms that the mothership operates as a means of escape from the disappointments of the post–Civil Rights era in at least two ways: "1) as a vehicle for social and cultural liberation and 2) as a specific social space or gathering place, albeit an interplanetary saucer, where one can escape, unite, and dance to funky music that raises consciousness."[30] These two functions of the

mothership—transport and transcendence—are useful because they describe the mothership not only as an imaginary vehicle through which listeners can be moved and transported from their social realities but also as a method of elevation of spiritual consciousness toward personal salvation and a sacred appreciation of black unity, which Maxile describes as "black nationalist."[31] The mothership appears in funk music as an imaginary vehicle through which listeners can be whisked away from their social realities, as they often were during the energetic live shows that Parliament was known for, but also as an articulation of black (masculine) racial identity.

Ethics scholar Theodore Walker Jr. writes about the importance of "mothership connections" in the philosophical underpinnings of the black Atlantic experience and thereby in constituting postmodern black identities. Walker bridges neo-classical metaphysics and black liberation theologies and cautions that when theologies fail to acknowledge or address the history of slavery that undergirds black Atlantic identity—what he calls mothership connections—those theologies will fail black subjects. He writes that "without these mothership connections, theology cannot be adequate to black Atlantic criteria for describing, evaluating, and overcoming modernism and modernity."[32] Walker argues that the only way to work toward any kind of useful black postmodernity—or what bell hooks called postmodern blackness—requires an attention to "mothership connections."

Taken together, the mothership and mothership connections link multiple ideas of spirituality, collectivity, black consciousness, and liberation. George Clinton also intones at the beginning of the song "Mothership Connection": "I *am* the mothership," thereby positing the possibility that an individual can be the mothership itself. In this way, the mothership also becomes an embodied vehicle, fusing technology and consciousness simultaneously as an emerging black cyborg identity. Therefore, what should be clear in this section are the multiple ways motherships and mothership connections are invoked in black popular culture, and that despite its numerous potential origin stories, the mothership maintains a liberatory symbolic valence throughout each location it appears. By tracing the multiple significances of and instances of the "mothership" in twentieth-century black cultural production, I hope to provide a background through which to interpret Badu's music and persona as a powerful vehicle of transcendence, transformation, and liberation. The following section explores how Badu becomes the Mothership through mothership connections in her work, developing specifically black woman–centered perspectives of transport and transcendence that relate to her identity as a single mother, which I identify as the mama's gun trope of the Mothership.

IN SEARCH OF OUR MOTHER'S MOTHERSHIP:
BLACK MATERNAL AGENCY IN POPULAR SONG

It is striking that there seem to be fewer instances of black women vocalists who take up the mothership as a metaphor of transport or transcendence in music than there are male artists who draw on the trope. Of all the mothership references identified in Maxile's essay, Badu's lyrics in her first single, "On & On," are the only example given that are authored by a woman. In that instance, Badu sings the memorable line "The mothership can't save you so your ass is gone get left," and Maxile characterizes her mothership reference as an "homage to the socially conscious funk and soul artists who preceded her."[33] While Badu's words do call forth those funk and soul artists who have influenced her neo-soul sound and performance style, Maxile's essay does not consider other ways that Badu's body of work expresses ties to the mothership. In particular, Badu invokes the mothership not as an explicitly imagined vehicle, like the one that Clinton's Star Child rides, but as a symbol of black women's individuality, autonomy, and freedom as well as a conduit for maternal reverence. Her song "Me" offers significant mothership connections that will be explored in this section.

Badu's memoiristic storytelling in the song "Me" bears an intertextual connection to a song by jazz vocalist Abbey Lincoln, "The Legend of Evalina Coffey," in which Lincoln memorializes her mother's life through music. Lincoln's song attributes her mother's bold life and maternal legacy to her transport from another time and space via mothership. Lincoln's song demonstrates how Afrofuturist metaphors of space travel can be used to describe the "otherworldliness" of transgressive black maternal figures. In the song, Lincoln remembers her mother's life through biographical lyrics. Badu's song "Me" addresses her choice to be a single mother as one of many expressions of her personal autonomy, and she sonically and lyrically connects her autobiography to the life story of her own mother, Kolleen. Both Badu and Lincoln generate work that bears resemblance to other efforts by black women writers to use their literary art to record the frequently forgotten lives of black mothers. By celebrating and commemorating these lives, black women vocalists transmit their "vivid thereness" to their audiences.

"The Legend of Evalina Coffey" appears on Abbey Lincoln's 1993 album *Devil's Got Your Tongue*. Lincoln's poetic tribute to the transformative power of her mother is expressed beautifully in these opening lyrics:

> Evalina Coffey / Made the journey here / Traveled in her spaceship / From some other sphere / Landed in St. Louis, Chicago and L.A. / The blue and

shining mothership / From 600 trillion miles away / Evalina Coffey lived, labored here / And her vessels multiplied / One for every year / When the number of the ships / Descending from the one / Came to number 84 / She knew her work was done.[34]

In an interview recorded in 2010 for National Public Radio, Lincoln explained how she was inspired to write about her mother, who had been "my greatest heroine, my greatest influence." From the lyrics, the loving tribute is apparent, and Lincoln uses the trope of the mothership to explain her mother's often magical and miraculous influence. She explains the extraordinary qualities of her mother, such as her ability to travel independently to major cities, by suggesting she comes from "some other sphere." This independence, strength, and resilience might have branded Evalina Coffey as a remarkably different woman for her time. Lincoln then refers to the "blue and shining mothership" that brought her mother to this earthly experience and memorializes Coffey's life through the repetition of her name and the valorization of her qualities. Among the triumphs that Lincoln ascribes to Coffey are her children, grandchildren, and great-grandchildren, generations that she produced that Lincoln refers to as "vessels multiplied." Lincoln's image of "ships descending from the one" to describe children parallels the Mother Plane imagery of the Five Percent Nation and signals similar figurative possibilities when the mothership itself is regarded as a maternal figuration in Lincoln's song.

Like so many black mothers and grandmothers, Abbey Lincoln's mother's name would not likely appear in history books. However, the effort to keep the names of these strong maternal figures alive has been the project of numerous black women writers, artists, and singers, like Lincoln. In the 1974 essay "In Search of Our Mother's Gardens," writer Alice Walker describes her personal literary project to commemorate "our mothers and grandmothers, some of them: moving to music not yet written."[35] Walker attributes her own creative force to her mother's legacy, extending a metaphor throughout the essay that likens her imagination to a "seed" in a garden sown lovingly by mothers who themselves had little space to blossom artistically. Walker writes:

> Unlike "Ma" Rainey's songs, which retained their creator's name even while blasting forth from Bessie Smith's mouth, no song or poem will bear my mother's name. Yet so many of the stories that I write, that we all write, are my mother's stories. Only recently did I fully realize this: that through years of listening to my mother's stories of her life, I have absorbed not only the stories themselves, but something of the manner in which she spoke, some-

thing of the urgency that involves the knowledge that her stories—like her life—must be recorded.[36]

By centralizing the lives of these women forebears in their songs, Lincoln and Badu share in the project of other black women who see the impetus for their creative practice rooted in recording their maternal legacies. Further, by reimagining the mothership as the vessel that brought her mother to Earth, Abbey Lincoln archives a portion of her mother's life, documents her name in song, and revises the iconic figuration of the mothership as it has appeared in funk music to centralize the maternal aspect.

Erykah Badu's song "Me" takes up a similar project of recording her maternal lineage, infusing the coda of the song with a narrative of her mother's life. She honors her maternal elder by singing her name and telling her story through music, providing the context for her own auditory memoir, which opens the song. "Me" provides an apt example of Badu's manipulation of mothership connections, bridging her narrative of single motherhood, love, and performance with her own mother's biography. Her blend of confessional poetry, public consciousness, and black unity come together in this song in a way that reflects Spillers's notion of "being for self," which I interpret through Badu's insistence on choosing "me" over all others. "Me" was released before the birth of her third child, and in the song Badu radically claims her maternal choice to have "two babies [with], different dudes." Badu's storytelling detours from the politics of respectability, which would identify her single motherhood as irresponsible or illegitimate. Instead, her song suggests that her autobiography and maternal perspective has the power to elevate black communities even as she promotes individuality and self-exploration. For Badu, black collective identity and personal individuality are not defined as mutually exclusive.

"Me" begins with a repeated beeping, characteristic of Badu's compositions, which are consistently an Afrofuturist fusion of digital and acoustic sounds. The beeps are followed by shimmying tambourines, hand claps, and soft horns that invite the listener to join Badu's groove, which is identifiably a synthesis of soul, R&B, and jazz elements. Her lyrics begin by naming multiple aspects of her personal presentation: "The ankhs, the wraps, the plus degrees / Yes, even the mysteries / All me." She references various African and Afrocentric details that have become part of her signature performance presentation, and she acknowledges that all of these reference points are aspects of her identity. Although she has shape-shifted throughout her career by assuming multiple personas and looks, she addresses the perceptions that these multiple identities are false and insincere. "The mysteries," those lin-

guistic and performance acts that have been known to baffle her audiences, are all a part of her complex subjectivity. The lyrics in this first verse reveal the risk it takes to display these multiple personas in public, particularly among those spectators and listeners who might see these shifts as fake or superficial, and therefore negatively judge the performer. Badu, instead, claims her multiple selves. Rather than remaining static as one kind of individual or performer, she is willing to risk the public criticism of superficiality in order to be "me."

The song continues with similar biographically revealing moments, each one punctuated with the phrase "it's all me." For example, Badu again addresses the subject of body image and describes her acceptance of her changing body as she ages. She sings that her "ass and legs have gotten thick" to describe the extra weight she has gained after childbirth.[37] Even as she expresses tolerance for these bodily changes, she worries about being set free from "vanity" about her body. She wonders whether attachments to her physical body will overcome her sense of self, or whether she will continue to "escape" these concerns by "smoking trees," which euphemistically refers to smoking marijuana. Revealing that she smokes marijuana to cope with emotional frailties disrupts any claims to respectability as a mother. A "good" mother, in addition to being married, is also imagined as law-abiding, and drug use would disqualify Badu from any claims to being a "good" mother. Yet, she allows access to this aspect of her storytelling, which acknowledges imperfection and insecurities and reveals the layered dimensions of black women's subjectivities. Between verses, she repeats the phrase "I feel lonely baby," again suggesting vulnerability and a need for companionship even as she asserts her need to be independent and autonomous. Each of these biographical, lyrical moments showcases the numerous emotional states being encompassed within an individual. This song, which did not rank on Billboard's charts, contradicts many of the simplistic and flat portrayals of black womanhood that circulate by more popular artists in the musical marketplace. Rather than remaining one-dimensional—a vixen, a tough girl, eye-candy, or one of the other popular personas embodied by popular black women singers—Badu chooses to be revelatory, contradictory, and complex.

The second verse of "Me" extends past personal confession and ventures into a social analysis of Badu's maternal role. She opens this verse with the words "Sometimes I don't know what to say, so many leaders to obey," which acknowledges the various powers that define the world that she lives in. Although she does not identify specific leaders she must obey, the line has the effect of invoking the social and political landscape of her contemporary moment. The conflict between individual and society is exemplified, and as a

black woman, Badu's insistence on her individuality within this social world has tremendous resonance as a resistant act. The expectation to conform to the directions of "leaders" results in the inability to express herself at times, and she admits that power has the ability to silence her. Badu describes her need for self-expression amid these constraints and expectations. Even in the face of silencing power, however, Badu counters her inability to "know what to say" through the following lines: "In this world of greed and hate / They may try to erase my face / But millions spring up in my place / Oooohhh / Believe me." As she acknowledges the physical and ideological efforts to render her invisible, or "erase her face," she resolutely reminds listeners that "millions spring up in my place." This phrase suggests creation, as Badu imagines figurative progeny, multiple versions of her black-woman-self that will flourish even after her own erasure by those destructive forces that come from the "greed and hate." "Greed and hate" reflect the social and political inequality that has become more established in the post–Civil Rights era, despite ideologies that promote the notion that gender and racial disparity have been eliminated.

It is against that looming ideological power that Badu inserts maternal imagery as resistance. The reference to the "millions" that will replace her demonstrates a belief that her subjectivity transcends her lived experience and her personal life and extends past her individual self into a larger collective. Her progeny may include both her literal, biological descendants and other figurative offspring, such as audiences and fans. These millions that will "spring up" implies, depending on whose side you are on, a promise or a threat.

These phrases act as "fissures of patriarchal discourses," as Spillers might say, in the way that Badu places her ability to create "millions"—a maternal effect—as a position of power in the face of prominent controlling ideologies that have previously silenced her. These millions are "all me," suggesting that they will bear resemblance to Badu herself or perhaps be one of her own creations. The imagery of numerous progeny emerging from a singular maternal figure bears striking similarity to the function of Abbey Lincoln's mothership in "The Legend of Evalina Coffey," whose multiple vessels emerged from the one "blue and shining sphere." Although Badu does not specifically cite the mothership by name, her reference to numerous progeny present an intertextual link in the figurative possibilities of the mothership trope connected to Lincoln's work. Another link between the songs emerges as both singers use their lyrical invention to tell the stories of their mothers' lives.

After singing the first four minutes of "Me," Badu interrupts her own memoir and replaces the words "It's all me" with the words "That's Kolleen."

Suddenly, the sonically dense song morphs into a sparse incantation, with Badu chanting vocals along with a trumpet. Badu and the trumpet sing together, with Badu providing the words to describe her mother's traits:

> Kolleen. Gipson. Wright. Was a girl from south Dallas, Texas. Gave birth to Erica, then Koryan, under Erica, and then she finally delivered Eevin. Kolleen's friends called her Twiggy cause she looked like a model with those eyes. She was witty and beautiful, people drawn to her smile. Lovely, young, and fresh. I could not think of a better soul that I've ever admired. Kolleen is tighter, smarter, quicker than the average bear. Even though. Even though. It was hard, you would never, ever know it.

The verse presents a daughter's admiration for her upbringing by her single mother, Kolleen. Badu first offers a genealogical description of her family, being sure to refer to her mother's entire name as if recording it for an archive. Again, this reflects the style of Lincoln's recitation of her mother's name. By stating their full names in these songs, these songwriters pay tribute to these figures and help document their lives. These songs appear also as a form of ballad, or a narrative song that can be used for storytelling purposes. Badu calls forth her mother's name and chronicles her life through her children, Erica, Koryan, and Eevin.[38] These three children become the central creations of Kolleen, but they are not her only significant traits. Badu recalls her mother as beautiful as a model, with striking eyes. She was witty and people were "drawn to her smile," suggesting that she was a warm and inviting figure in Badu's life and to others as well. Gipson-Wright was herself an actress and likely had an influence on Badu's decision to pursue a career as a performance artist.

Badu's tribute ends by honoring her mother's ability to provide a solid upbringing for her and her siblings, which is difficult for a single black woman, who may have faced economic and emotional struggles along with the daily difficulties of being black and a woman in America. Despite the fact that "it was hard," Kolleen's diligence made it possible for the children to experience joy and innocence rather than despair. In the final minute of the song, "Me" sonically transforms again with heavy bass, percussion, and vocal trills, and Badu chants, "Hold on, my people. Love is on the way." The song fades out with this chant, reminding listeners that "Me" transcends its focus on the individual and is meant to act as inspiration for the collective—"my people." In all, the song offers Badu's personal confessional perspectives on her strengths and weaknesses as a black woman and mother, documents and memorializes the life of her own mother, and ends with a soothing, loving

call to her listeners. The intertextual links between Badu's and Lincoln's songs are mothership connections, offering a variation on the trope that extends beyond its funk and jazz innovators and that includes black women's subjectivities and maternal narratives. Therefore, the Mothership is not only an imagined vehicle for transport or transcendence but also an embodied viewpoint that centralizes black mothers' independence, interdependence, and love.[39]

Badu's expression of "being-for-self" runs counter to the construction of the autonomous, bourgeois individual, and likewise undermines the dominant race-gender system that figures her black woman-ness as mere use-value. Yet she refuses to abandon self, selfishness, or autonomy, contingent modes of being that can contribute to a sense of collectivity, which also runs counter to the construction of the collective solely as a "nation." Neither wholly nationalistic nor individualistic, Badu's being-for-self is women-centered and hinges on numerous maternal figurations. Her use of the ideas of "queendom" and "wombiverse" provides insights into how these maternal figurations might be used to posit other modes of being that do not capitulate to nationalism and individualism.[40]

"RESPECT THE QUEENDOM": BADU'S NEOLOGISMS IMAGINE A NEW AMERYKAH

Erykah Badu's use of the terms "wombiverse" and "queendom" emerge in her music and in her interviews as self-fashioned reworkings of several gendered and sexualized signifiers, specifically the words *womb* and *queen*. Her neologisms centralize the symbolism of the divine, maternal, and feminine aspects of life, which she imbues with her own experiences and black vernacular inflections as translated through lyrics, melody, sound, and embodiment. Her terms have a distinctly Afrofuturist register and highlight her use of futuristic and science-fiction metaphors in her work. Through these terms, she defines her version of a New Amerykah for her listeners and spectators. Based on themes and imagery taken up in her music and performance, this New Amerykah would be a "nation" that values women for their individuality, freedom, and sexual agency. This section considers the possible ways Badu's wordplay extends her Afrofuturistic aesthetics to include maternal-centered words that illustrate her vision for an alternative "nation" that does not rely upon marriage to structure and legitimate families.

Badu has mentioned the word *queendom* in numerous interviews to describe the strong maternal relationships she has with her mother and

grandmothers. For example, she once stated: "I come from a long line of 'queendoms,' strong women who raised their children alone. I saw black women who are resilient and strong. We are best with our mates, but we can make it without them, too, but we are best with them."[41] According to her description, a queendom can be imagined as a realm of feminine autonomy and authority, one that replaces domination of women with reverence and respect for them. Her description also suggests that a queendom is a place where mothers raise their children without male influence, even though they desire to be the "best with [their] mates." Therefore, a queendom does not exclude men from its functions, but it does not require patriarchal influence to validate the women's lives. In some ways, Badu's term describes the nontraditional family structure of the single-parent, mother-headed, intergenerational household. While this family structure may be identified in sociological or historical texts with the misnomer "matriarchal," Badu's term rescues these family structures from the marginalization that is frequently imposed from outside. "Queendom" refuses pathology by revaluing the already existing experiences of numerous black women with an image that is affirming and empowering.

The Peace family in Toni Morrison's *Sula* (1974) serves as an essential literary example of an imagined queendom. The Peace household consists of three generations of black women—Eva, Hannah, and Sula—who live, learn, and love among each other without the domination of men. Men are a part of their lives; in fact, all three of the women have relationships with men. Yet the importance placed on masculine influence in the daily interactions in the Peace household is negligible. The women in the household negotiate their interconnected lives among each other and care for children, and no one laments the loss of a man or father. The women do not experience the absence of men in their lives as a "marriage crisis." Instead, each of the women in the household pursues intimacy and love in her own self-directed way. The notion of queendom appears in literature and other black cultural productions as well as within actual social spaces. For example, Kim Felsenthal writes about a group of trans women who live in an intentional community that allows them to live "freely without fear of ramifications that are often experienced in mainstream society."[42] Residents in this community call their home a "queendom" to denote the spaces in which their expressions of femininity can be honored and celebrated. In this context, the idea of queendom also takes on the sense of a sanctuary. A sanctuary symbolizes safety away from threats. Therefore, a queendom is a location that not only privileges women and femininity as primary agents in families but also suggests a safe space to avoid the marginalizing attitudes prevailing in the dominant society.

Greg Thomas, who examines the use of the term by both Badu and rapper Lil Kim, distinguishes *queendom* from *kingdom,* a word that typically conjures thoughts of patriarchal royalty and monarchy. The idea of queendom within black vernacular cultural spaces is not simply an inversion of a kingdom. Instead, it subverts the entire hierarchical framework of monarchy and in the process privileges women's sexual agency. Thomas writes that

> unlike the relatively rare queendom in Europe, this [black vernacular] queendom would not rule over a patriarchy of kings or princes as some sort of substitute-kingdom, succeeding on an incidental, individual basis until the next male heir is superimposed. Many African queendoms have boasted a radical sexual politics instead.[43]

Thomas's explanation places emphasis on the queendom as a location of sexual autonomy. He traces this black vernacular meaning of *queendom* to a 2004 interview with Badu, who playfully manipulates the public's perception about her sex life. In that interview, Badu admitted to making up rumors about herself to help get her name in the media and sell records. Those rumors— whether based in the truth or a fabrication—often paint Badu as a sexual temptress who cuckolds unsuspecting men, luring them with her freakiness and sexual daring. Thomas explains that the connotation of Badu's queendom incorporates this idea of sexual autonomy and power, which Badu herself manipulates at her whim. Unconcerned with respectability politics, Badu enacts "the role of a queen with many husbands, lovers or sexual partners, none of whom will ever be 'king' (or 'king' of *her,* specifically)."[44] Badu's playful engagement signifies on public perceptions about her as a woman who controls and transfixes her lovers, which she finds entertaining, even though some of her fans and others viewers have misunderstood her motivations.

In fact, a number of critics publically denounced Badu for her relationships—real and perceived—and accused her of being an unfit mother because of the relationships she engages in with her children's fathers. In response to those criticisms, which occurred primarily on the Internet, Badu wrote a scathing blog post to the okayplayer.com community to explain her point of view. She fiercely declares to her detractors: "HOW DARE YOU DISRESPECT THE QUEENDOM . . . AND MY CHILDREN AND MY INTELLIGENCE." The capitalization of her words emphasizes her outrage and has the effect of shouting or screaming in Internet communication. In her response, Badu attributes the "disrespect" to individuals who are limited in their perspective of family and "good" motherhood, particularly those who assert that the black family is dysfunctional if it does not maintain a nuclear ideal. Badu responds

by defending her motherhood and explaining her alternative, effective family structure: "I am an excellent mother and resent all of the negative comments and insults on my character." Badu rejects the assumption that the assessment of her maternal qualities should come from outside herself by claiming her position not just as a good mother, but as an "excellent" mother. She refuses to capitulate to others' perceptions, and she further explains that her relationships with the fathers of her children are healthy and supportive. She writes: "I put much time and thought into having and raising my children . . . The fathers of my children are my brothers and friends."

Within a nuclear family dynamic, a split between father and mother through divorce or breakup is portrayed as a family catastrophe, akin to experiencing the death of a loved one. The conventional wisdom asserts that former romantic partners can no longer maintain friendship when their intimate relationship ends due to feelings of jealousy and possession. However, within Badu's queendom, friendship and love outweigh feelings of ownership or loss at the end of a romantic relationship. She celebrates her ability to remain friends with her "brothers" with whom she raises her children. This perspective radically undermines the typical patriarchal arrangement that assumes that marriage is the only way to secure paternal responsibility and loyalty to children. Instead, Badu asserts her freedom to mother in the terms that work for her and her transgressive family.

At the end of her post, Badu brandishes the full power of mama's gun, writing that "I have defended myself here ON THIS SITE and hurled a few insults, but only in response to your insults of my music, my clothes, my lyrics, my hair, my being a woman, my spirit, my choices of partners. . . . these have all been on trial here. . . . Kiss my placenta." As a black woman performer, Badu understands and deftly manipulates her public persona in order to keep audiences talking about her and her music, but she still expects her audiences to focus primarily on her humanity, her creativity, and her artistry. Instead, she has found that many members of this black-identified online community use her playfulness to not only insult her but to attack her children as well. In defense of her children, their fathers, and herself, Badu steps into the role of queen to clear the record and end the discussion. Her sign-off—"kiss my placenta"—revises the insult "kiss my ass" in terms that accentuate her maternal embodiment and emphasize the womb.

Badu's notion of queendom is linked to the term *wombiverse*, which she mentioned in an interview, stating: "I come from a long line of strong matriarchs. I live in a queendom, ruled by a womb-iverse."[45] Badu's *wombiverse* combines the words *womb* and *universe* to invoke a sense of expansiveness that is governed by women's bodies, particularly the womb. The maternal

implications of the emphasis on "womb" should be clear, but I am particu-
larly interested in what it means to conceive of this part of the body not as a
bounded organ in the female body, but as an infinite source of creation. The
idea of a wombiverse expands and reimagines women's reproductive organs
as sources of creative potential that include the potential to give birth but also
the potential to create anything. The term "wombiverse" also demonstrates
Badu's Afrofuturist inclinations in her art and language, especially linguistic
revisions that elevate womanhood and femininity. Badu explained her use of
these terms in an interview:

> The pattern I see is the return of balance through femininity, through the
> mother, through the womb. The universe comes out of a wombiverse. What
> I see is woman's return to her throne, beside her king. I think it's a return to
> self-sufficiency. It's a return to ourselves, and that's how we lead.[46]

Therefore, her theory of the wombiverse incorporates a sense of selfhood as
well as unity with others. The wombiverse maintains balance between mascu-
linities and femininities, and Badu asserts that these aspects are compliments
of one another rather than adversaries. Yet, even so, within her heterosexual
notion of gender balance, Badu emphasizes women's authority, independence,
and control. She sees woman "return[ing] to *her* throne," which emphasizes a
place for women as leaders in her queendom. The emphasis on "her throne"
suggests that this seat of power always belonged to women, and it is simply
a matter of claiming that seat. This idea is reinforced through the repetition
of the word *return,* which suggests that these roles of leadership and self-
sufficiency were positions that women once possessed but have lost in recent
memory.

In keeping with Badu's emphasis on the divine meaning and sacredness
of motherhood, her words maintain a sense of matrifocality and reverence
for black femininity, which itself is a gender that is not composed solely of
Western qualities of femininity. Black femininity is not typically imagined
as docile, fragile, or passive. It is often imagined as witty, sensual, fluid, and
intuitive. While the phrase "beside her king" does prompt questions about the
limits of her Mothership influence, I claim that it does not suggest a reduced
power for black women in the creation of the wombiverse. It suggests inclu-
sivity and balance. The word *beside* does not mean "subordinate to." It implies
proximity, closeness, and sharing. Badu emphasizes self-sufficiency and lead-
ership in a way that does not rely upon masculinity to exist, but can coex-
ist when men are present. Overall, the wombiverse is the imagined space in
which the queendom can exist.

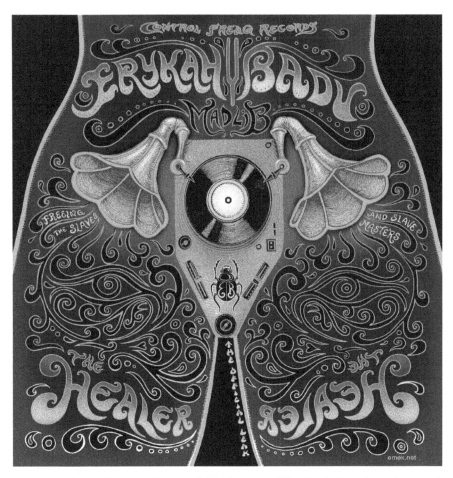

FIGURE 1. Artwork created by emek for the song "The Healer" on *New Amerykah Part One* (reprinted with the artist's permission)

A final artistic expression of this concept of the wombiverse comes from the artist emek, who frequently illustrates the liner notes and digital booklets that accompany Badu's musical releases. Badu and emek have collaborated dozens of times, and the image for her song "The Healer" offers a glimpse into one kind of visual manifestation of her wombiverse. In this image, a woman's body is outlined from the middle part of her abdomen to her upper thighs. Within this outline, Erykah Badu's name appears, and emek has drawn a record player where her uterus/womb would be. On either side of the record player are two gramophone-styled speakers that are suggestive of fallopian

tubes and ovaries. The record player is centered over a space that suggests a vagina. By imagining a woman's reproductive organs as instruments of music, rhythm, and sound, Badu expands the metaphor of birth and motherhood beyond literal childbearing and into the realms of the creation of music.

Sound vibrations and music are often thought to be universal mediums, and astronomers have sent sound recordings into the far reaches of the universe with the hope of using these sounds to communicate with other life forms that may exist. In this way, Badu's sonic womb, as imagined through emek's cover art, provides another interpretation of the notion of the wombiverse. Contained within her music, which comes from her womb, are all of the infinite possibilities of the universe. Furthermore, Badu's Afrofuturistic aesthetics return in this image because the female figure depicted—perhaps it is Badu herself—is imagined as fused with technology. In this instance, the wombiverse is contained within the body of a cyborg Mothership, yet another symbolic figure imbued with black feminist potential because of its status as a mediated form that resists fixed identity. Badu's music as represented by her sonically cyborg body has the potential to transport its listeners into realms that privilege the queendom as an alternative nation, a New Amerykah, which seeks gender balance, racial harmony, and creative freedom.

Thinking of Erykah Badu as Mothership includes all of the potential invocations brought forth through my reading of George Clinton's trope, including themes of transport and transcendence, as well as embodiment. Badu's mothering life—being an unmarried mother of three children—implies a futuristic focus on the development of life within and through her body. Badu's self-invention reveals a sexual and emotional subjectivity that transgresses a number of traditionally maternal ideas. Her subjectivity, even as it is constructed as "entertainment," allows for a kind of self-consciousness of persona that potentially sidesteps typical concerns with representation, especially the worry about "positive representation" that overdetermines so many discussions of black womanhood in America. In her book *Mutha is Half a Word*, L. H. Stallings calls for an alternative analytical concern for the politics of respectability, one that seeks to uncover "the spaces of the vocal and visible where black female sexuality is not defensive or concerned with the uplifting of the race, but radical and ever aware of its survival and evolution [through] folklore and vernacular culture."[47] Stallings writes that folkloric "forms and figures make it all the more plausible to articulate difference . . . in a less homogeneous manner." Black difference in this formulation is not simply how blackness is different from whiteness, but how the differences within black-

ness are actually expanded through a careful, rigorous, and creative interpretation of black cultural products, especially folklore, vernacular, and oral traditions. Erykah Badu transforms the folkloric, vernacular, and oral underpinnings by becoming the Mothership in ways that are suggestive of Stallings's concern.

4

"TO LIVE AND REPRODUCE, NOT TO DIE"

SURROGACY AND MATERNAL AGENCY IN OCTAVIA BUTLER'S *DAWN*

> The neoliberal reification of market logic is likely to expand the hiring of poor and low-income women of color for their reproductive services. The incidence of payments to these women to gestate fetuses or to produce eggs for genetic research could intensify even as they are encouraged to use genetic technologies to screen their own children.
>
> —Dorothy E. Roberts, "Race, Gender, and Genetic Technologies: A New Reproductive Dystopia?"[1]

WHILE AFROFUTURISM has proven to be a fruitful approach for studies of futuristic black cultural aesthetics, as demonstrated in my analysis of Erykah Badu in the preceding chapter, it has been less frequently invoked as an analytic within black science and technology studies, which explore the imbrications of medical, technological, and scientific discourses and the socio-politics of race.[2] In this chapter, I extend the critical possibilities of Afrofuturism to examine how bioethical questions about reproductive technology, genetic selection, race, sexuality, and class are taken up in Octavia Butler's futuristic novel *Dawn,* published in 1987. Lilith Iyapo, the black woman protagonist in *Dawn,* must navigate blurred lines of sexuality, motherhood, and reproduction in ways that actively engage sociocultural anxieties about genetics, kinship, and racial identity emerging in the post–Civil Rights era.[3] In the novel, Lilith is conscripted by an alien race to be the first human to repopulate a nuclear war–ravaged Earth in the far future. As a mama's gun figure I am calling the Surrogate, Lilith struggles against her use as a breeder for the colonizing aliens, and it is clear that Butler draws on black women's reproductive histories in her characterization of Lilith, allowing readers to

consider the complicated ways black motherhood is constructed through both biological and sociocultural meanings. Even though Lilith is not a true gestational surrogate in our contemporary sense, I have chosen to draw on this symbol as a way to examine the multiple aspects of black women's reproductive histories as they are implicated within a larger system of reproductive exploitation and inequality expressed through surrogacy and other reprogenetic technologies.[4]

Feminist writers such as Margaret Atwood and Doris Lessing have imagined various reproductive dystopias related to surrogacy and genetic selectivity, yet few black women writers have depicted surrogacy or reprogenetic technologies in their fictions about black mothers. Late science-fiction writer Butler may be the striking exception, because she consistently foregrounded themes of reproduction throughout her body of work.[5] *Dawn* considers how power, domination, seduction, and coercion affect Lilith's maternal agency by critiquing the circumstances of her forced motherhood: her capture and incarceration by aliens after an apocalyptic event on Earth. Lilith is used as a biological resource for the advancement of the Oankali, a three-gendered species that travels the universe to reproduce with other beings as they search for genetic and social perfection. The novel presents a kind of surrogacy arrangement in which Lilith is impregnated with a hybrid child that bears both human and Oankali genes. However, Butler alters the typical sense of surrogacy, which relies upon the technologies of artificial insemination or in vitro fertilization, by placing Lilith in direct sexual contact with the aliens. Butler's description of human-alien sex redefines Lilith's understanding of both sensual and sexual desire, and illuminates the concealed intimacies that are often overlooked in the transactional aspects of surrogacy as we know it. Through the intertextual use of slave narratives and allusions to the Hebrew legend of Lilith, Butler's novel offers a notable representation of surrogacy and blackness within African American literature. Identifying Lilith as the mama's gun trope of the Surrogate allows critics to grapple with the thorny issues of power that are embedded within various surrogacy arrangements while centralizing the reproductive histories of black women within those engagements.

Once thought to be primarily a white privilege, the advanced reproductive technologies that make gestational surrogacy possible present new challenges for black cultural studies approaches to the topic of black motherhood. Legal scholar Dorothy Roberts's prediction in the epigraph anticipates how the imperatives of racial neoliberalism continue to draw on historical myths of black motherhood and the black maternal body even as the ideology adapts itself to new technological conditions. In particular, she writes about new

dystopic futures in which women of color are not overlooked by purveyors of advanced reproductive services; rather, they are valued as gestational surrogates for more privileged families, including economically advantaged people of color. However, even as some black women may become more visible and "valuable" in this emerging surrogate economy, Roberts describes ways that advances in genetic screening may be used to intensify surveillance of women of color via race-based genetic inspections, thereby extending notions of unfit black motherhood expressed in other birth control, family planning, and welfare reform initiatives of the past. In other words, black women and other low-income women of color may be deemed fit or even coveted as gestational bodies for affluent families through a rhetoric of color-blindness, yet their roles as *mothers* remain devalued through the coded language of family values and personal responsibility. The intermingling of these neoliberal ideas demonstrates some of the ways that surrogacy and other related reprogenetic technologies are vital to our ongoing production of racial difference, and these concepts provide the ideological backdrop for my analysis of Lilith as a mama's gun maternal figure.

Dawn is the first novel in Butler's Xenogenesis trilogy, which traces the genetic colonization of humans by the Oankali, a species of biological "traders."[6] Like much of her other work, Butler's Xenogenesis trilogy continues her preoccupation with race, reproduction, technology, and genetics.[7] All three novels were published within the short span from 1987 to 1989, a period marked by both excitement and trepidation about the possibilities of medical technology to revolutionize human reproduction. As middle- and upper-class white Americans began to express increasing anxieties about their fertility rates, new medical techniques, such as artificial insemination and in vitro fertilization, were developed and perfected to assist in their desires to have children. These techniques now result in more than 60,000 U.S. births a year, or at least one of every 100 births.[8]

While white women and men are not the only racial group in the United States to use assisted reproductive technologies (ART), at this time they are more likely to avail themselves of these procedures than other racial and ethnic groups in the United States because of the high cost of ART.[9] Assisted reproductive procedures cost upwards of $9,500 per service, which does not include the costs of medication or surrogacy services, and this medical care is not consistently covered by health insurance. Therefore, the use of ART has been limited to those whose intersecting racial and economic privilege allow them to access and afford it, even though women who identify as black or Latina suffer from higher rates and longer duration of infertility than white women.[10]

Given these conditions, genetic and gestational surrogacy arrangements add another layer of complexity to the questions about motherhood and privilege through the use of ART. These arrangements occur through multiple symbolic shifts in the meanings of motherhood and often rely upon a maternal dispossession related to enduring historic structures of race and motherhood. Commercial surrogate mothers, who are often from less privileged racial and class groups than the "intended" parents, must often agree to give up legal, social, and emotional ties to the baby that they birth. Butler's novel *Dawn* invokes these transactional complexities, the tension between the emotional and biological definitions of motherhood, and the historic legacies of reproductive testing in ways that act as an allegory for black women's experiences of forced and coerced childbearing and reproductive experimentation.[11]

As the name *Xenogenesis* implies, the trilogy—consisting of *Dawn, Adulthood Rites,* and *Imago*—imagines how the alien strangers offer a new beginning to a group of humans who are survivors of a twentieth-century nuclear war. During their intergalactic travels, the Oankali find the human survivors and place them into a state of suspended animation on their spacecraft for two and half centuries, while they study the unconscious humans to determine their genetic qualities and how best to initiate reproduction with them. At the opening of *Dawn*, Lilith has just been awakened from her sleep by the Oankali, who have determined that she would be their first human "mate," a kind of genetic and gestational surrogate for their alien race. Though the nomadic Oankali refer to their reproductive process as a "trade," Lilith and the other awakened humans see the arrangement as exploitative and dangerous. Yet, as the story advances, Lilith begins to see her situation less as enslavement and more as an opportunity for new kinds of kinship bonds and sensual experience. Significantly, she begins to understand and enjoy the Oankali's three-gendered reproductive process, through which she revises her ideas about gender roles, sexuality, reproduction, and motherhood in ways that she ultimately finds more promising and liberating than her experiences as a twentieth-century black woman on Earth. Her choices, however, alienate her from the other men and women who have been awakened and who are also expected to participate in "trade."

Butler develops Lilith's maternal agency within this hybrid context. Lilith does not give birth to her hybrid children in *Dawn*; the climax of the novel occurs when she learns that she is pregnant with the first human-Oankali child. The successive novels in the trilogy follow the lives of her children, called "constructs," and her character has fewer appearances in the subsequent texts. The narration of *Dawn* centers most on Lilith's experience, which Butler figuratively connects to experiences of motherhood by naming the four

parts of the novel "Womb," "Family," "Nursery," and "The Training Floor." As each of these section titles suggest, Lilith's experiences are meant to evoke maternal motifs.

Lilith's story in *Dawn* revises themes of reproductive dispossession and exploitation by detailing the struggle to change and to sustain life through new ways of being and becoming centered on mutuality and interdependence, a motivation that Erin M. Pryor Ackerman locates in the realms of Lilith's desire and pleasure. Ackerman suggests that Butler centralizes "specifically erotic pleasure that is integral for such a shift in subjectivity to begin," allowing for a "new communal ethics."[12] Though sex with the Oankali is first presented as a frightening necessity and an inevitability for the purpose of reproduction, Lilith discovers pleasure and heightened sensation through intimacy with the aliens. In addition, she must interrogate what she believes are the fixed bounds of her own identity—in terms of both race and species—in order to explore a more hybrid existence with the Oankali. Therefore, the novel is more than a story of survival in the face of alien occupation or an allegory for colonial histories, although both of these readings are important and have been made well by other scholars. Rather, the novel imagines a future that requires an incorporation of diverse identities, and that incorporation relies on the mutuality of desire and pleasure to constitute change. This chapter, in addition to making connections to the histories of surrogacy, reproductive technology, and reproductive experimentation, focuses on scenes of sexuality and sensuality portrayed in *Dawn*, concentrating primarily on Lilith's pleasure in order to show how Butler presents these qualities as essential to a sustainable future.

Lilith's agency within the text is constantly mediated by a restriction of her freedom and her confrontation with power. Lilith's maternal capacities are both the reason for her captivity and the possibility of her freedom. This contradiction marks the Surrogate as an ambiguous figure, capturing all of the incongruity and messiness that identifies the mama's gun trope. Held against her will by the Oankali, Lilith chooses "to live and reproduce, not to die" by transgressing expectations of her emotional and physical capacities and by using her newly formed hybrid identity as her mama's gun (58). As a Surrogate maternal figure, Lilith must serve the needs of her alien captors, but she is not without opportunities for resistance. Her agency comes from a radical exploration of pleasure and desire with the Oankali, who are also transformed in their relationship with Lilith. Lilith's closeness to her alien captors represents the intimacies that are concealed in the transactional aspects of surrogacy as we know it. Butler's narrative undermines the strictly commercial

questions about surrogacy and asks readers to explore an affective ethics that informs these reproductive practices.

This chapter will first trace the race and class dynamics that shape contemporary uses of reproductive technology and the practice of surrogacy. Feminist, medical, and legal scholars have debated whether reproductive technologies are liberating and for whom. These technologies arguably provide greater freedom and access to parenthood for women who grapple with infertility, people in same-sex relationships, women who may want to postpone child-rearing, or those who do not wish to give birth. However, some critics have wondered if these benefits are available for women who cannot afford these procedures or if "freedom" is invoked for women who are hired to donate their eggs or wombs in service for another mother. Others have argued that ART may work only to further discipline and control certain women's bodies; privilege bourgeois, nuclear family formations; or enforce gender and ability discrimination among fetuses. Black feminist scholars have been particularly important voices in terms of critiquing the uses of ART and the ways that black women's reproductive histories have been elided in scholarly reflection on surrogacy. These undercurrents are often subtle and tacit, but they undergird the modes of power that Butler depicts in her novel.

Secondly, this chapter will describe two fundamental intertextual connections between *Dawn* and other texts. Of central importance is Butler's use of the slave narratives' description of first contact with Europeans as alien encounters and her use of the Lilith story of Hebrew legend. Tracing the intertextual connections among these key texts allows readers to see how Butler's story emphasizes blackness as central to the reproductive questions that her novel raises even though Lilith's racial identity is barely mentioned. Finally, I consider the uses of pleasure, sensuality, and desire as (re)productive maternal resources, and explore how Lilith draws on these resources to craft her own version of survival—or sustainability—as part of a new, hybrid life.

REPRODUCTIVE FREEDOM? BLACK FEMINIST CRITIQUES OF REPROGENETIC TECHNOLOGIES

Contemporary surrogacy arrangements reflect a logic that finds its roots in American slavery and the commodification of the reproductive capacities of black women. Recent studies of surrogacy have addressed concerns about race, class, power, and globalization; however, many studies do not locate the source of these arrangements in the history of slavery.[13] However, since the

1990s, black women scholars, such as Angela Y. Davis, Dorothy E. Roberts, Khiara M. Bridges, and Patricia Williams, have illuminated the ways that surrogacy relies upon a signifying chain of maternal dispossession invented and maintained in the system of chattel slavery. In their critiques, Davis, Roberts, and Williams highlight how the social and ethical justification of surrogacy relies upon an illusion of reproductive equality that has never existed. As the national media decry an epidemic of (white) infertility in the past few decades, conversations around who can or should avail themselves of these medical therapies and their motivations for pursuing those therapies reveal the continuing interlocking complexities of race, gender, class, and sexuality. It is important to note that the relations of power I am outlining here are not necessarily the personal *motivations* for families to seek surrogacy or for women to provide services. The intertwining of individuals and families in surrogacy arrangements often invoke feelings of trust, care, mutuality, altruism, love, and equality in the minds and hearts of their participants. Yet, those good feelings and positive motivations can conceal a set of social relations, privileges, and expectations about motherhood, kinship, and legitimacy that stem from social inequalities that are maintained if they are not laid bare and questioned.

There are at least three ways in which black feminist scholars have transformed the discussion of surrogacy and reprogenetic technologies and their relationship to U.S. black maternal histories. First, black feminist scholars have produced accounts of the ways that white fertility and the production of white children is socially privileged. Second, black feminist scholars have traced the "partializing" of black motherhood, which accounts for the ideological maneuvers necessary to see black women as reproductive vessels but not social mothers. Finally, black feminist scholars have critiqued surrogacy through an examination of the low-wage economic exploitation perpetuated in surrogacy contracts, which can be linked to the exploitative arrangements of slavery. By briefly exploring these three areas here, I show how assisted reproductive technologies maintain power dynamics that have their root in slavery and other colonial and imperialist engagements.

A similar "American grammar" that marked black women as hyperfertile in the late nineteenth century continues to mark them in the post–Civil Rights era.[14] Historic myths about hyper-reproductive black women continue to shape the construction of their foil, infertile white women. Therefore, the biological promise that reproductive technologies provide in transforming kinship as we know it is discursively undercut through its tangled sociopolitical history, which threatens to undermine the potential that ART has for ameliorating individuals' struggles with infertility and ensuring reproductive

justice for all. Black women are more likely to be infertile than white women, yet they are more likely to be reluctant to pursue ART and surrogacy options because of the issues of reproductive inequality that take root in history and persist in our contemporary moment.[15] Thinking about Lilith via the Surrogate figure allows for a grappling with these inequalities, and a partial, albeit ambivalent, reconciliation of these histories.

The disproportionate concern over white women's fertility is tied to a privileging of white babies as fulfillment of the American Dream and a disregard for the reproductive struggles of black women. Roberts traces the value of whiteness in the use of ART in her book *Killing the Black Body: Race, Reproduction and the Meaning of Liberty*.[16] Published in 1997, the book laid bare the high value placed on whiteness and the worthlessness accorded to blackness in the development of ART. Roberts explains that the then-new reproductive technologies had become increasingly popular in American culture not simply because of the focus placed on the genetic tie in nuclear family formations, but because of the significance placed on the *white* genetic tie.[17]

As the national media highlighted infertile white women as the primary benefactors of ART, they also trumpeted the promise of ART through images of "perfect" white babies, whose roles as desired commodities were highlighted through their juxtaposition to "dime-a-dozen" black and Latino children. Myths about the rampant fertility of nonwhite women and the "overpopulation" of the Global South also contributed to fears of a shortage of white babies. Television talk shows and magazine cover stories provided visual testimony to the promise that ART provided for these couples through images of cherubic white babies. Certainly, not every white couple consciously pursued ART for these eugenic reasons, but as Laura Doyle points out, "mothers reproduce bodies not in a social vacuum but for either a dominant or subordinate group."[18] Therefore, in this framework, ideas about white women's fertility become an intense site of hegemonic dominance, even if infertile white couples or same-sex couples sought ART only to fulfill their dreams of family bliss.

White people are interpellated into this order through a social and an aesthetic privileging of white babies. Roberts's research cites legal cases involving ART in which white families sued fertility clinics after birthing a black child through an error in the racial identification of the sperm or egg donor.[19] Their lawsuits hinged on receiving the "inferior product" of a black child rather than the more valuable, genetically related white baby they believed they were purchasing. More recently in 2014, Jennifer Cramblett, a white lesbian woman living in Ohio, filed a "wrongful birth" lawsuit after she was mistakenly inseminated with a black man's sperm. The sperm bank error

was discovered when Cramblett was five months pregnant with her daughter, and she and her wife expressed concerns about raising their visibly black daughter in an all-white, racially intolerant town.[20] In defense of Cramblett's lawsuit, various media commentators relied on problematic racial "common sense" arguments that amounted to reasoning, "Why would anyone want a black child?" In one editorial, a writer narrates Cramblett's experience as if she was literally shocked in delivery room with a baby that "comes out looking like someone else."[21] This dramatization masks the fact that Cramblett knew before she delivered her daughter that she would be biracial. In another commentary, the writer emphasizes that the sperm bank "erred big time" and lamented Cramblett's loss of a "traditional fairy-tale ending" in her quest to have a family.[22]

It is striking to think about how deeply rooted homonormative ideologies of monogamous married lesbians can invoke images of "traditional fairy tales," and that the only "boogieman" in the tale is the presence of black child. These commentaries also mark the head-spinning irrationality of postracial claims because at once these articles wish to absolve the white mother, Cramblett, of being identified as a racist for seeking legal redress for the "mistake" of birthing a black child. Yet this absolution can be articulated only through the invocation of the highly racialized language of difference and a disregard for blackness.

These arguments are further complicated by genetic research that proves there are no significant biological differences among racial groups, yet even so, as Roberts has pointed out in her work *Fatal Invention,* we have become more entrenched in discourses of scientific racialization. In other words, in our era of color-blindness, racialization has reverted to biological and intrinsic claims that are insidious in ways that mark U.S. sociocultural anxieties about genes and identity. Cramblett's story resides exactly at the intersection of whiteness, privilege, and genetics that Roberts described in the late '90s. Roberts's early observations collectively point to ways in which the promise of ART is selective and can have eugenic outcomes, and she doubts that there would ever be "a multi-billion-dollar industry designed to create black children!" (271). The only "industry" staged primarily for the creation of black children that comes to mind here is the system of slave breeding that, if evaluated in today's economic terms, would likely have been a multibillion-dollar industry.

The links between the uses of ART and slavery also extend into analyses of surrogacy, also known as commercialized contract motherhood (CCM) or third-party parenting. In particular, surrogacy is often rooted in unequal power relations in the sense that the surrogate mother, or "gestational carrier,"

may exist as both person and property, subject and object, in the transactional aspects of childbirth. This arrangement of power may not be how the participants—both the gestational carrier and the intended parents—think about their situations. However, the social and legal logic that makes this person/property simultaneity possible stems from what black feminist legal scholar Patricia Williams calls a "partializing social construction" that has its roots in slavery.[23] Williams describes her idea of "partializing" in her essay "On Being the Object of Property," in which she interweaves her personal and familial history and legal theory regarding reproduction. Williams explores the legal history of slavery and refutes the idea that blacks were conceptually totalized purely as objects of their owners' domination.[24] Instead, enslaved people were seen as partialized humans. Black people could be thought of simultaneously as chattel, unworthy of all but the most basic biological sustenance, and as freely willed individuals, who could be held to moral and legal codes.

Williams connects the idea of "partialized social construction" to surrogacy arrangements, particularly the 1986 Baby M case, in which a surrogate mother sued to keep the child she had carried. Even though the parties involved were all white, Williams argues that the judge's ruling in favor of the contracting couple could not be justified without the same kind of "partializing" logic that made slave codes operational. Williams deems the judge's ruling a kind of "rhetorical trick," comparing it to

> the heavy-worded legalities by which my great-great-grandmother was pacified and parted from her child. In both situations, the real mother had no say, no power; her powerlessness was imposed by state law . . . My great-great-grandmother's powerlessness came about as the result of a contract to which she was not a party; [the surrogate mother's] powerlessness came about as a result of a contract that she signed at a discrete point of time yet which, over time, enslaved her. The contract-reality in both instances was no less than magic: it was illusion transformed into not-illusion. Furthermore, it masterfully disguised the brutality of enforced arrangements in which these women's autonomy, their flesh and their blood, were locked away in word vaults, without room to reconsider—*ever.*[25]

Important to my consideration of reproductive technologies are the ways Williams and others link the use of these technologies to the illusion of a reproductive equality that has never existed in the United States. The social construction of the surrogate and the enslaved woman as breeder commingle around this site of partialized subjectivity.

In multiple ways, the U.S. slave society required a fractured sense of motherhood to keep the biological and affective intersections of maternal status separate. For example, the "condition of the mother" clause of seventeenth-century slave codes and the de facto "one-drop rule" that helped maintain ideologies of racial purity and white supremacy relied upon a privileging of certain aspects of motherhood over others. Among the earliest legal doctrines that defined American slavery, *partus sequitur ventrem* proclaimed that "all children borne [*sic*] in this country shall be held bond or free only according to the condition of the mother," thereby establishing slavery's legal history of maternal dispossession.[26] The use of the word *mother* in this law signals a relationship that was not consistently recognized or respected at the social levels of kinship or affect, but typically only at the genetic and gestational levels of reproduction. Enslaved women were not socially recognized as mothers, and this law, in effect, codified their reproductive value solely as breeders and wet nurses. In addition, the one-drop rule, which identifies an individual with any trace of black genetic ancestry as black, represents the primacy of biogenetic, "blood" ties over social, experiential, or cultural bonds in the racialization of American citizens.[27] In other words, the condition of the mother clause and the one-drop rule emphasize the biological and genetic relations of reproduction over the social aspects of kinship and maternal agency in ways that continue to resonate in our contemporary moment.[28] Genetic racial identification has replaced these concepts in the age of color-blindness as a way to maintain notions of racial difference without "seeing" color.

Black feminist analyses of reprogenetic technologies have also described an important link between surrogacy arrangements and intersecting race and class inequalities that operate from a market system that encourages economic exploitation of racialized bodies. Angela Davis argues that the payment for surrogacy services, which can amount to tens of thousands of dollars in payments and other kinds of care, can end up being less than minimum wage for the surrogate once you consider that pregnancy is a 24/7 job. This economic arrangement is exploitative, Davis argues, and it always carries racial and class-based undertones because "domestic work has been primarily performed in the United States by women of color, native-born as well as recent immigrants (and immigrant women of European descent), [so] elements of racism and class bias adhere to the concept of surrogate motherhood as potential historical features, even in the contemporary absence of large numbers of surrogate mothers of color."[29] In other words, regardless of the actual race and class of the surrogate who enters into contractual obligation with a

couple, the practice of surrogacy relies upon socially enforced inequalities of reproductive and domestic labor that emerge, at their root, from an unequal racial order and pervasive economic inequality.

In this section, I have addressed three ways in which surrogacy and the uses of assisted reproductive technology potentially perpetuate and maintain reproductive inequality. First, the representation of ART has typically emphasized the production of white babies because the common image of infertility is linked to whiteness and is juxtaposed with the idea of the hyperfertility of black women. The sense of freedom, access, and opportunity that ART provides to white families coping with infertility, gay and lesbian couples, or single white women wishing to mother without marriage often uncritically replicates the already privileged status of whiteness when it comes to reproduction. Second, the system of partializing personhood that emerged during slavery undergirds the legal and economic logic for contemporary surrogacy arrangements and builds upon already unstable and unequal race, class, and gender systems. Finally, many typical surrogacy arrangements place surrogate mothers in positions similar to other low-paid domestic workers, who may not receive adequate compensation for their labor because they are frequently women who are racially and economically less advantaged than their employers. All of these factors have rendered the "promise" of ART problematic.

The net historic result of these influential representations of fertility and infertility and advantage and disadvantage makes the notion of reproductive equality through ART a highly contested terrain. Skepticism and distrust for reproductive technologies has become a critical aspect of black women's collective reproductive politics, although there may be opportunities for change through direct engagement with the ethical issues at hand.[30] Black women's interaction with and perceptions of ART and surrogacy have socio-historical, political origins, and Octavia Butler's novel *Dawn* intimately engages with these politics through the character Lilith, who negotiates a strategy of survival and selfhood in spite of her situation as an exploited Other by a dominant, colonizing alien race.

INTERTEXTUAL INTERVENTIONS: BUTLER'S NEO-SLAVE NARRATIVE AND THE LILITH MYTH

While Butler's brilliant 1979 time-travel novel *Kindred* is frequently cited as a key text in the neo-slave-narrative literary canon, *Dawn* is rarely studied in that light. Perhaps this categorization has to do with the ways *Dawn* resists

the mimetic or quasi-mimetic expectations of the slave narrative genre itself. Although *Kindred* is not a work of realism, it operates as such in many ways. Time travel operates as a plot device, and the scientific quandaries of how the protagonist Dana moves back and forth between the present and her nineteenth-century past are barely considered in the novel, leaving it to operate more as an alternate history or historical fantasy than as a work of hard science fiction. *Dawn,* however, exhibits many of the genre preoccupations of hard science fiction in its play with biological, chemical, and genetic science; its consideration of the physics of space travel; and its presentation of the technical details of those scientific elements. Yet, like many other texts identified as neo–slave narratives, *Dawn* draws on the documented first-person histories of enslavement as intertextual referents. Butler's particular use of hard science fiction, however, places her work within a category of neo–slave narrative that "deconstructs realism as the dominant mode of historical narrative even as (in many instances) it implies that the past history of slavery is a knowable object, retrievable through written form."[31] Butler makes issues of race, class, gender, and sexual difference salient to debates about reproductive equality by depicting a black heroine at the center of *Dawn,* whose experience of capture and captivity by a colonizing alien force invokes narrative memory of enslavement.

Although Lilith's blackness is only subtly referenced throughout the novel, Butler uses intertextual references to emphasize the latent racial dynamics at play in thinking about the future of ART, surrogacy, cloning, and reproductive experimentation. To do so, Butler also draws on the Hebrew myth of Lilith and builds off of other literary renderings of Lilith by Jewish women and other feminist writers, who have also imagined Lilith as a black woman. By turning to the slave-narrative form throughout *Dawn,* Butler draws the reader toward associations with the history of racial slavery in the United States. Lilith's confining and disorienting imprisonment at the beginning of *Dawn* parallels the African experience during the Middle Passage, which also bears striking parallels to a number of other narratives within the genres of science fiction and speculative fiction. In doing so, Butler maintains readers' awareness that the unfolding story has a racial dimension that should not be ignored, even if it is not explicitly invoked.

Butler's intertextual methods have been transformative. At the time the novel was published in the late 1980s, there were still few notable black women writers within the science-fiction genre, and the depiction of black women protagonists in speculative fiction was also rare. In fact, many newer black women science-fiction and speculative-fiction writers cite Butler as a pioneer in terms of placing black women at the center of her stories. Butler,

who described herself as a black feminist writer, expressed her interest in writing against the prevailing norms of science fiction that focused solely on futuristic narratives of white males. By tracing Butler's use of intertextual references to Lilith's blackness, readers can more clearly see the interventions she makes in the norms of the science-fiction genre by making race, class, gender, and sexual difference central to our imaginings about the future.

Butler's allusions to the mythical Lilith figure fit within a longer tradition in women's science fiction. In her article "The Dawn of a New Lilith: Revisionary Mythmaking in Women's Science Fiction," Michele Osherow includes Butler's text in her examination of Lilith-like characters in science fiction written by women. Osherow notes that Butler's Lilith Iyapo resembles the legendary she-devil with amazing precision: "She resists tyranny, is independent, bold, and curious. Moreover, she has special powers, as Lilith is thought to have had . . . Lilith Iyapo's experiences mirror those of the original Lilith to a great extent."[32] However, Osherow limits the connection between Butler's Lilith and the Judaic figure, specifically regarding motherhood. The fact that Butler's Lilith must birth and "mother" an entirely new kind of hybrid being on a futuristic Earth is seen as a departure from the traditional symbolism of Lilith. Osherow concludes: "Motherhood is an unusual concentration for Lilith . . . [she] has never been the maternal type."[33]

As long as "maternal" remains tethered solely to notions of domesticity, nurturance, and purity, Osherow presents a compelling argument; the Lilith of Jewish oral tradition rejects the domestic refuge of Eden, she is an openly sexual being and promiscuous, and though she is fertile, her powers over children are threatening because she can cause sickness and even death in them. These descriptions are far from the traditional, Western conceptions of the maternal. However, if one considers alternate visions of motherhood, particularly ones theorized by and experienced by black women, then new readings of Octavia Butler's Lilith become available that link motherhood to qualities such as strength, power, sexuality, creativity, and hybridity.

The original "other woman," Lilith emerges in Jewish oral tradition and feminist interpretations of the Hebrew Bible as the first true mother of humanity, who is turned away from the Garden of Eden for her fierce determination not to be ruled by Adam. Described alternately as Adam's first wife or the deceptive snake in human form that tempted Eve, Lilith's disobedience has compelled numerous writers to explore this mythic figure in their work.[34] Most narratives detail Lilith's unwavering claim that since she is made of the same dust as Adam, she is his equal, and therefore she "will not lie below" him.[35] Her rebuff can represent an empowered figurative resistance to male supremacy, but also, if taken literally, is an assertion of preference for a par-

ticular sexual practice. Wanting to be the woman on top gets Lilith kicked out of Eden, and Eve is quickly sent in as a replacement.[36] Outside of the garden, Lilith becomes a phantom in the imaginings of Adam and Eve, and ultimately of their descendants. She is described in Jewish oral traditions as a demon that threatens women in childbirth and steals babies in the night.[37] Other tales tell of Lilith giving birth to demons after cavorting promiscuously with them after her flight from the garden. She is supposedly cursed to giving birth to 100 demons daily, each of which will die by nightfall. Other tales describe Lilith as the source of sickness in infants.[38] In the Western literary imagination, Lilith the demon becomes symbolic of a "womanhood that would forever try to stop man from precipitating the process of personal and cosmic salvation."[39] Yet her rebelliousness and independence also become a touchstone for feminist mythmaking. The "uppity" and "no-nonsense" Lilith, who in some stories forms a bond with Eve, becomes symbolic of women's solidarity against patriarchy.[40]

Of these many literary and theological interpretations of Lilith, however, the most fascinating and relevant to my project is Lilith imagined as a black woman. Often described in the Hebrew oral tradition as dark and brooding, Lilith's blackness is accentuated in the work of Jewish theologian Rabbi Jill Hammer, who describes her as "another Eve . . . this new Eve had skin like ink. Her white hair streamed down her black skin like a hundred comet tails, squiggling curving."[41] Poet and critic Alicia Ostriker connects the Lilith story with the lives and experiences of black women through her series *The Lilith Poems*. In "Lilith to Eve: House, Garden," Ostriker writes in the voice of the legendary Lilith: "I am the woman with hair in a rainbow / Rag, body of iron / I take your laundry in, suckle your young / Scrub your toilets / Cut your sugar cane and / Plant and pick your cotton / In this place you name paradise, while you / Wear amulets and cast spells / Against me in weakness."[42] In this stanza, Lilith confronts Eve with her experience as the woman rejected, shunned, and turned away by society. Here, Lilith's work is the work of black women: domestic service, childcare, and fieldwork. In Ostriker's poem, the marginalization of Lilith mirrors the social marginalization that black women experience in the "Eden" of the United States, thus unifying her version of Lilith with the lives of real black women. I find these references to Lilith's blackness—embodied and historical—fascinating because they provide new approaches to understanding the signification of the Lilith figure.

Butler's Lilith adds to these alternative signifiers in ways that can potentially transform the feminist potential of this mythical woman. If Lilith can be imagined as a black maternal figure, what other feminist iconography can be transformed to be more inclusive? Butler establishes Lilith's blackness in

Dawn through indirect references to her dark skin, yet her race maintains significance throughout the novel. She is first described in comparison to a human child who is brought into her room to stay with her during one of her disorienting Awakenings on the alien ship. The small boy had "smoky-brown skin, paler than her own" (8). Lilith's blackness is also indirectly referenced in a memory about her husband, Sam, who is of Nigerian descent. Sam's traditional Yoruba parents did not want their son to marry an African American woman, although he defied their wishes. Lilith also meets Paul Titus, another captive human, who was "as dark as me" and who "looked more than a little like one of her dead brothers" (85). While these references mention skin color only as a marker of racial identification, they are powerful yet subtle signifiers within the science-fiction genre. To simply imagine the protagonist's skin color as black or brown has been especially difficult for readers of science fiction who have been so indoctrinated by the norms of the genre that depict white males at the center.[43] Butler further centralizes blackness in her novel through intertextual references to slave narratives, particularly portions of *The Interesting Narrative of the Life of Oluadah Equiano*, published in 1794, which describes the initial capture of Africans as an experience that is similar to contemporary tales of alien abduction.

For four centuries, millions of captured Africans were snatched from their homes and forced to travel long, disorienting distances from the interior to the coast of the continent. They were then loaded onto unfamiliar vessels by which they traveled at sea for an unknowable amount of time. Upon their arrival to the alien landscape of the "New World," captives were forced to undergo strange experiments that sought to reveal their difference from their captors, and then they were put to work as subordinates. Therefore, some early slave narratives describe an alien-like first encounter with "men, whose faces were like the moon."[44] For example, an enslaved African woman named Belinda petitioned the legislature of Massachusetts for her freedom, and in the document she describes her capture as "scenes which her imagination had never conceived of, a floating world, [in] the sporting monsters of the deep."[45] Within Belinda's description, the qualities of the "fantastic" and the "alien" appear. This sensation of difference expressed by Belinda is demonstrated in numerous narratives of alien abduction, including *Dawn*, which bear significant resemblance to descriptions of African-European encounters at the dawn of Western modernity.

The Interesting Narrative of the Life of Oluadah Equiano, published in 1794, gives one of the most detailed accounts of trans-Atlantic abduction, describing the horror and confusion that Equiano endures through his journey. In 2004, preeminent Equiano scholar Vincent Carretta questioned the authentic-

ity of Equiano's narrative, especially his claims that he was born and captured in Africa and brought to the United States. The veracity of Carretta's claims notwithstanding, Equiano's story dominates my comparative reading here, in part, because his story draws on A. Timothy Spaulding's insistence that the postmodern slave narrative enacts a "need to critique the truth claims of objectivity and authenticity embedded in traditional history and narrative realism."[46] Or, as Paul Youngquist states, "Equiano's *Interesting Narrative* . . . is less the recounting of one man's past than the production of a diasporic people's future by means of the *disruption* and *transfiguration* of received cultural materials through found technologies. It multiplies possibilities for identity beyond the territories of nation and subject."[47] Youngquist, pursuing an Afrofuturist reading of Equiano's narrative, is unbothered by the question of authenticity of Equiano's narrative, favoring instead the motif of mixing evoked in contemporary DJ techniques attributed to hip-hop culture. He reads Equiano's narrative as a mix that reveals more about the transatlantic African experience through a transgression of the expectation of mimetic modes given to the abolitionist needs of the text in its original publication. Therefore, thinking about Equiano's narrative as a mix that bears striking resemblance to the opening pages of *Dawn,* I wish to link Lilith's sense of captivity and torture to the details of these kinds of encounters through an Afrofuturist reading of both.[48]

In his narrative, Equiano describes the "near suffocation" he experienced under the deck of the ship and the animal-like conditions in the hold of the vessel, where the captured Africans were kept in chains. Equiano also writes that seeing the ship that would transport him into the unknown "filled me with astonishment, that soon converted into terror," which overcame him to the point of fainting (57). When "he recovered a little," Equiano began to gather more details about his European captors. In the opening pages of *Dawn,* Lilith Iyapo awakes to the "nightmare sensations of asphyxiation" in a dimly lit room that is both familiar and strange to her senses (3). Disoriented and claustrophobic, she realizes that she has been repeatedly waking up in this room or a similar room for an unknown period of time. At this point, the narrative reveals little information about Lilith's surroundings, but it does reveal her frightened sense of captivity. Lilith knows that she is being "kept" but has no idea why. She recognizes the items she has been "given"— a toilet, a lumpy stew, a pile of clothing—though she has no idea who or what has control over her basic survival needs. Her confining room seems foreign and paranormal. Stains on the walls and floor vanish as if by magic. There is no identifiable light source, no obvious ventilation: "she imagined herself to be in a large box, like a rat in a cage" (5). The similar experiences of

"terror" (Equiano) and "nightmare" (Lilith) and the act of passing out from disorientation link these two narratives from the start. While held captive, both remark upon their closeness to animals; Equiano mentions the way the Europeans saw Africans as "brutes," while Lilith remarks upon being like a "rat in a cage." Upon regaining consciousness, Equiano and Lilith attempt to investigate their surroundings and the nature of their captors, which reveals a heightened sense of wonder.

Equiano writes that he believed "I had got into a world of bad spirits . . . Their complexions too, differing so much from ours, their long hair, and the language that they spoke . . . united to confirm me in this belief" that he was "to be eaten by those white men with horrible looks, red faces, and long hair" (57). Lilith experiences a similar fear when she first sees the humanoid Oankali. Above all else, she notices its difference in skin color and hair. She has brown skin (8), while the Oankali is covered in pale gray skin and darker gray hair that grows around its eyes, ears, and throat (11). As she looks closer at the being, Lilith realizes that the hair is actually a group of snakelike, moving sensory organs that the Oankali uses to perceive its environment. "She backed away, scrambled around the bed and to the far wall. When she could go no farther, she stood against the wall, staring at him. Medusa" (12). Frightened and disbelieving, Lilith fears that the strange-looking being may harm her or kill her. She backs away in disgust and fear.

Finally, both narratives describe acts of resistance toward captivity. Equiano writes about groups of Africans who would jump from the deck of the ship in order to drown themselves. In some cases these jumps were "successful"; captives could escape their torture and confinement through death. The slavers, however, did what they could to prevent this kind of resistance. When they could, Equiano writes, the slavers would go out to sea in smaller boats to bring back those who had jumped. Equiano describes the kind of brutal retribution exacted upon survivors: "Two of the wretches were drowned; but they got the other, and afterward flogged him unmercifully, for thus attempting to prefer death to slavery" (61). Similarly, Lilith mounts her own attempt at resistance prior to her first viewing of the Oankali. For an unknown amount of time, she is spoken to by her captors, though she is unable to see them. They ask her a series of questions, and she determines that they wish to gather information from her. In an effort to bargain with and resist her unseen wardens, Lilith stops answering their questions. This tactic does not work. Her captors simply stop speaking to her, initiating a kind of mental torture that sends her into a state of emotional exhaustion: "she sat on the floor rocking, thinking about losing her mind" (8). Lilith's attempt at resistance is thwarted by the Oankali in a way that heightens her sense of isolation and psychologi-

cal torture. Though Lilith's thwarted resistance is not the same as the beating of suicidal captives, I see parallels in the kind of psychological terrorism both stories depict.

Equiano's text offers a glimpse into the documented "alien" encounter that millions of Africans endured as captives. His stunning narrative provides a sense of the awe and terror, fascination and wonder that accompanied this moment of first encounter. Equiano's language of unconsciousness and awakening, of animal-like confinement and fear, and of thwarted resistance and psychological turmoil bears more than a passing resemblance to Lilith's experience. Lilith is "kept helpless, alone and ignorant," and this encounter can be read as a reflection of the histories of enslaved people (3). In a way, then, *Dawn* acts as a neo-slave narrative, joining a number of texts within the African American literary tradition that revisit the physical and spiritual devastation of enslavement.[49]

Moreover, *Dawn* provides an imaginative opportunity to extend the slave narrative tradition by reorienting the largely male voices of prominent enslaved writers (Equiano, William Wells Brown, and Frederick Douglass, for example) toward the concerns of black women, specifically their reproductive exploitation. By shifting Lilith's locus of concern from her general captivity, which parallels Equiano's story, toward her selection as a breeder for a new alien-human hybrid, Butler further complicates the gendered intertextual implications of her work. Tracing Butler's intertextual references to race and gender difference allows her novel to intervene within common representations of ART and surrogacy, which have been largely imagined as a white concern. Lilith appears in the novel as a mama's gun figure called the Surrogate, who transforms normative ideas about reproductive equality by centralizing a transgressive black woman character.

THE SURROGATE: TRANSFORMING A CONTEMPORARY MATERNAL FIGURE

Dawn opens with a section entitled "Womb," an image that establishes the novel's overlapping themes of reproduction and confinement. Lilith first gets a hint that she may have been reproductively altered after she awakens from one of her lapses of consciousness and discovers a scar across her abdomen. Bewildered, she thinks "she did not own herself any longer. Even her flesh could be cut and stitched without her consent or knowledge" (5). Though she eventually discovers that the Oankali had only removed a cancerous tumor from her, she continually feels a sense of foreboding about the Oankali's inter-

est in her body. When she asks her Oankali guide, Jdahya, what the Oankali intend to do with her and the other humans, he does not respond. Lilith feels helpless not knowing what will become of her interaction with the aliens, again equating her situation with that of an experimental animal: "This is one more thing they had done to her body without her consent and supposedly for her own good. 'We used to treat animals that way,' she muttered bitterly" (31). Lilith grapples with being kept like "a rat in a cage," used for scientific exploration and experimentation. She eventually discovers the reason for Jdahya's silences when she asks about the purposes of the research: the Oankali intend to use human genes to renew their species. Jdahya explains: "We do what you would call genetic engineering . . . We do it naturally. We *must* do it. It renews us, enables us to survive as an evolving species" (39).

What the Oankali call a genetic "trade," Lilith calls "inbreeding" and "crossbreeding," pointing to a conflict in language that exposes the unequal power dynamic between the Oankali and the humans (39). The word *trade* evokes a sense of egalitarian exchange, while *inbreeding* and *crossbreeding* are suggestive of exploitation and manipulation. Lilith eventually comes to understand her purpose as a captive of the Oankali:

> She was intended to live and reproduce, not to die. Experimental animal, parent to domestic animals? Or . . . nearly extinct animal, part of a captive breeding program? Human biologists had done that before the war . . . Forced artificial insemination.
>
> Surrogate motherhood? Fertility drugs and forced "donation" of eggs? Implantation of unrelated fertilized eggs. Removal of children from mothers at birth . . . Humans had done these things to captive breeders—all for a higher good, of course. (58)

Lilith's analysis of her situation with the Oankali likens it to a list of reproductive technologies and practices that she recalls from her life on Earth, from vivisection to surrogacy. She compares the Oankali reproductive system with common breeding practices that humans used on experimental animals, domestic animals, and other humans. She also describes reproductive practices including C-section surgeries, egg donation, and in vitro fertilization. Her recollection of human reproductive experiments and normalized practices in this passage is punctuated by ellipses and pauses. These stops and starts give a sense of disorientation, as her mind races to understand the Oankali's plans. She realizes that the reproductive practices of the Oankali, which she finds repulsive, are actually similar to numerous normalized medical practices that she took for granted on Earth.

Despite the normalization of those practices, however, Lilith's thoughts depict an inherent skepticism surrounding reproductive technologies as they have been used on Earth. Butler uses the oxymoron of "forced donation" to show that Lilith already had doubts about the power dynamics involved in emerging reproductive technologies that existed while she still lived on Earth. Her thoughts suggest that women who "donate" their eggs for in vitro fertilization may in fact be forced into these arrangements, perhaps through the economic incentive of a $20,000 check. Her final thought that "humans had done these things to captive breeders—all for a higher good, of course" further develops a sense of suspicion.

The fact that Butler uses the loaded term "captive breeders" to refer to the women who have undergone the aforementioned list of reproductive manipulations speaks again to the unequal power relations inherent in these techniques. Women who enter into surrogacy contracts, donate their eggs, or undergo forms of experimentation may not be literally captive, yet the novel refuses to decouple the development and use of ART from their ideological roots in enslavement and domestic servitude identified earlier in this chapter. Keeping these critiques in mind, then, Lilith's final remark, "for a higher good, of course," is sarcastic. Lilith's account of reproductive interventions and her cynical remark work to remind readers that certain bodily invasions were once touted as positive breakthroughs in human reproduction. The phrase "higher good" speaks to the promise of ART that is meant to hide its problematic realities.

Understandably, Lilith distrusts and fears the plans of the Oankali, and she craves other human contact because "only a human could reassure her—or at least understand her fear" (59). She is denied other human contact, at least initially, so she begins to bond with an Oankali child named Nikanj. Nikanj is *ooloi,* a third, neutral gender in Oankali life that is meant to create balance between male-female kinship units. The powerful ooloi are also integral to Oankali sex. At full sexual maturity, they possess an extra set of "arms." At the tip of each arm, a hand-like structure emerges that forms a bridge of stimulation in Oankali sexual encounters.

Lilith is introduced to Nikanj before it reaches puberty, before its sensory arms have developed. Nikanj is entrusted to teach Lilith the Oankali language and customs. Yet unlike the other Oankali, who approach Lilith in a sterile, calculated way, Nikanj truly bonds with Lilith. They share food and living quarters. They trust each other enough to ask questions and have conversations. Lilith begins to act as a mother-guardian to Nikanj, and "only Nikanj gave her any pleasure, any forgetfulness. The ooloi child seemed to have been given to her as much as she had been given to it. It rarely left her,

seemed to like her" (58). Lilith's connection to Nikanj deepens as it enters puberty, and it requests her comforting presence during its metamorphosis. In return, Nikanj facilitates Lilith's first sense of freedom on the Oankali ship; it allows her to roam parts of the ship unsupervised. Nikanj offers to alter Lilith's brain chemistry in order to allow her to learn the Oankali language more quickly and develop the ability to open and close walls with the touch of her hand.

She accepts the ooloi's offer, and through her increased freedom and mobility and her friendship with Nikanj she begins to reevaluate her role in the Oankali "trade." At the outset, she remains skeptical about her new powers and freedom, noting: "so she could walk the corridors and walk among the trees, but she couldn't get into anything Nikanj didn't want her in" (101). Again, Lilith remarks upon her conditions through a sarcastic comment that highlights how her freedom is conditional and limited by the wishes of the Oankali. Lilith uses sarcasm throughout the novel as a resistant speech act that juxtaposes her external and internal realities. Given freedom, yet still feeling like a "pet animal," Lilith struggles with her bitterness and gratitude toward her captors. Angrily, she abandons Nikanj as it begins a difficult part of its transformation, the growth of its sensory arms (100–101). Lilith watches Nikanj as it trembles on a bed in their shared quarters, and "she neither knew or cared what was wrong with it" (101). However, just as she walks out of the room to eat her first meal in freedom, she is compelled to return to the suffering Nikanj. She feeds it fruit and asks about how the transformation feels. She eventually lies down next to Nikanj, giving it comfort through its transition: "She sighed, tried to understand her own feelings. She was still angry—angry, bitter, frightened . . . And yet she had come back. She had not been able to leave Nikanj trembling in its bed while she enjoyed her greater freedom" (102).

At this point, Butler's narrative provides complicated insights into Lilith's navigation of her multiple roles as reproductive host and companion to Nikanj. On the one hand, she is compelled through a sense of nurturing, love, and care to provide attention to Nikanj. Yet, Lilith's nurturing is expressed as concomitant with the unmaternal feelings of anger, bitterness, and fear. Though these are typically seen as "negative" and unfeminine emotions, Lilith's anger, bitterness, and fear fuel her resistance to the Oankali. Her greatest gains—the freedom to move about the ship and the gift of writing implements—were secured after she harnessed her anger, bitterness, and fear into a more empowered position. I am not trying to suggest that anger, bitterness, and fear alone make Lilith an empowered character in this novel. But I do want to suggest that Butler evokes a dialectic framework for the under-

standing of Lilith's maternal agency that relies upon the mama's gun duality of anger/nurturing, fear/care.

Remarkably, Lilith overcomes her fear of the Oankali enough to become intimately attached to Nikanj. Her consistent resistance to Oankali domination and her acceptance of Oankali interaction demonstrates the strength of her character, a trait that surprises the Oankali, who have been studying human interaction for centuries. An older ooloi named Kahguyaht expresses its surprise that Lilith would be able to lead the Oankali/human interaction. Kahguyaht did not initially believe that Lilith, or any human female for that matter, would be capable of balancing the skills that would be necessary to work as a leader. Kahguyaht states: "I believed that because of the way human genetics were expressed in culture, a human male should be chosen to parent the first group. I think now that I was wrong" (110). The reference to the way "human genetics were expressed in culture" implicates an important aspect of how gender acts in human affairs. Males, because of their perceived biological difference from females, are positioned in many human societies as superior in strength and intelligence. Perhaps Kahguyaht, after observing and studying human societies, believed that males possessed superior qualities because of a genetic advantage, and that the leader of the Oankali/human trade should be man's work, so to speak. Yet, the ooloi is surprised to find that the strength and intelligence needed to re-create the new Earth would come from a human woman, Lilith.

Further complicating Kahguyaht's statement is Lilith's reaction to its choice of the word *parent*. She is puzzled by the word. "Parent?" she asks. Kahguyaht replies: "That's the way we think of it. To teach, to give comfort, to feed and clothe, to guide them through and interpret what will be, for them, a new and frightening world. To parent" (110). Lilith, still unable to reconcile the gender-neutral term *parent* with the qualities that her captor has described, says, "You're going to set me up as their *mother*?" (110). At this point in the narrative, Lilith must confront her gender identifications that attach nurturing behavior solely to women. What Butler is able to do in this narrative is detail Lilith's transformation, especially in terms of her relationship to gender roles, through her connection with the Oankali. It is in the second half of the novel, when she begins to accept her role as future "parent" to the Oankali/human hybrids that she transcends the kind of rigid gender designations that are exemplified in the earlier passage.

Lilith, at this point, remains unable to conceive of her work creating a new civilization as anything but mothering. But as the novel progresses, her work extends beyond clothing, guiding, nurturing, and support, which are idealized images of "mothering" that have already been shown to be problematic

when isolated or essentialized. Instead, Lilith begins to act as a mama's gun figure, engaging a transformational, transgressive identity that helps redefine her role as the Surrogate. The novel seems to offer Lilith's transformed self and her use of mama's gun as resistance to the Oankali reproductive imperative. Though she is unable to free herself completely from their control, Lilith manages self-preservation and asserts her subjectivity in the course of her participation in the awakening of other humans to their new existence as reproductive trade partners with the Oankali.

OUR COMMON FUTURE: SEXUALITY, SENSUALITY, AND SUSTAINABILITY

In her essay "Ecology Beyond Ecology: Life after the Accident in Octavia Butler's Xenogenesis Trilogy," Rachel Greenwald Smith describes *Dawn* as "a literary imagination of what it might mean to value the diversification of life over certain forms of expansion and growth."[50] In fact, the word *xenogenesis* itself forces one to consider what kinds of new beginnings are possible through the revaluation of difference, and the word works effectively to undermine its antonym: *xenophobia*. In Butler's literary imagination, Lilith encounters a world in which the Oankali have adapted and been adapted by numerous organic interactions. Large centipede-shaped carnivorous plants have been genetically modified as sleeping pods for humans so that both human and plant survive and thrive. All of the plates and utensils are edible, so that eating produces no garbage. An organism known as a tilio, which slides across surfaces on a thin layer of slime similar to a snail, is used as transport inside their vast spaceship. Even their spacecraft is organic, made to digest what little waste is produced through osmosis into the floor (52, 83).

Lilith does not understand the way the Oankali use living organisms as technology, and she asks her young Oankali guide, Nikanj: "Do you ever build machinery? Tamper with metal and plastic instead of living things?" Nikanj responds that they rarely manipulate nonorganic materials because "We . . . don't like it. There's no trade" (83). The Oankali's insistence on trade with other species defines them (11). "We are as committed to the trade as your body is to breathing" (41). The Oankali emphasize exchange in ways that defy Lilith's preconception of "technology," which is usually considered only in relation to its use-value to humans. Now she has to think about technology from an organic perspective that might include mutual benefits for both the user of technology and the technology itself.

Among Butler's many interventions into the notion of mutuality is her invention of the ooloi. As the Oankali third gender, the ooloi are considered "treasured strangers" within their communities, and they are the only member of the Oankali kinship unit that enters exogamously. Families need the ooloi in order to diversify their own genetic lines. Their gender provides the affective "glue" that bonds kinship units together. The ooloi are distinguished from the male and female Oankali by an extra set of "arms," or what Lilith describes as tentacles that resemble elephant trunks. These sensory arms are grown during a final stage of metamorphosis, after which an ooloi enters a family unit, and they facilitate sex between male and female through the secretion of calming chemicals that provide a euphoric sensation in the three-way sexual event.

Initially, Lilith is repulsed by the first ooloi she meets, named Kahguyaht: "How, she wondered, did these people manage their sex lives, anyway?" (49) The strangeness of the ooloi bodies, even in comparison to the other Oankali, frightens her and repulses her even as she comes to understand how their gender roles place them in a revered and powerful status. It is only when Lilith's guide Nikanj undergoes its transformation that Lilith learns to accept its difference. As Nikanj begins to grow sensory arms, Lilith cares for and nurtures it. In some scenes, she is described as lying down next to Nikanj to feed it and soothe it through her presence. Even without the use of the chemical stimulation, these moments of touch create bonds between them. Lilith is attracted to the ooloi's smell, the sound of its voice, and learns to read its body language during this process. The sensual contact provided in these moments allows Lilith to loosen her perception of difference and disgust. The ooloi, likewise, experiences the effects of this sensual bonding. After Lilith and Nikanj experience its metamorphosis together, they join the rest of the family, made up of a male and female Oankali. Lilith's presence begins to change them all. Tediin, one of the large female Oankali, tells her as she's about to leave with Nikanj to awaken other humans that "it has been good having you with us. I've learned from you. It's been a good trade" (106). Lilith responds: "I've learned too. I wish I could stay here." Lilith's perspective on uniting with the Oankali is the most unique of the humans' attitudes that they have encountered. Tediin continues: "You're rare—a human who can live among us, learn about us, and teach us. Everyone is curious about you" (106).

Nevertheless, Lilith also forms a bond with another human whom she helps awaken, Joseph Shing. Joseph and Lilith connect almost instantly, although their physical and emotional link baffles the other humans, who have identified both as unusual. Their difference from the other awakened

humans becomes the motivation for suspicion among those who are learning to adjust to their new environments. For example, Lilith's physical strength, a genetic enhancement given by the ooloi, confuses her human counterparts, and after punching another woman who had attacked her, Lilith is accused of being a man. The confusion other humans have about her toughness and her physical strength eventually leads them to believe that she is not even a human at all (147).

Joseph is also viewed with suspicion by the white humans because of his Chinese heritage and his small stature. Nikanj describes conversations that he has heard other men having about Joseph: "One has decided he's something called a faggot and the other dislikes the shape of his eyes. Actually, both are angry about the way he's allied himself with you" (159). Nikanj does not know what the word *faggot* means. It has to ask Lilith, who explains that it is a slur referencing a gay sexual identity, and she says that "there's some doubt about me too, I hear." Their racial and gender differences mark Lilith and Joseph as queer to the other awakened humans. Their unconventional expressions of gender and their love across their racial difference allow them to be read outside of a normative framework of sexuality. In both cases, their differences made them targets of physical violence and emotional distance from the other humans.

Ultimately, Lilith's bond with both Nikanj and Joseph precipitates a sexual experience for the three of them together. Joseph and Lilith's bond exists in part due to their similarities, which lie in the emotional strength that grounds them and keeps them connected. Yet they relate to the sex with Nikanj differently. Lilith, who had already experienced Nikanj's arousal while living with the Oankali family, knew that the sexual experience with an Oankali was intensely pleasurable when created by the touch of the ooloi's sensory arms. Via neural stimulation, all three participants in the sex act feel and experience intimacy and physical pleasure that is so compelling that it becomes hard to resist.

For Joseph's first time with an Oankali, he has to be induced through calming chemicals to participate. As Nikanj suggests that they share in this encounter, Lilith initially resists, unsure of Joseph's feelings about it, yet

> she thought there could be nothing more seductive than an ooloi speaking in that particular tone, making that particular suggestion . . . She did not pretend outwardly or to herself that she would resist it. Nikanj could give her an intimacy with Joseph that was beyond ordinary human experience. And what it gave, it also experienced. (161)

At this moment, Lilith recognizes a tumultuous desire not only for Joseph, who has become her lover, friend, and confidant, but also for Nikanj, whom she longs for too. The promise of intense intimacy with both Joseph and Nikanj proves to be a desire she is unable to control. She strips and seizes "the ugly, ugly elephant's trunk of an organ, letting it coil around her as she climbed onto the bed" (161). Compelled by the power of three-way erotic joy, Lilith embraces the ooloi, who lies between herself and Joseph. The sex is all neural stimulation created by the Oankali, who feels what its partners perceive. If they experience pleasure, it experiences pleasure. Pain: pain. This erotic relationship is central to the meaning of the novel and queer because it refuses a heterosexual imperative of sexuality.

The narrative elevates intimacy, perception, and feeling above procreation, and not simply between two but among three. Both Lilith and Joseph are essentially rendered without gender because the illegibility of their raced bodies and their nontraditional gender behaviors have "othered" them among "their own kind." Joseph and Lilith each chose different responses to the sexual experience with Nikanj. Joseph remains cautious, hesitant, and suspicious of the Oankali even as he continues to love both Lilith and Nikanj. However, Lilith realizes that she may be more family with the Oankali than anyone else. Throughout the rest of the novel, sexual experiences with the ooloi have varying effects on their participants. Each of the human pairs is joined with an ooloi who uses scent, touch, and sound to form bonds in spite of the humans' visual perception of difference. The Oankali appear ugly to the humans, yet they are able to overcome the visual perception of difference through other kinds of intimate sensations.

Lilith's bond with her ooloi seems to be the strongest, which helps her develop new ways of interpreting her situation with the Oankali. By drawing parallels between Lilith's post-apocalyptic capture by the alien Oankali and the capture and enslavement of Africans during the Middle Passage, *Dawn* fuses a futuristic narrative with the historic implications of race, reproduction, and exploitation. Questions of legitimacy and kinship have become increasingly muddled as the practice of surrogacy has become more widespread, and these questions have been at the heart of legal and ethical debates since 1978, when the first "test-tube baby," Louise Brown, was born.[51] The reproductive technology used in Brown's birth opened the door to a variety of surrogacy arrangements in which motherhood is determined at separate but overlapping genetic, gestational, and social levels.[52] While the reproductive technology that makes these maternal distinctions possible is barely forty years old, the arrangements of power that underwrite these differences in maternal status have roots in the history of American slavery. After draw-

ing these significant parallels, however, Butler's novel frees Lilith as a black maternal figure to explore the possibility of liberation and empowerment in the future through an exploration of sensuality and sexuality, thus revealing the intimacies always already contained within these reproductive exchanges.

MADEA'S BIG HAPPY FAMILY

TYLER PERRY AND THE POLITICS AND PERFORMANCE OF BIG MAMA DRAG

> Perhaps the most important point about black drag is that the performance and all of the qualities thereof have to be recognizable to the spectators of the community in order for them to be appreciated.
>
> —Marlon M. Bailey, *Butch Queens Up in Pumps: Gender, Performance, and Ballroom Culture in Detroit*[1]

DURING THE PAST two decades, filmmaker, playwright, actor, and comedian Tyler Perry has become one of the most familiar faces in black popular culture through his drag performance of a black grandmother named Madea, a Big Mama figure that reflects a post-Civil-Rights-era preoccupation with racial authenticity and nostalgia for maternal roles that trade in contemporary anxieties about black "family values." Madea appeals to audiences—particularly working- and middle-class black women—who desire entertainment that helps express and resolve their concerns with "black family failure." As I have discussed throughout this book, descriptions of black family failure abound in popular culture, media, and politics alongside narratives of urban crisis that depict the hardships within black communities as originating in defective, pathological, or incomplete family formations, and these notions exist as more than simply an idea in the white imagination. African Americans have come together within families, within churches, in community groups, at conferences, on university campuses, and in other venues to discuss solutions to their concerns with black family failure, including social and cultural anxieties about single-mother-headed households, crime, children in the juvenile justice system or in jail, unemployment, depression,

and drug and alcohol addictions. Black mothers often stand at the center of these discussions and are often held responsible for black family failure and community decline because they are unmarried, too young, materialistic, or otherwise unfit to be "good mothers."

Tyler Perry's Madea character intervenes in these discourses of black family failure by drawing on nostalgic sentiments for a Big Mama figure who can instruct viewers on "good," racially authentic mothering, as well as proper ways to be a wife or girlfriend. Although Marlon M. Bailey's observations about black drag performance expressed in this chapter's epigraph emerge from his specific ethnographic study of black LGBT ballroom culture in Detroit in the early 2000s, his conclusion is no less relevant to my interpretation of Big Mama drag here. I think Bailey's emphasis on cultural legibility—being "recognizable"—is pertinent to the uptake of drag as a performance method outside of explicitly LGBT communities. As I will explain in this chapter, it is Madea's legibility as a historically rehearsed figure that animates the popular interest in this character, which resonates with and responds to a host of sociocultural anxieties about black motherhood in the post–Civil Rights context.

Big Mama is a transgressive maternal figure because she does not fulfill the expectations of normative white motherhood, yet Perry's invocation of Big Mama vis-à-vis Madea ultimately reinscribes beliefs that bad black mothers are responsible for black family failure. While Perry's drag performances create moments of potential gender subversion that complicate any reading of his work, his particular style of performance rearticulates a history of theatrical black maternal performances that are rooted in the controlling images of the Mammy and the Matriarch. This chapter examines Perry's Big Mama drag by tracing the performative history of this black maternal figure in order to expose the intersections of race, gender, class, and sexuality that shape the conflicting meanings this figure represents in recent black popular culture. Further, I track the signifying chain of historical myths upon which Perry's performances are based in order to expose the limitations of his interpretation of Big Mama, which perpetuates sexism and homophobia via a black "family values" ethic embodied by the beloved Madea character. Finally, this chapter ends with an exploration of model, actor, and LGBT icon RuPaul Charles, who presents an alternative and potentially progressive example of Big Mama drag in his character Supermodel, who, like Perry's Madea, is based on memories of maternal figures in his family. Charles's queer interpretation of Big Mama resists a "family values" imperative and signifies on multiple controlling images of black womanhood in ways that disrupt their neoliberal instantiations.

During the post–Civil Rights era, the tough but nurturing black maternal figure known as Big Mama begins to appear more frequently in black culture—from literature to popular media—as a highly revered representation of black motherhood. Big Mama refers to a grandmother or "othermother" who supplements or replaces the functions of a biological mother in the family. Though she possesses multiple and varying attributes, Big Mama is often thought of as a wise woman who is known to speak her mind. She endures intense hardship and adheres to "old-school" discipline and tough love. Big Mama is usually religious, and she uses her faith to uplift her grandchildren, nieces, nephews, and entire family. Playwright Shay Youngblood lovingly describes this figure as "an old black woman who had a gift for seeing with her heart" in her collection of short fiction, *The Big Mama Stories* (1989), devoted to the iconic figure.[2] The role of Big Mama in African American culture becomes increasingly significant during the post–Civil Rights era because her presence seems to counter the tenacious controlling images of black mothers that preceded her. Combining strength and warmth into an affirming version of black motherhood, in many ways Big Mama "talks back" to the derogatory and pathological maternal imagery created and sustained by the dominant culture.

In the post–Civil Rights period, Big Mama also becomes a figure of nostalgic importance, a symbol of the bittersweet past. Although the decades of legal segregation, discrimination, and violence deprived black people the wealth of opportunity promised by the American Dream, there are black women and men who recall those earlier periods as ones that enriched African Americans with a sense of community and intraracial belonging. Big Mama symbolizes this bygone past, and films and literature that depict her frequently portray a longing for her ways of mothering, which are thought to be lost to the current generation.[3] Her nurturing wisdom and strict discipline become emblematic of an "authentic" black upbringing sometimes known as "home training," a style of child-rearing that emphasizes morality, common sense, and obedience. Home training is perceived as an esteemed sign of black difference; it is distinctly *not* influenced by white family values and parenting techniques that are seen as too permissive and inappropriate for black life. Big Mama's style of home training is represented as a cultural treasure, and throughout this period, writers, actors, and filmmakers have sought to capture the essence of this pillar of African American life. For example, the popular movie *Soul Food* (1997) depicts a multigenerational Chicago family that struggles to stay together after their Big Mama falls ill. While many of these Big Mamas are performed by black women actors, there are notable instances of black men who have performed Big Mama in drag.

Tyler Perry introduced his humorous Big Mama character, Madea, in his first play, "I Can Do Bad by Myself," in 2000 in Atlanta, and during the last two decades his performance has become the most popular and influential version of Big Mama drag.[4] Madea is a variant spelling of the African American family term of endearment *M'Dear,* which is short for *Mother Dear.*[5] Tyler Perry embodies this familiar version of a Big Mama character by dressing as an elderly woman, wearing a gray wig, glasses, and a fat suit meant to simulate large breasts and hips on Perry, who is six feet, five inches tall. Perry humorously alters his voice and speech patterns to impersonate Southern black vernacular and an elderly woman's voice. Madea always carries a pocketbook with a small pistol or a hammer inside, and she frequently threatens friends and family with her weapons, which exaggerates her physical dominance. In some cases, Madea is a concerned, forthright grandmother who is respectably dressed and stern. On the other hand, she is sometimes portrayed as happily wayward as she smiles and smokes a cigarette from behind bars in the movie poster for *Madea Goes to Jail.* In that image, the recognizable orange of an inmate's jumpsuit is given ruffles around the cuff and collar in order to maintain feminine, maternal elements.

This interplay between femme and butch personas exhibited in this drag performance identifies this character as an example of mama's gun. In the years since Madea's first appearances on the stages of America's black theaters, a new millennium "chitlin circuit," the character has appeared in nine stage plays and seven feature films, which all center around a variety of melodramas resolved by family cohesion and Christian morality.[6] To put the popularity of Madea into perspective, Perry went from living out of his car at the time he wrote his first play to having a net worth of $350 million through his portrayal of Madea, whose name always appears in the titles—such as *Madea's Family Reunion* (2006), *Madea Goes to Jail* (2009), *Madea's Big Happy Family* (2011), *Madea's Witness Protection* (2012), and *Madea's Tough Love* (2015).[7] Perry's fame and financial success has been attributed to working- and middle-class black women who make up the primary demographic in his audiences for the Madea franchise. Those women viewers have remarked in media interviews that they enjoy Madea because she seems "real," which speaks to the perceived authenticity of Perry's drag performance. Perry's own description of the sassy, gun-toting, marijuana-smoking grandmother Mabel "Madea" Simmons verifies that he intends her to be an amalgamation of traits resembling his actual mother and aunt.[8]

While Perry's plays and movies have garnered high box office returns and a devoted fan base, his work has been criticized in numerous, often conflicting ways, which speak to the complicated intersections of race, gender,

class, and sexuality inherent in this example of mama's gun. At once, Perry is accused of neo-minstrelsy while being credited with saving the careers of black actors in Hollywood. His work is seen as patriarchal condemnations of black women while also being read as male bashing and emasculating of black men because he performs in a dress. His drag performance of Madea has been interpreted as subversively queer at the same time as his stories appear heterosexist, if not blatantly homophobic. His style of broad, slapstick humor is seen as lowbrow pandering, even as scholars situate his work within celebrated histories of black theater traditions. His performances of Madea are considered examples of organic black (male) feminism or, in some cases, as antifeminist.[9] Of all of these debates, questions about the effect of Perry's work on contemporary black gender and sexual politics are the most salient to this book: Do Perry's performances of a beloved black maternal figure promote or inspire transgressive visions of black maternal subjectivities? Or rather, do these cultural productions reinscribe beliefs that bad or non-normative mothers are the root of black family failure? And what, if any, constructive intervention does Perry's drag performance make toward destabilizing mainstream racialized gender norms and sexual hierarchies?

Timothy Lyle provides an apt description of Perry's work as a "theater of paradox" that offers both "activist and oppressive" possibilities.[10] On the one hand, Perry's Madea plays and movies provide opportunities for black women viewers to see topics pertinent to their lives dramatized for enjoyment and edification in popular culture. Matters such as women's friendships, sisterhood, body image issues, racism and sexism in the workplace, the criminal justice system, physical and sexual abuse, child-rearing, and marital intimacy are all addressed in Perry's works. Since many black women rarely have opportunities to see their subjectivities portrayed in popular media, Perry's plays and movies satisfy an important black feminist and womanist concern with giving public voice to black women's experiences, thereby validating their knowledge and empowering them. On the other hand, however, Madea ends up being the only woman character in these plays and movies that has the opportunity to use her voice without judgment, and Madea's voice is almost always used to condemn the actions of the other black women characters, who are stock characters and stereotypes. Lyle and others have raised the point that Madea upholds heteropatriarchy and thus undermines the critical black feminist potential that exists in the production of these texts. Perry's drag performance of a beloved female character ultimately delivers messages to black women audience members that submission to black masculinity will help them achieve happiness. I agree with

Lyle's assessment that Perry's movies and plays contain more hegemonic than subversive content. His work exploits audiences' hunger for depictions of black life in popular culture in order to transmit a didactic, family values message.

Yet, the popularity of Tyler Perry and his Madea movies and plays remains a rich source for understanding mama's gun. By engaging with Madea, this chapter describes how Perry's Big Mama figure functions transgressively in contemporary black popular culture. I take seriously the perspective offered by theater scholar Nicole Hodges Persley, who cautions academic critics and feminists not to discount the meaningfulness of Perry's work to the working- and middle-class black women who make up the majority of Madea fans and find pleasure in this entertainment. Persley regards the harshly negative critiques of Perry as a result of gender and class distinctions between the critics who dismiss Perry and the everyday black women who make up Perry's audiences."[11] She contends that black male elite critics as well as some academic black feminists fail to acknowledge the grassroots black feminist or womanist underpinnings of Perry's intervention into black popular culture. By centralizing the lives and experiences of black women and addressing formerly taboo subjects such as domestic violence, rape, and incest, Madea movies and plays give voice to silenced aspects of black women's existence. In addition, the broad performance styles of Perry's work transgress the aesthetics of mainstream Hollywood, and instead draw on black theatrical conventions that resonate best within predominantly black working-class environments. Therefore, this chapter is not meant to be dismissive of the value that audiences find in Perry's work, but rather to interpret why this value has such meaning in the post–Civil Rights era.

In the following sections, I analyze the movie *Madea's Big Happy Family* (2011) as an exemplary text in Perry's oeuvre demonstrating how Madea's character operates as a nostalgic Big Mama. I trace the performative origins of the Big Mama figure, whose traits and qualities reiterate a set of dominant norms cited in the Mammy and the Matriarch figures. In addition, I draw on a book "authored" by Madea, *Don't Make a Black Woman Take Off Her Earrings,* which further describes Madea's perspectives on femininity and family. The last section of this chapter will describe the moments of transgressive potential in Big Mama drag and considers the recent work of RuPaul Charles as an alternative, subversive drag performance of Big Mama. Perry and Charles both invoke memory and nostalgia for their Big Mamas through their performances.

BIG MAMA: A "MAGNIFICENTLY PHYSICAL" POST-CIVIL RIGHTS ICON

The underpinnings of Big Mama bear close resemblance to aspects of the Mammy and the Matriarch. Big Mama synthesizes the performative elements of those earlier black maternal figures and reiterates their familiar characterizations, particularly in film.[12] These visual and performance elements have become central to the representation of Big Mama in black literature and popular culture and have influenced her iconography. The characteristics of Perry's Madea act performatively, which means that Madea's traits reiterate a variety of symbolic referents that incorporate aspects of other figurations circulating in the American imagination. Since performativity relies on the reiteration and citation of a set of norms repeated over time, the history of those articulations is important to consider in order to recognize their manifestations in current contexts.[13] However, those historical points of reference are muted within social relations and cultural production, which can have the effect of normalizing their reiterations. It is this process that allows Madea to be described as "real" by viewers. Madea gets understood as an "authentic" Big Mama in the vernacular spaces of theatrical performance, especially among audiences made up largely of black women. What makes Madea seem real and recognizably familiar are the ways that her characteristics act performatively in cultural spaces and how their images circulate in the post–Civil Rights "black culture industry."

The primary performative elements of the contemporary Big Mama figure are structured visually. Those visual significations then mark a set of historic social relations and ideologies about black maternal figures that produce meanings outside of simply what is seen. Despite Big Mama's mythically revered status within black communities, the visual markers of her type reproduce the troublesome history and politics of race, gender, and sexuality that black women have struggled against for centuries. She is a figure rehearsed, rehashed, and suspended in time. For the most part, Big Mama figures possesses the physical qualities found within the images of both the Mammy and the Matriarch: She is often depicted as fat, with large breasts, and is usually dark skinned. Her natural hair is covered either by a handkerchief or by a fairly obvious-looking wig. However, in terms of cultural function and value, Big Mamas are distinct from those earlier figures because the development of Big Mama stems from efforts by both black women and men to reread and revise the excessive traits of the Mammy (docility and servitude) and the Matriarch (dominance and aggression) through a positive and affirming lens. The fusion of the expressive and visual qualities found in

these two national archetypes exemplifies an African American vernacular cultural adaptation in response to the legacy of these controlling images.[14]

Mammy is by far the most powerful, enduring, and complicated of all the images of black motherhood that emerged in the nineteenth century, and throughout several generations she has served many functions as a familiar national maternal figure.[15] Throughout the twentieth century, Mammy was the subject of nostalgic recollections by both whites and blacks, and also appeared in movies and television. She continues to be revered in the twenty-first century in modernized variations, but one thing remains consistent: Mammy appears as a benevolent nurturer who is a widely recognized and influential portrait of black female existence in the United States.[16] She is a quintessentially maternal figure, a "consummate supermother," but the nurturing energies symbolized by her exaggerated breast size are rarely portrayed as focused toward the care and well-being of her own black children.[17] Instead, her fat flesh and ample bosom provide the sustenance, literally and figuratively, for whites only. Her size, strength, and departure from white feminine beauty standards also place her outside of the political and social privileges of white womanhood. As a result, her image was also invoked as a means to discipline white male sexual attraction toward black women. The physicality of Mammy, most often represented as excessive—a heaving, voluptuous bosom; a wide girth; a fat, smiling face spilling out from underneath a head rag—is mitigated by her obsequious and servile nature. Her subservience keeps her physical bulk in check, so to speak, rendering her a nonviolent and nonthreatening entity, which helped ameliorate mainstream fears of the physically strong, sexually desirable, and rebellious black woman. Barbara Christian writes that "all the functions of mammy are magnificently physical. They involve the body as sensuous, as funky, as part of woman that white Southern America was profoundly afraid of. Mammy, harmless in her position as slave and unable because of her all-giving nature to do harm, is a needed image, a surrogate to contain all those fears of the physical female."[18] The physicality of Mammy, her funkiness and her bodily strength, suggest a figuration that cannot be ignored. Fears of a funky, strong black mother were mitigated via a set of expressive behaviors that are unassuming, placating, and self-deprecating. The juxtaposition of physical and expressive dimensions of Mammy describe this trope.

Patricia A. Turner cites Aunt Chloe in Harriet Beecher Stowe's *Uncle Tom's Cabin* (1851) as the first literary Mammy and describes how the "dark skinned, rotund, benevolent black woman" eventually became an American theatrical and cinematic icon.[19] In the novel, Aunt Chloe is the loyal cook and servant of the Shelby family, who has devoted her care and kindness to the life of

Mas'r George rather than to her own children, who she shamed and abused. As "part of the vocabulary of . . . proslavery plantation fiction," Aunt Chloe embodies a desire and longing for plantation life, including the distorted picture of a content black woman who lives solely for the betterment of her white masters, mistresses, and children.[20]

While the novel was wildly popular, the story of *Uncle Tom's Cabin* reached even greater audiences through the numerous stage adaptations that appeared as early as 1853 and continued on until the middle twentieth century. These antebellum "Uncle Tom Shows" were modeled after characters in Stowe's novel and gave birth to stage versions of Aunt Chloe, which were performed by white men dressed in blackface and costume, a practice that continued well into the twentieth century. Blackface female impersonation, or blackface drag, had long been a convention of minstrel performance that predated stage appearances of Aunt Chloe, yet these particular performances helped further refine and stylize the Mammy stereotype, even as they helped confirm mainstream beliefs about black female difference.[21] At times these blackface drag performances were punctuated by revealing some aspect of male embodiment—a large pair of feet peeking out from under a skirt or a slip into a deeper voice by the actor—that was played for laughs. The juxtaposition of male and female imagery underscored the "joke" of these characters. I will return to this aspect of drag performance in a later section of this chapter that centers on the function of gender slippages in drag performance. For now, however, there is enough to make the point that a legacy of drag performance shapes the meaning of this particular representation of black womanhood; Mammy's qualities as they appear in the popular imagination emerge from these moments of cross-dressed spectacle. Both the physical and expressive traits of Mammy are consolidated through these nineteenth-century performances.

Therefore, by the time black actresses such as Louise Beavers and Hattie McDaniel portrayed Mammy figures in the films *Imitation of Life* (1934) and *Gone With the Wind* (1939), respectively, the white male performance of Mammy had become so recognizable and assimilated by black women performers that they could "act" like Mammy too by "playing a truly fictional character [from] a past that never was."[22] Wallace-Sanders writes that "the success of their [Beavers and McDaniel] portrayals was predicated on [the stereotype] being deeply embedded within the popular imagination."[23] Throughout the early twentieth century, these popular portrayals maintained mainstream cultural capital as "authentic" depictions of "real" black maternal figures. These portrayals have been so compelling that black women who did not make a living as actors but rather worked as real domestics may, in some

cases, have adopted the "authentic" performative traits of Mammy into their daily lives, a phenomenon described by E. Patrick Johnson as he researched the life of his grandmother. Johnson, who traces a number of performances of black motherhood in *Appropriating Blackness,* describes the attributes of Mammy as "language" that was learned by black women domestics, who could then use that language to manage and sometimes subvert their situations working for white families in their homes:[24]

> As with any racist stereotype image, the mammy trope came to be taken as exemplary of "authentic" black womanhood. In other words, the attributes of the mythic figure became ontologically fastened to the black female bodies onto which they were projected . . . Although the "mammy" prototype and the accompanying acquiescing behaviors attributed to her may be viewed as representative of authentic black womanhood in the white racist imaginary, my grandmother's narrative constructs a counterimage.[25]

Myth becomes yoked to embodied reality, yet Johnson notes how this problematic conflation has provided black women uneasy and unstable access to resistance within the domestic space of white homes. After completing an ethnographic study of his grandmother, who worked in white homes from 1955 to 1973, he concludes that "my grandmother appears to have variously adhered to the 'mammy' contract . . . She played the role in goodwill and/or out of pride . . . other times . . . she appropriated the 'white' construction of the mammy and used it to her own 'black' advantage."[26]

The adherence to "authentic" performances of Mammy's traits becomes both a tool of subversion and a pleasurable component of black women's lived reality and subjective experience, as exemplified by Johnson's emphasis on the potential for this performance to produce sensations of "goodwill" and "pride." Moreover, when the stereotypical physical traits of Mammy are also present, the mark of "authenticity" is intensified. The recent Oscar-winning performance of Octavia Spencer as a domestic in 1960s Mississippi in the film *The Help* (2011) reinforces these insights.[27] Therefore, the complexity of this figure and her continued role in the figuration of black motherhood is undeniable.

If Mammy is primarily white-identified—that is, if her mothering labor is primarily focused upon white children—then her counterpart, the Matriarch, occupies the other end of the caregiving spectrum. The Matriarch's mothering is fully directed toward the raising of black children and, on occasion, childish and childlike black men. Strong, aggressive, loud, asexual, and domineering, the Matriarch figure offers an image that explains and justifies black male

social disenfranchisement to whites as well as provides proof of the inherent dysfunction of black families to the dominant culture. The Matriarch's qualities were primarily established in the national imagination through sociological studies, in particular the study *The Negro Family: A Case for National Action* (1965), also known as the Moynihan Report. However, other works contributed to the establishment of this controlling image, including works by W. E. B. DuBois and E. Franklin Frazier.

Ignoring the social, political, and economic inequalities that dictated black life, black matriarchy theories offered social scientists and subsequently the American public ways to justify their perceptions of black inferiority. Racism was not the cause of poverty, crime, low education, and other social problems faced by the urban underclass; bad black mothers were. Within the logic of white patriarchy, so-called black matriarchy usurped the traditional Western family structure that placed men at the head of families, and instead placed excessively strong black women at the heads of families, with or without male support. Matriarchy theories, which were advanced by both black and white sociologists alike, exerted power through the reinforcement of gender hierarchies and by depoliticizing concerns such as poverty or crime. As a result, all women were kept in check through the negative imagery of the Matriarch. Since she did not conform to Western patriarchal expectations, the Matriarch was seen as aberrant. She was dispossessed of femininity. The perceived failures of her family were blamed on her pathological gender identification or, in other words, her excessive masculinity. Therefore, white women and other nonblack women could mark their femininity against this black female Other.

While the Matriarch was primarily constructed through a sociological lens, she has also been imagined through the tropes and figurations of literature and performance, much like the image of Mammy. She has been portrayed as the quintessential Strong Black Woman. The prominent characteristics of the black Matriarch are that she

> regards the black male as undependable and is frequently responsible for his emasculation, she is often very religious, she regards mothering as one of the most important things in this life, and she attempts to shield her children from and prepare them to accept the prejudices of the white world.[28]

Trudier Harris traces the appearance of these kinds of characters in *Saints, Sinners and Saviors: Strong Black Women in African American Literature.* Throughout the mid-twentieth century, Black women frequently portrayed

the Matriarch in performances, yet the character possessed the composite physical characteristics of the Mammy. Claudia McNeil's and Esther Rolle's performance of Mama Lena in Lorraine Hansberry's *A Raisin in the Sun* serve as a prototypical examples; both women are gray haired, dark skinned, and full figured. To be sure, McNeil and Rolle were consummate, accomplished actors who gave defining, memorable performances of Mama Lena. What is remarkable, however, is that reviews and biographies of both McNeil and Rolle describe their characterization of Mama Lena with the term "matriarch," despite the fact that the word never appears in the original script written by Lorraine Hansberry in 1959. The idea of the Matriarch—her physical and expressive traits—was so recognizable to audience members and critics that the word *matriarch* became immediately synonymous with these performances.

It is critical to situate how the Big Mama figure and her performative characteristics of strength and power play off of complex race and gender fantasies circulating in the national imagination. There is no coincidence that the most prominent popular portrayals of Big Mama come from men, because of the history and legacy of her foremothers, the Mammy and the Matriarch, and their relationship to images of masculinity. Unlike other drag performances of women characters by men, which trade on male transgression of femininity as well as the glamour and the spectacle of the archetypical female form, portrayals of Big Mama by black men do not work in quite the same way, because Big Mama is always already outside of that symbolic economy of femininity. Tyler Perry's Big Mama drag navigates this difficult history and contemporary moment simultaneously because of the nostalgic resonance of the Big Mama figure in post–Civil Rights black culture.

Tyler Perry laments in *Don't Make a Black Woman Take Off Her Earrings* that "Back around the 1970s, the Madeas in our neighborhoods began to disappear and they have left an unmistakable void."[29] These losses are typically attributed to the failures of black women for a number of reasons and are usually characterized in identifiable ways. There are those black mothers who have abandoned traditional "tough love" disciplinary methods because of their immaturity or their own lack of personal discipline. There are those black mothers who have refused the role of "othermother" for extended families and children of the community in order to care for their biological children. They are sometimes women who forego motherhood completely, instead pursuing relationships and a career. However, regardless of why Big Mamas have disappeared, they are remembered for their tough but nurturing qualities.

LONGING FOR BIG MAMA: NOSTALGIA AND AUTHENTICITY IN *MADEA'S BIG HAPPY FAMILY*

In a 2004 essay entitled "Bring Back Big Mama," columnist and former senior editor for *Ebony Magazine* Joy Bennett Kinnon exemplifies the longing for the return of Big Mamas who have the power to resolve familial dysfunction. In fact, Kinnon attributes the disappointments of black communities in the post–Civil Rights era to the disappearance of these maternal figures or the lack of respect offered to them. Kinnon suggests that issues such as jobs, education, housing, or voting, which have been the typical concerns of black civil rights discourse and the primary political issues of contemporary black communities, can be best solved when we honor and give thanks for Big Mamas, whose wisdom transcends political concerns:

> The old-school savvy of our mothers and grandmothers was like living water to black people. It was a weapon, a warning, a balm, and a map. It was a way out of no way. And "the hardheaded" (Big Mama's words) ignored such advice at their peril, because as grandmother predicted, you would return, beaten by the world, to be soothed by her gnarled hands. Where are Big Mama, Muh Dear, Grandma, and her peers?[30]

Both a weapon and a balm, Big Mama's words and affection act as mama's gun keeping black folks afloat through hard times. Kinnon's description underscores a common perception of these mothers, and she shares her thoughts within the pages of a major national black publication, appealing to a kind of racial common sense that is reinforced through speaking to an audience that would share in her memories.[31] Her nostalgia is not unlike the sentimental invocation of idealized motherhood through the figure of the race mother at any other time of social and political crisis. Kinnon asks reverently where these important women have gone, because it seems to her that the contemporary generation lacks Big Mama's influence. Structural and institutional inequalities faced by black people are attributed to a degradation of the family structure that placed strong mothers and grandmothers at the head. Therefore, Big Mama emerges in recent black cultural production as a figure that possesses a vocal power that allows her to speak her mind in ways that younger mothers cannot.

Sharifa Rhodes-Pitts, author of *Harlem Is Nowhere: A Journey to the Mecca of Black America,* takes a different approach when writing about her Big Mama in an article in *Essence* magazine in 2011, even as she draws on nostalgic themes similar to Kinnon. Although Rhodes-Pitts says she was just six

years old when her Big Mama died, she still asks herself, "How would my Big Mama . . . see me? What would she make of the life I led?" Wondering what her Big Mama would say about her modern life—"different cities and lovers and an unconventional career had delayed the external markers of adult life, like partnership and motherhood"—leads her to consider what price she has paid for her freedom. She believes that the life she lives might be considered "disjointed" and "rootless" to her Big Mama, whose life was "contained and predictable."[32] Rhodes-Pitts writes:

> Lately I think more and more about everyday women, ordinary and present, who held things together and kept things moving along so that the moment we now occupy is even possible. We must answer to them. We must keep their counsel. This is the hold history has on us, not so much that we should measure our lives and expectations by the standards of years past, but because it offers us integrity out of which to create the future.[33]

Rhodes-Pitts is not specific in terms of *how* we must answer to our Big Mamas, but it is clear from the tone of the essay that young, professional women, particularly those without spouses or children, should feel incomplete. What seems to be just under the surface of this story is a sense that black women who do not fulfill their expected roles as wives and mothers experience "rootlessness." Rhodes-Pitts insinuates this idea at the end of her essay when she says that Big Mama would wish her to live her life "whole." The notion of incompletion and failure permeates this essay.

Tyler Perry's Madea draws on a post-Civil-Rights-era nostalgia for Big Mama as expressed by Kinnon and Rhodes-Pitts, yet her character masks a fundamentally neoliberal rhetorical position. While Perry's films and plays seem to celebrate the network of community mothering that exemplifies black working- and middle-class traditions, Perry uses these sites of female conversation to promote the same ideological positions that have been used to chastise and blame black mothers in the public political sphere. Emphasizing personal responsibility, respectability, and nuclear family values as solutions to black family failure, Madea transforms these communal locations into places where her voice dominates over all others. In addition, by focusing primarily on personal responsibility, Madea depoliticizes systemic issues such as crime, incarceration, violence, unemployment, and poverty. Depoliticizing these structural issues mystifies how members of a community understand their collective situations by focusing on individual reasons for problems rather than on how ideology, politics, and economic motives shape everyday experience. Therefore, I contend that Madea's popularity in contemporary

black popular culture of the post–Civil Rights era is not just a coincidence or a matter of shifting cultural tastes. Rather, Madea's popularity and the market for her media presence are *produced* by the technologies and sociocultural anxieties of racial neoliberalism.

In the movie *Madea's Big Happy Family*, these key moments of depoliticization appear in scenes that depict the private spaces of female bonding that have been vital to black women's healthy relationships and mutual caregiving. Domestic spaces such as the kitchen or front porch have been understood as gendered locations of the household in which women are often sequestered, but those same spaces of gender segregation also can be productive because they allow women to speak freely among each other without men imposing themselves in conversation. Interestingly, Tyler Perry infiltrates those spaces in Big Mama drag and then transforms opportunities for conversation and dialogue into one-sided sermons and lectures.

In a critical scene in *Madea's Big Happy Family*, Madea uses her vocal power to counsel Shirley, who has just found out her son Byron has been arrested again. Madea joins Aunt Bam and Shirley in the kitchen to discuss what to do about Byron's arrest. The night before, Byron was jailed by the police for failure to pay child support, and Shirley is struggling to collect enough money to bail him out. The three women come together to brainstorm how to raise bail money and support each other. None of these women have very much money themselves, but among them, they might be able to come up with enough. In this scene, Shirley is distressed and overwhelmed that her daughter Kimberly, who has the most economic privilege of her children, refuses to contribute any money toward Byron's bail. As Shirley begins to cry, Madea interrupts her and chastises her for feeling bad. Madea reminds Shirley that she has done all she can to make sure her children turned out well: "Let me tell you something, parents shouldn't be putting theyself on no guilt trip after you done raised the child. Hell, that's what you were supposed to do. Raise them . . . That was your responsibility." On one level, this exchange seems supportive of Shirley, exemplifying the Big Mama qualities described by Kinnon. Madea validates Shirley's mothering by saying that she did all that she could and that she should not feel guilt because of the difficulties that her children face. Madea seems to be saying that the outcome of the children's lives should not distress Shirley as long as she feels she did her best.

Yet, Madea's language and demeanor in the scene exceed the impression of supportiveness and emphasize judgment rather than caregiving. First, Madea cuts Shirley off in the middle of expressing herself and denies her room to grieve and worry among supportive relatives. Madea's interruption denies Shirley the opportunity to be self-reflexive about her mothering and to reflect

on what she feels her shortcomings are and perhaps come up with new solutions. Madea alone determines how and when it is appropriate for someone to evaluate her own parenting and judges Shirley's mothering competency. Second, Madea extrapolates Shirley's concerns into a larger assessment of all parents. She begins this diversion with the introductory phase: "Let me tell you something," which asserts the authority of her voice over all others. She then addresses the more general "parents" who are remiss for evaluating or mourning their mistakes. Finally, she emphasizes the "responsibility" of parents. As a mother, Shirley should only care about fulfilling her *responsibility* rather than worrying about the quality of her care or her own feelings about her experience, which are ultimately not for her to determine, according to Madea. In some ways, this act of authoritative speech is not out of character for Big Mama figures in the sense that as elders in the family, Big Mamas possess the power to interrupt and scold younger women in order to assert their perspective, which is usually seen as wise and sage advice. However, issues of personal responsibility in this scene are enhanced when read along with other contradictory ways that Madea assesses the responsibility of other maternal figures in later scenes.

After talking to Shirley, Madea offers to help gather her children together for dinner that evening. Madea goes to find Tammy first, who is at her husband Harold's car repair shop with their two sons. As she enters the repair shop, Madea begins by berating a silent Harold for two minutes, referencing how badly he repairs cars and how lazy she thinks he is. Harold is rendered speechless by Madea's insults. When she is finished, she finds Tammy in the office with the boys. The oldest son, H. J., is by far the meaner of the two boys, and he is always seen scowling throughout the film. He calls his mother by her first name and refers to his father as a "punk-ass." He does not do chores around the house, and he spends most of his time playing video games. He rolls his eyes and ignores instructions from any adult. When Madea enters the room with Tammy and the boys, she invites them to Shirley's for "dinter," which is Madea's hyper-pronunciation that is meant to sound "proper" and provide a moment of laughter. Immediately, H. J., who is seated, looks up and says he is not going to go to dinner and calls his mother "Tammy." Madea's face registers shock, her eyes widen, and her lips become tight in response to H. J.'s disobedience. Tammy, who sees Madea's tension, defends H. J. by saying, "He's just a kid." Madea replies, "Just kids end up being just adults who are in just damn jail! Don't let no child talk to you like that!"

Madea's retort identifies one of the concerns about black family failure resonating throughout this chapter. Jail has become increasingly an aspect of life that young black men face in communities all over the nation. Much of

this mass incarceration can be attributed to structural effects of privatization of prisons and the prison industrial complex, mandatory minimum sentencing guidelines, and the racial and gendered injustices of law enforcement and courts.[34] However, Madea's retort distills parental fears of jail into the simple explanation of mothering failures. Tammy's permissive parenting and the lack of home training she offers to her son—such as how to address elders and authority figures—will result in a mother's disappointment: jail for her son. Furthermore, Madea's comment contradicts the perspective she shared when talking to Shirley. In that case, Madea explains that mothers should not be guilt-ridden if their children do not live up to their standards. On one hand, Shirley was told she did the "best" she could; on the other, Tammy's mothering decisions have the potential to send her son to jail.

Madea seeks to solve this scene of mothering failure when Tammy steps out of the office. Without a word, Madea begins to slap both of the boys across the face over and over again. When she finishes, the once mouthy H. J. is now submissive as he looks up into Madea's eyes as she towers over him. Madea chastises him for being disrespectful and laments the entire generation's loss of respect. She finishes by admonishing: "You be disrespectful again, I'm gone beat your ass." In some cases, physical discipline, such as spanking and whoopings, are considered important tools for properly home-training children. Throughout this movie and in most Madea movies, she references beating children, and in some cases she carries it out. What Tammy lacks as a mother is the necessary impulse to hit her children when they misbehave in order to train them properly. Madea, as representative of "old-school" mothering, does not hesitate to threaten or physically punish a child. The impression is made in this scene that nostalgic ways of mothering that included corporal punishment of children have a causal relationship with preventing incarceration. Madea depoliticizes the social problem of mass incarceration by identifying Tammy's mothering failures as pathways to jail for her sons.

Madea's contradictory interactions with Tammy reflect the didacticism in this film; Tammy is less of a character and more of a teaching tool. On one hand, she is too passive in her parenting: she lets her sons disobey and disrespect her. Yet, in scenes with her husband, she is portrayed as domineering, loud, and bossy. In a scene entitled "Put Your Foot Down," Madea chastises Harold for accepting Tammy's controlling behavior. The scene begins when Tammy and Harold are arguing at the family dinner, and Madea interrupts to offer her advice. She explains to Harold as Tammy listens that the problems in their marriage and with their children have to do with the fact that Harold "lets" Tammy talk to him however she choses. When Tammy says that she

"gets so mad" at Harold, Madea dismisses the couple so that they can discuss their issues in another room.

In the adjacent room, Harold snatches Tammy by the arm to bring her closer to hear what he has to say. The scene quickly cuts to Madea whispering, "Be a man! Be a man!" to Harold from the other room. As Harold tells Tammy to "stop being mean to me," he slams the table and looks again at Madea for approval. In this moment, Madea offers no support to Tammy and continues to direct Harold by praising him for his forcefulness, his manliness. Almost instantly, Tammy becomes subdued by Harold's behavior, and she apologizes in response to the way he has "put his foot down." However, Tammy's apology is not enough for Madea, who instructs Harold to tell Tammy to "sit your ass down!" even after she has apologized. Harold yells at Tammy in a demeaning way and continues to tell her to sit by saying, "You heard me. S-I-T!" By spelling the letters of the word "sit," Harold infantilizes Tammy, speaking to her as if she were a child or even a dog. The scene ends with Tammy standing silently as Harold returns to the dinner table. Madea punctuates the moment by saying, "I'm glad I'm here. I got all this straightened out."

In this entire episode, Madea uses Big Mama drag as a disguise. Instead of acting as the wise elder who presides over women-centered and maternal networks of the family in order to offer guidance and occasionally tough love, Madea works on behalf of restoring the power as well as the physical and verbal dominance of the father in the household. This dominance, according to Madea, can be achieved only by the literal silencing of Tammy, who has been stereotypically characterized as a Sapphire. Interestingly, it is Madea who in an earlier scene verbally abuses Harold when she goes to his garage to invite the family to dinner. In that case, her verbal abuse is played for laughs, with Madea reeling off a set of one-liners and snaps on Harold and his inability to repair cars. However, Tammy's loud-talking demeanor and anger are not portrayed as funny or justified. In fact, her behaviors are positioned in the movie as the cause of the failure of her marriage as well as the imminent criminality of her children. Madea's outspokenness and brash behavior trump Tammy's because Perry's Big Mama drag is meant to disguise, rather than transform, male privilege in black families. In fact, the expression of male privilege and physical dominance is scripted in these scenes as black women's desire for black men to exercise control in relationships. This situation explains why Tammy appears to enjoy Harold's forcefulness, suggesting through submissive body language that the more domineering the husband, the more happily passive the wife.

Throughout *Madea's Big Happy Family*, black women characters are silenced. Madea's appearance in the course of the movie forecloses any pos-

sibility of black women using their voices to talk back to controlling images or even to reflect on and change the individual circumstances in which they find themselves. Another example appears through the character of Sabrina, the "baby mama" of Byron's infant son, whose nasal speaking voice is so disturbing that other characters have to tell her to "shut up." The character of Sabrina embodies the controlling image of the Baby Mama. She is rude, self-absorbed, and disrespectful. She is dressed in cheap but flashy clothing and wears long hair and nails, which insinuates that she is more preoccupied with being fashionable and looking sexy than caring for her son. In addition, when she enters any scene she calls out a loud, annoying nasal pronunciation of Byron's name—"By-reeeeeeen!" Because her voice is grating, viewers literally want to silence this character, because the sound produces the worst sensations, like a buzzer going off on an alarm clock. When Sabrina pronounces Byron's name, she shakes her head back and forth, flopping her hair around, and performs as the stereotypical "chickenhead," which is a derogatory term to describe young black women. Through this performance, Sabrina's character is meant to evoke intense feelings of disapproval by the audience as well as provide comic relief.

When the family finally comes together for dinner as Shirley had hoped, Sabrina's shrill, siren voice interrupts the first words of the family prayer. Each person at the table winces at the sound. Aunt Bam calls her the "Baby Mama from Hell." Sabrina is clearly marked as outside of the family because she is not invited to the "private family dinner," even though her son is Shirley's grandchild. Madea makes it clear that Sabrina is not welcome at the dinner table, and in one of the final scenes of the movie Madea finally snaps and tells Sabrina to "shut the hell up!" The Baby Mama character is literally silenced by Madea, and when she speaks she is shown to have a voice that is not valued. Even the *idea* of the chickenhead/baby mama invokes Madea's anger and violent temper. In another brief scene, Madea appears with her brother Joe and together they make jokes about a service called "Smack That Ho," which they want to provide for men who have to deal with baby mamas. The service would allow Uncle Joe to hit the women so that their men do not have to in order to make them submissive. Madea and Uncle Joe sit together on a couch and repeat the phrase "smack that ho" multiple times as they laugh together. Therefore, in *Madea's Big Happy Family,* the voices of Shirley, Tammy, and Sabrina are all silenced through words or threat of violent action by Perry's Madea. Although each woman presents a different controlling image of black motherhood, each type is available for Madea's scorn and admonishment.

Although this section describes selected scenes from *Madea's Big Happy Family,* variations of these representations appear in many other Madea mov-

ies and plays. These moments of silencing and violence are missed opportuni-
ties to challenge the race-gender matrix of contemporary black life through
pop culture via a beloved characterization of Big Mama. The transgressive
act of Perry donning women's clothing and taking on the persona of a black
mother is consistently undermined by the characterizations of other women
in his movies. By relying solely on controlling images to write the lives of
black women characters, Perry reiterates the histories embedded in those
images. In addition, his portrayal of Madea heightens the imagery of the
Mammy and the Matriarch without radically altering them. Even so, there
are subversive possibilities in using drag performance as a means of talking
back to dominant narratives about black motherhood as well as revising ste-
reotypes about black masculinity. The next section explores some of those
potential moments of subversion in Perry's work and explains how Perry's
claims to authenticity actually undermine those possibilities. The final section
considers the work of drag performer and gay icon RuPaul Charles as a radi-
cally alternative expression of Big Mama drag.

BIG MAMA DRAG: "THE POWER OF 'YES' TO THE 'FEMALE' WITHIN"

If mama's gun describes transgressive black maternal figures found in con-
temporary literature and popular culture, then what could be more desta-
bilizing and potentially transformative than men adopting the personas of
a maternal figure? Hortense Spillers suggests that black men's affirmation of
"the female within" has the potential to undercut the dominant American
race and gender system.[35] She writes that

> the black American male embodies the *only* American community of males
> which has had the specific occasion to learn *who* the female is within itself,
> the infant child who bears the life against the could-be fateful gamble,
> against the odds of pulverization and murder, including her own. It is the
> heritage of the mother that the African-American male must regain as an
> aspect of his own personhood—the power of "yes" to the "female" within.[36]

Spillers locates radical potential in the figure of the black mother, who is
deemed a monstrosity by the dominant culture because her experiences
often defy traditional Western gender norms and nuclear family ideals. How-
ever, what has been framed as gender deviance—the "masculinity" of black
women—not only provides an opportunity for female empowerment outside

of traditional gender norms, but also can allow black men to imagine and enact alternative masculinities that reject heteropatriarchy. When and if black men can understand and value the "heritage of the mother," new opportunities to revise gender hierarchies emerge. While Spillers's thoughts here do not explicitly address drag performance, her work does describe a promising elasticity within black gender performance that seems essential to transformation.

E. Patrick Johnson's work in *Appropriating Blackness: Performance and the Politics of Authenticity* addresses drag performance specifically, and he suggests that the gender elasticity of black cultures can be accessed through drag performance, which can destabilize normative expectations of black gender and sexual politics in ways that embrace alternative kinships outside the nuclear family. For example, black men who perform as "mothers" within gay, urban ball houses draw on the performative elements of a variety of black maternal figures.[37] Furthermore, Johnson's work explores the construction of black motherhood through an ethnography of his grandmother, adding to the understanding of the performativity of black motherhood.[38] Taken together, Spillers's and Johnson's work suggest that black men's affirmation of black women's subjectivities can be accomplished, and that performance, specifically drag performance, is an opportunity for this black gender and sexual fluidity to be imagined and enacted.[39] This section considers how certain slippages in Perry's performances have subversive potential; identifies how those performances "gain insurgent ground" for a "female social subject," as Spillers advocates; and explores how claims to racial authenticity and legitimacy complicate those possibilities in Perry's work.[40]

There are two kinds of moments that present slippages in the heteropatriarchal norm of Perry's work: Madea's baritone voice and her diva impersonations. In both cases, the reliance on the aesthetics of camp performance destabilizes the perception of gender as fixed and natural, and instead draws audience attention to the construction of gender as performance. In addition, the playfulness of camp provides audiences a way to experience gender transgression that is both pleasurable and funny.

In the filmed versions of the plays *I Can Do Bad All By Myself* (1999) and *Madea's Class Reunion* (2003), Perry slips out of Madea's voice and into Tyler Perry's own baritone sound. Generally, Perry performs Madea by impersonating a voice of an older black woman that is not exactly high-pitched but is certainly meant to be a caricature of a woman's voice. About this voice, Perry says: "My aunt inspired . . . the voice. She overpronounces her words and puts an 'r' on everything to make it sound proper."[41] However, at abrupt moments in the dialogue, Perry speaks in his natural voice, a smooth baritone, that stands out against Madea's sound. In those moments, Perry slips

out of character and vocally calls attention to the construction of Madea. Her authenticity as a Big Mama recedes behind the already obvious fact that she is portrayed by a man, yet these moments of juxtaposition create surprise and laughter. By eliciting laughter from the audience, these moments work as a kind of "wink" to spectators. The "wink" of camp aesthetics and cross-dressing performance, according to Kate Davy, acts as a sly but knowing acknowledgement between performer and audience that "(re)assures its audiences of the ultimate harmlessness of its play, its palatability for bourgeois sensibilities"[42] Therefore, on one level, Perry's baritone voice acts much in the way it might have in the theatrical spaces of blackface drag of the nineteenth century. In those performances, white actors who were costumed to portray black women occasionally "revealed" an aspect of their body—a hairy leg or a large-size shoe—that "reminded" audiences that the actor was not who he was supposed to be and that their enjoyment of the spectacle was a socially safe space. However, within the context of Perry's stage performances, these moments could also mark the transgressive possibility of acknowledging the construction of gender rather than celebrating the effacement of black identities, as the blackface drag performances certainly did.

Camp also comes into play through Madea's diva impersonations. An example of this appears in the recording of the play *Madea's Class Reunion*. In one scene, Madea sits with a woman at a hotel café as they discuss family and relationships. To make her point in the conversation, Madea abruptly breaks into song and begins performing songs by Patti LaBelle, Diana Ross, and the late Whitney Houston. Acting as Houston, Madea sings the song "I Will Always Love You," taking care to exaggerate the performance as she sings the difficult, sustained high notes that are the signature of the song. After Madea performs the song, she refuses to be addressed as "Madea" and instead answers only to the name "Whitney" because she is so fully overcome with Whitney Houston's persona. During this layered representation of black women vocalists, the audience becomes engrossed in the spectacle of Madea—remember Madea is still dispensing her sassy Big Mama wisdom in this particular scene—and the audience finds humor when Madea then becomes yet another persona. Perry's choice of Whitney Houston as the female identity to assume also harkens to the camp aspects of drag, in which male performers take on the stage personalities of divas. *Diva* by definition refers to the lead female singer in an opera, but the word is also related to the term "prima donna," a temperamental and conceited person, as well as to its Latin root, meaning "goddess." In the vernacular, divas are those women performers known for giving stunning, show-stopping performances. Imper-

sonating divas, such as Houston, Cher, Tina Turner, and Diana Ross, is a staple of male drag performance. In this particular scene, Perry's appropriation of the identities of R&B divas via Madea's characterization signals toward this aesthetic found in drag performance culture. While Perry does not make this connection explicit, it provides another potential moment of subversion within his body of work. His diva impersonations, use of camp aesthetics, and subversive winks may contribute to new ways of reading his work.

Yet, the transformative potential held within the space of Perry's performance of Madea wanes, if not disappears, because of the way his Big Mama theatricality relies on notions of nostalgia and authenticity to function. Perry's reliance on audience perceptions that his performance of Madea is just like a "real" Big Mama leads to an untenable claim to authenticity, which is demonstrated in a passage from *Don't Make a Black Woman Take Off Her Earrings*. In the foreword, Perry recalls a man in the community he grew up in who took on the role of a Madea:

> I remember a guy on the corner of my neighborhood who wanted to be a Madea. He would come out of his house every morning with the curlers in his hair and a bandanna and just look around and see what the kids were doing. He would then run and tell their parents. But he was kind of illegitimate.[43]

When the "guy with curlers in his hair" acts as a Madea, Perry dismisses him as illegitimate, and compares him to the "authentic ones (my mother and aunt included)." The women in his family were not "*trying*" to be a Big Mama figure, he writes, but simply responded to their circumstances. The point of view in this passage about the "guy with curlers in his hair" leaves the neighbor static and voiceless, unable to articulate for himself the reasons for his Big Mama impersonation and what it might have meant to him to act as this complicated but confident maternal figure. The fact that Perry specifically highlights the "illegitimate" nature of this portrayal of a Madea, yet does not see himself as illegitimate or inauthentic seems striking. How do Perry's own performances resist interpellation into the very margins of black masculinity that he has marked as "illegitimate" in the case of his childhood neighbor?

The demarcation between the illegitimacy of the "guy with curlers in his hair" and the authenticity of a "real" Madea lies at the complicated intersection of gender performance, performativity, and sexuality. The "lexicon of legitimation," described by Judith Butler, delineates the contours of one's power over another's "public and recognizable sense of personhood."[44] It is a power that is derived from the perpetuation of normative values of the

bourgeois family, the construct through which desire, sexuality, and sexual practice are scrutinized, disciplined, and legitimated. Despite the multiple references to nontraditional networks of kinship within black communities in Perry's work, his performances as Madea ultimately enforce black middle-class family values, which grant him, via Madea's voice, the power to mark what is legitimate and illegitimate. Therefore, Perry is seen as legitimate by his audiences because his drag performances primarily reinforce traditional family ideals. The campy, subversive winks are few and are not made central in the work, especially in the film versions. Not only that, Madea also possesses the authority and privilege to deem others legible, as she does in her talk with Shirley in *Madea's Big Happy Family*. She can similarly mark their illegibility, as she does in her scenes with Tammy and Sabrina in that same movie. The "guy with the curlers in his hair" is deemed illegitimate, because he lacks the "natural" capacity for maternal behavior possessed by black women and because his performance is tangential to the dominant model of the nuclear family. Whereas Perry creates movies that privilege "family values" through a depiction of deviance in non-normative black families, that depiction of deviance is often played for entertainment and laughs. Perry's performances sidestep marginalization within black popular culture because of his intentional reification of black heteropatriarchy and black family values. As a result, his performances have become central to recent black popular culture and his movies have dominated the box office.

Throughout his years of popularity, Perry's sexual identity has been questioned by interviewers and audiences, and he consistently confirms that he is heterosexual. Although his sexual practices and gender and sexual identity should not matter in interpreting his work, I believe that *questions* about his sexuality exhibit a kind of social disciplining in black cultural spaces that further constructs his legitimating power as a popular cultural figure. When Perry refutes a gay or bisexual sexual identity, he strengthens his heteropatriarchal power to legitimate his Big Mama performance as an authentic use of drag over other kinds of performances, such as the "guy with curlers in his hair." Were Perry to acknowledge a gay or bisexual identity publically, his popular legitimating power might be in jeopardy, and perhaps the sage wisdom of Madea would become suspect among the audiences who enjoy her.

Marlon M. Bailey's discussion of LGBT identities within black families illustrates these tensions when he explains that "black LGBT people face many challenges as a result of their exclusion from black families and other forms of belonging that bring attention to the social, psychological, and spiritual ramifications of dislocation."[45] This sense of dislocation described by black LGBT individuals leads to what Bailey calls a "familial deal," in which queer

black people may have to hide their gender and sexual difference in order to remain connected to their biological families and to retain access to the material benefits of family life, such as food, shelter, and clothing.[46] Thinking from this vantage point, it seems that regardless of Perry's sexual identity, it would be particularly necessary for him to refute an LGBT identity publically as a kind of "familial deal" with his black audiences. Further, the gay rumors that circulate within black popular cultural spaces about Perry could be read as potential move to "dislocate" him from those audiences and undermine his complicated influence.

An episode in the *Don't Make a Black Woman* text signals toward how perceptions about Perry's sexual identity might affect audiences. At one point, Madea "writes" about Perry, whom she met when he "was a little boy":

> I knew his mother and his auntie. They were all worried about him because he talked to himself. He walked around a lot by himself and spent a lot of time alone. We were really worried one day. We saw him with a pink dress on. He said it was because it was Mardi Gras, but I don't know. We were all very concerned.[47]

The full intention of the passage is unclear. Whether it is true or a bit of humor is not revealed; the episode is not mentioned again in the book, and I have not been able to find reference to it in any interviews of Perry.[48] Perhaps it is meant to foreshadow Perry's interest in theatrical performance. Yet, the emphasis on the community's concern about his dress-up play leads to a more ambivalent reading of this passage. Could there have been a sense, even at a young age, that Perry enjoyed cross-dressing? Further, could that enjoyment have been read within his family as a marker of a gay or bisexual identity or a transgender identity that was ultimately rendered illegitimate, unless, perhaps, it was expressed on stage only?

Questions about Perry's sexuality seem to bear some influence on the totality of his Madea performance in the sense that he must confront these questions simply because he performs in drag. Yet, popular rumors about Perry's sexuality are mitigated by the encompassing heteropatriarchal themes of his work, perhaps lending to an exaggeration of these messages in his work. To be clear, I do not find Perry's sexuality relevant from some moralistic, normative point of view. I reject the critiques of his work that simply claim that his drag performance emasculates black manhood or makes black people look bad. However, the interplay between popular discourses about Perry's sexuality and his use of drag performance in Madea plays and movies seems

to suggest a dialectic discursive relationship between performance and performer that can reveal much more about the effects of family values and racial authenticity narratives in contemporary black life.

A BOLD, BLACK BITCH: RUPAUL AS BIG MAMA

Entertainer RuPaul Charles, who goes only by his first name on stage, in film, and on television, emerged in American popular culture during the 1990s with a style of drag performance that became accessible to mainstream audiences. Coming of age in the world of drag queen culture in Atlanta and New York in the 1970s and '80s, RuPaul distinguished himself in the mainstream through a persona that was every bit as fierce and glamorous as major queens at the clubs, but one that emphasized love, rather than the catty, bitchy attitude associated with glamour queens. He developed a persona—RuPaul, Supermodel of the World—who he has said is based on his mother, who was known to call herself a "bold, black bitch."[49] RuPaul continues to portray a version of his Supermodel character in the reality competition television series *RuPaul's Drag Race* (2008–present), in which he serves as a judge and inspiration for aspiring drag queens. His mother was so much of an influence and inspiration that he devotes a chapter to Ernestine Charles in his 1995 memoir, *Lettin It All Hang Out*. He writes,

> [My mother] was my ultimate inspiration because she was the first drag queen I ever saw. She had the strength of a man and the heart of a woman. She could be hard as nails, but also sweet and vulnerable—all the things we love about Bette Davis, Joan Crawford, and Diana Ross. To this day when I pull out my sassy persona, it's Ernestine Charles that I am channeling.[50]

Ernestine Charles had a strong personality that strayed from the idyllic image of traditional mothers of the 1960s. She cursed heavily around her children and was prone to violent outbursts against romantic rivals. Divorced when RuPaul was in elementary school, she raised her son and two daughters on welfare alone in San Diego. Even though his mother was a "bold, black bitch" that her children feared, RuPaul remembers her lovingly; from her, "I learned how to stand up for myself. I learned how to break away from the pack, how to do my own thing."[51] Typically, in male coming-of-age narratives the qualities of independence and individualism that are the hallmark of traditional masculinity derive from the father, or at least some other male role model.

Yet, in RuPaul's story, the combined qualities of glamour and independence, which operate at opposite ends of a heteropatriarchal gendered spectrum, are transmitted from mother to son.

Significantly, RuPaul's drag differs from Perry's cross-dressing performance because RuPaul diverges from the visual signifiers of the Big Mama figure, inspired by the Mammy and the Matriarch. Like Perry, RuPaul claims that his inspiration comes from his mother. However, RuPaul performs his version of his mother through a character called "Supermodel," an homage to "Mean Miss Charles." RuPaul writes: "My mother was a fashion plate . . . she was the best dressed woman in the United States. Simple but elegant."[52] In black vernacular, "mean" possesses two connotations: one describes a person who is not nice, and the other describes a person or thing that is stylish and well put together, akin to the vernacular term "bad." So, RuPaul's invocation of "Mean Miss Charles" works on at least two levels, describing his mother's disposition—she was known to curse at his friends when they visited—but also her sense of style and sense of self. Therefore, RuPaul's performance of a black maternal figure is adorned in tight-fitting dresses, sexy high heels, and blond wigs, which defy the normative performative image of a Big Mama, who is not imagined as sexually attractive.

RuPaul's sexuality also stands out in his performances. While Madea does talk about sexuality in her movies and plays—she makes a quip about how a Lenny Williams song led to one of her pregnancies and references work as a stripper—this kind of expression is always mediated by her visual symbolism, which is played for laughs. The audience is meant to get a kick out of the juxtaposition of Madea's asexual body and her frank sexual talk. The Mammy and the Matriarch were both conceived of as asexual or undesirable, and that symbolic history is written all over their large bodies. Although Big Mama certainly has much more freedom to talk about her sexuality and desire than her symbolic predecessors, the fact that she is still imagined as asexual and unattractive makes Madea's sex talk work for laughs rather than as a subversive statement. More than that, RuPaul is an openly gay man, and this aspect of his sexuality acts within his performances in ways that Perry's straightness forecloses.

Even so, both performers play with visual signifiers of femininity, specifically U.S. black femininities that convey dominance. Perry depicts the prototypical Big Mama—a postmenopausal grandmother whose large body is accentuated by large breasts; outlandish clothes, often with loud, large prints and patterns; big glasses; and a gray wig. On the other hand, RuPaul's Supermodel riffs off of models and divas, who can also be physically and figuratively large. RuPaul portrays "fierceness" as Supermodel in

high heels, body-contouring clothing, makeup, and a large, cascading blonde wig. Fierceness could be thought of a masculine trait, but its valence lies somewhere in the ambiguous spaces between femininity and masculinity. Therefore, RuPaul's fierceness is comparable to the gender ambiguity found in the toughness typically associated with Big Mama. RuPaul describes how successful diva performances rely on the choice of the right song and the right personality: "You have to live the song, every breath, and every beat. Beyond that it doesn't really matter if you know the words or not . . . If the attitude is right, the words are the last thing you need."[53] Less about content than gesture and spectacle, the diva performance is critical to drag. Seeing Tyler Perry-as-Madea-as-Whitney Houston harkens to these aesthetics, yet Perry does not develop them to the extent that RuPaul does, nor are Perry's performances meant for audiences that are versed in drag aesthetics.

Both Perry and RuPaul have developed in their work an alter ego that manifests aspects of the Big Mama. They each call their personas by different names—Madea and Supermodel—but these figures share similar symbolic resources for their work, and both are transgressive performances of black maternal figures. However, the stark difference in their performance styles can conceal important similarities. First, both characters share inspiration from actual mothers; both Perry and Charles have acknowledged explicitly in their writings that their respective performances come from a conscious desire to embody the ways of their own mothers as well as the ways of the "othermothers" in their communities. Examining men's performances of their maternal role models could be indicative of a tacit or explicit acknowledgement of the power of embracing the subjectivity of the "female within," which is a critically necessary step for disempowering modes of dominance.[54]

Overall, Tyler Perry's performance eschews the kind of elements found in RuPaul's drag. The subversive winks are there, but without the signifyin(g) and without a transformation of visual imagery, Perry's performance stops short of its full transgressive potential. The popularity of Tyler Perry as Madea seems, in large part, to reflect the "replication of ideology" that is encased via the visual representation of black women, which is "never simple in the case of female subject-positions, and it appears to acquire a thickened layer of motives in the case of African-American females."[55] Certainly Perry has made it clear he wishes to exercise the "power of 'yes' to the female within," but he does not "gain insurgent ground" for a new female social subject. What is at stake are not only questions of authenticity and essentialism in contemporary U.S. culture, but also the advancement of new imaginative resources for the representation of black maternal figures in the future, particularly by black men.

Tyler Perry and RuPaul incorporate and resist the performative nature of the Big Mama figure, leading to an uneven use of mama's gun. Whereas drag performer RuPaul's invocation of his "Supermodel" persona enacts what Seth Clark Silberman calls "the archetypal black mother," Tyler Perry's broad comedic performance of Madea eschews much of the radical possibility available in not only the depiction of transgressive maternal figures outlined in previous chapters, but also in drag and the cultural practice of signifyin(g).[56] Instead, Madea appeals to senses of nostalgia and authenticity, which resonates strongly in the post–Civil Rights moment for a wide spectrum of black audiences. While a number of black artists and writers have struggled to break from ossified notions of blackness to create their own new black aesthetic(s), there remains a vigorous consumption of popular works, Madea plays and films included, that appeal to the notion of an essential black experience and an authentic black maternal subject.[57] Racial essentialism can be used as a socio-political strategy, yet within the context of Perry's work, Johnson's observation rings true: "When black Americans have employed the rhetoric of black authenticity, the outcome . . . excluded more voices than it included."[58] Perry's Madea character enacts this exclusivity, appealing to audiences who report that they enjoy Madea plays and movies for their sense of authenticity because "it's not only humorous, but it's real."[59]

CONCLUSION

TRANSGRESSIVE BLACK MATERNAL FIGURES AND THE FUTURE OF BLACK FEMINIST CULTURAL STUDIES

> The lack of engaged and critical discussion in the cultural studies area about the effect of late twentieth century public policies on the lives of young black women has left these women open to be the scapegoat for national anxieties at the hands of both black men and conservative politicians.
> —Brittney Cooper, "Excavating the Love Below"[1]

> What story/construction of black womanhood is employed in the coded language of policy discourse?
> —Julia Jordan-Zachery, *Black Women, Cultural Images, and Social Policy*[2]

THE TRANSGRESSIVE black maternal figures defined in *Mama's Gun*— the Young Mother, the Surrogate, the Blues Mama, Big Mama, and the Mothership—draw on black vernacular concepts in order to demonstrate transgressive and subversive ways of interpreting the presence of negative stereotypes of black motherhood in contemporary black literature and culture. In each chapter, I have outlined the specific historic and cultural origins for my development of these new figurations, and I have identified specific political and social anxieties of black motherhood that each figuration addresses. Yet, the boundaries that mark these definitions and identifications are fluid. For example, Billy Beede, who is transformed into a Blues Mama through the ancestral instruction of her mother Willa Mae, is also a Young Mother figure like Precious. As Young Mother figures, the textual presences of Precious and Billy challenge readers to reconsider the controlling images of black

169

teen motherhood and centralize these characters as knowing, speaking, and agential subject-citizens. Consider also Erykah Badu's invocation of "vivid thereness" as the sexually autonomous presence invented by black women vocalists that can be traced back to the blues women of the 1920s. Therefore, Badu can be imagined as a Blues Mama like Willa Mae, just as much as she enacts the Mothership figuration in her music and performance art. Yet, Lilith shares some of Badu's Mothership qualities, especially because both examples emphasize the hybridity of black womanhood that can be defined as "cyborg" representation. Badu and Lilith exemplify the centrality of Afrofuturistic imaginings to the transformational ethics of black motherhood. While I have been the most critical of the limitations of Tyler Perry's Madea, I offer a reading of RuPaul's version of the Big Mama as a way of acknowledging the power of gender transgression as an important subversion of hegemonic black maternal representation. From this vantage point, how might we read the transgender parent Dill in *Getting Mother's Body* as yet another example of mama's gun? It is my hope that the new figures I have described in this book raise as many questions as they answer. This book strives to provide an alternative typology for black feminist cultural critics to produce other inventive readings of fiction and performance that grapple with the contemporary politics of black motherhood.

Engaging in this kind of critical analysis of black maternal figures presents a vital challenge for black feminist cultural critics at this time. On the one hand, I understand the long-standing appeal of "positive" images and narratives of black mothers as a corrective to the misreadings and coded language that saturate our society. The need for empowered, articulate, beautiful, and strong imagery of "good" black motherhood—the image of Michelle Obama, for example—has intensified during the post–Civil Rights era, especially as traditional maternal ideologies have found a new visibility and value within a number of neoliberal ideological projects. On the other hand, I have observed ways that recent black culture has responded to and resisted black maternal controlling images through enhanced moments of transgression and a rejection of respectability. *Mama's Gun* identifies and analyzes these instances of dissent in order to privilege the images, narratives, voices, and other cultural productions that depict black mothers who are ignored, dismissed, misunderstood, or forgotten in our fields of study. I see these transgressive maternal figures acting as powerful cultural responses to the regressive social policies and political backlash that have become a hallmark of our times. My "politics of transgression" centralizes the black maternal characters and individuals who have been placed on the periphery of our social and political imagination.

Taking up Brittney Cooper's call for an "engaged and critical discussion" of the dialogic and dialectic relationships between culture and politics, my work in this book moves back and forth between these modes.[3] It is messy work; the analyses I have presented here are interdisciplinary, transhistorical, and at times ambivalent. In fact, I refuse to claim any singular black feminist critical perspective on motherhood here or to offer an "answer" to the empowerment of black mothers specifically and black women generally. Instead, I have opted for a multivoiced approach that sketches possibilities for new reading practices that I hope will continue to transform black feminist cultural studies, even as they contribute to the broader fields of African American studies, American studies, and women's, gender, and sexuality studies. My work here builds on the radical, transformative, and progressive contributions of countless other voices in these fields, and especially owes a debt to the consistent and powerful claims made by black women writers, activists, artists, and intellectuals who have struggled for freedom and equality with or without the moniker "black feminist" attached to their names.

The "politics" I am most concerned with in this book is the advent and development of racial neoliberalism. As the system of racial neoliberalism has deepened its hold, we have seen dramatic shifts in the ways that individuals and groups are imagined as included or excluded from the American democratic project. These are the stories and constructions that are "employed in the coded language of policy discourse" identified in Julia Jordan-Zachary's work on black women and social policy.[4] Words such as *entitlement* become associated with policies such as food stamps, Social Security, unemployment benefits, and Medicaid rather than capital gains revenue, corporate tax shelters, or legacy admissions to Ivy League schools. Imagery of bloated government and irresponsible spending relies on the scapegoating of social programs and the people who are presumed to be their major beneficiaries—black people, the poor, immigrants, and women—who are imagined to be "milking" the system. Finding themselves at the intersection of these categories, black women, especially poor, black single mothers, have become a national signifier of the "undeserving." However, even as the race, class, gender, and sexual scapegoating of the "other" has become more entrenched, we see frequent examples of cultural resistance to these structures of power through the use of mama's gun.

I will end the book with a description of a recent personal experience that I believe illustrates the relevance of the topics discussed in this book to social justice projects that rely on progressive cultural activism.

One night at a bar on a casino cruise, my husband and I struck up a conversation with an older white man sitting next to us. He was wearing an

orange and blue hat with the logo of my graduate institution, so I made a quick reference that I was an alum, and he bought us some drinks. The conversation started off pleasantly. I asked him if he was also an alumnus, and he said "no," but one of his sons was and that is why he wears the team's logo. He quickly added that he was a hardworking man and a Vietnam veteran who had made some good money as a contractor installing audio equipment in various kinds of buildings. The son who went to my college works for the family business, while the other son "mostly surfs and smokes weed." We laughed and continued to chat with each other, establishing our common backgrounds in a number of ways. He had two sons, and so did I although they were quite a bit younger than his adult children. He went to Vietnam, and so did my husband's dad. He was born and raised in North Florida, and so was I, and so on. As the conversation grew friendlier, he finally said: "Let me ask you this: Why do you think certain people just want to live off the system?" Suddenly, it was as if all the air had been sucked out of the room. My fiancé and I looked at him with puzzled expressions and then at each other. Was all of this jovial bar conversation just a ploy to ambush us with a loaded question? Not one to back away from a good debate, I followed up with: "Well, what do you mean by that?" hoping he'd clarify his position so I could explain my point of view.

He squinted at me as if I'd asked the dumbest possible question. He elaborated: "You know what I'm talking about. Those gals who get pregnant to get a welfare check." Really?! His statement confirmed my assumptions about his intent. Alarmed, I asked him if he knew how much money a person gets on welfare and how long a person can collect benefits. He did not. I explained that it would be highly unlikely that a woman would choose to take on a lifetime of child-rearing, not to mention go through the trials of pregnancy and childbirth, just to get a couple hundred dollars a month for a few years. I asked him if he had an example of someone who had done that, and he replied, "You know what I mean."

Then I told him about myself, having provided for my two sons through food stamps and Medicaid benefits off and on over the course of several years. I explained that I am now a college professor and that my children are stellar students, in part due to the state support I received when I was the poorest I had ever been in my life. I shared that I knew other women who needed public assistance at critical times in their lives, and that the benefits they received helped them raise some wonderful children. I told him that the kind of women he was talking about do not exist; they are just made up to get men like him to vote a certain way. Besides, choosing to have a child is a complex decision that cannot be reduced to a simplistic kid = welfare check equation.

I explained that I am a scholar who researches this topic and cited many of the examples of coded language and racial neoliberalism that appear in this book. He looked at me as if I were from Mars. He did not acknowledge my personal experience. He did not acknowledge my academic expertise. Instead, in a matter of the next ten minutes, he kept on his tirade, taking up every conservative talking point he could as quickly as he could, as if he were in a speed-dating round with Rush Limbaugh. Obamacare. Check. Reverse racism. Check. Lazy poor people. Check. He spent several minutes valorizing his own hard work while criticizing those who just "sit around waiting for a check." My husband remembered his description of his own son, the one who surfs and smokes weed all day, and asked rhetorically: "What about your son? Is he a freeloader too?" The older man squinted his eyes again to indicate his disapproval. He never answered the question.

The last straw for me was when he brought up the murder of Trayvon Martin just two years earlier. He explained that George Zimmerman was a hero for killing that "thug" who had no business walking through that nice neighborhood at night. My husband started to explain the finer points of the investigation and trial in order to refute the man's claims. I was furious. I explained to him that his words were not only ignorant but also hurtful and offensive because I have two teenage sons, young black men, who on any given night could be profiled just as Trayvon had been. My eyes welled up with tears as I said these words. My voice cracked. He just squinted his eyes. He could not see my maternal love for my sons spilling over into emotion. The old man had asked earlier why race relations in America were so bad, and so I explained to him that it is because people like him refuse to see how his perspectives were hurtful. He could not understand for even an instant that we were not really talking about abstractions. We were talking about my life and the lives of so many people I love. His refusal to see my motherhood, my humanity, or our shared identity as citizens left us in a stalemate that has become the stagnant condition of our supposedly postracial times.

For me, this conversation illustrates the insidious ways that ideologies of racial neoliberalism and hegemonic representations of black motherhood foster the most hateful and inhumane responses and actions of dominant men and women. The fact that the older man squinted at me every time he was confronted with a fact that disturbed his preconceived notions seemed symbolic of a general refusal to "see" me. Much of the work in *Mama's Gun* is about visibility and our collective ability to "see" black mothers who don't conform to "good" motherhood. Toggling between invisibility and hypervisibility, black mothers struggle for a location through which to participate in the social world, and all black people—women and men, mothers or not—

experience the multiple effects of this struggle for recognition. Through an emphasis on vernacular revision as black feminist praxis, I privilege the theorizing of everyday black women who confront these social and political realities. I hope that the perspectives presented in this book engage readers' emotional reactions of discomfort, anger, and sadness, as well as activate sensations of joy, humor, and pleasure to help strategize effective public and personal responses to the fact of black women's social and political marginalization. It is my hope that identifying transgressive black maternal figures as subject-citizens allows readers to explore radical alternatives to normativity as potential ways to transform our imaginative worlds and ultimately our political perspectives and social policies.

NOTES

NOTES TO PREFACE

1. Cohen, "Deviance as Resistance."
2. Juffer, *Single Mother*.
3. Though the particulars of these scrutinizing effects vary for different groups of mothers, the origins of this disciplinary gaze emerges from similar hetero-patriarchal foundations. For more on the contemporary scrutiny of motherhood, see Ladd-Taylor and Umansky, *"Bad" Mothers*.
4. Shear, "New Romney Ad."
5. Timothy Williams, "Jailed for Switching Her Daughters' School District," 1.
6. http://www.jimiizrael.com/?p=131.

NOTES TO INTRODUCTION

1. Cohen, "Deviance as Resistance," 29.
2. Griffin, "At Last . . . ?," 135.
3. Harris-Perry, *Sister Citizen*, 45.
4. Van Meter, "Leading By Example," front cover. Photographs by Annie Leibovitz.
5. Van Meter, "Leading By Example," 254.
6. "Remarks by the First Lady at Tuskegee University Commencement Address," *Whitehouse.gov*, accessed July 2, 2015, https://www.whitehouse.gov/the-press-office/2015/05/09/remarks-first-lady-tuskegee-university-commencement-address.
7. The July 21, 2008, cover of *The New Yorker* magazine depicts Michelle Obama as an Afro-wearing militant. The image reimagines the congratulatory fist bump the Obamas shared at the Democratic National Convention as a "terrorist fist jab," as some conservative pundits had labeled it. The image, entitled "The Politics of Fear" by cartoonist Barry Blitt, was meant to satirize the way the Obamas have been portrayed by their opponents, but the cartoon was seen by many as reinforcing the problematic imagery. In a November 21, 2013, article in the online magazine *Politico*, journalist Michelle Cottle refers to Michelle Obama as a "feminist nightmare." Cottle's article criticized Obama because she had not been feminist enough in

transforming the role of First Lady. Cottle's idea of feminism was limited to a liberal white feminist framework, which is an inadequate frame for understanding black womanhood. On December 10, 2013, at the memorial for Nelson Mandela, Michelle Obama was caught by a photographer looking "serious" as her husband, British Prime Minister David Cameron, and Danish Prime Minister Helle Thorning-Schmidt took a "selfie" self-portrait on a cell phone. For two days following the publication of this image, the First Lady was described in the media as "icy," "not impressed," and "grim" for the apparently disapproving look she had toward the president. However, AFP photographer Roberto Schmidt, who snapped the photo, explained that Michelle Obama's appearance had not been disapproving at all, and she had been participating in the celebration just moments before the picture had been taken. The photographer's perspective revealed some of the assumptions about the First Lady that circulate in the public sphere. For more on media coverage of Michelle Obama, see Lugo-Lugo and Bloodsworth-Lugo, "Bare Biceps and American (In)Security"; Lauret, "How to Read Michelle Obama"; Ulysse, "She Ain't Oprah, Angela, or Your Baby Mama."

8. Barbara Christian in *Black Feminist Criticism: Perspectives on Black Women Writers* explains three "angles of seeing" when interpreting black motherhood: white America's view of mothering, white America's view of black mothering, and black America's view of black mothering. *Mama's Gun* reads the second and third positions outlined by Christian in both dialectic and dialogic ways. However, in all cases, the latter perspective—black America's view of black mothering—is privileged.

9. I am using the phrase *maternal figure* throughout this book as a distinct term from the word *mother* to distinguish between symbolic and actual mothers. I refer to black maternal figures, which are representations of black mothers. I make claims throughout this book that the everyday lives of actual mothers exist in relationship to the numerous maternal figures that circulate culturally. In addition, maternal figures include numerous possibilities not limited to biological relationships, such as adoptive mothers, grandmothers, aunts, and so on. Related concepts such as pregnancy and childbirth will also be related broadly to the adjective *maternal*.

10. Gates, *The Signifying Monkey*; Baker, *Blues, Ideology, and Afro-American Literature*; hooks, *Talking Back*.

11. Numerous other racialized maternal figures abound in contemporary American culture. The suburban Soccer Mom and her conservative counterpart, the Mama Grizzly, are both figures of white motherhood that have resonated powerfully in popular culture in recent decades. Asian and Asian-American Tiger Mothers and the nagging, overbearing Jewish Mother are other examples of common racialized maternal figures. Therefore, I am not implying that black mothers are the only mothers who are stereotyped. Rather, I wish to mark the distinct ways that blackness affects the processes of maternal signification in the contemporary United States.

12. More than simply stereotypes, controlling images are an exercise of power used by dominant groups to manipulate attitudes about those who are not thought to be suitable for inclusion into mainstream structures of power and privilege. Controlling images are, as Patricia Hill Collins describes, "designed to make racism, sexism, poverty, and other forms of social injustice appear to be natural, normal, and inevitable parts of everyday life" (60). Controlling images act as a "regulatory ideal," in a Foucaultian sense, in that they have the power to produce or enact what they seem only to name. This productive power functions through a number of cultural institutions such as the university, the media, and the family. For more on controlling images, see Collins, *Black Feminist Thought*, which identifies and describes the four major historical images: Mammy, Matriarch, Jezebel, and Sapphire. Newer versions of these controlling images have emerged in the late twentieth century, including Baby Mama, Gold Digger, Freak, and Earth Mother. For more on contemporary controlling images, see Stephens and Few, "Effects of Images of African American Women in Hip Hop

on Early Adolescents' Attitudes Toward Physical Attractiveness and Interpersonal Relationships."

13. Benedict Anderson uses the phrase "imagined community" in his book *Imagined Communities: Reflections on the Origin and Spread of Nationalism* to describe how modern national identities form out of a sense of collective or community kinship. The American Dream is but one example of an imagined unity that reflects national identity. However, I agree with Felipe Smith's assertion that Anderson "dodges the critical issue of subjectivity—the fact that those legally entitled to call themselves members of the nation, the 'dreamers,' determine the image of the community 'dreamed'" (Smith, *American Body Politics*, 4). That is, simply "dreaming" these identities is not enough; people have to have access to power to be "dreamers," because national identities are disciplined and legitimated through relations of power and dominance.

14. Grewal, "'Security Moms' in the Early Twentieth-Century United States," 30.

15. The idealized nuclear family is not a static entity; in fact, the gender roles within this family model have been reformed intensely over time. For example, the strict public-private gender ideology that undergirded bourgeois family formation in the early twentieth century has given way to expectations that wives and mothers work outside of the home. The "Father Knows Best" model—male breadwinner, female homemaker—has also lost popular favor, mostly due to economic shifts that have made it nearly impossible for families to survive financially under those conditions. However, those wives and mothers must still maintain hegemonic notions of feminine parenting in order to be understood as "good mothers," which is why Michelle Obama must still be seen as placing "her children first" even as she navigates an intensely public role in her family.

16. Ladd-Taylor and Umansky, *"Bad" Mothers*.

17. The first decade of the millennium saw an intensification of public xenophobia that unfairly pointed toward certain racialized mothers as "threats" to American safety. On the one hand, Americans were instructed to fear "anchor babies," children of undocumented immigrants, mostly Latinas, who were said to be intentionally giving birth to children in the United States to guarantee their children's citizenship as well as their own. On the other hand, pregnant Muslim women were said to be emigrating to the United States to bear American citizens who would be raised to be terrorists and would attack the nation from within in twenty or thirty years. While these so-called terror babies became a limited fixation for only a few of the most extreme right-wing politicians, the perception that these stories created contributes to a problematic mythology. Latina mothers and Muslim mothers are implicated as outlaw women who use their wombs to secure "illegitimate" citizenship for their children.

18. Barbara Christian uses the phrase "contested terrain" to describe black women's perspectives on motherhood to explain the fraught intersection of perceptions that black women must navigate about their motherhood in public discourse. Christian describes three significantly competing points of view on motherhood that influence black women's consciousness on the subject: "the African-American community's view of motherhood; the white American view of motherhood; and the white American view of *Black* motherhood" (98; emphasis added). These perspectives create complex and often conflicting ideologies about motherhood from interracial and intraracial perspectives that direct either reverence or derogation toward mothers, real or imagined. See Christian's "An Angle of Seeing: Motherhood in Buchi Emecheta's *Joys of Motherhood* and Alice Walker's *Meridian*," 98.

19. Hurston, "Characteristics of Negro Expression (1934)," 24.

20. The song "Theme from Shaft" refers to the male character from the 1971 blaxploitation movie as a "baaaad mutha." See also, Sonia Sanchez's vernacular revision of the word "bad" in her poetry collection "We a baddDDD People," 1970.

21. Stallings, *Mutha' Is Half a Word*, 25.

22. Gates, *The Signifying Monkey*.

23. Susan Searls Giroux, "Sade's Revenge," 3.

24. Neoliberalism has not been practiced exclusively by one political party in the United States. For example, Democratic president Jimmy Carter deregulated banking and transportation industries before Republican president Ronald Reagan took office, while Democratic president Bill Clinton "ended welfare as we know it" in 1996. Without a doubt, Democrats have espoused neoliberal politics and ideologies and have been responsible for their institutionalization in local, state, and federal politics. However, the most recent iterations of this free-market perspective are frequently identified with neoconservatives, the Religious Right, and the Republican and Libertarian Parties.

25. Goldberg, *Threat of Race*, 29.

26. Ibid., 91.

27. Ibid., 71.

28. Angela Y. Davis, *Are Prisons Obsolete?* (New York: Seven Stories Press, 2003), 10; Peter Wagner and Leah Sakala, "Mass Incarceration: The Whole Pie," *Prison Policy Initiative*, accessed January 26, 2015, http://www.prisonpolicy.org/reports/pie.html.

29. Gilmore, *Golden Gulag*, 225.

30. Alexander, *The New Jim Crow*, 11.

31. Rick Perlstein, "Exclusive: Lee Atwater's Infamous 1981 Interview on the Southern Strategy." Atwater was responsible for the 1988 Willie Horton ad that blamed Massachusetts governor Michael Dukakis for the release of a black inmate who allegedly raped a white woman, drawing on old racist fears of violent black sexuality.

32. "Full Transcript of the Mitt Romney Secret Video."

33. Henry A. Giroux, "The Terror of Neoliberalism," 5.

34. Levin, "The Real Story of Linda Taylor, America's Original Welfare Queen."

35. Emphasis added. See Levin, "The Real Story of Linda Taylor, America's Original Welfare Queen." Levin's article traces the life of Linda Taylor, a Chicago woman who was tried and convicted on welfare fraud in the 1970s. President Reagan's reference to Taylor has frequently been labeled as a myth, but Linda Taylor was a real woman. For decades the image of the welfare queen has persisted, and politicians regularly return to scapegoat those who abuse welfare as a means to gather votes for their regressive campaigns. Candidate Mitt Romney resuscitated welfare scapegoating in a 2012 campaign ad in which he attacked President Obama by saying that under Obama's policies, "you wouldn't have to work and wouldn't have to train for a job. They would just send you your welfare check." Earlier that year, Newt Gingrich called Obama the "food stamp president" in a debate. Corporate "news" outlets inflame hostile feelings by showing images of black women when reporting on welfare despite the fact there are fewer black women on welfare than white women.

36. Hancock, *The Politics of Disgust*, 72; emphasis added.

37. Ibid., 91.

38. Greenfield, *The Myth of Choice*, 160.

39. Davis, "Recognizing Racism in the Era of Neoliberalism."

40. On the day the bill was signed, three women—two black women and one white woman—who had lived on welfare flanked President Clinton. Lillie Harden, a black former welfare recipient from Little Rock, Arkansas, introduced the president. The appearance of Harden, Penelope Howard, and Janet Ferrell reinforced the public perception that welfare is primarily a black issue.

41. In June 2009, MTV Networks premiered the hour-long documentary series *16 and Pregnant*. Each episode follows several months in a teen's life to offer "a unique look into the wide variety of challenges pregnant teens face: marriage, adoption, religion, gossip, finances, rumors among the community, graduating high school, getting (or losing) a job. Faced with incredibly adult decisions, these girls are forced to sacrifice their teenage years and their high

school experiences" (*16 and Pregnant* website, http://www.mtv.com/shows/16-and-pregnant/). Several months later, MTV premiered the spin-off series *Teen Mom.* Its 2.1 million viewers made the show the most watched new series launch that year. The program follows the lives of the young women in *16 and Pregnant.*

42. For nontraditional mothers and their representations, visibility implies the presence of and value for their subjectivities. Seeing nontraditional mothers on television or hearing stories about them across various media, while more common today than in mid-twentieth-century America, nevertheless distorts their social meaning in significant ways, resulting in a kind of "hypervisibility." Like Jean Baudrillard's formulation of the hyperreal, hypervisibility acts as irony. The more prevalent these maternal figures seem, the more they are effaced at the level of structural and institutional power. This is what Daphne A. Brooks calls "spectacular marginalization." This situation can demonstrated in both the popular and political realms of recent American culture. See Baudrillard, "Simulacra and Simulation," 4; Brooks, "All That You Can't Leave Behind," 183.

43. "Vice President Dan Quayle—The 'Murphy Brown' Speech."

44. Twila L. Perry, "Family Values, Race, Feminism and Public Policy," 352.

45. Stephens and Few, "Effects of Images of African American Women," 252. "Baby mama" is a slang term loaded with racial, sexual, and class biases, which has slipped uncritically into mainstream American popular culture largely through daytime talk shows, such as *Jerry Springer* and *Maury Povich.* Often on those television programs, men publically lambaste the mothers of their children for "infractions" such as dating someone new or requiring child support payments. Under these circumstances, the women, almost always young, black, or Latina and from working-class or poor backgrounds, seem emotionally uncontrollable, promiscuous, irresponsible, and nagging. Through these exchanges, audiences are instructed to objectify the "baby mama" as a specific kind of single mother—racially, sexually, and economically marginalized and generally unfit for her maternal duties. The baby mama, once a part of black vernacular culture, has become a part of an intricate network of black maternal controlling images. See also, Cooper, "Excavating the Love Below."

46. "FOX refers to Michelle Obama as 'Baby Mama,'" *Today.com,* http://today.msnbc.msn.com/id/25129598/ns/today-entertainment/t/fox-refers-michelle-obama-baby-mama/#.TxQwb-hwQIcM. The following month, Michelle Malkin tried to defend the "Baby Mama" incident by pointing to the fact that once Michelle Obama had called Barack Obama her "baby's daddy" as she introduced him in a speech. Blogger John Scalzi addresses the problems of Malkin's argument with a bit of well-played humor and snark: "Malkin defends . . . the phrase by essentially making two arguments. First, Michelle Obama once called Barack Obama her 'baby's daddy,' and as we all know, a married woman factually and correctly calling her husband her child's father is *exactly the same* as a major news organization calling a potential First Lady some chick what got knocked up on a fling. Second, the term 'baby-daddy' has gone out into the common culture; heck, even Tom Cruise was called Katie Holmes' baby-daddy, you know, when he impregnated her and she subsequently gave birth while the two were not married, which is *exactly* like what happened between Michelle and Barack Obama, who were married in 1992 and whose first child was born six years later" (http://whatever.scalzi.com/2008/06/12/). Scalzi points to the subtle but important linguistic difference between the phrases "my baby's daddy" and "baby mama." The use of the possessive in the former changes the phrase from a slang term into a descriptive phase. Furthermore, the parallelism that Malkin suggests makes sense only if we equated the Obamas with examples of actual unwed parents.

47. Actor and comedic writer Tina Fey makes ironic use of the phrase "baby mama" in her movie of the same name, released in 2008. Fey portrays an upper-middle-class, unmarried, professional white woman who decides to use a gestational surrogate so that she can have a baby. The surrogate, played by actor Amy Poehler, is a working-class white woman whose

coarse behavior is supposed to mark her as the stereotypical "baby mama." I read the "white trashiness" of Poehler's character as a sly wink to the audience regarding this stereotype, as if to say, "Look, even white women can be 'baby mamas.'" The joke is on us, however, because the movie is unable to pull this subversion off for at least two reasons. First, the major black male character in the movie is an "expert" on baby mamas, thereby upholding the racial coding of the term. Second, there are no black women with speaking roles in the movie. Comedic subversion of racial stereotypes has to go farther than simple inversion, which is Fey's approach; it must also include the representation of the subjectivities of those who have been silenced by the stereotype.

48. Bonilla-Silva, *Racism without Racists,* 93.

49. In *Fatal Invention,* Dorothy E. Roberts explains how "genetic researchers routinely force genetic samples into preexisting racial categories," which can then be used to explain disparities in health outcomes, education, and incarceration (73). When used this way, gene-based research can act as a stand-in for "color" in the maintenance of the American racial caste system. Roberts identifies this development as a "dangerous biopolitics of race fueled by a new racial science based on cutting-edge genomics, a staunch refusal to acknowledge enduring racial inequality, and a free market fundamentalism" (309). Color-blindness and uncritical genetic science actually work together to incite anxieties of racial identification rather than ameliorate them.

50. Griffin. "At Last . . . ?," 134.

51. Spillers, *Black, White, and in Color,* 257.

52. Cohen, "Deviance as Resistance," 29.

53. Ibid.

54. Fleetwood, *Troubling Vision,* 4.

55. Moon, "From Badu, Material to Wrap Around Your Mind," n. pag.

56. McGuire, *At the Dark End of the Street,* 191.

57. Moon, "From Badu, Material to Wrap Around Your Mind," n. pag.

58. Marshall, *Brown Girl, Brownstones.*

59. Ibid., 69.

60. Ibid., 70.

61. Ibid.

62. Ibid.; emphasis added.

63. Lugo-Lugo and Bloodsworth-Lugo, "Bare Biceps and American (In)Security," 214.

64. Many thanks to Venetria K. Patton for bringing this association to my attention.

65. Mama's gun reflects the literary legacy articulated in Alice Walker's poem within the essay "In Search of Our Mother's Gardens": "They were women then / my mother's generation / husky of voice—stout of / step / With fists as well as / Hands." The dialectic of mama's gun reflects the way "fist" and "hand" operate in this verse.

NOTES TO CHAPTER 1

1. Abdur-Rahman, *Against the Closet,* 115.

2. Sapphire, *PUSH.* (New York: Vintage Books, 1996). Subsequent references to the novel will appear parenthetically. Sapphire is the pen name of writer Ramona Lofton (born 1950).

3. Abdur-Rahman, *Against the Closet,* 116.

4. For more on the use of oral traditions in African American women's autobiographical and fictional narratives of slavery, see Fulton, *Speaking Power* and Patton, *Women in Chains.*

5. Liddell, "Agents of Pain and Redemption in Sapphire's *PUSH,*" 145.

6. Dubey, *Signs and Cities,* 55. Since its publication, *PUSH* has been criticized for portraying negative stereotypes, and Sapphire has been simultaneously dismissed as the perpetrator of leftist polemic or of racial double-cross. *The New York Times* book critic Michiko Kakutani wrote of *PUSH* in 1996: "We learn that white social workers are foolish, patronizing liberals, and that men are pigs who only think about sex. Though it's easy to understand how Precious might hold all of these views, it soon becomes clear that Precious's creator, Sapphire, is also stacking the deck." (See "A Cruel World, Endless Until a Teacher Steps In," *The New York Times,* June 14, 1996, C29.) In addition, the year the novel was published, book reviewer Vaughn A. Carney wrote that *PUSH* "feeds white America's morbid fascination with the most depraved, violent, misogynist, vulgar, low-life element in the African American experience . . . I resent having my people defined by the lowest elements among us." (See "Publishing's Ugly Obsession," *The Wall Street Journal,* June 17, 1996, A14.) Carney was not alone in his appraisal of *PUSH,* and similar conversations have reemerged as the film adaptation, *Precious* (2009), gained popular and critical attention.

7. Lidell, "Agents of Pain," 145.

8. For recent scholarship on Sapphire's prose, poetry, and performance art, see Elizabeth McNeil, Neal A. Lester, DoVeanna S. Fulton, Lynette D. Myles, eds., *Sapphire's Literary Breakthrough: Erotic Literacies, Feminist Pedagogies, Environmental Justice Perspectives* (New York: Palgrave Macmillan, 2012); "Recovering the Little Black Girl: Incest and Black American Textuality" in Abdur-Rahman, *Against the Closet,* 114–50; and Fulton, *Speaking Power.* See also the special issue of *Black Camera: An International Film Journal* 4, no. 1 (Winter 2012) on critical perspectives on the film *Precious.*

9. Lidell, "Agents of Pain," 142.

10. Ibid., 138.

11. Each of these terms is a variation on the Jezebel controlling image, which highlights the hypersexuality, promiscuity, and irresponsibility of black women. The terms "hood rat" and "hoochie mama" both are urban black slang popularized in rap music, meant to describe black girls and women who are poor and sexually available for men. In 1995, the rap group 2 Live Crew recorded the song "Hoochie Mama" for the soundtrack for the black cult classic film *Friday.* The chorus of the song featured a call and response between Luther Campbell and the rest of the group. Campbell calls: "You ain't nothing but a hoochie mama," and the rest of the group responds, "Hood rat, hood rat, hoochie mama." Throughout black popular culture, hood rats and hoochie mamas are portrayed as loud and obnoxious black women who wear outrageous clothing and hairstyles, such as blond weaves, gold teeth, and long, acrylic nails, a style some refer to as "ghetto fabulous." The term "baby mama" also emerges from hip-hop music and African American culture to define a woman who is neither married nor attached to the father or fathers of her children. She is also thought of as a woman who uses sex to maintain financial or emotional control over the father or fathers. It is a racially and sexually loaded slang term that has slipped into mainstream American popular culture largely through daytime talk shows hosted by white men, such as *Jerry Springer* and *Maury Povich,* as discussed in the introduction to this book. These disparaging images proliferate even if the terms are not explicitly stated through a series of visual and auditory signs. The fact that all of these terms are related shows the permeability of the boundaries of dominant and marginalized discourse communities. Both white and black men have developed their own terms to exert power and control over black women in different, yet related ways. For more on controlling images, see Collins, *Black Feminist Thought.*

12. Dubey, *Signs and Cities,* 62.

13. Tate, *Domestic Allegories of Political Desire,* 26.

14. Ibid.

15. Ibid.; emphasis added.

16. Ibid., 25.

17. Omolade, *The Rising Song of African American Women*, 38; Doyle, *Bordering on the Body*, 21; Roberts, *Killing the Black Body*, 209.

18. "Surrogates and Outcast Mothers: Racism and Reproductive Politics in the Nineties," in Davis, *The Angela Y. Davis Reader*, 213.

19. Omolade, *The Rising Song of African American Women*, 38.

20. In 1996, President Bill Clinton signed into law sweeping reforms of welfare policy, fulfilling his promise to "end welfare as we know it." These new rules dismantled existing programs, such as AFDC, and in effect exposed millions of American families to the devastating risks of poverty. "The new law," writes Dorothy Roberts, "represents a disastrous turn in the way we think about welfare. Numerous critics have noted that American welfare policy . . . has long branded AFDC recipients as immoral freeloaders who are responsible for their own fate" (209). Originating in New Deal era legislation, AFDC had been a safety net to poor children and their families for decades, providing modest financial assistance to those in need. AFDC, along with a constellation of other federal benefit programs such as food stamps, WIC (a nutrition program for women, infants, and children), and Medicaid, have been understood generally by the term "welfare" in public discourse since the 1960s. See U.S. Department of Health and Human Services. *A Brief History of the AFDC Program*, https://aspe.hhs.gov/pdf-report/brief-history-afdc-program. Originally, the AFDC program allowed states to discriminate against blacks, an option many states exercised until black women Civil Rights activists lobbied for their inclusion in the benefits program in the 1960s. However, as Roberts describes, it did not take long for myths of welfare dependency to become associated with blackness once black women were included in the program (*Killing the Black Body*, 206–7).

21. Ruth Sidel, "The Enemy Within: The Demonization of Poor Women," *Journal of Sociology and Social Welfare* 27, no. 1 (March 2000): 75.

22. Roberts, *Killing the Black Body*, 110–14.

23. Ibid., 209. In addition, a spate of criminal cases emerged in the 1990s that "punished women," disproportionately black and poor, for having children. Roberts explains that women who are arrested for drug use while pregnant often face sentencing options that hinge on curtailing their reproductive choices: "Prosecutors and judges see poor Black women as suitable subjects for these reproductive penalties because society does not view these women as suitable mothers in the first place" (152). When not promoted directly by the state, a number of private organizations have been willing to push these controls with tacit or direct support from the government. Jennifer Nelson describes the work of CRACK (Children Requiring a Caring Community), a private California organization that paid drug-addicted and recovering women $200 if they agree to be sterilized or placed on long-term contraceptives. Though the state does not fund CRACK, the sterilizations that the private group creates incentives for end up being paid by Medicaid (Nelson, *Women of Color and the Reproductive Rights Movement*, 181). In recent years, the organization has been renamed Project Prevention, and its founder, Barbara Harris, continues her crusade (see http://www.projectprevention.org/). Therefore, Jennifer Nelson describes the sterilization coercion emerging in the 1990s as a "eugenic force" and a highly contradictory abuse of state power because "sterilization is funded by the federal Medicaid program, while abortion, a non-permanent method of fertility limitation, is not" (*Women of Color and the Reproductive Rights Movement*, 182). Roberts's work supports Nelson's conclusion that these practices, while not actual eugenics, share similar premises as eugenics, which is that multiple social problems can be curbed by preventing "undesirable," "undeserving," and "irresponsible" women from procreating.

24. Michael A. Fletcher and Brian Faler, *The Washington Post*, October 1, 2005 (http://archive.sltrib.com/story.php?ref=/nationworld/ci_3077832).

25. Alexander, *The New Jim Crow,* 2.

26. Bill Cosby, speech at 50th Anniversary commemoration of the *Brown vs Topeka Board of Education* Supreme Court Decision, May 17, 2004, http://www.eightcitiesmap.com/transcript_bc.htm.

27. See Patricia Hill Collins, *Black Sexual Politics: African Americans, Gender and the New Racism* (New York: Routledge, 2004).

28. *The Color Purple* struggles with some of the same criticisms that *PUSH* has, and therefore shares an affinity with my reading of *PUSH*. *The Color Purple*, which belongs in the same literary lineage as *Incidents* and *Our Nig*, has not been categorized as an instance of heroic maternal self-transformation because of its insulated narrative world of a coming-of-age black woman and the depiction of the intimate violence that marks this process for its heroine. Although Alice Walker's novel became a literary sensation in 1982, winning both an American Book Award and a Pulitzer Prize the following year and spending several weeks on *The New York Times* bestseller list, it faced a scrutiny around issues of respectability similar to that of Jacobs's text, which was published more than 120 years earlier. *The Color Purple* is an extension of the tradition that Tate identifies, with a slightly different focus: a concentration on the patriarchal violence waged at the hands of black men, rather than white slave owners. I think Tate's insights into the implications of maternal discourse in black women's texts provide a glimpse of new possibilities for reading *The Color Purple*, and later, Sapphire's novel *PUSH*, which I argue extends Walker's work in *The Color Purple* to situate motherhood not only as heroic but also as a transgressive identity for black women.

29. The novel intentionally presents misspellings of words to indicate Precious's developing literacy.

30. Sharon Darling, "Literacy and the Black Woman," in *Readers of the Quilt: Essays on Being Black, Female and Literate,* ed. Joanne Kilgour Dowdy (Cresskill, NJ: Hampton Press, 2005), 23.

31. Hélène Cixous, "The Laugh of the Medusa," *Signs* 1, no. 4 (Summer 1976): 882. Debra King writes convincingly that "the freedom and subversive nature of writing as proposed by Cixous suffocates beneath the weight of blackpain. Although inspiring and liberatory for some women, Cixous' gendered metaphors do not consider the plight of those held captive by gendered and racialized fictions" (114). In King's work, blackpain involves a myriad of physical traumas experienced individually and collectively by black people. King discusses traumas specific to black women during enslavement, including involuntary breeding, forcible wet-nursing, and sexual assault. See *African Americans and the Culture of Pain* (Charlottesville: University of Virginia Press, 2008), 114.

32. Anne Goldman, "'I Made the Ink': (Literary) Production and Reproduction in *Dessa Rose* and *Beloved*," *Feminist Studies* 16, no. 2 (Summer 1990): 326.

33. The centrality of mother's milk is exemplified in one of Sethe's moving re-memory scenes in *Beloved* (1987). During this exchange, Sethe describes to Paul D how desperately she needed to be reunited with her baby girl, whom she had sent ahead toward freedom before escaping the Sweet Home plantation herself: "Anybody could smell me long before he saw me. And when he saw me he'd see the drops of it [breast milk] on the front of my dress." Yet, worse than her wasted milk shed into a muslin dress, worse than a chokecherry tree planted by rawhide across her brown skin, was the violation Sethe experienced at the hands of Schoolteacher's nephews, who took the milk meant to feed her baby. Sethe's words haunt the narrative as she tells the story to Paul D, suggesting that the men had stolen from her not just nourishment for her child but also her sense of self. Mothering, milk, and subjectivity are conflated when Sethe boasts to Paul D, "Nobody was going to nurse her *like me*" (16; emphasis added). The phrase "like me" distinguishes Sethe in her ability to nurse her own daughter, and it is here she makes a critical claim to maternal autonomy. Without a doubt, motherhood provides critical

links to notions of womanhood, such that Sethe's potential for agency as a formerly enslaved black woman hinges upon her recognition as a mother.

34. Goldman, "'I Made the Ink,'" 325.

35. The move from silence to voice in black women's literature has been steadily marked by a tenuous relationship with writing. Mastery of writing often appears in texts as representative of black participation in the social and political life of the nation or, alternately, as scenes of alienation from the black community, which is often imagined as preliterate and oral utopias. Despite the primacy and privilege often given to the function of oral forms in black women's literature, I ultimately agree with Madhu Dubey, who concludes that a number of contemporary novels, including *PUSH,* "continue to be profoundly invested in the modern idea of print literacy as a vehicle for social critique and advancement" (*Signs and Cities,* 56). Dubey's assertion about writing is often at odds with other major perspectives. For example, Karla F. C. Holloway situates black women's literary tradition squarely in the realm of the oral: "Because black women's literature is generated from a special relationship to its words, the concerns of orature and the emergence of textual language that acknowledges its oral generation must affect the critical work that considers this tradition." Kevin Everod Quashie, drawing on the poetry of Marlene Norbese-Phillips and Dione Brand, describes how black women writers often view colonial languages as "untrustworthy, a vehicle of erasure, violence and separation." See, respectively, Holloway, *Moorings & Metaphors: Figures of Culture and Gender in Black Women's Literature* (New Brunswick, NJ: Rutgers University Press, 1992), 69, and Quashie, *Black Women, Identity and Cultural Theory: (Un)Becoming the Subject* (New Brunswick, NJ: Rutgers University Press, 2004), 133. By focusing on literacy rather than other forms of self-expression and "textuality," I hope to make the point that black women's literal reading and writing practices are also important to study. I am particularly interested in the way that literacy constructs black women's capacity for social and political citizenship because I think it is vital not to overlook the "scriptocentric" aspects of black women's expression.

36. Alice Walker, *The Color Purple* (New York: Pocket Books, 1982), 4. Subsequent references will be noted parenthetically.

37. Though this chapter focuses primarily on the instances of biological mothering that appear in these primary texts, it is important to note that there are opportunities to consider adoptive mothering in this scene as an experience that also offers an opportunity for understanding heroic maternal self-transformation.

38. Tate, *Domestic Allegories of Political Desire,* 38.

39. Precious's respect for Louis Farrakhan eventually fades in the story when she finds out that he condemns homosexuality. Her teacher Miz Rain is a lesbian, and Precious decides that Farrakhan is not right about everything because "Ms Rain the one who put the chalk in my hand, make me queen of the ABCs" (81).

40. See Dubey's chapter "Books of Life: Postmodern Uses of Print Literacy" in *Signs and Cities* for an elaboration on the familial bonds created among the members of the literacy class in *PUSH.*

41. bell hooks, "The Politics of Radical Black Subjectivity," in *Yearning: Race, Gender and Cultural Politics* (Boston: South End Press, 1990), 19.

NOTES TO CHAPTER 2

1. McGuire, *At the Dark End of the Street,* 93.

2. Ibid., 91. McGuire's book focuses on the multiple ways that sex and sexuality were racialized during the postwar era and effectively shows how perceptions about the sexuality of black women made them particularly vulnerable to multiple physical, emotional, and political

violences. For more on Colvin's experience, see also Paul Hendrickson, "The Ladies Before Rosa," 287–98.

3. Wright, "Casting the Bones of Willa Mae Beede," 142.

4. Edwards, *Charisma and the Fictions of Black Leadership*, 145.

5. Ibid., 147.

6. Zora Neale Hurston famously writes "de nigger woman is de mule uh de world" in her novel *Their Eyes Were Watching God* (1937). The phrase has come to indicate the multiple marginalizations that black women face, and the specific reference to beasts of burden marks the inevitability of their servitude. Blues women's personas challenged this perception of black womanhood on multiple levels.

7. For more on the role of ancestral voices in black women's fiction, see Patton, *The Grasp That Reaches beyond the Grave*.

8. Throughout the novel, characters refer to Dill with the feminine pronouns of "she" and "her," or occasionally by the name "Delilah," yet it is clear that Dill does not identify as a woman throughout the novel. For the purposes of my analysis, I have identified Dill as a transgender man based on Dill's first-person narratives in the novel, even though this terminology was not common in 1963 rural Texas. Dill first introduces himself by saying, "They call me a bulldagger, dyke, lezzy, what-have-you . . . Let them say what they want. It don't bother me none" (34). However, throughout the novel Dill's identity as a man is described in numerous ways, culminating in Dill's self-acknowledgement that "I am a man, but an old man" (244).

9. Norman, *Neo-Segregation Narratives*, 2.

10. Ibid., 3.

11. Norman, "The Historical Uncanny," 454.

12. Parks, *Getting Mother's Body*, 187.

13. Norman, *Neo-Segregation Narratives*, 3.

14. "SIECUS—A History of Federal Abstinence-Only-Until-Marriage Funding FY10," accessed January 25, 2015, http://www.siecus.org/.

15. Billy's quest also mirrors Dewey Dell's situation in Faulkner's *As I Lay Dying*. In that novel, the Bundren daughter, Dewey Dell, spends much of family's quest to bury their mother looking for a sympathetic pharmacist or doctor who can sell her an abortifacient. In this search, Dewey Dell is raped by one shopkeeper and told to return to her boyfriend and get married by another. Faulkner leaves the conclusion of her narrative in an ambiguous state, but it is clear she is left to give birth to her child.

16. Parks, *Getting Mother's Body*, 97. Subsequent references to the novel will appear parenthetically.

17. The last several years have seen a sharp increase in conservative legislative initiatives that serve to undermine women's reproductive health and freedom, culminating in the so-called War on Women we witnessed throughout the 2012 and 2016 election seasons. In 2011 alone, state legislatures introduced 1,100 provisions affecting women's reproductive rights, up from 950 the year before, according to the Guttmacher Institute, a policy research organization that "advances sexual and reproductive health." This sharp uptick includes measures that restrict abortion access—including bans, waiting periods, and clinic regulations—or cut funding to family planning services in a variety of ways. Of these measures, 135 were enacted in thirty-six states. As if these numbers were not enough, 2012 piled on what seemed to be never-ending rhetorical assaults on women, from the sometimes laughable—such as "binders full of women"—to the much more alarming use of the terminology of "forcible rape" added to federal legislation or the unfathomable idea of "legitimate rape." It is in this fray that I first took notice of "personhood amendments," one of the many legislative options arising in the last several years that roll back gains made by women in acquiring safe, legal, and affordable access to both contraception and abortion services as well as access to treatments for infertil-

ity. Specifically, proponents of "personhood amendments" seek to provide legal and moral rights to fertilized eggs and further seek to protect these "persons" under the provisions of the 14th Amendment, which defines citizenship and ensures rights to due process and equal protection. Defining *persons* in this way would effectively outlaw all abortion procedures under any circumstances, including rape and incest, and would outlaw several birth control options, such as morning-after pills and IUDs, which work by preventing the implantation of a fertilized egg into a woman's uterus. In addition, assisted reproductive technologies such as in vitro fertilization could also be forbidden. In some instances, it is believed that women who miscarry could also be prosecuted under personhood legislation. Fortunately, the Draconian effects of these proposals have not reached fruition—no state has passed a bill—yet that has not stopped a rising movement of people pressing for laws to redefine who is a person and a growing number of supporters who eventually seek a federal constitutional amendment redefining personhood.

18. Parks also foregrounds these issues in relationship to white women through the characters of Myrna and Birdie. While I am primarily focused on the race, class, gender, and sexual matrix experienced by the black women characters in this novel, the minor characters of Myrna and Birdie present opportunities for further study of this novel.

19. Blues scholars divide blues music into various, often contested, categories. Classic blues describes a blues style that combines both folk blues, minstrel show traditions, and popular song forms of the early twentieth century. Classic blues also typically refers to the style that has become associated with women singers, which was also some of the first black music that was recorded and broadcast via radio. Blues historian Paul Oliver, for example, has troubled the legitimacy of the blues-literature connection, and has expressed his skepticism about the relevance of blues in contemporary black culture because "I don't think blues has any significance for the black community as a whole, as gospel still has" (Horn, David, and Paul Oliver, *Popular Music* 26, no. 1 [January 1, 2007]: 5).

20. Unfortunately, there do not seem to be any book-length studies devoted to the feminist implications of the performances of contemporary blueswomen as of the time this chapter was drafted. Blues singers such as Koko Taylor and Etta James, who have performed since the 1950s and '60s, and newer artists, such as Shemekia Copeland and Zora Young, have carried on in the blues traditions within the past twenty years. These artists have carried on traditions established by the classic blueswomen, but their work has also been categorized differently—as Chicago blues, rhythm and blues, or even rock and roll. The lack of attention paid to blueswomen of the latter half of the twentieth century suggests an area worthy of further inquiry.

21. Lordi, *Black Resonance*, 3.

22. Davis, *Blues Legacies and Black Feminism*, xi.

23. Ibid., 11.

24. Quoted in ibid., 310.

25. Ibid., 18.

26. Hazel Carby, "It Jus Be's That Way Sometime: The Sexual Politics of Women's Blues," in O'Meally, *The Jazz Cadence of American Culture*, 474.

27. Ibid., 479.

28. Davis, *Blues Legacies and Black Feminism*, 13.

29. Ibid.; emphasis added.

30. duCille, *The Coupling Convention*, 71.

31. Ibid.

32. In almost every instance, reference to the slang term *Mama* or *Ma* is particularized to black American culture and the sexual availability of a black woman. Clarence Major's *Dictionary of Afro-American Slang* (1970) and its updated version, *From Juba to Jive* (1994), are devoted to cataloging black language traditions, and both texts have entries for the word

mama. The 1970 reference simply defines *mama* as "a pretty black girl" (80), while the latter reference defines it thusly: "a male term for girlfriend or wife; any woman, any girl" and dates the usage from the 1650s to the 1990s. The word shows up in general American slang dictionaries, too, but with a distinctly racialized and sexualized cast, including "a young woman, a woman (US 1917), originally black usage"; "a very attractive woman . . . *cf.* sweet mama [originally and primarily black use]"; and "a sexually active or promiscuous woman . . . *cf.* red-hot mama." See, respectively, *The New Partridge Dictionary of Slang and Unconventional English,* vol. 2, ed. Tom Dalzell and Terry Victor (New York: Routledge, 2006), 1260; *Slang and Euphemism,* ed. Richard A. Spears (New York: Jonathan David Publishers, 1981), 244; *Oxford Dictionary of Modern Slang,* ed. John Ayto and John Simpson (Oxford: Oxford University Press, 1992), 142.

33. Lindsay, "The Nomenclature of the Popular Song," 371.

34. Hart, "Jazz Jargon," 243.

35. Ibid.

36. Recently, even the word *mommy* has joined this semantic legacy, turning up in hip-hop lyrics as a reference to a female sexual partner or an attractive woman who takes care of herself. Hip-hop songwriter and performer Missy Elliott defines *mommy* as "the boss" in a 2004 song that describes a sexually aggressive and manipulative woman who is able to control men for her economic and sexual gain. See Missy Elliott's "Mommy," *The Cookbook,* Atlantic Records, 2005.

37. *Wild Women Don't Have the Blues,* dir. Christine Dall, VHS, 1989.

38. Harrison, *Black Pearls,* 65.

39. "PUBLIC FORUM: Wynton Marsalis & Suzan-Lori Parks."

40. Patton, *The Grasp That Reaches beyond the Grave,* 7.

41. Ibid., 56.

42. I have created substitute titles for the untitled compositions in order to help distinguish them in this discussion.

43. McGuire, *At the Dark End of the Street,* 86.

44. Norman, *Neo-Segregation Narratives,* 6.

NOTES TO CHAPTER 3

1. Fleetwood, *Troubling Vision,* 112.

2. Badu has not publically acknowledged a legal marriage at the time of publication.

3. Lordi, *Black Resonance.*

4. Ibid., 3.

5. Psychologist Linda Malone-Colón, writing for the socially conservative foundation Institute for American Values in 2007, explains, "Declines in rates and quality of Black marriages have profound, well-documented negative effects on Black adults and children, their communities and the broader society." Malone-Colón's report, "Responding to the Black Marriage Crisis," identifies policy actions necessary for creating a "new, healthy black marriage culture in America." Responding to similar concerns about "fractured" families, writer Maryann Reid created Marry Your Baby Daddy Day in 2005, which offers all-expense-paid weddings to unmarried couples with children. The idea is to encourage marriage for black parents who had opted otherwise (see Appleton, "Marry Your Baby Daddy Day"). Reid spun off this idea into a novel called *Marry Your Baby Daddy* (2010), about three black women who must marry their children's fathers in order to receive an inheritance from their grandmother.

6. Although historically, black single motherhood has been demonized and black single mothers scapegoated in social theories from E. Franklin Frazier's "culture of poverty" to Daniel

Patrick Moynihan's "tangle of pathology," the contemporary discourse about single parenthood focuses on the marriageability of black women. Popular comedian and talk show host Steve Harvey wrote the self-help book *Act Like a Lady, Think Like a Man: What Men Really Think about Love, Relationships, Intimacy, and Commitment* (2009). Ralph Richard Banks's 2011 book *Is Marriage for White People?* enters the discourse by provocatively suggesting that black women consider dating eligible men of other races, concluding that the black marriage crisis has a lot to do with the paucity of eligible black men in "the marketplace." Banks also suggests that without proper role models for marriage, younger black people will continue to reject marriage, writing, "children are the most impressionable witnesses to the fracturing of black intimacy" (Banks, Ralph Richard, *Is Marriage for White People? How the African American Marriage Decline Affects Everyone* [New York: Dutton, 2012], 6). Banks offers an alternative message, which is that black women desperately want to be married and they have become victims of an intimate marketplace that actually disadvantages them for their successes. This position has been gaining in popularity.

7. Erykah Badu frequently identifies herself with various names for her alter egos. See "Window Seat: Erykah Badu's Explanation" (http://www.youtube.com/watch?v=bI3qRovp1A8 &feature=youtube_gdata_player).

8. Erykah Badu tweets under the name @fatbellybella.

9. In July 2008, Badu was criticized on message boards and by bloggers after it was announced that she was pregnant with her third child and had no intentions of getting married. In response to those criticisms, Badu posted a reply on the website okayplayer.com, which was then reposted on numerous websites. The full text of her response can be found here: http://streetknowledge.wordpress.com/2008/07/14/erykah-badu-goes-nuclear-on-okayplayer-bloggers/

10. Chicago rapper Hot2def released the song "Erykah Badu" in 2010, which describes this alluring power that Badu possesses (see "Erykah Badu" by Dat Boy Hot aka Hot2def).

11. Emerson, "'Where My Girls At?'" 132.

12. Marlo D. David, "Analog Girl in a Digital World: Afrofuturism and Post-Soul Possibility in Black Popular Music," *The African-American Review* 41, no. 4 (Winter 2007): 695–707.

13. Spillers, *Black, White, and in Color*, 167. This essay, which was published in 1984, anticipates much of the work done in Spillers's landmark essay "Mama's Baby, Papa's Maybe: An American Grammar," published three years later.

14. Spillers, "Interstices," 165.

15. See "Director's Cut."

16. "Window Seat."

17. Dealey Plaza was not literally used for this purpose. It was constructed between 1934 and 1940.

18. "Erykah Badu Is Super Pissed."

19. Spillers, *Black, White, and In Color*, 167.

20. Moore, "Black Freaks, Black Fags, Black Dykes."

21. "A Philosophy of Funk: The Politics and Pleasure of a Parliafunkadelicment Thang!" in Bolden, *The Funk Era and Beyond*, 43.

22. Vincent, *Funk*.

23. Clinton explained to music journalist Abe Peck that he and Collins had a strange, perhaps alien, encounter after a show in Toronto in 1975: "We saw this light bouncing from one side of the street to the other. It happened a few times and I made a comment that 'the mothership was angry with us for giving up the funk without permission.' Just then the light hit the car. All the street lights went out and there weren't any cars around . . . I said 'Bootsy, you think you can step on it?' " (qtd. in Vincent, *Funk*, 240). While Vincent seems to suggest

that Clinton's story is "non-serious," he nevertheless traces a cosmology of the mothership as it extended throughout other P-Funk performances.

24. Vincent, *Funk*, 254.

25. War, "The World Is a Ghetto," *The World Is a Ghetto*, United Artists Records, 1972.

26. The myth of flying Africans recurs in a number of forms, perhaps originating in Igbo lore, but it is most commonly recalled as the story of captured Africans who were said to have jumped off of slave ships to fly back home. Through this legend and its variations, the longing for escape, deliverance, and flight becomes one of the defining tropes of the black Atlantic experience.

27. Elijah Muhammad described the "Mother Plane" as a large plane built in 1929 in the form of a spinning wheel, thereby fulfilling the prophecy of Ezekiel (1:16), which describes the appearance of a gleaming spinning wheel within a wheel just above Earth. The Mother Plane was said to fulfill the prophecy of Ezekiel, which claimed that this gleaming wheel was a throne-chariot of God, or a Merkabah, as it is known in Hebrew mystical traditions. (It is important to note here that Badu's youngest daughter is named Mars Merkaba, which I will return to later in this chapter.) Elijah Muhammad's Mother Plane was said to be filled inside with 1,500 smaller planes, each small plane commanded by a black pilot, who, awaiting God's instructions, would initiate the fall of America and the "resurrection" of God's original people, the righteous black nation. In other words, the Mother Plane would give birth to the emissaries of black (masculine) revolution.

28. Tate identifies these potential conceptual sources and connections as Clinton's "funk gnostics," a term that seems appropriate for its invocation of gnosticism, which suggests that spiritual transcendence should be claimed through intuitive, interior, and personal means and that religious experience expresses itself significantly through myth (email interview with Greg Tate, February 21, 2012).

29. Maxile, "Extensions on a Black Musical Tropology," 602.

30. Ibid.

31. Ibid., 601.

32. Walker, *Mothership Connections*, 70.

33. Maxile, "Extensions on a Black Musical Tropology," 603.

34. "Abbey Lincoln Tribute."

35. Walker, "In Search of Our Mothers' Gardens," 12.

36. Ibid., 15.

37. For black women, being "thick" is valued in multiple ways, despite the commonly held perception that black women do not worry about their weight and do not suffer from body image issues. For the most part, thickness, which could be described as being full-figured and curvy, is seen as an attractive sign of femininity, but its value is generally assigned through a heteropartriarchal male gaze.

38. McIver, *Erykah Badu*.

39. I want to make it clear that my tracing of Erykah Badu's Mothership—her being-for-self as a black woman performer—is not meant to signify nor reify the kind of self-centered, solipsistic project of Western liberal subject, nor does it mean to participate in what Jack Turner calls "individualist ideology," the belief that "each person is solely responsible for his or her success or failure; each is expected to 'pull himself up by his bootstraps.'" (Turner, *Awakening to Race Individualism and Social Consciousness in America*, 198, n.1). This bootstrap ideal has found new traction in the contemporary neo-liberal social and political landscape and has become synonymous with ideals such as self-sufficiency, personal responsibility, in-dependence, and personal liberty. Turner writes that "individualists assign no weight to the idea of social structure; set on seeing themselves as masters of their own fate, individualists

deny social structure's significance and even existence to preserve their self-image and world-view. . . . the language of individualism is the moral rhetoric of choice for prejudiced whites" (215).

40. I appreciate the questions posed by Su'ad Khabeer that helped push me to clarify this idea of "selfishness" within Badu's song "Me."

41. Waldron, "Erykah Badu," 60.

42. Felsenthal, "Creating the Queendom: A Lens on Transy House," 244.

43. Thomas, "Queens of Consciousness & Sex-Radicalism in Hip-Hop," 31.

44. Ibid., 32.

45. Horan, "'I Don't Require Sex for Happiness.'"

46. Eliscu, "The Soul and Science of Erykah Badu."

47. Stallings, *Mutha' Is Half a Word*, 11.

NOTES TO CHAPTER 4

1. Dorothy E. Roberts, "Race, Gender, and Genetic Technologies: A New Reproductive Dystopia?", *Signs: Journal of Women in Culture and Society* 34, no. 4 (2009): 799.

2. Scholars such as Evelyn Hammonds, Harriet Washington, Dorothy Roberts, Alondra Nelson, Karla Holloway, Alex Weheliye, and Rayvon Fouche, among others, have produced significant work in this regard, helping orient contemporary black cultural studies and black feminist thought toward a deeper engagement with STEM epistemologies.

3. Subsequent references to this novel will be parenthetical.

4. Dillaway, "Mothers for Others," 307. There are two types of surrogacy, known as traditional surrogacy and gestational surrogacy. In traditional surrogacy, the surrogate is inseminated with the sperm of the father via intrauterine insemination. The resulting fetus will have the genetic structure of the father and the surrogate. The second type of surrogacy is known as gestational surrogacy, which is where the surrogate carries the embryo, created in vitro and produced by the infertile couple, also known as the intended parents. The infant will have the genetic makeup of the intended parents. In gestational surgery, the intended mother undergoes an in vitro fertilization cycle where she receives medication to stimulate her ovaries to produce multiple eggs. If the intended mother does not have viable eggs, an egg donor may be used. The eggs are withdrawn through the vagina and combined with the male partner's sperm in a petri dish. The dish is then placed in an incubator until ready for transfer, usually in three to five days. The gestational surrogate receives hormones to synchronize her cycle with the mother's. The mature embryos are transferred to the surrogate mother using a small catheter.

5. Elyce Rae Helford cites Butler's recurring interest in themes of reproduction: "From the Medusa-like appearance of the alien Oankali in her Xenogenesis trilogy and the archetypal power of the matriarchal shape shifter Anyanwu in her 1980 novel *Wild Seed* to Gans 'female' reproductive function for the Tlic in 'Bloodchild,' Butler is deeply invested in science-fictional metaphors for the 'feminine' which challenge traditional representations" ("Would You Really Rather Die Than Bear My Young?", 260).

6. The trilogy is also known as Lilith's Brood.

7. Butler explains her recurring themes of family, reproduction, and genetics: "Perhaps as a woman, I can't help dwelling on the importance of family and reproduction. I don't know how men feel about it. Even though I don't have a husband and children, I have other family, and it seems to me our most important set of relationships. It is so much of what we are. Family does not have to mean purely biological relationships either. I know families that have adopted outside individuals; I don't mean legally adopted children but other adults, friends,

people who simply came into the household and stayed. Family bonds can even survive really terrible abuse" (Potts and Butler, "'We Keep Playing the Same Record,'" 333).

8. "IVF Used in Record-Setting 1 in 100 Babies in U.S."

9. Jain, "Socioeconomic and Racial Disparities among Infertility Patients Seeking Care."

10. Inhorn and Fakih, "Arab Americans, African Americans, and Infertility."

11. For more on medical experimentation on black women, see Harriet A. Washington, *Medical Apartheid: The Dark History of Medical Experimentation on Black Americans from Colonial Times to the Present* (New York: Doubleday, 2006); Rebecca Skloot, *The Immortal Life of Henrietta Lacks* (New York: Broadway Paperbacks, 2011).

12. Ackerman, "Becoming and Belonging," 25.

13. In her essay "Cheap Labor," B. K. Rothman examines the patriarchal assumptions about the "ownership" of both women and babies rooted in surrogacy arrangements. Rothman also decries the fact that the social concern that contemporary surrogacy arrangements in which "the baby has become a commodity" forgets the fact that certain babies have already historically been considered commodities (22).

14. I am using Hortense Spillers's term "American grammar" here to refer to the symbolic order that "remains grounded in the originating metaphors of captivity and mutilation so that it is as if neither time nor history . . . show movement" (*Black, White, and in Color,* 208). Spillers's term explains how meaning is inscribed and ascribed to certain bodies, and how these meanings persist over time.

15. There have been at least two high-profile examples of black families who have used surrogates in recent years, which may go a long way toward reshaping the stigma that surrogacy has for black women. Married actors Angela Bassett and Courtney B. Vance had twins in 2006 with the help of a gestational surrogate, a married mother of two who was not named in the magazine coverage of their story. Black feminist scholar and former host of an MSNBC network public affairs show Melissa Harris-Perry and her husband James had a baby girl in 2014 with the assistance of a "gestational carrier." Harris-Perry writes in an essay published a day after her daughter's birth that she had "concerns with the ethics of surrogacy." By working through those concerns with her husband, family, attorneys, doctors, and the surrogate, "we are all bonded for life and our daughter has a bevy of grandparents, aunties, and siblings tied to her by blood and love." See Harris-Perry, "How We Made Our Miracle."

16. Roberts, *Killing the Black Body.*

17. Ibid., 269.

18. Doyle, *Bordering on the Body,* 4.

19. Roberts, *Killing the Black Body,* 271.

20. Justin Kmitch, "Woman Who Says She Got Wrong Sperm Forced to Move Lawsuit to DuPage County," *Chicago Daily Herald,* April 4, 2015. The outcome of this legal case was not available at press time.

21. Dahleen Glanton, "In Defense of Couple Suing Sperm Bank," *Pittsburgh Post-Gazette,* October 27, 2014.

22. Dianne Williamson, "They Don't Deserve All the Outrage," *Telegram & Gazette* (Massachusetts), October 7, 2014.

23. Williams, *The Alchemy of Race and Rights,* 221.

24. Ibid.

25. Ibid., 225.

26. "Slavery and Indentured Servants."

27. Khanna, "'If You're Half Black, You're Just Black.'"

28. I would describe maternal agency as the capacity for individual choice exercised by a mother or another maternal figure, including her power to make independent choices about the nature and content of her care of her children.

29. Davis, *The Angela Y. Davis Reader*, 215.

30. For more on African Americans' distrust of medical institutions, see Harriet Washington's *Medical Apartheid*.

31. A. Timothy Spaulding, *Re-Forming the Past: History, the Fantastic, and the Postmodern Slave Narrative* (Columbus: Ohio State University Press, 2005), 123.

32. Osherow, "The Dawn of a New Lilith."

33. Ibid., 76.

34. For more on Lilith's depiction in the Hebrew literary tradition, see chapter 2 in Aschkenasy, *Eve's Journey*, and Avraham Balaban, *Between God and Beast: An Examination of Amos Oz's Prose* (University Park: Pennsylvania State University Press, 1993). Conversations with Balaban helped steer me toward the rich literary meaning Lilith holds within the Hebrew literary tradition, which has influenced my readings of Lilith in a black woman's text.

35. Ostriker, *Feminist Revision and the Bible*, 8.

36. Exploring the variety of interpretations of the Lilith story has also uncovered fascinating alternate readings of the role and symbolism of Eve in the Genesis story. I am particularly drawn to the reading of Eve exemplified in Marge Piercy's poem "Applesauce for Eve," in which she writes, "You are indeed the mother of invention, the first scientist" (Piercy, Marge, "Applesauce for Eve," *Ms.*, January 1992). Eve's decision to eat the forbidden fruit takes on different meaning if thought of as deliberate scientific exploration and experimentation, qualities valorized among men, rather than as foolishness and treachery that dooms humanity.

37. While the Hebrew Bible mentions Lilith directly only once, in Isaiah 34:14, she appears through the Jewish tradition of Midrash, an oral tradition of close reading and interpretation of the holy text. Midrash is built on the assumption that everything in the Torah is a clue to deeper understanding of its meaning; it is a "means of extracting meaning from the Bible, but also a way of reading meaning into the text" (Hyman, *Biblical Women in the Midrash*, xxix). The Lilith story appears in the medieval text *Alphabet of Ben Sira*, which also describes Lilith as Adam's first wife. I appreciate the insights provided by Maren Linett that helped me distinguish among these various texts within the Hebrew tradition.

38. Hyman, *Biblical Women in the Midrash*, 9.

39. Aschkenasy, *Eve's Journey*, 51.

40. Plaskow, "The Coming of Lilith," 206.

41. Hammer, *Sisters at Sinai*, 7–8.

42. Ostriker, "The Lilith Poems," 251.

43. The 2012 release of the motion picture *The Hunger Games*, based on Suzanne Collins's young adult dystopian novel, set off a Web-based outrage over the blackness of two of the characters, Rue and Thresh. Despite the fact that Collins described these characters in the book as having dark skin, some white fans of the book were disappointed to see black actors portray the characters that they had imagined as white. See Rosen, "'Hunger Games' Racist Tweets."

44. Carretta, *Unchained Voices*, 142.

45. Ibid.

46. Spaulding, *Re-Forming the Past*, 123.

47. Paul Youngquist, "The Afro Futurism of DJ Vassa," *European Romantic Review* 16, no. 2 (April 1, 2005): 191; emphasis added.

48. I am using the Gates collection of slave narratives and will refer only to page numbers in subsequent references.

49. Notable works written by black women that exhibit the neo-slave narrative impulse include *Dessa Rose* by Sherley Anne Williams and *Beloved* by Toni Morrison. For more on neo-slave narratives, see "Witnessing Slavery after Freedom," in Deborah McDowell, *"The Changing Same": Black Women's Literature, Criticism and Theory* (Bloomington: Indiana University Press, 1995); Patton, *Women in Chains*, particularly chapter 5; and Angelyn Mitchell, *The Freedom*

to Remember: Narrative, Slavery, and Gender in Contemporary Black Women's Fiction (New Brunswick, NJ: Rutgers University Press, 2002).

50. Rachel Greenwald Smith, "Ecology beyond Ecology: Life after the Accident in Octavia Butler's 'Xenogenesis' Trilogy (Accidents in the Form of Environmental Catastrophes and Technological Breakdown) (Critical Essay)," *Modern Fiction Studies* 55, no. 3 (2009): 548.

51. "Test-Tube Baby Conceived in a Laboratory."

52. Dillaway, "Mothers for Others," 307.

NOTES TO CHAPTER 5

1. Bailey, *Butch Queens Up in Pumps*, 132.

2. "About Shay"; Youngblood, *The Big Mama Stories*, 12.

3. For more on Big Mama nostalgia, see Nash, *Bigmama Didn't Shop at Woolworth's*, and Big Mama, *When We Were Colored*.

4. Although Perry's performance has become the most notable of these drag performances, he joins the ranks of other notable black men, mostly comedians, who have dressed in drag to portray black mothers and grandmothers in the post–Civil Rights era: Martin Lawrence has made three movies as "Big Momma" and Eddie Murphy has cross-dressed as Sherman Klump's mother and grandmother in *The Nutty Professor* movies (Gosnell, *Big Momma's House*; Whitesell, *Big Momma's House 2*; Whitesell, *Big Mommas: Like Father, Like Son*; Segal, *Nutty Professor II: The Klumps*; Shadyac, *The Nutty Professor*).

5. I have been unable to trace any linguistic connection between the black vernacular term *Madea*, which also has variant spellings such as *Ma'Dear* or *Muh'Dear*, with the Medea of Greek mythology. However, there is an uncanny figurative connection between the two. The Medea of the ancient Greeks was known as an enchantress or a witch who kills her two children in a fit of jealousy after her husband falls in love with another woman. The power and dominance of Medea is similar to the perceptions of Madea in black popular culture.

6. "Entertainment," TylerPerry.com, accessed October 2, 2015, http://www.tylerperry.com/entertainment/.

7. I am grateful for the assistance of Milixa Vasquez, who helped me locate and catalog all of Perry's works.

8. Johnson, "Diary of a Brilliant Black Man," 10.

9. Some critics, such as veteran filmmaker Spike Lee, have suggested that the white-dominated movie industry privileges black entertainment that portrays "coonery and buffoonery," and that black audiences blindly and uncritically support their work at the box office ("Spike Lee on Tyler Perry's Movies Shows!"; "War Of Words"). Perry's Madea character is frequently referenced at the center of this debate, which has circulated in venues as varied as university classrooms, blogs, and academic conferences as well as within everyday conversations among friends and family. His plays and movies are also frequently critiqued as harshly critical of women. His portrayal of Madea has been likened to the Mammy stereotype and the other women characters have been described as stereotypical and flat. Still, despite these controversies, Madea movies remain popular, especially among black women viewers, who are Perry's target audience.

10. Lyle, "'Check With Yo'Man First,'" 944.

11. Persley, "Bruised and Misunderstood," 217.

12. For more on the connections and disjunctions between performance and performativity and their implications within critiques of race, gender, and sexuality, see Jacques Derrida, *Limited, Inc.* (Evanston: Northwestern University Press, 1977); Butler, *Bodies That Matter*; and E. Patrick Johnson, *Appropriating Blackness*.

13. Judith Butler explains in *Bodies That Matter*: "Performativity is thus not a singular 'act,' for it is always a reiteration of a norm or set of norms, and to the extent that it acquires an act-like status in the present, it conceals or dissimulates the conventions of which it is a repetition. Moreover, this act is not primarily theatrical; indeed, its apparent theatrically is produced to the extent that its historicity remains dissimulated" (12). In other words, for a particular "act" or "performance" of a particular norm to understood as a singular moment, the historical referents that structure that "act" or "performance" must be disguised, hidden, masked, and forgotten. In addition, the "act" or "performance" contributes to the production of a subject who manifests that set of norms and in turn constructs herself as the "originator" of her performance (13). So, not only are the historical referents of a particular performance muted within social relations, but those referents also remain concealed within the subjectivities through which they act.

14. Patricia Hill Collins describes how this formulation of power and strength emerged for black women. For black women, the historic legacy of slavery as well as African cultural retentions in the diaspora have necessarily created a view of motherhood that revolves around community, group survival, identity formation, and empowerment ("Shifting," 48). White feminist theories of motherhood assume, for example, that black women's everyday lives operate in discrete realms of work and family, public and private, or that black women's most pressing liberatory concerns are for their own, individual freedoms, rather than those of their collective racial and/or ethnic groups. However, black women continue to clarify how their lives do not adhere to the models of motherhood expressed by the dominant culture. Within many black communities, the status and advancement of an individual woman often has as much to do with her cultivation of others, especially children, as it does with the development of "self." Add to that the value placed on collective action and community building that came out of the civil-rights and black nationalist movements and it becomes clear that mothering work and child-rearing take on a prominent and powerful role in black culture that works on both theoretical and vernacular levels. As a result of these influences, a rhetoric of empowerment, Collins argues, becomes the central theme within black women's articulations of motherhood, and the figure of Big Mama exemplifies this site of difference.

15. Wallace-Sanders, *Mammy*, 5. As early as 1827, the Mammy appears in popular writing in her classic type—described as a dark-skinned black woman nursing a white child, signifying her prominent role as a patient and selfless nurturer of whiteness. Often portrayed as a wet nurse, but also as a cook, Mammy was used by the Southern planter class to portray slavery positively in opposition to the mounting abolitionist cause in the early nineteenth century, and she later shifted into the commercialized image that circulated in the postbellum period, exemplified by the character Aunt Jemima, who first appears in popular culture in 1893. In addition to Wallace-Sanders's study, other works have traced the history of Mammy in American culture. See McElya, *Clinging to Mammy*; Harris, *From Mammies to Militants*; Hale, "Domestic Reconstruction," in *Making Whiteness*.

16. A number of contemporary black women visual artists, including Carrie Mae Weems, Beverly McIver, and Kara Walker, have created works that draw on the ubiquity of the image of Mammy in U.S. culture but challenge the racist and sexist underpinnings of the icon. For example, Betye Saar depicts a sculptural Aunt Jemima in a shadow box holding a broom, a pistol, and a shotgun in her mixed-media assemblage titled *The Liberation of Aunt Jemima* (1972). The background of the shadowbox is tiled with repeated images of the smiling Aunt Jemima popularized by advertising, while the foreground includes an image of a Mammy holding a white baby. The signs of Mammy's subservience—broom, headscarf, and smile—are radically revised by the appearance of the guns, which implies that Mammy might have been resistant to the role that was ascribed to her.

17. Turner, *Ceramic Uncles & Celluloid Mammies*, 44.

18. Christian, *Black Feminist Criticism*, 2.

19. Turner, *Ceramic Uncles & Celluloid Mammies*, 52. Though Stowe's serialized novel was written as an expression of her abolitionist views, *Uncle Tom's Cabin* has become associated with popularizing on a mass scale some of the most troubling images of black slave existence.

20. Wallace-Sanders, *Mammy*, 44.

21. Dan Gardner (1816–80) is cited as the first performer to do a female part in black-face in 1835, and Nelson Kneass first played Aunt Chloe in a Tom Show in 1853. For more on blackface female impersonation in minstrel shows, see Mahar, *Behind the Burnt Cork Mask*, 327–28. Mahar's text provides helpful detail on the history of this performance convention; however, I disagree with his conclusion that blackface female impersonation was not centralizing a racial critique, nor were these acts "projected onto black representatives." The portrayal of black womanhood does not seem to be the "point" of blackface female impersonation in his view, and he argues that the representational effects of these performances on the lives of black women seems to be incidental. Sarah Meer's description of the practice seems more compelling when she describes the practice of blackface in Tom Shows thus: "Far from signaling a break with blackface representation, the interchangeability of Stowe's characters with stage ones is an indication of their kinship" (*Uncle Tom Mania*, 22). Therefore, the literary and stage versions of Aunt Chloe, as well as all of the major characters of the story, become conflated in the realm of performance. For Meer, blackface was the "benchmark" against which portrayals of black people were measured in the 1850s, which provides evidence for the lasting influence of blackface drag on the construction of the enduring image of Mammy. Patricia Turner also points to Tom Shows and blackface drag as influential in shaping the racialized and gendered performance of Mammy (*Ceramic Uncles & Celluloid Mammies*, 44).

22. McDaniel became the first black person to win an Academy Award for her portrayal of this "beloved" figure (Turner, *Ceramic Uncles & Celluloid Mammies*, 44).

23. Wallace-Sanders, *Mammy*, 2.

24. Johnson, *Appropriating Blackness*, 109.

25. Ibid., 110.

26. Ibid., 132.

27. Taylor, *The Help*. I do not intend to undermine the craft and superior artistic ability of Spencer or to suggest that her award was undeserved. However, I do want to emphasize the fact that Spencer also "looked the part," in the sense that she is a full-figured and dark-skinned black actress. Mammy-inspired characters are rarely, if ever, portrayed by light-skinned, thin, or small-breasted black women in stage or cinema, further yoking the image of the Mammy to a "magnificently physical" type. Patricia Turner notes that the popular visual image of Mammy contradicts the historic evidence that suggests that most of the enslaved house servants, cooks, and baby nurses were likely to be lighter skinned, mixed-race black women (*Ceramic Uncles & Celluloid Mammies*, 44). The "mulatto mammy" does appear in literature, however, as Wallace-Sanders's study discusses, in the works of Harriet Beecher Stowe, Mark Twain, and Charles Chestnutt. See *Mammy*, 73–76.

28. Mary Louise Anderson, "Black Matriarchy," 93.

29. Perry, *Don't Make a Black Woman Take Off Her Earrings*, xi.

30. Kinnon, "Bring Back Big Mama," 48.

31. For more on "black common sense," see Wahneema H. Lubiano, "Black Nationalism and Black Common Sense: Policing Ourselves and Others," in *The House That Race Built: Black Americans, U.S. Terrain* (New York: Pantheon Books, 1997).

32. Rhodes-Pitts, "My America," 148.

33. Ibid.

34. Alexander, *The New Jim Crow*.

35. Hortense Spillers, in her essay "Mama's Baby, Papa's Maybe: An American Grammar," argues that black mothers become "powerful" in contemporary terms only because legal enslavement removed access to the "Law of the Father" for captive children. Slave children followed the condition of the mother, but received no benefit or social legitimacy in this arrangement. Mothers themselves held no legal claim to their descendants, nor did they possess any real day-to-day control over their children's lives. However, since the Law of the Father represents "the prevailing social fiction" in the United States, the matricentric kinship system enforced by slave codes represents a source of degradation and abjection for the black female subject (228). This derivation of the black Matriarch symbol explains the strength of character that could exert itself only in the home, and there only very little, but whose mythical "strength" made her seem like a man. However, that masculinity was also limited in scope because her kinship units did not conform to heteronormative and patriarchal ideals of family. In other words, Spillers makes the point that black women's maternal strength is in legal and economic terms a reality of limited power; it is unrecognizable, unvalued, and outside the symbolic economy of the dominant culture.

36. Ibid., 228.

37. For more on race, class, gender, and sexual expression in ballroom culture, see Bailey, *Butch Queens Up in Pumps*.

38. Johnson's other transformative ethnographic work can be found in *Sweet Tea: Black Gay Men of the South*.

39. duCille, "Phallus(ies) of Interpretation." DuCille's essay offers insight into the problems of black men's gaze on black women's fiction. DuCille questions the "authority of the critical *I* to constitute the *Other* it beholds, even in the midst of reading the *Other*'s celebration of its own subjectivity" (445). If the male drag performer is the "critical *I*" and the black maternal figure is the "Other," what kind of authorial power does the male drag performer bring into his performance of the black mother? DuCille concludes that the imperative toward racial patriarchy often undergirds black men's analyses of black women's texts, leading to a misreading of their work and their representations. She later asks, rhetorically: "Is it possible for the male *I* to read the female text it others without reinscribing hierarchies of one kind or another, without in effect deauthoring and even deracializing the female beheld?" (445).

40. Spillers, *Black, White, and in Color*, 228.

41. Pamela K. Johnson, "Diary of a Brilliant Black Man."

42. Kate Davy, "Fe/Male Impersonation," 145. For more on camp vocalization and aesthetics, see also, Esther Newton, *Mother Camp*, 48.

43. Perry, "Don't Make a Black Woman," xi.

44. Butler, *Undoing Gender*, 105.

45. Bailey, *Butch Queens Up in Pumps*, 86.

46. In this section of his text *Butch Queens*, Bailey is careful to explain that black families are not distinctive in their exclusion of LGBT kin, and he refutes the popular notion that black people are more homophobic than other groups. However, he describes a sense of dislocation and the "familial deal" as means of describing the particular experiences that his interlocutors shared with him during his ethnographic study of black ballroom performance (86).

47. Perry, *Don't Make a Black Woman Take Off Her Earrings*, xvi.

48. Questions about Tyler Perry's sexuality have circulated on the Internet for many years, and rose to a peak when Perry described his childhood sexual abuse to Oprah Winfrey in 2010.

49. RuPaul, *Lettin It All Hang Out*, 26.

50. Ibid., 32.

51. Ibid.

52. Ibid., 23.

53. Ibid., 113.

54. For discussions of the "other" in black feminist criticism, see Mae Gwendolyn Henderson, "Speaking in Tongues: Dialogics, Dialectics, and the Black Woman Writer's Literary Tradition" and Valerie Smith, "Black Feminist Theory and the Representation of the 'Other'" in Cheryl A. Wall, *Changing Our Own Words.*

55. Spillers, *Black, White, and in Color,* 227.

56. Silberman, "Why RuPaul *Worked,*" 170. Charles I. Nero identifies signifyin(g) as a technique essential to the inclusion of black gay male voices into the body of African American literature, providing a revision of the "Black Experience" within African American literature, a way for black gay men to "create a space for themselves" ("Toward a Black Gay Aesthetic," 401).

57. Black comedian David Alan Grier spoofed the proliferation of black mother characters portrayed by men on his variety show "Chocolate News" in 2008.

58. Johnson, *Appropriating Blackness,* 3.

59. Johnson, "Diary of a Brilliant Black Man," 3.

NOTES TO CONCLUSION

1. Cooper, "Excavating the Love Below," 320.
2. Jordan-Zachery, *Black Women, Cultural Images, and Social Policy,* 14.
3. Cooper, "Excavating the Love Below," 320.
4. Jordan-Zachery, *Black Women, Cultural Images, and Social Policy.*

BIBLIOGRAPHY

"Abbey Lincoln Tribute—(Part Two) A Legendary Jazz Musician Has Died." Published September 6, 2010. YouTube. http://www.youtube.com/watch?v=cXFM_M0E33c&feature=youtube_gdata_player.

Abdur-Rahman, Aliyyah I. *Against the Closet: Black Political Longing and the Erotics of Race.* Durham, NC: Duke University Press, 2012.

"About Shay." Shay Youngblood's official website. Accessed May 9, 2013. http://www.shayyoungblood.com/about.php.

Ackerman, Erin M. Pryor. "Becoming and Belonging: The Productivity of Pleasures and Desires in Octavia Butler's Xenogenesis Trilogy." *Extrapolation* 49, no. 1 (Spring 2008): 24–43.

Alexander, Michelle. *The New Jim Crow: Mass Incarceration in the Age of Colorblindness.* Rev. ed. New York: New Press, 2012.

Anderson, Benedict R. O'G. *Imagined Communities: Reflections on the Origin and Spread of Nationalism.* Rev. ed. London: Verso, 1991.

Anderson, Mary Louise. "Black Matriarchy: Portrayals of Women in Three Plays." *Negro American Literature Forum* 10, no. 3 (October 1, 1976): 93–95.

Appleton, Andrea. "Marry Your Baby Daddy Day: Activist Marries Unwed Parents." *Christian Science Monitor*, February 14, 2008. Accessed June 3, 2013. http://www.csmonitor.com/USA/Society/2008/0214/p20s01-ussc.html?nav=topic-tag_topic_page-storyList.

Aschkenasy, Nehama. *Eve's Journey: Feminine Images in Hebraic Literary Tradition.* Detroit: Wayne State University Press, 1994.

Bailey, Marlon M. *Butch Queens Up in Pumps: Gender, Performance, and Ballroom Culture in Detroit.* Ann Arbor: University of Michigan Press, 2013.

Baker, Houston A. *Blues, Ideology, and Afro-American Literature: A Vernacular Theory.* Chicago: University of Chicago Press, 1984.

Baudrillard, Jean. *Simulacra and Simulation,* trans. Sheila Faria Glaser. Ann Arbor: University of Michigan Press, 1994.

Big Mama. *When We Were Colored: A Poetic Look at How It Was before We Overcame.* Aurora, CO: National Writers Press, 1986.

Bolden, Tony, ed. *The Funk Era and Beyond: New Perspectives on Black Popular Culture*. New York: Palgrave Macmillan, 2008.

Bonilla-Silva, Eduardo. *Racism without Racists: Color-Blind Racism and the Persistence of Racial Inequality in the United States*. Lanham, MD: Rowman & Littlefield Publishers, 2010.

Brooks, Daphne A. "All That You Can't Leave Behind: Black Female Soul Singing and the Politics Surrogation in the Age of Catastrophe." *Meridians: Feminism, Race, Transnationalism 8, no. 1* (April 2008): 180–204.

Butler, Judith. *Bodies That Matter: On the Discursive Limits of "Sex."* New York: Routledge, 1993.

———. *Undoing Gender*. New York: Routledge, 2004.

Butler, Octavia E. *Dawn*. New York: Warner Books, 1987.

Carretta, Vincent. *Unchained Voices: An Anthology of Black Authors in the English-Speaking World of the Eighteenth Century*. Lexington: University Press of Kentucky, 2004.

Christian, Barbara. *Black Feminist Criticism: Perspectives on Black Women Writers*. New York: Pergamon Press, 1985.

———. "An Angle of Seeing: Motherhood in Buchi Emecheta's *Joys of Motherhood* and Alice Walker's *Meridian*" in *Mothering: Ideology, Experience, and Agency*. Eds. Evelyn Nakano Glenn, Grace Chang, and Linda Rennie Forcey, New York: Routledge, 1994.

Cohen, Cathy. "Deviance as Resistance: New Research Agenda for the Study of Black Politics." *DuBois Review* 1, no. 1 (2004): 27–45.

Collins, Patricia Hill. *Black Feminist Thought: Knowledge, Consciousness, and the Politics of Empowerment*. New York: Routledge, 2000.

———. "Shifting the Center: Race, Class, and Feminist Theorizing about Motherhood," in *Mothering: Ideology, Experience, and Agency*. Eds. Evelyn Nakano Glenn, Grace Chang, and Linda Rennie Forcey, New York: Routledge, 1993.

Cooper, Brittany. "Excavating the Love Below: The State as Patron of the Baby Mama Drama and Other Ghetto Hustles." In *Home Girls Make Some Noise: Hip-Hop Feminism Anthology*, edited by Gwendolyn D. Pough, Elaine Richardson, Aisha Durham, and Rachel Raimist, 320–44. Mira Loma, CA: Parker Publishing, 2007.

Davis, Angela Y. *The Angela Y. Davis Reader*. Ed. Joy James. Malden, MA: Blackwell, 1998.

———. *Blues Legacies and Black Feminism: Gertrude "Ma" Rainey, Bessie Smith, and Billie Holiday*. New York: Pantheon Books, 1998.

———. "Recognizing Racism in the Era of Neoliberalism." *Truthout*. Accessed December 10, 2013. http://truth-out.org/opinion/item/16188-recognizing-racism-in-the-era-of-neoliberalism.

Davy, Kate. "Fe/Male Impersonation: The Discourse of Camp." *The Politics and Poetics of Camp*. Moe Meyer, ed. 130–48. New York: Routledge, 1994.

Dillaway, Heather E. "Mothers for Others: A Race, Class, and Gender Analysis of Surrogacy." *International Journal of Sociology of the Family* 34, no. 2 (October 1, 2008): 301–26.

"Director's Cut: Matt and Kim's 'Lessons Learned.'" *Pitchfork*. Accessed October 15, 2012. http://pitchfork.com/news/35215-directors-cut-matt-and-kims-lessons-learned/.

Doyle, Laura. *Bordering on the Body: The Racial Matrix of Modern Fiction and Culture*. New York: Oxford University Press, 1994.

Dubey, Madhu. *Signs and Cities: Black Literary Postmodernism*. Chicago: University of Chicago Press, 2003.

duCille, Ann. *The Coupling Convention: Sex, Text, and Tradition in Black Women's Fiction*. New York: Oxford University Press, 1993.

———. "Phallus(ies) of Interpretation: Toward Engendering the Black Critical 'I.'" *Callaloo* 16, no. 3 (1993): 559–73.

Edwards, Erica R. *Charisma and the Fictions of Black Leadership* (Difference Incorporated). Minneapolis: University of Minnesota Press, 2012.

Eliscu, Jenny. "The Soul and Science of Erykah Badu." *Rolling Stone,* April 15, 2010. Accessed June 29, 2013. http://www.rollingstone.com/music/news/the-soul-and-science-of-erykah-badu-20100415.

Emerson, R. A. "'Where My Girls At?': Negotiating Black Womanhood in Music Videos." *Gender & Society* 16, no. 1 (February 1, 2002): 115–35.

"Erykah Badu by Dat Boy Hot (aka Hot2def)." Uploaded on November 4, 2010. YouTube. http://www.youtube.com/watch?v=8-KIf79BHdY&feature=youtube_gdata_player.

"Erykah Badu Is Super Pissed at the Flaming Lips Right Now, About That NSFW Video." *Pitchfork*. Accessed June 12, 2013. http://pitchfork.com/news/46765-erykah-badu-is-super-pissed-at-the-flaming-lips-right-now-about-that-nsfw-video/.

Felsenthal, Kim D. "Creating the Queendom: A Lens on Transy House. " *Cultures* 6, no. 3 (November 2009): 243–60.

Fleetwood, Nicole R. *Troubling Vision: Performance, Visuality, and Blackness*. Chicago: University of Chicago Press, 2011.

"Full Transcript of the Mitt Romney Secret Video." *Mother Jones*. Accessed March 15, 2014. http://www.motherjones.com/politics/2012/09/full-transcript-mitt-romney-secret-video.

Fulton, DoVeanna S. *Speaking Power: Black Feminist Orality in Women's Narratives of Slavery*. Albany: State University of New York Press, 2006.

Gates, Henry Louis, ed. *The Classic Slave Narratives*. New York: Signet, 2002.

———. *The Signifying Monkey: A Theory of Afro-American Literary Criticism*. New York: Oxford University Press, 1988.

Giroux, Henry A. "The Terror of Neoliberalism: Rethinking the Significance of Cultural Politics." *College Literature* 32, no. 1 (2005): 1–19.

Giroux, Susan Searls. "Sade's Revenge: Racial Neoliberalism and the Sovereignty of Negation." *Patterns of Prejudice* 44, no. 1 (February 2010): 1–26.

Goldberg, David Theo. *The Threat of Race: Reflections on Racial Neoliberalism*. Malden, MA: Wiley-Blackwell, 2009.

Goldman, Anne. "'I Made the Ink': (Literary) Production and Reproduction in *Dessa Rose* and *Beloved*." *Feminist Studies* 16, no. 2 (Summer 1990): 313–30.

Gosnell, Raja, dir. *Big Momma's House*. Twentieth Century Fox. 2000.

Greenfield, Kent. *The Myth of Choice: Personal Responsibility in a World of Limits*. New Haven, CT: Yale University Press, 2011.

Grewal, Inderpal. "'Security Moms' in the Early Twentieth-Century United States: The Gender of Security in Neoliberalism." *Women's Studies Quarterly* 34, no. 1/2 (April 1, 2006): 25–39.

Griffin, Farah Jasmine. "At Last . . . ?: Michelle Obama, Beyoncé, Race & History." *Daedalus* 140, no. 1 (January 1, 2011): 131–41.

Hale, Grace Elizabeth. *Making Whiteness: The Culture of Segregation in the South, 1890–1940*. New York: Pantheon Books, 1998.

Hammer, Jill. *Sisters at Sinai: New Tales of Biblical Women*. Philadelphia: Jewish Publication Society, 2001.

Hancock, Ange-Marie. *The Politics of Disgust: The Public Identity of the Welfare Queen*. New York: New York University Press, 2004.

Harris, Trudier. *From Mammies to Militants: Domestics in Black American Literature*. Philadelphia: Temple University Press, 1982.

Harris-Perry, Melissa. "How We Made Our Miracle." MSNBC. Published February 18, 2014. Accessed March 20, 2014. http://www.msnbc.com/melissa-harris-perry/how-we-made-our-miracle.

———. *Sister Citizen: Shame, Stereotypes, and Black Women in America*. New Haven, CT: Yale University Press, 2011.

Harrison, Daphne Duval. *Black Pearls: Blues Queens of the 1920s*. New Brunswick, NJ: Rutgers University Press, 1988.

Hart, James D. "Jazz Jargon." *American Speech* 7, no. 4 (April 1, 1932): 241–54.

Helford, Elyce Rae. "'Would You Really Rather Die than Bear My Young?': The Construction of Gender, Race, and Species in Octavia E. Butler's 'Bloodchild.'" *African American Review* 28, no. 2 (July 1, 1994): 259–71.

Hendrickson, Paul. "The Ladies Before Rosa: Let Us Now Praise Unfamous Women." *Rhetoric & Public Affairs* 8, no. 2 (2005): 287–98.

hooks, bell. *Talking Back: Thinking Feminist, Thinking Black*. Boston: South End Press, 1989.

Horan, Tom. "'I Don't Require Sex for Happiness': Erykah Badu, First Lady of Nu-Soul, Has Three Children by Three Raps Stars." *The Daily Telegraph*, April 10, 2010, national edition.

Hyman, Naomi. *Biblical Women in the Midrash: A Sourcebook*. Northvale, NJ: Jason Aronson, 1997.

Inhorn, Marcia C., and Michael Hassan Fakih. "Arab Americans, African Americans, and Infertility: Barriers to Reproduction and Medical Care." *Fertility and Sterility* 85, no. 4 (April 2006): 844–52.

"IVF Used in Record-Setting 1 in 100 Babies in U.S." *NBC News*, February 17, 2014. http://www.nbcnews.com/health/kids-health/ivf-used-record-setting-1-100-babies-u-s-n32026.

Jain, Tarun. "Socioeconomic and Racial Disparities among Infertility Patients Seeking Care." *Fertility and Sterility* 85, no. 4 (April 2006): 876–81. doi:10.1016/j.fertnstert.2005.07.1338.

Johnson, E. Patrick. *Appropriating Blackness: Performance and the Politics of Authenticity*. Durham, NC: Duke University Press, 2003.

Johnson, Pamela K. "Diary of a Brilliant Black Man." *Essence*, March 1, 2006. 120–24.

Jordan-Zachery, Julia S. *Black Women, Cultural Images, and Social Policy*. New York: Routledge, 2009.

Juffer, Jane. *Single Mother: The Emergence of the Domestic Intellectual*. New York: New York University Press, 2006.

Khanna, Nikki. "'If You're Half Black, You're Just Black': Reflected Appraisals and the Persistence of the One-Drop Rule." *Sociological Quarterly* 51, no. 1 (2010): 96–121.

Kinnon, Joy. "Bring Back Big Mama." *Ebony*, May 1, 2004. 48.

Ladd-Taylor, Molly, and Lauri Umansky, eds. *"Bad" Mothers: The Politics of Blame in Twentieth-Century America*. New York: New York University Press, 1998.

Lauret, Maria. "How to Read Michelle Obama." *Patterns of Prejudice* 45, no. 1–2 (2011): 95–117.

Levin, Josh. "The Real Story of Linda Taylor, America's Original Welfare Queen." *Slate Magazine*, December 19, 2013. http://www.slate.com/articles/news_and_politics/history/2013/12/linda_taylor_welfare_queen_ronald_reagan_made_her_a_notorious_american_villain.html.

Liddell, Janice Lee. "Agents of Pain and Redemption in Sapphire's *PUSH*." In *Arms Akimbo: African Women in Contemporary Literature, Janice Lee Liddell and Yakini Belinda Kemp, eds. 135–46.* Gainesville: University of Florida Press, 1999.

Lindsay, Charles. "The Nomenclature of the Popular Song." *American Speech* 3, no. 5 (1928): 369–74.

Lordi, Emily J. *Black Resonance: Iconic Women Singers and African American Literature.* New Brunswick, NJ: Rutgers University Press, 2013.

Lugo-Lugo, Carmen R., and Mary K. Bloodsworth-Lugo. "Bare Biceps and American (In)Security: Post-9/11 Constructions of Safe(ty), Threat, and the First Black First Lady." *WSQ: Women's Studies Quarterly* 39, no. 1 (2011): 200–217.

Lyle, Timothy. "'Check With Yo'Man First; Check With Yo'Man': Tyler Perry Appropriates Drag as a Tool to Re-Circulate Patriarchal Ideology." *Callaloo* 34, no. 3 (2011): 943–58.

Mahar, William J. *Behind the Burnt Cork Mask: Early Blackface Minstrelsy and Antebellum American Popular Culture.* Urbana: University of Illinois Press, 1999.

Malone-Colón, Linda. "Responding to the Black Marriage Crisis: A New Vision for Change." Institute for American Values. Published 2007. Accessed June 3, 2013. http://www.americanvalues.org/bookstore/pub2.php?pub=30#.UazvtLbaiyA.

Marshall, Paule. *Brown Girl, Brownstones.* Chatham, NJ: Chatham Bookseller, 1972.

Maxile, Horace J. "Extensions on a Black Musical Tropology: From Trains to the Mothership (and Beyond)." *Journal of Black Studies* 42, no. 4 (May 1, 2011): 593–608.

McElya, Micki. *Clinging to Mammy: The Faithful Slave in Twentieth-Century America.* Cambridge, MA: Harvard University Press, 2007.

McGuire, Danielle L. *At the Dark End of the Street: Black Women, Rape, and Resistance—A New History of the Civil Rights Movement from Rosa Parks to the Rise of Black Power.* New York: Vintage Books, 2011.

McIver, Joel. *Erykah Badu: The First Lady of Neo-Soul.* London: Sanctuary, 2002.

Meer, Sarah. *Uncle Tom Mania: Slavery, Minstrelsy, and Transatlantic Culture in the 1850s.* Athens: University of Georgia Press, 2005.

Moore, Darnell L. "Black Freaks, Black Fags, Black Dykes: Re-Imagining Rebecca Walker's 'Black Cool.'" *The Feminist Wire.* Accessed June 12, 2013. http://thefeministwire.com/2013/02/black-freaks-black-fags-black-dykes-re-imagining-rebecca-walkers-black-cool/.

Nash, Sunny. *Bigmama Didn't Shop at Woolworth's.* College Station, TX: Texas A&M University Press: 1996.

Nelson, Jennifer. *Women of Color and the Reproductive Rights Movement.* New York: New York University Press, 2003.

Nero, Charles I. "Toward a Black Gay Aesthetic: Signifying in Contemporary Black Gay Literature." In *African American Literary Theory.* Edited by Winston Napier, 399–420. New York: New York University Press, 2000. First Published in *Brother to Brother: New Writings by Black Gay Men* (Boston: Alyson, 1991).

Newton, Esther. *Mother Camp: Female Impersonators in America.* Chicago: University of Chicago Press, 1979.

Norman, Brian. "The Historical Uncanny: Segregation Signs in Getting Mother's Body, a Post-Civil Rights American Novel." *African American Review* 43, no. 2/3 (2009): 443–56.

———. *Neo-Segregation Narratives: Jim Crow in Post-Civil Rights American Literature.* Athens: University of Georgia Press, 2010.

O'Meally, Robert G. *The Jazz Cadence of American Culture.* New York: Columbia University Press, 1998.

Omolade, Barbara. *The Rising Song of African American Women.* New York: Routledge, 1994.

Osherow, Michele. "The Dawn of a New Lilith: Revisionary Mythmaking in Women's Science Fiction." *NWSA Journal* 12, no. 1 (2000): 68–83.

Ostriker, Alicia. *Feminist Revision and the Bible.* Oxford, UK: Blackwell Publishers, 1993.

———. "The Lilith Poems." *Women's Studies* 26, no. 3/4 (May 1997): 251.

Parks, Suzan-Lori. *Getting Mother's Body.* New York: Random House, 2004.

Patton, Venetria K. *The Grasp That Reaches beyond the Grave: The Ancestral Call in Black Women's Texts.* Albany: State University of New York Press, 2013.

———. *Women in Chains: The Legacy of Slavery in Black Women's Fiction.* SUNY Series in Afro-American Studies. Albany: State University of New York Press, 2000.

Perlstein, Rick. "Exclusive: Lee Atwater's Infamous 1981 Interview on the Southern Strategy." *The Nation,* November 13, 2012. http://www.thenation.com/article/170841/exclusive-lee-at-waters-infamous-1981-interview-southern-strategy#.

Perry, Twila L. "Family Values, Race, Feminism and Public Policy." *Santa Clara Law Review* 36 (1996): 345–74.

Perry, Tyler. *Don't Make a Black Woman Take Off Her Earrings: Madea's Uninhibited Commentaries on Love and Life.* New York: Riverhead Books, 2006.

———. *Madea Goes to Jail.* Tyler Perry Company. 2009.

———. *Madea's Big Happy Family.* Tyler Perry Company. 2011.

———. *Madea's Family Reunion.* Lions Gate Films. 2006.

———. *Madea's Witness Protection.* Tyler Perry Company. 2012.

Persley, Nicole Hodges. "Bruised and Misunderstood: Translating Black Feminist Acts in the Work of Tyler Perry." *Palimpsest: A Journal on Women, Gender, and the Black International* 1, no. 2 (2012): 217–36.

Plaskow, Judith. "The Coming of Lilith: Toward a Feminist Theology." In *Womanspirit Rising: A Feminist Reader in Religion,* edited by Carol P. Christ and Judith Plaskow, 198–209. New York: Harper & Row, 1979.

Potts, Stephen W., and Octavia E. Butler. "'We Keep Playing the Same Record': A Conversation with Octavia E. Butler." *Science Fiction Studies* 23, no. 3 (November 1, 1996): 331–38. doi:10.2307/4240538.

"Public Forum: Wynton Marsalis & Suzan-Lori Parks." Published March 18, 2013. YouTube. http://www.youtube.com/watch?v=MgoaVV0FfTo&feature=youtube_gdata_player.

Rhodes-Pitts, Sharifa. "My America." *Essence,* August 2011, 148.

Roberts, Dorothy E. *Fatal Invention: How Science, Politics, and Big Business Re-Create Race in the Twenty-First Century.* New York: New Press, 2011.

———. *Killing the Black Body: Race, Reproduction, and the Meaning of Liberty.* New York: Pantheon Books, 1997.

Rosen, Christopher. "'Hunger Games' Racist Tweets: Fans Upset Because Of Rue's Race." *Huffington Post*. Published March 26, 2012. Accessed March 21, 2014. http://www.huffingtonpost.com/2012/03/26/hunger-games-racist-tweets-rue_n_1380377.html.

Rothman, B. K. "Cheap Labor: Sex, Class, Race—and 'Surrogacy.'" *Society* 25, no. 3 (1988): 21–23.

RuPaul. *Lettin It All Hang Out: An Autobiography*. New York: Hyperion, 1995. Sapphire. *PUSH*. New York: Vintage Books, 1996.

Segal, Peter, dir. *Nutty Professor II: The Klumps*. Universal Pictures. 2000.

Shadyac, Tom, dir. *The Nutty Professor*. Imagine Entertainment. 1996.

Shear, Michael D. "New Romney Ad Attacks Obama on Welfare Waivers." *The Caucus* (blog), *New York Times*, August 7, 2012. Accessed October 9, 2012. http://thecaucus.blogs.nytimes.com/2012/08/07/new-romney-ad-attacks-obama-on-welfare-waivers/.

Silberman, Seth Clark. "Why RuPaul *Worked*: Queer Cross-Identifying the Mythic Black (Drag Queen) Mother." *Territories of Desire in Queer Culture: Refiguring Contemporary Boundaries*. 166–82. Edited by David Alderson and Linda Anderson (Manchester: Manchester University Press, 2000).

"Slavery and Indentured Servants." Law Library of Congress. Accessed January 19, 2013. http://memory.loc.gov/ammem/awhhtml/awlaw3/slavery.html.

Smith, Felipe. *American Body Politics: Race, Gender, and Black Literary Renaissance*. Athens: University of Georgia Press, 1998.

Spaulding, A. Timothy. *Re-Forming the Past: History, the Fantastic, and the Postmodern Slave Narrative*. Columbus: Ohio State University Press, 2005.

"Spike Lee on Tyler Perry's Movies Shows! Its Coonery Buffoonery." Uploaded December 29, 2009. YouTube. http://www.youtube.com/watch?v=Ciwhh3fB6vE&feature=youtube_gda-ta_player.

Spillers, Hortense J. *Black, White, and in Color: Essays on American Literature and Culture*. Chicago: University of Chicago Press, 2003.

Stallings, L. H. *Mutha' Is Half a Word: Intersections of Folklore, Vernacular, Myth, and Queerness in Black Female Culture*. Columbus: Ohio State University Press, 2007.

Stephens, Dionne P., and April L. Few. "Effects of Images of African American Women in Hip Hop on Early Adolescents' Attitudes Toward Physical Attractiveness and Interpersonal Relationships." *Sex Roles* 56 (2007): 251–64.

Tate, Claudia. *Domestic Allegories of Political Desire: The Black Heroine's Text at the Turn of the Century*. New York: Oxford University Press, 1992.

Taylor, Tate, dir. *The Help*. DreamWorks. 2011.

"Test-Tube Baby Conceived in a Laboratory." *Time* 112, no. 4 (July 24, 1978): 47.

Thomas, G. "Queens of Consciousness & Sex-Radicalism in Hip-Hop: On Erykah Badu & The Notorious KIM." *The Journal of Pan African Studies* 1, no. 7 (March 2007), 23–37.

Turner, Jack. *Awakening to Race Individualism and Social Conscqiousness in America* Chicago: The University of Chicago Press, 2012.

Turner, Patricia A. *Ceramic Uncles & Celluloid Mammies: Black Images and Their Influence on Culture*. New York: Anchor Books, 1994.

Ulysse, Gina Athena. "She Ain't Oprah, Angela, or Your Baby Mama: The Michelle O. Enigma." *Meridians: Feminism, Race, Transnationalism* 9, no. 1 (2008): 174–76.

Van Meter, Jonathan. "Leading By Example." *Vogue*, April 2013.

"Vice President Dan Quayle—The 'Murphy Brown' Speech." May 19, 1992. In *Live from the Campaign Trail*, by Michael A. Cohen. Accessed March 16, 2014. http://livefromthetrail.com/about-the-book/speeches/chapter-18/vice-president-dan-quayle.

Vincent, Rickey. *Funk: The Music, the People, and the Rhythm of the One*. New York: St. Martin's Griffin, 1996.

Waldron, Clarence, "Erykah Badu Tells Why It Took 5 Years for CD *New Amerykah*." *Jet* 113, no. 8 (2008): 56–61.

Walker, Alice. *The Color Purple*. New York: Pocket Books, 1982.

———. "In Search of Our Mothers' Gardens." *Ms* 8, no. 2 (1997): 11–15.

Walker, Theodore. *Mothership Connections: A Black Atlantic Synthesis of Neoclassical Metaphysics and Black Theology*. Albany: State University of New York Press, 2004.

Wall, Cheryl A. Changing Our Own Words: Essays on Criticism, Theory, and Writing by Black Women. New Brunswick: Rutgers University Press, 1989.

Wallace-Sanders, Kimberly. *Mammy: A Century of Race, Gender, and Southern Memory*. Ann Arbor: University of Michigan Press, 2008. http://hdl.handle.net/2027/mdp.39015082696587.

"War of Words: Tyler Perry Vs. Spike Lee." NPR, April 21, 2011. Accessed March 5, 2013. http://www.npr.org/2011/04/21/135610190/war-of-words-tyler-perry-vs-spike-lee.

Washington, Harriet. *Medical Apartheid: The Dark History of Medical Experimentation on Black Americans from Colonial Times to the Present* (New York: Doubleday, 2006).

Whitesell, John, dir. *Big Momma's House 2*. Twentieth Century Fox. 2006.

———. *Big Mommas: Like Father, Like Son*. Regency Enterprises. 2011.

Williams, Patricia J. *The Alchemy of Race and Rights*. Cambridge, MA: Harvard University Press, 1991.

Williams, Timothy. "Jailed for Switching Her Daughters' School District." *New York Times,* September 27, 2011, 1.

"Window Seat: Erykah Badu's Explanation." Uploaded April 26, 2011. YouTube. http://www.youtube.com/watch?v=bI3qRovp1A8&feature=youtube_gdata_player.

Wright, Laura. "Casting the Bones of Willa Mae Beede: Passing and Performativity in Suzan-Lori Parks's Getting Mother's Body." *Tulsa Studies in Women's Literature* 30, no. 1 (2011): 141–57.

Youngblood, Shay. *The Big Mama Stories*. Ithaca, NY: Firebrand Books, 1989.

INDEX

Abdur-Rahman, Aliyyah, 30

abortion: Bill Bennett and, xii, 37; in *Getting Mother's Body*, 55, 61, 69, 71, 80; in *As I Lay Dying*, 185n15; legal access to, 62, 185–86n17; maternal ancestors and, 61, 73–75, 78, 80. *See also* reproductive rights

abstinence-only-until-marriage programs, 60–61

Affordable Care Act (ACA), 17

African American studies, 22, 171

African American vernacular English (AAVE): call and response in, 41, 181n11; in *PUSH*, 30, 39–40

African Diaspora, 88, 94, 127–28, 194n14

Afrocentrism, 94, 100

Afrofuturism: in *Dawn*, 23, 112; of Erykah Badu, 23, 88, 100, 104, 110; family networks and, 83; *The Interesting Narrative of the Life of Oluadah Equiano* and, 128–29; mothership and, 88–89; "queendom" and, 104

Aid to Families of Dependent Children (AFDC), 36, 182n20

"American Dream," 2, 5, 14, 42, 119, 142, 176–77n12

Ancestors, maternal presence, 61, 73–75, 78, 80

"anchor babies," 177n17

Appropriating Blackness, 149, 160

artificial insemination, 114

As I Lay Dying, 55–56, 185n15

assisted reproductive technologies: commodification of babies, 119; in *Dawn*, 124, 130–32, 138–39; domestic workers and, 122–23; errors with, 119–20; ethics of, 112; eugenics and, 119; fertility and, 114, 117–19; "forced donations," 132; monetary expense of, 114, 132; power and, 118, 132, 138; promise of, 132; reproductive experimentation and, 124; histories of black women and, 112–13; reproductive rights and, 185–86n17; slavery and, 120–21; surrogacy and, 124, 130; whiteness and, 119. *See also* surrogacy

Atwater, Lee, 13, 178n31

Atwood, Margaret, 113

"baaaad mutha," 6–8

baby mama, 2, 4, 18–19, 21, 33, 158, 176n12, 179–80

"bad mother," 5–7

Badu, Erykah: Afrofuturism and, 88, 100, 104, 110; agency of, 92, 104; albums of, 86; black maternal figures and, 87; black vernacular and, 111; as a Blues Mama,

BLACK PERFORMANCE AND CULTURAL CRITICISM SERIES
Valerie Lee and E. Patrick Johnson, Series Editors

The Black Performance and Cultural Criticism series includes monographs that draw on interdisciplinary methods to analyze, critique, and theorize black cultural production. Books in the series take as their object of intellectual inquiry the performances produced on the stage and on the page, stretching the boundaries of both black performance and literary criticism.

Mama's Gun: Black Maternal Figures and the Politics of Transgression
 MARLO D. DAVID

Theatrical Jazz: Performance, Àṣẹ, and the Power of the Present Moment
 OMI OSUN JONI L. JONES

When the Devil Knocks: The Congo Tradition and the Politics of Blackness in Twentieth-Century Panama
 RENÉE ALEXANDER CRAFT

The Queer Limit of Black Memory: Black Lesbian Literature and Irresolution
 MATT RICHARDSON

Fathers, Preachers, Rebels, Men: Black Masculinity in U.S. History and Literature, 1820–1945
 EDITED BY TIMOTHY R. BUCKNER AND PETER CASTER

Secrecy, Magic, and the One-Act Plays of Harlem Renaissance Women Writers
 TAYLOR HAGOOD

Beyond Lift Every Voice and Sing: The Culture of Uplift, Identity, and Politics in Black Musical Theater
 PAULA MARIE SENIORS

Prisons, Race, and Masculinity in Twentieth-Century U.S. Literature and Film
 PETER CASTER

Mutha' Is Half a Word: Intersections of Folklore, Vernacular, Myth, and Queerness in Black Female Culture
 L. H. STALLINGS

Printed in the USA
CPSIA information can be obtained
at www.ICGtesting.com
LVHW091530131023
760626LV00001B/3